Art apart

Art apart

ART INSTITUTIONS AND IDEOLOGY
ACROSS ENGLAND AND NORTH AMERICA

edited by Marcia Pointon

Manchester University Press

Manchester and New York

distributed exclusively in the USA and Canada by St. Martin's Press

Copyright © Manchester University Press 1994

While copyright in the volume as a whole is vested in Manchester University Press, copyright in individual chapters belongs to their respective authors, and no chapter may be reproduced wholly or in part without the express permission in writing of both author and publisher.

Published by Manchester University Press
Oxford Road, Manchester M13 9NR, UK
and Room 400, 175 Fifth Avenue, New York, NY 10010, USA

Distributed exclusively in the USA and Canada
by St. Martin's Press, Inc.,
175 Fifth Avenue, New York, NY 10010, USA

British Library Cataloguing-in-Publication Data
A catalogue record is available from the British Library

Library of Congress Cataloging-in-Publication Data
Art apart : art institutions and ideology across England and North America / edited by Marcia Pointon
 p. cm.
 Includes bibliographical references.
 ISBN 0-7190-3917-7. – ISBN 0-7190-3918-5 (pbk.)
 1. Art Museums–Great Britain–Management. 2. Art museums–North America–Management.
 I. Pointon, Marcia R.
 N1020.A78 1994
 708'.0068–dc20 93-44614

ISBN 0 7190 3917 7 *hardback*
ISBN 0 7190 3918 5 *paperback*

Designed in Adobe Minion
by Max Nettleton

Typeset by Servis Filmsetting Ltd, Manchester

Printed in Great Britain
by Bell & Bain Limited, Glasgow

Contents

Illustrations

Introduction

Le dessein de faire une Exposition propose, aussitôt conçu, une quantité de problèmes dans tous les ordres possibles. On pourrait même dire qu'il en propose une infinité, puisque, à chaque fois que l'on y pense, l'esprit ne manque pas de nous offrir une question nouvelle et quelque difficulté non encore aperçue.[1]

IN A RECENT DEBATE in the English upper chamber, the House of Lords, the young Earl Spencer, brother to the Princess of Wales and heir to one of the country's great and most ancient estates, made his maiden speech on the subject of managing and controlling public access to the historic sites of which he had recently become the owner. The gist of his speech was that the public needed to be corraled in one place, removed from sight, in order that 'one has them where one wants them . . . and not where one does not want them, which is everywhere'.[2] Implicit in Lord Spencer's speech is an acknowledgement that the public (that is, those who do not own acres of property and material goods of historical interest) have a right to some degree of access to those benefits and, at the same time, an expression of the unquestioned and unquestioning conviction that the object of any exercise in access is to keep people away for most of the time from most of what is owned in order for those who own it to go on enjoying it in an apparently timeless tradition. That this debate took place at all might be seen as a sign of the times in which even earls have to augment their income by opening theme parks and 'heritage' is just one more branch of business. On the other hand, it might be understood as yet one more attempt to engage with a politics of cultural control in which terms such as 'public' and 'access' have a long and problematic history.

Earl Spencer's preoccupations would have sounded a familiar note to the founders of what are now recognised as England's and North America's great public museums. Indeed, the theme of 'having people only where one wants them' – the recognition at one and the same time of the *necessity* of a public and the *uncontrollable* nature of that public – is reiterated through an imagery of imprisonment and criminality in the discourses of cultural institutions in England in the nineteenth century as Taylor and Trodd point out in this book. The shift from princely collection to public gallery in Europe in the early nineteenth century may often have appeared almost imperceptible to those at the centre of organising national museums; royal collections in many instances formed the core of national galleries.[3] Moreover the new public collections were often housed in former royal palaces or provided with new buildings

resembling palaces. They were, and still are, supervised by trustees drawn from wealthy (banking) and aristocratic classes.

The word 'trustee' reminds us that the role of such individuals was to hold in trust for the public good objects acquired on behalf of the nation. It remains the case that chairmen of boards of trustees wield more power than directors. Such men (and they were and continue to be almost always men) regarded national museums and their collections as extensions of their own private property – an attitude that has survived into a new era of museum-building, as the example of the Los Angeles Museum of Contemporary Art discussed in this book demonstrates. Twenty years ago, students of nineteenth-century culture would probably, in studying the development of museums and galleries, have studied the lives of men like Sir Henry Cole or John D. Rockerfeller Jnr. The authors of this book reject a history of art institutions as a history of the selfless generosity of a series of great men. But, in examining institutional structures they do not ignore individuals; the complex significance of Alfred Barr, for one, is established in Grunenberg's account of the early years of the Museum of Modern Art in New York. Individuals appear in this book, however, as part of a discursive account of cultural formation rather than as figures in a gallery of liberal heroes. It is the interaction of the individual with structures of government and forms of public morality and aspiration that are critically set out in many of the accounts in this book.

National museums were founded with the principle of 'access' as their very *raison d'être* and yet the trusteeship principle and the way it was practised ensured that these institutions would exist in a state of contradiction, in which the notions of private and public would provide the unresolved tension that both ensured their continuity and constantly threatened their permanency. Every museum, as many of the contributors to this book point out, involves a dialogue between inside and outside: the interior of the building versus its exterior; the curators versus the visitors; the objects contained within in relation to identical, comparable or different objects not inside the museum but elsewhere; the body of knowledge claimed and guarded by those designated museum professionals and contested by others outside claiming comparable but different knowledges. This oscillation might be summed up by the powerful image of the great doors of a museum slowly swinging shut at the end of the day, imprisoning its objects and excluding the visitors. For museums – which articulate via their displays, the organisation of their spaces and their written inscriptions, the principle of inclusion – are also of necessity about exclusion.

Museums, and I use the term generically, have become objects of fascination in academic discourse in the past ten years. Yet for all the publications that this fascination has provoked, there is a marked paucity of detailed

published research which links the often wide-ranging theoretical concerns of 'museology' with historically specific situations.[4] This book focuses particularly on institutions concerned with the fine and decorative arts – it does not deal, for example, with natural history museums – but it also seeks to demonstrate the blurring of distinctions and the uncertainty of boundaries across a range of institutions devoted to what is now loosely termed 'material culture', that is objects made by human beings and used in social circumstances. Thus, in Stanworth's study of the Literary and Historical Society of Quebec and in Coombes's examination of the ways in which the British Museum handled (and handles) its ethnographic collections, we have exemplary cases of an unresolved search for clarity of definition in the classification of objects.

There may be many reasons for the growth area of what has become known as 'museology': there simply are more museums in more places open more of the time and showing more things than before.[5] The invocation of 'heritage' and its metamorphosis into an industry has spawned its own professional publications and training programmes, and has provoked an increasingly sophisticated critical apparatus in the academy. There is, however, more to this fascination than opportunism or crude reaction. It is undoubtedly the 'inside/outside' quality of the museum (and I take the formulation from Stein's chapter in this book) that makes it such a rich paradigm for historical and critical evaluation. As Duncan and Wallach commented in a pathbreaking essay in 1980, the visitor to a museum follows an architectural script, engaging in an activity most accurately described as ritual.[6] The visitor to an exhibition or display apparently has free choice and yet the spatial structure and other elements of organisation predetermine a range of meanings to be produced. It is, in short, a dialectical space insisting on constant interrogation and definition.

The museum, moreover, offers the cultural historian a precise exemplar of the working of ideology – the ways in which interest, whether it be of the state or of a particular class or group, permeates and patterns cultural practices and acts of communication. Study of the museum offers the opportunity to understand artefacts functioning neither as isolated cultural icons or masterpieces, nor as emblems of personal wealth, but as components in a perpetually shifting language that works to create understandings of concepts such as 'the past', 'the present', 'art', 'nation', 'state', 'individual'. These are concepts that have a crucial part to play in recognising structures of power in a modern world and how those structures function.

I have so far used the word 'museum' and many of the chapters in this book do address institutions that would recognise themselves under this designation. Indeed, one of our objects is precisely to demonstrate the genesis and organising principles in some classic examples of the Anglo-American

museum. Thus we include studies of the National Gallery in London, the Museum of Modern Art in New York, the South Kensington Museum, the American National Portrait Gallery and the Tate Gallery. But this book also seeks to challenge the category 'museum', at the same time as it mounts a history and a critique of certain institutions described as museums. By drawing the analyses of the founding of a paradigmatic group of museums into a wider discourse of the institution, the very notion 'museum' is subject to a rigorous cultural critique. And here I come to the important elucidation of the senses in which the word 'institution' is used in this book.

Museums are institutions in the sense that they are specific types of organisation.[7] The Arts Council in Harris's essay and the Boston Institute of Contemporary Art in Guilbaut's are also clearly institutions in this fairly straightforward sense. But when Rorimer and Steyn explore the interaction between contemporary art-works in the spaces of the Chicago Art Institute in the 1970s and 1980s or in the Whitechapel Art Gallery in 1914 and the urban environment outside the gallery walls they are foregrounding the notion of the institution in an equally important but different way. They, and Brookeman, who writes about the covers designed by Norman Rockwell for the *Saturday Evening Post*, are overtly concerned not only with organisation but also with institution in the sense of general practices established in certain ways and having a strong connection with society and laws and customs. In Giddens's phrase, 'Institutions by definition are the more enduring features of social life'. Referring to the 'structural properties of social system' he intends to be understood 'their institutionalized features, giving "solidity" across time and space'.[8] All the essays in this book – both those that deal with the structures of organisations and those that deal with specific instances of how those organisations work, such as exhibitions – explore the interaction between the institution as organisation and the invention, preservation, rendering visible and subversion of features of social life designed to be enduring and thus to fulfil the demands of institution. The institution as organisation is thus the arena for the struggle of institutions as ideology.

Underpinning all the chapters in this book is a critical awareness of the importance of Walter Benjamin, Theodor Adorno, Michel Foucault, Pierre Bourdieu, Jean Baudrillard and other twentieth-century writers in whose work issues of space, viewing and spectatorship, power and control, have been extensively addressed. But whilst all contributors have a clear theoretical framework within which to work, the object of this book is not to parade theoretical know-how or to offer homage to theoreticians of culture but rather to provide a series of case studies accompanied by an informed interpretative analysis. So this book recognises the primary importance of documentary evidence – whether it be Hansard's reports of parliament or the visitor's book at

the Smithsonian's 'The West as America' exhibition – as an anchor in a critical/ historical interrogation. Consequently the reader will often find substantial sections of quotation; these passages permit a sense of the rhetorical strategies and the linguistic tenor of what were, and are, highly charged debates. They will also allow readers to undertake their own critical projects, drawing on primary material here made available often for the first time. At the same time, in interpreting the data presented, contributors to *Art apart* have borne in mind both the specific dynamic and the particular imperatives of the institutions they are investigating, *and* the wider issues of cultural politics that have helped to make the issue of arts organisation and museum management such an important topic in English-speaking societies in the late twentieth century.

Notes

1 P. Valéry, 'Une Probleme d'Exposition' (1937) reprinted in *Paul Valéry: regards sur le monde actuel et autres essais*, Paris, 1945, p. 293.

2 Reported in *The Guardian Magazine*, 13 July 1993, p. 3.

3 For a readily accessible general account, see D.Horne, *The Great Museum*, London, 1984.

4 For a summary of recent literature and its origins, see S. Selwood, 'Museums, heritage and the culture industry', *Art History*, 16:2, June 1993, pp. 354–8.

5 For a few among the many interesting recent studies, see R. Lumley, *The museum time machine*, London, 1988; P. Vergo, ed., *The new museology*, London, 1989; S. M. Pearce, ed., *Museum studies in material culture*, Leicester, 1989; I. Karp, C. M. Kreamer and S. D. Lavine, eds, *Museums and communities*, Washington DC and London, 1992.

6 C. Duncan and A. Wallach, 'The universal survey museum', *Art History*, 3:4, December 1980, p. 450.

7 See R. Williams, *Keywords*, London, 1976.

8 A. Giddens, *The constitution of society*, Cambridge, 1984, p. 24.

I

Whose museum?
Whose gallery?

FROM PENITENTIARY TO 'TEMPLE OF ART': EARLY METAPHORS OF IMPROVEMENT AT THE MILLBANK TATE

Brandon Taylor

THE ORIGINS AND EARLY HISTORY of the Tate Gallery at Millbank in London have thus far been examined only by art historians working within the institution, and then quite briefly.[1] I want to argue here that a more fully social account of these origins and this history will embrace concerns that extend far beyond the gallery as a self-enclosed institution, touching upon some central questions of British artistic culture in the later 1880s and 1890s. These concerns include the role of the government in sponsoring art, the development of a new middle-class public for 'British' art, the description and location of the working classes within that development, the redesign of London, and the articulation of the concept of 'nation' towards the end of Queen Victoria's reign. Many of these processes, I want to insist, emerge from the contemporary accounts – both public and official – in the form of metaphors of 'improvement': they are metaphors which mobilised the interests and investments of this new class by helping to define the character of its leisure spaces and the character of the 'cultural' within them, as much as they also integrated closely with the new images of national 'tradition' that that culture was thought to require. They are odd metaphors, I should say at once, and they emerge in some unexpected places. At their most general they involve ideas of order, cleanliness, posture and certain late-Victorian forms of enjoyment. They also include a particular sub-text that is worth emphasising for its very unfamiliarity – a fantasy about the eradication of crime.

It is impossible to begin to talk about a British art institution of the 1890s without referring to some basic stratifications within late nineteenth-century British social life, at least the social life of the metropolis and its dominant

groups. One image of the nation – that, roughly, presented to itself by the patrician, gentry and educated upper middle classes – was that of a nation at the height of its industrial and military powers, capable of virtually immeasurable 'progress' at home and abroad. The picture is still sometimes painted – for example in Winston Churchill's *History of the English speaking peoples* – of a nation basking in the sunshine of its conquests and effortlessly dominating whole regions of Africa and the wider world with a combination of military and diplomatic prowess resting on stable government and efficient manufacture at home. Victoria herself, for this constituency, was the very embodiment of the virtues of Progress, Prosperity and Empire.[2] But there is another image: that of a nation beset by declining trade, a crumbling urban fabric, and a government trapped in interminable debate over the Irish question. The trade slump of the mid-1880s and the ensuing riots in London had rung alarm bells of revolution for a few;[3] and the poor were giving rise to continued concern in regard to housing, education and pay. But for a larger middle-class consituency incomes were rising, business remained buoyant, and there was evidence from the aftermath of the Dock Strike of 1880 that well-managed unionisation could lead to the formation of a self-restraining and self-regulating working class.[4]

The experience of class was to prove central to the organisation of consciousness in, and of, the art museum in the 1890s, as it already had done in the 1830s and before. Visits to the museum could already be described as routine for the better classes by 1889, the year that Henry Tate first offered his collection of British pictures to the nation;[5] but because there was as yet no 'national' collection on view to the public in London – such as could be found in most other European capitals – the question of how such a collection should be displayed, where it should be housed, by whom it should be viewed, and when, admitted of no simple or obvious answer. Other collections had been given or left to the nation before, notably Sheepshanks's and Vernon's, but these were still housed in unsatisfactory accommodation at South Kensington, and were kept there in no clear relation to older British pictures at Trafalgar Square. The separating out of a specifically British 'modern' collection presented conceptual and logistical problems that are arguably still not solved today.

Much remains to be said about Tate's background in grocery and sugar retailing in Liverpool, his philanthropic philosophy and in particular his Unitarianism, and his activities as a cultural sponsor before he arrived in London in 1881. Having set up home in the grand style in Streatham he quickly became a friend of several prominent Royal Academicians and developed a *modus vivendi* which combined energetic devotion to the sugar business (now transferred to Silver Hill in East London) with the patronage of what he called British 'modern' art on a sizeable scale.

The characterisation of Tate's growing collection, the terms and prices of his acquisitions and even the nature of his preferences in art are matters which will also have to be dealt with elsewhere.[6] Given the opportunities for purchase in the 1880s, his relative lack of experience of the art of France and of other European countries, and his tendency to look primarily to England and its artists – less frequently the British principalities, or sculpture – Tate's collection was on any terms a fine one, certainly for the most part an admired one, at least by those who chose to visit Park Hill, his Streatham home, on Sunday afternoons, when it was laid open to view. Ranging from Constable, Etty and Crome to Millais, Waterhouse and Leighton, and including many of the so-called 'anecdotalist' painters of the later nineteenth century – Hook, Orchardson, Faed, Gow, Douglas and others – by the later 1880s it was expanding beyond the confines even of Tate's ample home, and it comes almost as an inevitable extension of his other philanthropic gestures – to hospitals, educational trusts and libraries – that he should begin to conceive of it as the basis for a national gallery of specifically national art.[7]

The actual transfer of property was far from simple. Tate's offer, first addressed to the National Gallery in a letter of 23 October 1889, was subject to three conditions, that:

> a room or rooms be devoted exclusively to the reception of the pictures; that such room or rooms should be provided or erected within two, or at most, three years from the date of the acceptance of the gift; and that the pictures when hung . . . should be called 'The Tate Collection'.

The Treasury, who had responsibility for marking the funds for such a gallery, at first sounded unhopeful unless room could be found in the already overcrowded space at Trafalgar Square; a condition that was thus unlikely to be satisfied.[8] Protracted discussions ensued, and the number of Tate's pictures on offer was reduced to a more manageable and more selective fifty-seven. From 1890 to the spring of 1892 a number of sites for a separate building were considered. Locations in or near the South Kensington Museum, Kensington Palace, and a site on the Embankment between Temple and Sion College were all explored. But progress was extremely slow. Lingering doubts about the quality of Tate's collection combined with negative press comment about his status as a 'sugar boiler' chimed well with a degree of uninterest on the part of Lord Salisbury's government – permanently preoccupied at this stage with the Irish tangle – aided by indecision and delay on the part of the Chancellor, Edward Goschen. Such shortcomings were at odds, of course, with the stated desire of the London art establishment to have a gallery of British art.[9]

The affair was galvanised, however, in 1892 by a proposal that had first been aired in connection with finding new buildings for the National Gallery back

in 1890. In a letter to *The Times* of 17 March 1892, Sir Edward DuCane, a water-colour painter and chairman of the commissioners of the Prison Act (1877), proposed that the land occupied by a disused penitentiary at Millbank might be put to use.[10] A further twist – the fall of the Conservative government at the election of 16 August 1892, defeated over Irish Home Rule and in disarray – had an immediate effect. Goschen's successor as Chancellor, the elderly liberal Sir William Harcourt, readily agreed for a portion of the land to be made over for a new gallery, and on 4 December 1892 demolition of the old penitentiary began.

The sudden change of location from central London to the Thames embankment made for a very different social and geographical understanding of the gallery that was shortly to be built. Away from the Kensington lands used for the 1851 Exhibition, which the London public had grown to associate with exhibition-going, Millbank, though near to Whitehall, had long remained a 'dangerous' location, excluded from the civilized city and heavily associated with dirt, inaccessibility and crime.

The Millbank prison, built as a massive structure of six polygons radiating from a central hexagon between 1813 and 1816, had been the largest penitentiary in Europe at the time of its construction (fig. 1.1). In a history of the prison published in 1884 it is described as 'the sole metropolitan prison for females', having already earned a reputation for performing service as 'the sole reformatory for promising criminals, the first receptacle for military prisoners, the great *depot* for convicts *en route* to the Antipodes'.[11] By the time this account was written the Millbank prison was on its last legs: a malfunctioning,

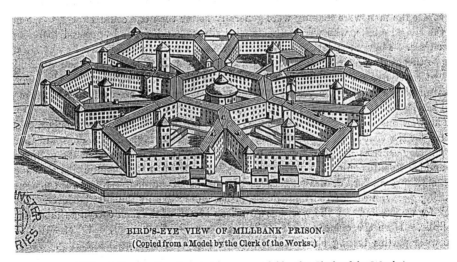

1.1 Millbank Penitentiary (copied from a model by the Clerk of the Works),
Westminster City Libraries archive (E137, Millbank per 3–5)

disease-ridden wreck, unsuitable for incorporation into the new centralised prison system and long since overtaken in design by Pentonville and other places.[12] There are several reports, from fiction and elswhere, of this almost forgotten corner of London. In *David Copperfield*, written in mid-century, Dickens had described the area as a site of decaying buildings and obsolete machinery:

> A sluggish ditch deposited its mud at the prison walls. Coarse grass and rank weeds straggled all over the marshy land in the vicinity. In one part, carcasses of houses, inauspiciously begun and never finished, rotted away. In another the ground was covered with rusty iron monsters of steam-boilers, wheels, crank-pipes, furnaces, paddles, diving-bells, windmill-sails and I know not what strange objects . . .[13]

Or there is Henry James's heroine Miss Pynsent, struggling through the gloom of the embankment with the young Hyacinth Robinson to visit the child's mother in gaol (James had visited the prison in 1884):

> They knew it, in fact, soon enough, when they saw it lift its dusky mass from the bank of the Thames, lying there and sprawling over the whole neighbourhood, with brown, bare, windowless walls, ugly, truncated pinnacles, and a character unspeakably sad and stern . . . This penitentiary struck her as about as bad and wrong as those who were in it; it threw a blight over the whole place and made the river look foul and poisonous, and the opposite bank, with its protrusion of long-necked chimneys, unsightly gasometers and deposits of rubbish, wear the aspect of a region at whose expense the gaol had been populated.[14]

It will be clear that I am trying to evoke the mood of desolation and remoteness that still pervaded this corner of London at the end of the 1880s. Although the areas to the south of the river – Vauxhall, Clapham and lands to the south and west – had been built up as suburbia since the 1860s, the inaccessibility and dirtiness of the area were still being regularly remarked. *The Daily News* said it was 'altogether unsuitable [for a gallery], being full in the face of half-a-dozen manufactories . . . a dirty spot . . . blue mould and green damp are the prevalent conditions of the region'.[15] DuCane in his letter to *The Times* warned that Millbank was far from the fashionable parts of London: the route from Westminster was 'narrow and is bordered by some shabby old houses . . . I cannot think, however', he said optimistically, 'that this one bad approach would deter anyone from visiting the picture gallery who wanted to, or who would derive any benefit from it'.[16]

The remote and despoiled character of the Millbank location made the successive designs for the new gallery all the more startling. Through a series of architectural signs they attempted to reclaim territory for 'civilized' London from the ravages of darkness and sin: firstly, with a series of elevations that

bore a structural resemblance to Wilkins's National Gallery and other more centrally placed museum prototypes where architecture already signified 'authority' and 'learning'; secondly, on the basis of a mass of regal and nation-alistic detail that provided signifiers of 'nation', 'tradition' and 'state'; and thirdly, on the basis of a 'temple' outlook over the river Thames, that was said to evoke ancient Rome.

Tate had already employed Sidney R. J. Smith to design a carriage entrance and a large garden folly at Park Hill in the classical style.[17] The first of his designs for Tate's gallery, intended for the site in South Kensington, followed Wilkins's pattern of central pedimented entrance flanked by two symmetrical wings, though Smith provided corner galleries on the ends (where Wilkins had to go back from the street), and a large sculpture of Britannia over the pediment. Lacking the gravitas of the British Museum or the elegance of Trafalgar Square, this first design was considered too light in scale in compari-son with what might be considered proper for a state or civic building.[18] To Goschen's complaint about its lack of height, Smith had already replied that it was not so insignificant: 100 feet to the cupola and 72 feet in the main part, compared with Wilkins's 62 feet and the National Portrait Gallery's projected 68. Smith claimed it would be as prominent as the Natural History Museum:

> I may say that Mr Tate instructed me to spare no trouble in producing a design which should have the best lighted galleries obtainable, and in order to attain this end I visited many of the picture galleries on the continent and in the provinces.[19]

With the move to the Millbank site now in prospect, Smith worked up his designs to an almost imperial scale. Now, in the spring of 1893, he proposed a massive central dome over a central Corinthian portico, with smaller glass domes on the wings and an elongated flight of steps at the front, raising the building up over its river frontage with some strenuous rustication in the basement (fig. 1.2). Now too there was pediment sculpture over the doorway, as in Bloomsbury, and a determined grandeur throughout.[20] This, the most imposing version of the design, the *Magazine of Art* called 'Italian in style . . . faced with Portland stone';[21] but objections were immediately voiced about the height of the glass domes, not least by some of the Royal Academicians whose works were in Tate's collection.

Several modifications were published before the final scheme emerged at the end of 1894, this time lacking the corner domes and the central drum and comparatively modest in ornament. The order was still Corinthian, but the niche statuary was gone – however, Britannia on the roof was now flanked by the lion and unicorn at the pediment ends (fig. 1.3). The *Art Journal* remarked on how it 'proclaimed its monumental purpose' externally.[22] *The Times*

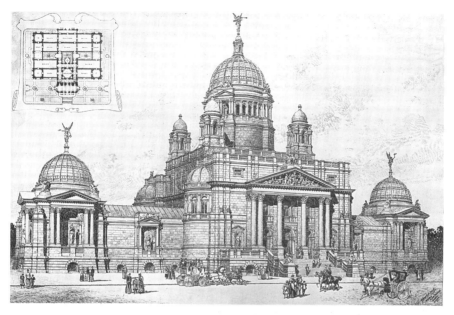

1.2 Illustration from *Magazine of Art*, June 1893. Courtesy of Tate Gallery Archive

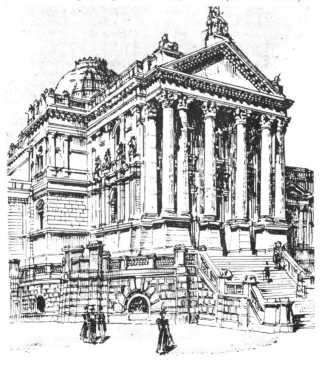

1.3 Tate Gallery, Millbank, front façade, 1897.
Courtesy of Tate Gallery Archive

thought the building was 'actual and permanent expression given to noble thought'.[23] *The Spectator* demurred

> It seems ungrateful to criticise Mr Tate's gift, but it is impossible not to wish that the outside of his building had been simpler and less grandiose in style. It is difficult to put an exact name to the architecture. Classic it is not, in spite of pediment and orders. There is something heathenish about its heavy pillars and frowning portico. This type of architecture has been happily called the Gorgonesque, and no other word defines the present building more closely . . .[24]

The reviewer in *The Year's Art* for 1898 called it 'a very poor and commonplace piece of construction',[25] but did not elaborate. In the spacious area provided by the demolished prison, the building was no doubt capable of looking isolated and squat. Alain-Fournier wrote some years later that it 'stands alone, small, circular, ugly'.[26]

But the most prominent assessment of the building had little to do with its classicism – which was mostly taken for granted – or with its ornament or its scale. It was the language of the 'temple' that came to the fore, frequently in conjunction with its river frontage. Here is one description from 1912:

> A shrine, no less sacred to Art than those classic monuments dedicated to Apollo and the Muses, or that lovely temple of Venus which is still standing on the flowing Tiber, is happily to be seen reflected in the waters of the Thames; flights of easy steps lead up to open portals, inviting and open to all . . .[27]

Indeed it was the image of the Tate Gallery as a 'temple' that was to be the enduring one, at least in the short and medium term. Both the appearance and the description of the gallery created a set of associations between art and religion that seemed to gratify the journalists, the more helpful politicians and the artists alike. Not only was the symbolism deemed to be appropriate, it served to identify the interior of the gallery as a place of escape from the cares of the outside world. Art, it was being implied, was akin to a spiritual value that would sanctify the urban mass at the same time as illuminate a dismal corner of London (and hence of the nation) with more elevated images and ideals.

The particular form given to this metaphor of enlightenment relied massively upon the demise of the old prison, combined with the appearance of the new gallery in its guise as harbinger of the 'progress of civilization'. It was a network of associations that was regularly endorsed. The opening of the building on Wednesday 21 July 1897, a glittering event attended by the Prince and Princess of Wales and numerous celebrities from government and the arts, was one such event. Having ascended the entrance steps to the accompaniment of the band of the Artists' Volunteer Corps, the royal party

were shown round the gallery, now replete not only with Tate's pictures but with those of the Chantrey and Vernon gifts from South Kensington, a number of British pictures from the National Gallery and a gift from G. F. Watts of his own works.

It is conventional to pay little attention to the speechifying that takes place on such occasions, shot through as it so often is with conventional plaudits and vague sentiments. True to form, the principal speakers on this occasion – Tate, Balfour, Harcourt and the Prince of Wales – liberally congratulated each other on the 'magnificence' of the new institution. But more specific values were celebrated too: the state's effective and prudent management of the arts, its concern for 'culture' and the 'nation', the balm of royal patronage, and the climactic progress of the history of England at the end of the reign of the Queen. Balfour referred to the 'radiance' which the Prince of Wales shed on the occasion, showering him with epithets connecting his very being with the health of art:

> The presence of no other individual [said Balfour] could by any possibility have shed such a lustre on the occasion or could more fittingly give public expression to the national gratitude for the generous gift which has today been opened to the public . . . We should all feel that had his Royal Highness not been able to be present today, this opening ceremony, this initiation of a new era and epoch in connexion with British art [cheers] would have lost half its grace and significance.

The Prince replied that he 'gave way to none in the love and appreciation that [he had] for Art', and that of all the year's ceremonies, 'none had given him greater pleasure than the one in which he was now taking part'.[28]

However, it was the theme of the prison that was most prominent. Balfour this time congratulated Sir William Harcourt:

> I believe it was his ingenious and happy thought to call into existence this cheerful temple of art upon a site hitherto associated only with suffering and crime, and none who can remember the old Millbank prison could, in their wildest imagination, have conjectured that in so short a period, by the generosity of one man, so vast a transformation could have been effected . . .

Harcourt, inserting a line from Byron – 'a prison and a palace on each hand' – and referring to the prospect of a soldiers' hospital and model dwellings which would also take the place of the old gaol, suggested that:

> the present appropriation of the site of Millbank is an illustration of what we have been contemplating in the last few weeks – the progress of society in England in the reign of the Queen [cheers]. When I first recollect Millbank it was a philosophical specimen of a reformatory prison; today it contains [a] Palace of Art.

The Prince of Wales, finally, had his say on the conversion:

> I am glad to think that in place [of the Millbank prison] we have this beautiful temple of art instead of a building where unfortunate criminals were undergoing punishment. I am inclined to think that in the gift which Mr Tate has made to the nation the nation will take now the place of the gaoler by taking care of all these valuable pictures, which I hope will ever remain within these walls, and to which many more, I hope, may be added . . .[29]

There is much to be gained, I think, from dwelling upon the metaphors which came so readily to the Prince's and others' lips in 1897. The sense of an equivalence between the gaol and the gallery was in danger of becoming a running joke in the speeches of 21 July. Certainly the language of the art museum – one which treated the pictures as 'in care' and the gallery as the 'keeper' of art – lent itself readily to a metaphorical connection of the two institutions. In fact, the possibilities of conceptual play which were contained in the building of a gallery on the site of an ancient gaol had already been recognised, well before the official speeches of July 1897. Back in December 1892, shortly after the demolition of the prison had begun, *Punch* had depicted the relations between Tate and the academicians as one of gaoler and gaoled (fig. 1.4), the artists trudging round the exercise yard with their pictures, Mr Punch looking on. The inversion was perhaps inevitable: the very unlikeliness of academicians in the gaol-yard is what made it a passable cartoon. At the same time, the cartoon may be said to have concealed (and therefore expressed) a pervasive anxiety about how to comprehend the re-use of a prison for political and cultural purposes, in a location so close to the heart of civilised London and the elite culture of the Academy itself.

I mean, in effect, that in 1892 the metaphor of 'improvement' was not yet quite a possibility at Millbank. For one thing, the prison structure was still standing, and the plans for the gallery were still in dispute. No sooner had the prison structure disappeared – demolished by disenfranchised workers from the docks and building trades – than the metaphor of 'transformation' became the most readily available motif. *The Daily News* in December 1893 hailed Sidney Smith's plans as leading to a gallery which 'some day no doubt would adorn a neighbourhood over which the hideous old gaol for so many long years threw a gloom and a general air of degredation and depression'.[30] By the time of the opening, three and a half years later, many of the daily and weekly papers had begun to elaborate on the change. *The Daily Graphic* spoke not merely of the replacement of the prison by the gallery, but of 'the splendid example set us by the *transformation* of Millbank Prison into Millbank Palace'.[31] The Prince's wry remark at the opening about 'the nation taking the place of the gaoler' met its response too. *The Daily News*, continuing the wordplay, hoped that the Prince's analogy would not be taken too literally when it

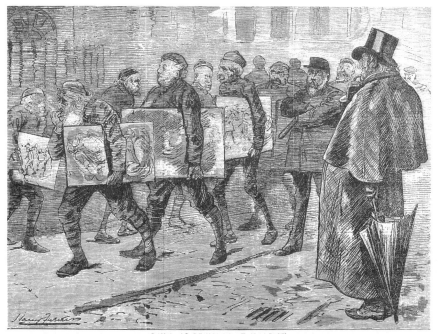

ROYAL ACADEMICIANS AT MILLBANK.

[" We understand that Millbank Prison, the site offered by Sir WILLIAM HARCOURT for the National Gallery of British Art, has been accepted by Mr. TATE."—*Morning Papers.*]

1.4 Cartoon, *Punch*, 17 December 1892

came to framing regulations for discipline in, and access to, the new establish-ment.[32]

It was a metaphor that was also flippantly elaborated in the upper-class press. The weekly magazine *Truth*, much given to puzzles and quizzes, expen-sive kitchen gadgetry and social events, invited readers' suggestions for the name of the new institution. They poured in. A significant number played on themes of the Queen, Britishness, or Tate himself: 'The Victorian Art Gallery', 'The British Gallery', 'The National Gallery', 'The Jubilee Gallery', 'Ars Britannica', 'The Art Temple', 'The Tatonian Institute', the 'Tate and Up-To-Date Gallery', the 'Tate, ah Tate (tête-à-tête) Gallery' – the latter suggesting the gallery as a place of rendezvous. Several more played upon the prison theme: 'The Reformed Art Gallery', 'The Millbank Prison Art Exhibition', 'The Cubicle' (a reference to Tate's cubed sugar), 'Penitentiaries', 'Prisoners' Base Gallery', 'The Transformed Gallery', the 'Lock Tallery or the Lock Tate' (a play on Charles Eastlake's middle name), and then finally 'The Millbank Gallery' – 'Why not?', wrote its proponent; 'There is nothing undignified in the name ... [it] is associated with crime and a prison ... Why not take it up, redeem it, glorify it with a new association?'[33]

Other suggestions were accompanied by poetry. The name 'The People's Rest' was delivered with the following verse:

> Where Millbank Prison frowned on noble Thame
> A Palace now doth play a worthy part
> And, gone for aye the dungeon's deepening shame
> We hail the People's Rest – fair home of art.

'Phoenix Gallery' had an explanation appended: 'I suggest this name as it is a thing of light and beauty arising on the crumbling dust of a place hitherto seethed in sorrow and shame'.

Its author was skilful at alliteration too, witness this pair of epigrams:

> 1. Where prisoners ate 'skilly' in their cells
> Skill'd artists now exhibit to the 'swells'

> 2. Here stood Millbank Prison, where convicts were confined
> Because each played in life dishonest part
> Not altogether chang'd, the Gall'ry to my mind
> For many here are captive held by art

A poem by H. D. Rawnsley in *The Westminster Gazette* echoed the problematic of 'capture':

> When the old monkish men of Westminster
> Wandered among their fields and watched the tide
> Surge up and brim and seaward turn, they cried:
> 'By ebb and flow Heaven's parable is clear!'
> And we who watched the generous builder rear
> His palace home for British painters' pride
> Where crime was purged and law was satisfied
> We feel God's river of good is refluent here

> Still by the ebb and flow of London's stream
> The Tides of Art will ebb and flow along
> No longer here pale prisoners shall be brought
> But multitudes in fetters pure and strong
> Shall stand enchained to dream the painter's dream
> And find these halls the prison-house of Thought[34]

We are now quite suddenly, I think, on different ground. Notice how each piece of verse – doggerel though the epigrams, at least, may be – shifts the principal image, changes the central metaphor. The second epigram ironically proposes that the gallery is '*not* altogether chang'd' from the prison function – the art audience is 'held captive' by art. Rawnsley's poem capitalises on 'enchainment' to convey a similar idea, that art 'holds captive', 'captures' or 'captivates' its beholders – its purpose is precisely to redeploy the language of 'capture' to characterise the experience of art.

Associations between the prison and the gallery have been frequent in recent art history, proposing, more often than not, a Foucauldian reading of the art museum that underscores the interpellation of an unsuspecting mass in regimes of surveillance and social control, before the spectacle of official culture.[35] These literary fragments from the 1890s represent a complete inversion of the Foucauldian thesis, suggesting, indeed, the kinds of positive valuations that one part of the art audience of 1897 wanted the experience of art to be accorded.[36] Clearly it was a romanticised and idealised valuation; a sort of ecstatic encounter from which this audience could not escape, nor be found wanting to.

But we already know that not all art is encountered on these terms, and that not all audiences would so describe the kinds of attraction exerted by the gallery's objects. The question then becomes *which* audience – and how that particular clientele was seeking to define itself against its old class adversaries in the 1890s with the help of a series of representations of the gallery, its spaces, and the decent way to behave and be made to feel within those spaces, that would make those divisions evident.

The way the Millbank public was constituted in 1897 – the way in which it represented itself to itself – provides much evidence for an obsession with deportment and with the pleasures to be gained from regularity and order. It was an essentially middle-class group. It comes as no surprise, given what has already been said, that the cameo illustrations printed in the London daily and weekly magazines between 1892 and 1897 produce Millbank as an educational and leisure site – in one case complete with sailing boats on the Thames – precisely contrasting with the gloom and redundancy of the old prison (fig. 1.5).[37]

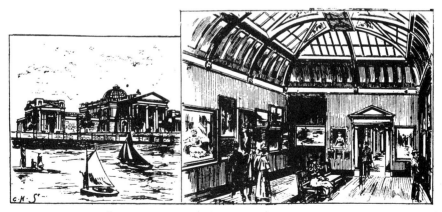

MR. HENRY TATE'S GIFT TO THE NATION: THE NEW ART GALLERY
AT MILLBANK, OPENED BY H.R.H. THE PRINCE OF WALES.

1.5 Illustration from *Penny Illustrated Paper*, 24 July 1897. Courtesy of Tate Gallery Archive

Early proposals for the remainder of the prison lands centred upon schemes for public gardens, that ideal of healthy and sober recreation that had come in during the 1820s to alleviate the confinement of the working class, but which now almost epitomised the rectitude of the middle class.[38] By 1897 the plans included an area for a military hospital and a sizeable new layout for London County Council housing for 'the poor of Clare Market' – soon to be demolished – although in practice it was scheduled for 'artisans', that new category of the respectable working class that had by now been effectively separated from the 'residuum' of the unredeemable poor.[39] The housing blocks that were (by 1902) eventually built at the back of the gallery site would be named after British artists, many of them Royal Academicians: a signifying practice for which the artisan class would presumably be expected to feel grateful, or at least worthy.[40]

There are few enough accounts in the contemporary journalism of the gallery-going public at Millbank – more space is devoted to the collection and to Smith's building – but several reports can be consulted. The gallery was not opened to the public until 16 August 1897; after which *The Norwood Press* found that

> many working men and women were to be seen wandering through the rooms and gazing with much interest at the pictures, for Grosvenor Road borders on a very busy working-class neighbourhood, and it seems evident that the residents there are not going to neglect the beautiful art gallery which has been placed so close to their doors . . .[41]

In some ways the report is typical of the attitude taken by the middle-class press towards working-class engagement with 'art'. The verbs 'wandering' and 'gazing' may be significant. They seem to imply that working men and women were at the very least unfamiliar with art – which conceivably they were – and with the codes of deportment and interest that were natural to the middle class. They may also be said to carry the suggestion that this 'other' audience was simple and relatively brainless. *The Daily Graphic*, too, depicts the working class as more or less stupefied by their first days in the gallery.

> Carriage folk were there in considerable numbers, but the majority of the visitors came from the immediate neighbourhood – people who had seen the vast octagonal prison-house disappear from among them and Mr Tate's handsome art temple rise in its place. Where once stood a building the inside of which no one wished to see, another has arisen, whose doors stand open . . . whose cool fountain courts and cheerful galleries invite the reposeful contemplation of things of beauty. And so the crowd, nothing loth, entered yesterday into possession of their new palace of art, gazed in curious admiration at the fountain with its goldfish, wondered at the clean tesselated floor, and having thoroughly

appreciated both, tried to understand the pictures, in which lay a new world of romance and mystery, mingled with the world they know better: on the one hand the allegories of Watts, on the other the realism of Frith . . .[42]

It is easy to tell – this is the point – who the real audience for the pictures was supposed to be. The same journal carried a line drawing the following week (fig. 1.6), to which a description was appended. The description says that the crowd was

as interesting as the pictures. The well-to-do citizen who was there to see some of the pictures he 'remembered years ago', and the citizen who having but doubtful domicile went in to have a rest; the dainty maiden, the costermonger, and the old maid; school board children, foreigners, the fashionable curate with his sister or somebody else's sister, the nondescript individual who may have passed a few days or longer in the original building – all were there . . .[43]

This then was the main fantasy – of a mixed audience at ease with itself, variegated and occupied. The drawing itself however shows a more consistent social milieu – the fashionable curate is on the right, perhaps, and the gentleman asleep, centre foreground; but he is surely not a 'person of doubtful

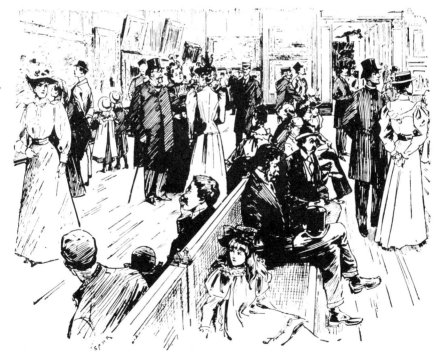

OUR NEW NATIONAL GALLERY : INSPECTING THE PICTURES AT MILLBANK

1.6 Illustration from *The Daily Graphic*, 24 August 1897. Courtesy of Tate Gallery Archive

domicile'? *This* crowd is represented as a gratifying unity; self-possessed, upright, well-dressed, peaceable, and apparently absorbed in art. It is in fact a class audience, precisely undefiled by the 'costermonger' or 'the nondescript individual' of the written note. The sole participant from the lower orders is the figure, lower left, with a working man's jacket and hat. Significantly, his face remains turned away from the viewer, kept out of sight; his body is thinly sketched – he is at best a *repoussoir* figure over whose shoulder we see the main audience constituted of the better middle class.

I think we can be fairly sure that the desire of the new art public was to be free of the contamination of the lower classes altogether. The right-hand part of the drawing in the *Penny Illustrated Paper* (fig. 1.5) shows a very sparsely populated interior, peopled by a pair of expensively dressed couples, accompanied by two symbols of the law: a uniformed attendant at the rear, and a policeman.[44] In fact the image arranges a constellation of class signs: it appeared at the foot of the 'World of Pastimes' page, below an article about fashion at the Sandown Race enclosure and the Henley Regatta, with which concerns it was apparently thoroughly continuous. The page as a whole presented an entire set of leisure 'pastimes', a well-dressed clientele, and above all that clientele's posture and social training. Inside the gallery, these individuals were secreted with the pictures they had come to see; undisturbed by alien class elements, social misfits, crime, poverty and the labouring mass. The highly polished floors, the classical door-arches, the comforting presence of the law, the day off – these are among the major significations of this art public in its new ambience. Such scenes, then, represented regulated, prosperous, even luxurious spaces for the actual or aspiring well-to-do.

But these representations of the gallery dovetailed neatly with other ways of describing its contents. The kind of solace that was on offer inside the Tate Gallery in its earliest months can be discerned from various written orderings of the pictures. One system – that of the gallery's *Descriptive and historical catalogue* of 1897 – was alphabetical, by artist's surname. It provided biographical information on every artist and a description of each work in terms of the narrative and action portrayed (e.g. 'a boy, balancing himself on his left foot, reaches forward with his right to touch a knuckle-bone standing on end in front of him; he must recover his position behind the line which he toes without putting his extended foot to the ground').[45]

Such descriptions can be called 'literary'. Their more interesting characteristic is that they tell the reader what is there to be seen reductively, that is, in terms of narrative and action, while omitting mention of methods of manufacture, means and devices of representation, and anything else that bore upon the language within which the piece had been conceived or made. Little beyond an ability to recognise what was written could be said to have been

needed for such a mode of attention: in conveniently fitting words to image such descriptions offered (and arguably foreclosed) the experience of paintings and sculptures primarily as manageable and unchallenging conversation-pieces. Moreover, as an official guide, the *Descriptive and historical catalogue* was scarcely permitted to cavil or criticise – that was left to independent publications such *The Sunday Times short guide*, published in September 1897. But this too, although it spoke from a non-institutional viewpoint, again reiterated a conviction in the propriety of the collection and its status as a legitimate display of modern British art. As particularly praiseworthy it singled out the works of Millais, Stanhope-Forbes, Constable, Waterhouse and the Pre-Raphaelites; while a few artists were distinguished as 'national' or 'typically English' such as H. S. Tuke or Briton Riviere, whose *Polar bear* of 1894, with its 'red sun-set [which] detects a white bear climbing a hill of blue ice' was described as being 'painted in the colours of the Union Jack'.[46]

The new audience for this writing, in fact, was made aware at most available opportunities that here was a British collection that would not suffer in the comparison with any other nation – particularly the French (as *The Sunday Times short guide* had it, 'the English public have in the National Gallery and the Tate Gallery an exact counterfeit [*sic*] to the Louvre and the Luxembourg at Paris').[47] Here, then, is a final 'improvement' metaphor that animated the official rhetoric of the later 1890s. Hitherto only France had had a vigorous national school and a vigorous commitment to its modern painters. Now Britain, or sometimes England, could participate in the stakes for national self-definition. There was some lurking confusion about the identity of the Millbank institution, nevertheless: on the one hand a collection of 'modern' British art (enshrined in the title 'Tate Gallery of Contemporary Art'); on the other, a showcase for the whole of the British School after 1790 (enshrined in the official title 'The National Gallery of British Art').[48] But most official voices inclined to a 'British', or sometimes an 'English', emphasis, notwithstanding the popular habit of calling the gallery merely 'the Tate'.

A graphic example of the latter tendency is the essay 'A national gallery of British art', which appeared as a preface to the catalogue of the Tate Gallery following its first extension rearwards from the river, in 1898–9. It is by Lionel Cust, Director of the recently opened National Portrait Gallery, and it attempted to construct the emergence of a 'British school' out of the general prejudice which had said

> that there is no national art in Great Britain . . . that our whole art is a mere worthless pastime, pursued . . . by foolish people who have nothing better to do, and by more foolish people who either cannot keep their money in their pockets or merely want a bright and handy decoration for their homes.

The prejudice, Cust continued, insisted that the 'British race' (*sic*) was no more artistic than it was musical, that it 'really prefers a Christmas oleograph, a touched-up photograph, a barrel organ, or a good swinging waltz tune'.[49]

Such was Cust's self-mocking description of the English (or was it British?) artistic malaise. But now he felt confident in claiming that in works from Reynolds and Gainsborough, through Hogarth, Crome and Constable, to Landseer, Morland, Ward, Maclise and Frith, there were 'inherent ideas of life and art which are not to be found . . . in the art of any country other than England'.[50] What Cust now defined as a 'British school' he claimed to be a century and a quarter old: it had supposedly begun with Sir Godfrey Kneller and William Hogarth at the Lincoln's Inn Fields academy in the first quarter of the eighteenth century and had produced some twenty-five or thirty thousand artists since. What, asked Cust, had become of their works, and what in their subject-matter and technique defined them as British?

In subject-matter, he claimed that

> Art in England has been for the greater part of its history, and more than in any other country, devoted to the purpose of illustration of historical and literary anecdote . . . It has formed part of the national desire for literary expression . . . it is not difficult to draw an analogy between the enormous literary output of the English-speaking race, and its efforts to express itself in art.[51]

Of technique, Cust was able to say only that if you took Reynolds, Hogarth, Opie, Turner, Constable and Landseer and hung them 'in a gallery with other foreign masterpieces of every school . . . the eye will be at once arrested, the mind at once instigated, by the presence of something peculiar to themselves . . . in the handling of the painting'.[52]

It was not much of an argument, perhaps; but it was the attempt at producing one that counted, in 1899. There was something millennial, too, in the suggestion that 'British art' had been born in the nineteenth century and would triumph in the twentieth: as Cust proudly related, 'in the closing years of the nineteenth century the nation is prepared to back its own countrymen to produce paintings or sculpture . . . equal in merit, if not superior, to those of any other nation'.[53]

Whether or not Cust realised it, that statement formed part of a much larger theme in 1899. In the first place, 'Britain' and 'England' still amounted to very much the same thing. Furthermore, the 1890s was, as Brian Doyle has recently argued, a period of reassessment of what it meant to be 'English' as a nation. It was the period of the elevation of 'English' as a substitute for classical languages within the national education system; a period too of the erection of national monuments to prominent Englishmen, the foundation of the National Trust for Places of Historic and Natural Beauty (1895), the launching

of the *Oxford English dictionary* (1884–1928) and *The dictionary of national biography* (from 1885), and the construction of historical traditions in such works as J. R. Green's three-volume *Short history of the English people* (first edition 1874). These projects formed part of a wider network to which the National Gallery of British Art belonged, and which can be said to have created, as well as catered to, a prevailing mood of national reassessment and rapid, if occasionally repetitive, redefinition.[54] Pride in 'the nation' was the important trope – but a nation that was now increasingly free of poverty, artistic illiteracy, and above all crime.

Of course, the metaphors of refashioning, reordering and redefining that were mobilised by, and echoed in, the opening of the Tate Gallery represent only one significant aspect of the event. The founding of the gallery also raised the possibility that 'philanthropic' individualism was ultimately compatible with a cultural authority deriving from the state and its civil service, and that something identifiable as 'the public good' could be defined by the conjuncture of the two. It apparently caused no difficulties either to Tate or his admirers that a plaque was erected in the sculpture hall of the new gallery at the moment of its opening which read: 'This gallery and sixty-five pictures were presented to the nation by Henry Tate for the encouragement and development of British art and as a thank-offering for prosperous business of sixty years'.[55] The Tate Gallery also represented a relatively new – for 1897 – compromise between the interests of entrepreneurial capitalism and the amateurish style of cultural management typical of the old nobility and aristocracy who still wielded power in government.

All that is true, and important. But I have tried to argue in this chapter that a far richer and essentially fictional discourse did most of the work in establishing the Tate Gallery as a site of culture and leisure (mostly) for the middle-class English public. In an act of almost consensual imagination, a set of images was circulated and legitimated, by comparison with which the financial or administrative investment in the gallery (pretty minimal anyway) pales into insignificance. The very idea of an institution of 'art' on the site of a former prison at the end of the nineteenth century provided an almost perfect vehicle for the real cultural work that could then be done: cultural work that was to prove powerful and enduring, and in which Henry Tate and his assorted pictures played an essential part.

Notes

This chapter is a revised and extended version of a paper read to the Annual Conference of the Association of Art Historians at the Courtauld Institute, London, on 13 April 1991. I am greatly indebted to John House, Alan Wallach, Edward Morris, Richard Wrigley, Marcia Pointon,

Jennifer Booth, Krzysztof Cieszkowski, Daphne Hayes-Mojon, Bill Rusby, Saxon Tate and Sir Henry Tate, for many different kinds of help and advice.

1 There are selective accounts of the origins of the Tate Gallery in the gallery's own publications from 1897, to which can be added K. Cieszkowski, 'Millbank before the Tate', *The Tate Gallery 1984–86: illustrated biennial report*, Tate Gallery Publications, London, 1986, pp.38–43, and R. Hamlyn, 'Tate Gallery', in G. Waterfield, ed., *Palaces of art: art galleries in Britain 1790–1990*, Dulwich Picture Gallery, London, 1991, pp. 113–16.

2 Churchill calls the period 'the climax of the Victorian era'; see his *History of the English speaking peoples*, vol. 4: *The great democracies*, p. 303. A less partial account is L. C. B. Seaman, *Victorian England: aspects of English and imperial history, 1837–1901*, Routledge, London, 1973, 1990, chapters 13–15.

3 'The proletariat may strangle us', Samuel Smith had written in the previous year, 'unless we teach it the same virtues which have elevated the other classes of society', in S. Smith, 'The industrial training of destitute children', *Contemporary Review*, xlvii, January 1885, p. 110; G. Stedman Jones, *Outcast London: a study in the relations between classes in Victorian London*, Oxford, 1971, p. 291.

4 For a useful summary, see Stedman Jones, *Outcast London*, pp. 239–349.

5 The number of museums of all kinds rose in Britain from fifty in 1860 to some two hundred by the end of the century. The statistic is from D. White, *New Society*, 20 October 1983.

6 The project of which this chapter forms a part is concerned with a longer yet still historically selective account of the major tropes and devices employed in the construction of an audience for art in London, from about 1820 or so onwards, at present reaching until about 1975. For the time being entitled *Art and the London public*, it will, I hope, one day show in some detail how the national institutions of art – principally the National Gallery, the Tate Gallery, the Royal Academy and latterly the Hayward Gallery – have been administered less by men (not yet women) than by ideas, images, metaphors and more or less faulty and pragmatic notions of artistic 'tradition'. The story is one of the intersection of these formulations with an equally rich and problematic set of notions about the audience and its modes of desire, over the same period. I also consider the patrons of London art, not only Tate but also Angerstein, Carr, Duveen, Courtauld and others, in more detail than is possible here.

7 It is not to be supposed that Tate's purchases were exclusively English, or British – a confusion I shall refer to again. Tate's 'foreign' collection, which he did not offer to the nation, is revealing. Here are forty-nine heterogeneous works by artists from France, Spain, Italy, America and Holland. None are Impressionists or members of the 'modern' school in that restricted sense. For the complete list, see *Catalogue of the collection of pictures of Henry Tate, Park Hill, Streatham Common*, London, 1894, which lists 101 British paintings, 49 'foreign' works, and 28 variegated watercolours.

8 For Tate's letter, the Treasury's response and subsequent correspondence, see *1890 report of the National Gallery to the Treasury*, pp. 4–5.

9 Ruskin had lectured to the British Institution in 1867 on the benefits of a gallery of national art; see his 'On the present state of modern art, with reference to the advisable arrangements for a national gallery', not published until 1905; see E. T. Cook and A. Wedderburn, *The works of John Ruskin*, vol. III, George Allen, London, 1905; he had been periodically supported since, so much so that it had become an accepted desideratum by about 1890. For example, the landscape painter James Orrock delivered a lecture at the Royal Society of Arts on 11 March 1890, which was supported by correspondents to the press; see e.g. *The Times*, 13 March 1890.

10 Letter from E. F. DuCane, *The Times*, 17 March 1892. DuCane was the author of *The punishment and prevention of crime*, 1885.

11 A. Griffiths, *Memories of Millbank, and chapters in prison history*, Chapman & Hall, London, 1884, pp. 1–2. The building of the penitentiary was supervised by Sir Robert Smirke, architect of the British Museum (1823–47).

12 See R. Evans, *The fabric of virtue: English prison architecture 1750–1840*, Cambridge, 1982, pp. 346–87.

13 C. Dickens, *David Copperfield*, London, 1850. Some other references can be found in K. Cieszkowski, 'Millbank before the Tate', to which I am again indebted.

14 On the inside, Miss Pynsent and Hyacinth had a 'confused impression of being surrounded with high black walls, whose inner face was more dreadful than the other, the one that overlooked the river; of passing through gray courts, in some of which dreadful figures, scarcely female, in hideous brown, misfitting uniforms and perfect frights of hoods, were marching round in a circle; or squeezing up steep, unlighted staircases at the heels of a woman who had taken possession of her at the first stage, and who made incomprehensible remarks to other women, of lumpish aspect, as she saw them erect themselves, suddenly and spectrally, with dowdy untied bonnets, in uncanny corners and recesses of the draughty labyrinths' (Henry James, *The Princess Casamassima* (1886), Harmondsworth, 1977, 1986, pp. 79, 82).

15 *The Daily News*, 3 November 1892.

16 E. DuCane, *The Times*, 17 March 1892.

17 S. R. J. Smith (d. 1913) is a forgotten figure. He was an eclectic architect who opened an independent practice in 1879 and whose buildings include public libraries at Norwood, South Lambeth Road, Brixton, Kennington, Streatham, Balham, Greenwich, Hammersmith; additions to All Saints Church, south Lambeth, All Saints' Institute, the Cripplegate Polytechnic Institute, Golden Lane, the library of New Bedford College, Regent's Park, and of the picture gallery at Park Hill, Streatham. There is a short obituary in *The Journal of the Royal Institute of British Architects*, 12 April 1913, p. 412.

18 It was published in *The Builder*, 19 March 1892, p. 226.

19 *The Times*, 18 March 1892.

20 *Building News*, 17 March 1893, p. 389.

21 *Magazine of Art*, June 1893, p. 264.

22 *Art Journal*, September 1897, where the building is described as 'Italian renaissance with Grecian motives', p. 287. See also *Art Journal*, December 1894, p. 373. The *Graphic* later had it as 'pseudo-classical in style, dignified in elevation and simple in plan', 17 July 1897. The *Daily Chronicle* expressed relief that it wasn't Gothic; that it 'has returned to the classic models that served for the National Gallery and British Museum', in the issue for 15 July 1897. See also *The Builder*, 2 January 1897, p. 17 for a summary of most of the changes to the design.

23 *The Times*, 15 July 1897.

24 *The Spectator*, p. 113.

25 H. Heathcote Statham, 'Notes on architecture in 1897', *The Year's Art*, J. S. Virtue & Co, London, 1898, p. 14–15.

26 Alain-Fournier, *Towards the lost domain: letters from London, 1905*, ed. and trans. W. J. Strachan, Carcanet, Manchester, 1986, p. 129.

27 Anne Ritchie, 'Alfred Stevens', *Contemporary Review*, April 1912, p. 487.

28 *The Times*, 22 July 1897.

29 *The Times*, 23 July 1897. See also *The Daily News*, 22 July 1897, p. 2, and the report in *The Daily Graphic*, 22 July 1897, pp. 1, 3.

30 *The Daily News*, 2 December 1893.

31 *The Daily Graphic*, 22 July 1897, p. 7. The contrast between the worlds of crime and art was again drawn, some four weeks later, by Lord Herschell in his opening speech at Reading Art Gallery: 'We all [he said] passed much of our time in the midst of what was calculated rather to depress than to elevate us, surroundings that were sordid, mean and unlovely. And this was the case none more than those who were engaged in the profession of the law. It must do us all good to come for a time from these surroundings to look upon pictures which depicted acts of heroism or self-sacrifice, or a quiet reposeful piece of nature which reminded us that our worries did not bulk so mightly in the arrangement of the world as we were apt to suppose. Those who came to this gallery would find not only enjoyment but would go away with their better selves refreshed and strengthened, and might carry away also a very real love of nature itself by seeing that nature depicted in works of art' (*The Daily Graphic*, 20 October 1897, p. 8).

32 *The Daily News*, 22 July 1897, p. 5.

33 They are all from *Truth*, 16 September 1897. The next issue of *Truth* admitted that 'It is quite clear that the public intend to call the new building at Millbank the Tate Gallery, so that it is useless to expect any of the suggestions made by the competitors to this competition to be adopted. To withhold the prize, however, on that account, is not my intention, and it will therefore be divided between [those who suggested] . . . "The British Art Gallery"' (*Truth*, 30 September 1897, p. 861). Tate himself, apparently, had not wanted his name attached. 'I do not wish it to bear my name, and I most certainly object to its being called "The New Tate Gallery". I have recommended the Government to call it "The National Gallery of British Art", and I hope it will be known by that name for all time' (H. Tate, letter to *The Daily News*, 4 December 1893).

34 *The Westminster Gazette*, 26 July 1897.

35 These might include parts of D. Preziozi, *Rethinking art history*, University of California Press, Berkeley, 1989, and my own 'Displays of power: with Foucault in the museum', *Circa*, 59, September–October 1991, pp. 22–7.

36 It would be perverse not to mention a certain geographical continuity between Foucault's 'carceral archipelago' and the gallery at Millbank. A London guide of 1820 says that 'the plan of this edifice [the Millbank Penitentiary] was principally founded on the *Canopticon* [*sic*] of that illustrious philanthropist, Mr Jeremy Bentham. The external walls form an irregular octagon . . . this vast space is intended to comprehend seven distinct . . . masses of building, the centre being a regular hexagon, and the others branching from its respective sides. By this means, the governor or overseer may, at all times, from windows in the central part, have the power of overlooking every division of the prison'; the aim of the establishment being to 'try to effect a system of imprisonment founded on humane and rational principles, in which the prisoners should be separated into classes, and be compelled to work; and their religious and moral habits properly attended to, as well as those of industry and cleanliness' (*London and its environs*, London, 1820, p. 117). It can safely be asserted that Bentham's inspection principle, in various forms, became the unifying principle of early nineteenth-century prison architecture (for a similar assessment see Evans, *Fabric of virtue*, p. 228). Built between 1812 and 1816 and finally finished in 1821 to a design of Messrs Williams, Hardwicke & Braithwaite, Millbank nevertheless contained several non-panoptic features that made it

something other than a pure 'iron cage, glazed'. It is ironic that it was at Millbank, or to be precise at nearby Tothill Fields in Pimlico, that Bentham had wanted his 'Panopticon, or Inspection House' built – the scheme was finally vetoed by the Home Secretary in 1811. But the penitentiary never fulfilled its reforming function in anything like Bentham's terms. By the 1890s it was precisely its reputation as unbeautiful and disease-ridden that provided the terms of the metaphors of cleanliness and enlightenment that became installed in representations of the new gallery. The gallery's foundations were built from the bricks of the old prison – that too made for a certain poignancy in the 'transformation'. But the argument that museums in general and art museums in particular are 'panoptic' in Foucault's terms is a wider one, and requires separate treatment. For a Foucauldian argument as it might be applied to the very different architecture of the nineteenth-century fairs and international expositions, see T. Bennett 'The exhibitionary complex', *New Formations*, 4, spring 1988, pp. 73 –102, and its review by L. Purbrick.

37 See for example *Penny Illustrated Paper*, 24 July 1897, p. 56.

38 See for example the diagram of the park on the Millbank side in *Pall Mall Gazette*, 31 March 1892, p. 2; proposed on the grounds that 'the park and the gallery would be within eight minutes easy walk from the Houses of Parliament. There is a steam-boat pier near, and Victoria Station is only a few minutes distant' (p. 2).

39 For a proposal that the area be populated by 'clerks, and others of a similar standing', see *The Daily News*, 2 December 1893: 'the eight or nine acres of land might thus be converted into a residential colony of a class somewhat superior to the "artisan" neighbourhood, and a little more in keeping . . .with the vicinity of this splendid national institution'. A plan which resembles the scheme eventually built was published in *The Daily Graphic*, 21 October 1897, p. 11. At this stage the LCC housing was reported as being for 'poor people who will be turned out of Clare Market in order to make room for other London improvements'. It would be 'a poor man's village; it may raise the tone of the Westminster slums, and it will be a boon to the Clare Market people, whom it will house at a distance not too distant from their means of livelihood in Covent Garden' (p. 11). For the concept of the 'residuum', see Stedman Jones, *Outcast London*, passim.

40 The artists whose names were affixed were: Reynolds, Morland, Maclise, Mulready, Millais, Ruskin, Rossetti, Hogarth, Stubbs, Turner, Gainsborough, Leighton, Landseer, Lawrence and Wilkie.

41 *The Norwood Press*, 21 August 1897.

42 *The Daily Graphic*, 17 August 1897.

43 *The Daily Graphic*, 24 August 1897.

44 See *Penny Illustrated Paper*, 24 July 1897, p. 56.

45 *Descriptive and historical catalogue*, 1897; the text concerns W. Goscombe John's Sculpture *Boy at play*, bought by the Chantrey Bequest in 1896 and exhibited near the visitors' entrance in 1897 and 1898.

46 *The Sunday Times short guide to the Tate Gallery of Contemporary Art*, Sunday Times, London, 1897, p. 28.

47 *Sunday Times short guide*, p.6.

48 For a residual confusion between 'modern' and 'contemporary' see the letter from Lord Leighton to *The Times*, 21 May 1891. I am indebted to Edward Morris for this reference.

49 Lionel Cust, 'A national gallery of British art' in *Catalogue of the National Gallery of British Art (Tate Gallery)*, Eyre & Spottiswoode, London, n.d., p. 6.

50 Lionel Cust, 'A national gallery of British art', pp. 6–7.

51 Lionel Cust, 'A national gallery of British art', p. 7.

52 Lionel Cust, 'A national gallery of British art', p.8.

53 Lionel Cust, 'A national gallery of British art', p. 10.

54 B. Doyle, 'The invention of English', in R. Colls and P. Dodds, eds, *Englishness in politics and culture 1880–1920*, Croom Helm, London, 1986, pp. 89–115. Green's history defines the chain of English history and society from the origins of 'the fatherland of the race' in the fifth century (vol. I, p. 1) to the second Disraeli government of 1874 (vol. III, p. 1850), complete with illustrations of English treasures, coinage, genre scenes, politicians and royalty, tables of genealogy, chronologies and explanations of the composition of the Union Jack. See also H. T. Buckle. *History of civilisation in England*, vol. I, London, 1902.

55 Reported in, for example, *The Sketch*, 28 July 1897, p. 3.

CULTURE, CLASS, CITY:
THE NATIONAL GALLERY, LONDON AND
THE SPACES OF EDUCATION, 1822–57

Colin Trodd

In the present times of political excitement, the exacerbation of angry and unso-
cial feelings might be much softened by the effects which the fine arts had ever
produced on the minds of men. Of all the expenditure, that like the present, was
the most adequate to confer advantage on those classes which had but little
leisure to enjoy the most refined species of pleasure. The rich might have their
own pictures, but those who had to obtain their bread by their labour, could
not hope for much enjoyment . . . The erection of the edifice [the National
Gallery] would not only contribute to the cultivation of the arts, but also to the
cementing of the bonds of union between the richer and poorer orders of state.

Sir Robert Peel[1]

[I must announce my misgivings] to the fitness of the present site for the collec-
tion of very valuable pictures, combined with unrestricted access, and the
unlimited right to enter the National Gallery, not merely for the purpose of
seeing the pictures, but of lounging and taking shelter from the weather; to
attempt to draw distinctions between the objects for which admission was
sought, to limit the right of admission on certain days might be impossible; but
the impossibility is rather an argument against placing the pictures in the great-
est thoroughfare of London the greatest confluence of the idle and unwashed.

Sir Robert Peel[2]

PEEL'S STATEMENTS articulate with some clarity the amorphous nature of the
National Gallery during the early years of its existence, for he sees it as some-
thing which oscillates and hesitates between a public gallery and an open space
of mass assembly. To be sure, these contradictory announcements represent
the two dominant positions from which this cultural institution is surveyed

and examined during a period in which it is drawn into the general economy of state administration through the agency of the Government Report.[3]

If, to paraphrase Raymond Williams, the cultural institution is not so much a concept as a problem,[4] this may have something to do with the values, practices, assumptions and customs which inform Peel's double reading of the National Gallery. What significant forms and forces are present in the language of this trustee of the institution? What are the structuring elements of his rhetoric? Well, his focus is established in and by such terms as leisure, labour and citizenship. In its movement from the subject to the body his language engages with a cluster of issues: the aestheticisation of power; the value of work as a marker of cultural identity; the gallery as a symbolic space of union; the interplay between dirt and idleness. In both statements the values of culture cannot be detached from the materials of urban life.

These articulations, and the relations between them, constitute some of the most important elements of the institutional lexicon by which Peel and other mid-nineteenth-century commentators addressed the National Gallery. Clearly it is impossible to form a history of the National Gallery in this period without addressing the network of discourses by which it was figured, framed and defined. In this chapter I will concentrate upon two areas of analysis: firstly the association of art with education and discipline and, secondly, articulations of history and the body in cultural discourse. Each is concerned with cultural and social identity. In both cases I will argue that identity is a relational term: that it involves the relay of meaning and the construction of models of value. In addition, I will look at the way in which contemporary conceptualisations and descriptions of space within the National Gallery were involved in these processes of identity formation. However, before developing an analytical overview of the National Gallery, it is necessary to map out some important historical markers in its emergence as a cultural institution.

The formation of the National Gallery

In April 1824 Parliament sanctioned the purchase for the state of the collection of the banker John Julius Angerstein. A Russian émigré, Angerstein had established an impressive collection comprising thirty-eight works by masters such as Raphael, Rembrandt, Sebastiano del Piombo and Claude. These paintings were acquired by Lord Liverpool's government for £57,000. In addition to buying the collection, the government took up the lease of his house, 100 Pall Mall, which became the first site of the National Gallery.[5]

The National Gallery opened to the public on 10 May 1824 under the administration of a keeper, William Seguier, and a Committee of

Superintendence. Also known as the Committee of Gentlemen, this group –
which consisted of Lord Liverpool, Lord Aberdeen, Sir Charles Long,
Frederick Robinson, Sir George Beaumont and Sir Thomas Lawrence –
formed the official governing body. However, the Trustees of the institution
did not convene on a regular basis until the appointment of Agar Ellis and
Robert Peel in 1827. They seem to have been responsible for the development
of a more professional practice of administration, because, in 1828, the first
minutes of the meetings of the Trustees were made. During the brief period of
Canning's administration (April to August 1827) the title of the National
Gallery became The Royal Gallery of Pictures, and then the Royal National
Gallery. However, there is no record of George IV visiting the institution, and
none of his pictures was donated to the growing collection. It was not until the
death of this monarch that the institution was once again called the National
Gallery.

By 1831 Long, now Lord Farnborough, and Ellis, who as Lord Dover was
Commissioner of Woods and Forests (and thus responsible for public build-
ing programmes in London), supported the transference of the enlarged
collection from Angerstein's house, where it was confined to three rooms. In
1832 C. R. Cockerell, John Nash and William Wilkins were all requested to
provide plans for the development of the National Gallery at a site on the
north side of a square which is now Trafalgar Square (fig. 2.1).

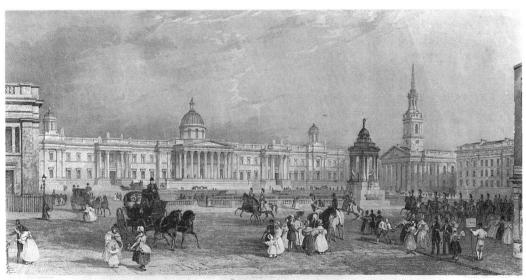

THE NATIONAL GALLERY — CHARING CROSS,
FROM THE DESIGN OF A. WILKINS ESQ." ARCHITECT.

2.1 The National Gallery, London, shortly after it opened, engraved after a drawing by Allom

The scheme proposed by Wilkins was approved in 1833, although his designs were the source of continued controversy in the press, parliamentary committees and the offices of government itself. Wilkins's proposals for a new building were attacked on a number of grounds: they assumed a structure which was to be low in proportion to length; his original design affirmed an axis which would interfere with the view of St Martin-in-the-Fields; the entire venture was deficient in terms of architectural decorum owing to the use of such pointless elements as the dome and turrets, as well as the appearance of the entablature which was more spartan than the florid capitals of the columns. In addition, the budget of the project was a constant problem and by the time the new building was opened by Queen Victoria on 7 April 1838 the initial estimate of £43,000 had been replaced by a bill to the Treasury which exceeded £77,000.

In the context of this essay it is important to note how criticisms of Wilkins's plans, designs and finished building drew upon the 'social profile' of a site boxed in by a workhouse and barracks. Thus we find *The Literary Gazette and Journal of Belle Lettres, Arts and Science* attacking Wilkins's conception in the following terms:

> It is proposed that the National School of Arts, the Barracks, and the poor-house, shall be erected and connected all together, in order that the artists who fail may enter at once into the army and commence drill; or if too old, or too short, or too feeble, for the service, that they may find the poor-house as handy as possible for their reception.[6]

A similar attempt to associate the 'failure' of Wilkins's project with the architecture of discipline and control was made five years later, in 1838, by *The Times*, when it referred to paintings 'deposited' within 'a honeycomb of cells'.[7]

Education, discipline, art

Before I examine the points of contact between specific systems of representation in critical discourse associated with art education, and particular technologies of power by which the National Gallery was encouraged to carve out for itself an institutional identity, it is necessary to consider how the value of education could be articulated in this period.

The monitorial method of education was one of the main sources for the association of instruction with discipline. Embodied in the schools associated with the educationalist Lancaster, and expressed in the writings of Colquhoun,[8] this system was based on the hierarchical division of subjects within controlled spaces. This process was supported on the grounds of efficiency and the creation of competition between students. Here discipline is to

be enforced because, in delegating work to the monitors, the teacher is able to exercise power over all elements of the assembled student body:

> The province of the master or mistress is to direct the whole machine in all its parts . . . it is for their business to see that others work, rather than work themselves. The master and mistress, from their respective chairs, overlook every part of the school, and give motion to the whole.[9]

We are not only dealing with a system in which education is identified as the manufacture of forms of communication and control, for, by observing the way in which the functions of the monitor and student are mapped out, we can see the manner by which the principle of the division of labour is extended to many areas of social life. No longer a technique confined to the economic realm, the division of labour makes its appearance within the classroom well before Prince Albert declares, in 1851, that because of its presence in the spheres of science, literature and the arts, it has become 'the moving force behind civilisation'.[10] Through the division of labour – the breaking down of the labour process into a series of discrete operations and the distribution of tasks within a regimented sequence – the space of education is identified as productive because it manufactures instruction as discipline. Thus we read in *The Westminster Review* of 1824:

> By this system attention is fixed: there is no idleness; the mind might be engaged in the business in hand; a lesson is to be said every ten minutes; the monitor's eye is on every child . . . the knowledge which is communicated is clear and precise, and it is fixed indelibly in the mind by repetition.[11]

Repetition within the temporal sequence, the reduction of the experience of education to the functional logic of work-time: this is the production of a narrative about time in which it is an infinity of separate yet repeatable moments. Within this discourse education becomes a process in which learning is identified with the specific culture of work; and the division of labour is mirrored by the division of time. The student is

> employed every minute of the time . . . either in the acquisition or communication of knowledge . . . instead of the languor and restlessness that too frequently prevails, all is activity and energy. More noise is heard; but the sounds are sweet, for they are the sounds of labour.[12]

Clearly the student is a unit in a system where everything is subject to a process of measurement and examination. Here is a mode of classification based on the complete transparency of instruction, discipline and power. All tasks, actions and movements are monitored or regulated within a space where education is employment because knowledge is equated with the management of time. Foucault is surely right to characterise the

development of this form of discourse as an example of the way in which the school is identified as a 'mechanism for training . . . a pedagogical machine'.[13] The monitorial school is a space where education produces hierarchical systems in which the subject becomes a functional element within the social mass. The logic of this model is that it operates as a disciplinary technology which provides total integration between the temporal and spatial orders through the codification of all acts, commands and signals. Thus the school becomes a 'machine for learning, in which each pupil, each level and every moment, if correctly combined, [are] permanently utilised in the general process of teaching'.[14] It should come as no surprise, therefore, that James Mill, one of the most important writers associated with *The Westminster Review*, went so far as to affirm that the ideal society would be structured like a monitorial school.[15]

If this was the dominant view of education, what of art education? How was it possible for contemporary commentators to identify or articulate the value of art education to the masses? What disciplines and pleasures was it seen to give rise to? Writing in 1861, George Godwin, editor of the *The Builder*, chairman of the Art Union of London and commentator on the urban question, claimed that:

> an acquaintance with works of art gives dignity and self esteem to the operative, a matter of no slight value as regards the stability of society, besides making him a better workman and furnishes him with delight, independent of position, calculated to purify and exalt.[16]

Godwin asserts that art is one of the forms and processes whereby the people can be socialised into the political culture of the nation: it directs their leisure-time and gives form to their work practices; and it thus displays both democratic characteristics and universal values. Art, it seems, is one of the means by which the operative gains access to his social being as both productive worker and respectable citizen. So, in this context, the value of the cultural institution lies not so much in what it exhibits as in what it represents: the formation of an educational space in which culture is made vivid as both symbolic form and social process.

Godwin's statement needs to be seen as part of the establishment of a framework in which culture is associated with rule, government and discipline. For instance, in 1832, during a parliamentary debate on education, the radical J. A. Roebuck affirms: 'as a mere matter of policy the education of the people ought to be considered as a part of the duties of government . . . I would give such knowledge as would create a taste for art'.[17] Fifteen years later *The Times* presents modern government as the symbiosis of law and culture:

Session after session we are amplifying the province of the legislature and assert-
ing its moral prerogatives. Parliament . . . is laying aside the policeman, the
gaoler and the executioner, in exchange for the more kindly and dignified func-
tions of the father, the schoolmaster, and the friend.[18]

Godwin's claim that 'the masses should not regulate art but art the masses'[19]
can be explained as part of a process whereby art education becomes one of
the cultural technologies for the dissemination of systems of discipline. By
addressing the sentiment – by associating power with aesthetics – it is possi-
ble to domesticate rule: to transform it into the social furniture of everyday
life in both its private and its public forms.[20] Culture is identified as the process
by which the subject is able to police himself in the art of citizenship. Thus, in
1849, *The Builder* claims that it is no longer possible to separate the people
from the fine arts: 'treasures . . . should be now opened to them, and they
should be trained for them by means of artistic discipline being made, hence
forward, an important part in the system of our national instruction'.[21] Twelve
years earlier *The Edinburgh Review* had declared that 'as education has
become a necessity to every class of the community, so must the fine arts be
made subservient to general education, to the moral and intellectual instruc-
tion and recreation of the people'.[22]

One could also refer to the case of Thomas Wyse, MP, chairman of the select
committee examining Art Unions, governor of the National Gallery, educa-
tionalist and reformer. For Wyse, education inducts the masses into the polit-
ical and cultural structures of the state. By defining the value of public
education as 'the management of the masses',[23] he echoes the language used by
Godwin. Discipline and instruction are presented as the formative elements
in the production of a leisure culture for the masses because social identity is
secured by cultural technologies which pattern education as a model of
citizenship. Here education is a cultural rather than a coercive power of the
state; and thus Wyse defines its value in the following terms: 'it induces habits
of regularity, industry and contentment'; and the educated labourer 'is a
citizen' because 'the structure of society, the principles of social happiness, are
familiar to him'.[24] He goes on to affirm that education and art are essential: 'the
legislature might pass laws, and the executive might punish; but . . . education
was the only thing to improve the moral condition of the people – the human
heart was the only and best police'.[25]

The display of identity

How could the National Gallery be articulated as a space concerned with
education, instruction and mass leisure? What sequences and norms were
associated with the articulation of its space? How were narratives of cultural

value identified with the processes of education? I shall argue that the princi-
pal agency by which this institution became associated with popular educa-
tion was the historicist discourse. Very briefly, this presupposed the
management of the collection and the display of the paintings according to
historical chronology. So, in traversing the space of the institution, the subject
would be absorbed into the spaces of history. This position becomes the norm
in the cultural criticism of the 1840s and 1850s. It is stated in the 1857
Government Report that

> the arts . . . cannot be properly studied or rightly appreciated by means of the
> insulated specimen alone . . . Your committee think that the funds appropri-
> ated to the enlargement of the collection should be expended with a view, not
> merely of exhibiting to the public beautiful works of art but of instructing the
> people in the history of that art, and the age in which, and the men by whom,
> those works were produced.[26]

Such language is echoed by Prince Albert. As an advocate of this system of
cultural management he declares public collections to be valuable as
'educational' resources to the extent to which they are 'scientific' and
'historical':

> If art is the purest expression of the state of mental and religious culture, and of
> general civilisation, of any age or people, an historical and chronological review
> given at one glance cannot fail to impress us with a just appreciation of the
> peculiar characteristics of the different periods and countries the works of
> which are here exhibited to us, and of the influence which they have exercised
> upon each other.[27]

Indeed, in the Government Report of 1853 he states that the National Gallery
should be a 'complete school of art' instead of a 'collection of pictures by good
masters, such as private gentlemen might wish to possess'. As a cultural
institution it should 'afford the best possible means of instruction and educa-
tion in the art to those who wish to study it scientifically in its history and
progress'.[28] Here the discipline of cultural management is articulated as an
agency of cultural authority whose legitimation is secured by the discipline
and order of history. Here art appreciation is managed and organized by a
model of history which is identified as the vector by which the meanings and
values of the moments of art can be grasped. For the historicists, then, art is a
series of temporal sequences which must be explained within a spatial pattern
in order to communicate with a mass audience. But what is it that this system
of cultural management is taken to communicate by managing and policing
the morphology of the collection?

Ruskin emerges in the 1850s as an important supporter of the historical
system of gallery management. In his evidence before the 1857 Government

Report he assumes that curators must establish the conditions that enable viewers to re-enter the space of history. Indeed, he sees the historicist discourse as the formation of a new system of knowledge, a new way of seeing history. 'Totally new results might be obtained,' he says,

> from a large gallery in which the chronological arrangement was perfect . . . [The works] should be . . . thoroughly characteristic and expressive of the habits of a nation; because it appears to me that one of the main uses of Art at present is not so much as Art, but as teaching us the feelings of nations. History only tells us what they did; Art tells us their feelings, and why they did it.[29]

He places art within a pedagogic network: we do not succumb to the beauty of art *qua* art; instead, we succumb to the beauty of the image of history which specific objects provide. Ruskin affirms that the National Gallery should recognise in paintings the symbolic language by which communities communicate in history by expressions of cultural identity; and he argues that the historicist discourse reunites art with its essential being because it reconnects it with history: in seeing art correctly we view history directly. The collection, then, is readable and educational to the extent to which it vivifies the identity of history.

The people, the spirit, the community: either or all of these subjects is the whole to which the fragments of historical representation aspire; and Ruskin therefore presents art as the totality which maps history as presence, reconstituting its being by delineating the collective body which is the source of its value. Clearly he believes that knowledge of history is knowledge of its referent; and thus he identifies the National Gallery as the space in which nations speak to contemporary subjects through art: 'the chronological arrangement' is, he states, a system of 'study' enabling the public to 'examine the general history of nations'; and painting is taken to be 'precious evidence'. Thus he affirms that it is 'the philosopher's work to examine the art of a nation as well as its poetry.'[30] In this account the historical understanding of art enables history to speak itself as art; and by studying the history of art we can decide whether or not a nation is 'energetic and fiery', or, as with the Dutch, 'imitating minor things, quiet and cold. All these expressions of feeling cannot come out of history. Even the contemporary historian does not feel them; he does not feel what his nation is'; in contradistinction, 'art speaks a language' and relates a 'tale which no written document can affect' because 'the whole soul of a nation generally goes with its art . . . in its art the mind of the nation is more or less expressed.'[31]

A similar approach is adopted by Mrs Jameson when she rearticulates the nature of aesthetic value which she connects with the knowledge of history:

There are pictures of little intrinsic beauty or merit which yet have great value and interest; they mark the transition from one style to another, or they indicate a particular phase in the life of the independent painter, or they illustrate a certain aspect of faith, of civilisation, of morals in the country which produced them.[32]

The spaces of social identity

So far I have examined figures for whom education absorbs subjects into the art of citizenship, or writers, like Ruskin, for whom the space of the cultural institution connects the viewer with the forms of history. Here the identity of the cultural institution or the collection is taken to be transparent: in both cases the construction of the relationship between cultural identity and social being is not seen to be problematic. In this section I will examine how articulations of social identity can affirm or transgress forms of cultural identity; and I address the interplay between social and discursive space because I want to demonstrate that at key moments patterns of discourse are shaped and managed by forms of group assembly.[33] These fields of analysis can be framed by examining two important declarations on the nature of aesthetic pleasure as an experience of value. The first is by the critic William Hazlitt in Angerstein's gallery in 1822, immediately before it became the National Gallery; the second is by the German art historian Gustav Waagen in 1853:

> The eye is not caught by glitter and varnish; we see the pictures by their own internal light. This is not a bazaar, a raree-show of art, a Noah's ark of all the Schools marching out in endless procession; but a sanctuary, a holy of holies, collected by taste . . . It is a cure . . . for low thoughted cares and uneasy passions. We are transported to another sphere . . . We breath empyrean air; we enter into the minds of Raphael, of Titian . . . and look at nature with their eyes; we live in times past, and seem identified with the permanent forms of things. The business of the world at large, and of its pleasures, appear like a vanity and an impertinence. What signify the hubbub, the shifting scenery, the folly, the idle fashions without, when compared to the solitude, the silence of speaking looks, the unfading forms within.[34]

> I have . . . been in the National Gallery, when it had all the appearance of a large nursery, several wet nurses having regularly encamped there with their babies for hours together; not to mention persons, whose filthy dress tainted the atmosphere with a most disagreeable smell. The offensiveness . . . from these two classes . . . I have found so great that, in spite of all my love for the pictures, I have more than once been obliged to leave the building . . . It is highly important, for the mere preservation of the pictures, that such persons should in future be excluded from the National Gallery. The exhalation produced by the

congregation of large numbers of persons, falling like vapour upon the pictures, tend to injure them; and this mischief is greatly increased in the case of the two classes of persons alluded to . . . it is scarcely too much to require, even from the working man, that, in entering a sanctuary of Art . . . he should put on such decent attire as few are without.[35]

These statements enable us to chart the early history of the National Gallery through the dominance of two discourses whose oppositional terms are best presented in the following manner. If Hazlitt defines the gallery as a cathedral of cognitive pleasures, Waagen describes a space of pollution. If Hazlitt refers to the gallery in terms of the purity of taste, Waagen finds in it nothing but endless traces of miasma. From the ethereal enchantment of empyrean air to the epic excreta of 'foreign' bodies, we witness the way in which the city enters the language of cultural discourse and the space of the cultural institution via the collective form of the crowd.

It would not be flippant to suggest that through the pronouncements of Hazlitt and Waagen the early history of the National Gallery could be written in terms of the substitution of the discourse of hygiene for the discourse of connoisseurship: first we see Angerstein's gallery as a cornucopia of aesthetic delight; then we see the space of culture invaded by a concatenation of malodorous forces. Hazlitt presents the gallery as an escape from the thraldom of urban life – the vulgar, theatrical aspects of commercial society – into the abstract and transcendental sphere of art; Waagen presents the body as the material form by which the power of the city reproduces its own identity *inside* the domain of culture. The image of the city is taken to deracinate aesthetic pleasure because it acts as the barrier between the commentator and the space of art.

For Hazlitt the experience of the gallery is charted as an entry into the space of pure meaning; and so attendance here affirms his status as a discoursing subject for whom engagement with art is absorption into a domain of universal value and communication. In this space of art the perception of value is indistinguishable from the being of consciousness, for in this realm of absolute and abstract knowledge, reflective consciousness, in coming into contact with the value of art, comes to know the value of personal identity. Hazlitt sees Angerstein's gallery as a landscape of retreat, a place totally removed from the shifting configurations of the urban domain whose quotidian pleasures are made and remade by the symbiotic powers of fashion and commerce. Later in the same article he writes:

A capital print shop . . . is a point to aim at in a morning's walk – a relief and satisfaction in the motley confusion, littleness, the vulgarity of common life: but a print shop has but a mean, cold, meagre, petty appearance after coming out of a collection of pictures.[36]

To see art is, for Hazlitt, to be absorbed by the vision it creates: it is to enter a space of pure vision which is beyond the body. However, at the same time, he presents aesthetic pleasure as a process which establishes and secures individual indentity. To understand art involves abstraction from the body itself and absorption into the language of the image. Clearly Hazlitt writes in order to affirm the self-authenticating nature of art, to confirm that the aesthetic is the highest form of consciousness and to demonstrate the cultural purity of Angerstein's domain within the environs of a commercial city.

In opposition to this, Waagen exemplifies the commentory of the 1840s and 1850s: that in becoming an 'environment' the National Gallery has become part of the corporate logic of urban life; and here the working-class body is identified as a mobile sign of a city defined as a network of filth and pollution. Indeed, Waagen presents the crowds at the National Gallery as more vivid than the culture they witness: bodies become barriers to the 'real' experience of aesthetic pleasure. Both the source and medium of dirt, the working-class crowd is seen to destroy the value of the experience of culture because Waagen defines its members as the form by which he is connected to the thick, material body of space. So, space becomes tactile as well as visual because it is now visceral as well as conceptual. In short, the collective working-class body transforms space itself into a body which must be resisted by the revisionary processes of Waagen's own discourse, for, like Hazlitt and other writers, this cultural commentator articulates space as the imaginary place or moment of purity in which communication should occur without unnecessary social contact.

Once identified as a space free from 'low' practices, formerly a place of polite assembly in which the alignment of body, discourse and taste was made vivid, by the 1850s commentators see in the National Gallery pollution, decay and the negation of the discursive purity of culture. Thus the assistant keeper, Thomas Uwins, is asked in the 1853 Government Report:

> The evils arising to the pictures from the atmosphere, appear to arise from the crowds who go there in cases of bad weather, and who go there without any regard for the pictures; have you observed that many persons, out of the 3,000 a day that . . . go into the Gallery do go there without reference to seeing pictures of high art?

He responds by saying:

> I have seen that many persons use it as a place to eat luncheons in, and for refreshments . . . many persons who come, do not come . . . to see pictures . . . I saw some country people, who had a basket of provisions, and who drew their chairs round and sat down . . . they had meat and drink; and when I suggested to them the impropriety of such a proceeding in such a place, they were very good humoured.[37]

Elsewhere the National Gallery could be presented as a space in whose iden-
tity people are literally unable or unwilling to see any value or quality that is
in any way different from that of the city. Here again is Uwins:

> there is a difference in the visitors on different days. Mondays . . . are . . . when
> a large number of the lower classes of people assemble there, and men and
> women bring their families of children . . . and they are subject to all the little
> accidents that happen with children, and which are constantly visible on the
> floors of the place; and on the days especially that the regiment which is quar-
> tered behind the National Gallery is mounting guard on St. James's; the music
> attracts the multitude; an immense crowd follows the soldiers, and then they
> come into the National Gallery . . . [they] certainly do not seem to be interested
> at all about the pictures.[38]

The city, then, speaks through the bodies of the working class for whom the
National Gallery is taken to be merely one point in a chain of interchangeable
spaces. Faced with a variety of different events, spaces and experiences, the
working class, Uwins claims, merely add them together and apportion equal
value to them all.

There are a couple of points which are worth mentioning here. Firstly, as
the National Gallery leaves the 'private' space of Angerstein's residence in Pall
Mall, and is transferred to Trafalgar Square, it is defined as an arena of popular
instruction and recreation within the institutional matrix of the urban
environment: a place where the materiality of social relations can be regis-
tered. Secondly, in addition to being subject to a panoply of investigatory
practices which focus upon hygiene, dress, appearance and behaviour, the
body of the working-class subject is surveyed in detail because it is seen to be
devoid of those traces which would denote the 'correct' use of leisure-time. As
early as the 1841 Government Report, Thwaites (Uwins's assistant) is asked
about the appearance of the working class in the National Gallery: 'have they',
asks the chairman, 'shown much interest in the pictures?'[39] In the 1853
Government Report, Frederick Hurlstone, president of the Society of British
Artists, is asked:

> Must you not subtract from the number who visit the gallery all mere loungers
> who, happening to be in the vicinity of the gallery, go in order to fill up time;
> there are large numbers . . . who go in to escape bad weather, and there are
> others who go for other purposes . . . excluding all such persons, do you think
> there is any considerable portion of the working classes who go to the gallery
> for the purpose of visiting and looking at works of art?[40]

These accounts may be seen to lack an ability to conceptualise the value of
leisure. They cannot establish the content of leisure, such commentators
believe, because they do not involve themselves in the mental and physical

labour of leisure. Such figures are taken to be the shifting and amorphous forms by which the crowd establishes its vagrant identity; and thus the presence of these subjects is codified through the language of hygiene rather than that of leisure. So, for instance, Lord Russell claims in the 1853 Government Report:

> I think you will find that on wet days many persons go in there with no other object than to obtain shelter from the rain; and much more copious emanations and exhalations would arise from their clothing than from that of other persons who went decently dressed, and for the real purpose of seeing the pictures.[41]

In the 1835 Government Report the architect C. R. Cockerell is asked:

> Do you think that it is desirable even among artisans to encourage the knowledge of correct principles of design, to encourage among the lowest class all that portion of art founded upon principle, which might be called almost the science of art . . . would such instruction be . . . a benefit to the mind of the artisans . . . ?

He replies in the following manner:

> I do not think such knowledge compatible with the occupations of artisans, and the encouragement of it would mislead them and interfere with their proper callings, and right division of labour, in which excellence already requires all their ability. There is a wide distinction between art and fine art; in the latter the knowledge of artisans whose bread is earned in laborious work, must be always very limited, compared with those who have original genius for it.[42]

The Government Reports confirm that the spatial and temporal matrices of nineteenth-century urban capitalism begin to register in an institutional environment hitherto defined by its autonomy from the practices and rituals of the city. Indeed, we see with the testimony of Cockerell that the commodification of time and space which capitalist work practices engender leads to the conclusion that the working-class subject is unable to extract aesthetic value from the contents of leisure or instruction in the National Gallery. The worker is, according to this perspective, compromised for two reasons. Firstly, his identity is taken to be secured, not by himself but by the division of labour: he is his occupation. Secondly, this occupation is deemed to be sufficient evidence that here is a mode of consciousness shaped and patterned by the particular processes of work within the system of the division of labour: work divides the worker from that expansiveness of being which is a prerequisite of disinterested aesthetic contemplation.

In the 1857 Government Report the architect James Fergusson suggests

that the working class cannot distinguish between ordinary buildings and real architecture; that they appreciate images of smugglers rather than representations of noble historical or religious subjects.[43] In the same document Waagen declares that the working class enjoy images but cannot understand art.[44] In both cases working-class identity is seen to block any real understanding of the true value of collections of art. The Government Reports, then, demonstrate that the issue of working-class involvement in the National Gallery could not be separated from the contemporary realisation that the capitalist mode of production – and the disciplinary technologies associated with the surveillance of labour in its definition as labour power – acted upon the material conditions and patterned the structural dynamics of working-class social existence.

If the organisation, discipline and management of the school is bound up with the idea of employment, then the logic of work-time is seen as the structuring process by which to calibrate the value of the gallery visit by the working-class subject. We can conclude by affirming that the Government Reports indicate that the spatial and temporal matrices of nineteenth-century urban capitalism were the determining factors in the classification and definition of working-class presence in the National Gallery, and that the commodification of time and space inherent within capitalist work practices confirmed the distance between the worker and the realm of culture. Segmented, serial, homogeneous, and perfectly divided: the capitalist temporal matrix works on and organises the relation between work and leisure.[45] If disciplinary technologies were present in the factory, they also acted as the discursive frame for the formal account of the value of the working-class visit to the National Gallery. In the Government Reports work-time is the medium by which leisure is given value, for work is presented as the truth of leisure-time. Thus for workers, 'instruction' is, as one contemporary writer put it, 'adapted to their condition',[46] because the substance of instruction sustains its value or meaning in relation to the recursive nature of 'universal and objective' work-time.

I have addressed two narratives. Firstly by the 1840s and 1850s the National Gallery was involved in the construction of an institutional identity which focused upon history, education and popular instruction. Secondly, at the same time, cultural managers and cultural critics examined the identity of one of the gallery's main targets – the working class – and saw in it a series of blank signs. They thus articulated the body of the working-class subject as that which blocks out culture. In both cases what we have discovered is that while the cultural institution needs the concept of a public, given the economic management, social discipline and cultural organisation of the capitalist state, this public can never be realised.

Notes

1 Sir Robert Peel, *Hansard*, XIV, 3 July–14 August 1832, col. 664.

2 Lord Russell quoting from a letter addressed to him by Sir Robert Peel, *Select Committee on the National Gallery*, 1853, British Parliamentary Papers, republished by Irish University Press, Education and Fine Art, 1858–3, III, para 8186. Other important documents include: *Select Committee on Arts and Manufactures*, 1835–6, British Parliamentary Papers, IX:1, Reports and Committees (3); *Report from the Select Committee on National Monuments and Works of Art* 1841, British Parliamentary Papers, Irish University Press, Education and Fine Art, 1841–7; II, *Select Committee on the National Gallery*, 1850, British Parliamentary Papers, Irish University Press, Education and Fine Art, III, 1847–63; *The National Gallery site commission*, 1857, British Parliamentary Papers, Irish University Press, Education and Fine Art, III, 1847–63. In this text I refer to such documents as Government Reports; and thus the abbreviation *GR* is used in all subsequent references to these works.

3 See chapters 2 and 3 of my D.Phil. thesis, *Formations of cultural identity: art criticism, the National Gallery and the Royal Academy, 1820–1863*, Sussex University, 1993.

4 R. Williams, *Marxism and literature*, Oxford, 1977, p. 11.

5 G. Martin's 'The founding of the National Gallery in London', *The Connoisseur*, April–December 1974, is a nine-part chronicle of the events which contributed to the emergence of this institution. A useful summary of the development of the collection can be found in F. Owen, ed., *Noble and patriotic. . .*, London, 1988. Rodney Mace's *Trafalgar Square*, London, 1976, contains interesting material on the political significance of this public site.

6 *The Literary Gazette and Journal of Belle Lettres Arts and Science*, 869, 14 September 1833, p. 586.

7 *The Times*, 11 April 1838, p. 187.

8 See, for instance, P. Colquhoun's *A new and appropriate system of education for the labouring people*, London, 1807.

9 Colquhoun, *A new and appropriate system*, p. 15.

10 Prince Albert, *The principal speeches of H.R.H. the Prince Consort*, London, 1862, p. 110. The phrase is used in his opening address at the Great Exhibition of 1851.

11 Education', *The Westminster Review*, I, January–April 1824, p. 56.

12 'Education', p. 66.

13 M. Foucault, *Discipline and Punish*, trans. A. Sheridan, Harmondsworth, 1977, p. 172.

14 Foucault, *Discipline*, p. 165.

15 Cited by W. E. S. Thomas, *The philosophical radicals*, Oxford, 1979, p. 143.

16 *Art Union of London*, Minutes, 1861, p. 10.

17 J. A. Roebuck, *Hansard*, third series, XX, 30 July 1833, col. 140.

18 *The Times*, 4 May 1847, p. 16.

19 *Art Union*, Minutes, 1862, p.9.

20 See chapter 1, 'Free particulars' in T. Eagleton's *The ideology of the aesthetic*, Oxford, 1990, where he writes: 'The ultimate binding force of this bourgeois social order, in contrast to the coercive apparatus of absolutism, will be habits, pieties, sentiments and affections. And this is equivalent to saying that power in such an order has become *aestheticized*' (p. 20).

If pleasure, well-being and identity are secured by a subject from whom law and custom are conflated as expressive characteristics of the self, then the process of education is to present custom and duty as the very desires and appetites of the autonomous, self-regulating citizen.

21 *The Builder*, XI:347, 29 September 1849, p. 549.

22 *The Edinburgh Review*, LXV, April–July 1837, p. VIII.

23 T. Wyse, *Education reform*, London, 1836, p. 41.

24 Wyse, *Education*, 1836, p. 47.

25 'Report on a meeting', *The Spectator*, 46, 1837, p. 517.

26 *GR*, 1853, p. xvi.

27 Prince Albert, *The principal speeches*, 1862, p. 181.

28 *GR*, 1853, Appendix, xvii, p. 791.

29 *GR*, 1857, para. 2437.

30 *GR*, 1857, para. 2474.

31 *GR*, 1857, para. 2437, 2475.

32 *The Edinburgh Review*, January–August 1853, XCVIII, pp. 406–7.

33 See P. Stallybrass and A. White, *The politics and poetics of transgression*, London, 1986, pp. 80–124.

34 W. Hazlitt, 'The Angerstein Gallery', *The London Magazine*, XXXVI, December 1822, pp. 489–90.

35 G. Waagen, 'Thoughts on the new building to be erected for the National Gallery of England', *Art Journal*, 1 May 1853, p. 123.

36 Hazlitt 'The Angerstein Gallery', p. 491.

37 *GR*, 1850, para. 82.

38 *GR*, 1850, para. 83.

39 *GR*, 1841, para. 2584.

40 *GR*, 1853, para. 7151.

41 *GR*, 1853, para. 8187.

42 *GR*, 1835–6, para. 1460.

43 *GR*, 1857, para, 2631.

44 *GR*, 1850, para. 607.

45 A. Giddens, *A contemporary critique of historical materialism*, London, 1981, pp. 109–56.

46 F. Von Raumer quoted by J. M. Golby and A. W. Purdue, *The civilisation of the crowd*, London, 1984, p. 88.

1968 AND ALL THAT: THE FOUNDING
OF THE NATIONAL PORTRAIT GALLERY,
WASHINGTON DC

Marcia Pointon

I

IN OCTOBER 1968 the American Embassy in Grosvenor Square, London was under siege from students protesting against the continued American presence in Vietnam. In France the universities were in turmoil. *The Washington Post* for 6 October covered the Apollo flight – the first step to the moon – uprisings in Columbia University, the top model of the 1960s, Twiggy, in person, and a debate about when the Bikinians might return to their island used for nuclear testing. Nixon was edging his way towards the presidency in a year that had seen the assassination of Robert Kennedy and Martin Luther King, a year in which Johnson decided not to stand for another term in order (allegedly) to devote himself to ending the Vietnam war, in which the Democratic convention took place in Chicago in the midst of violent clashes between police and demonstrators.

On the following day, 7 October, three thousand shivering guests gathered in Washington DC to listen to the US marine band and to hear the speech of Mr Walter E. Washington, the Mayor Commissioner of the District of Columbia, at the official opening of the American National Portrait Gallery.[1] The opening exhibition, 'This new man: a discourse in portraits,'[2] was organised into sections which described him as: restless and mobile (explorer and expansionist), citizen and sovereign (lawmaker, peacemaker), rebel and non-conformist and so on. The location, a few blocks north of The Mall, must have presented at that time an extraordinary view of burnt-out buildings. 'As we look at these portraits,' declared Mr Washington, 'we feel a part and parcel of this rich heritage of ours which is America . . . The Gallery is a levelling force,

a synthesising force, a pulling together force.'[3] His words were not reassuring to all those attending the opening symposium. Margaret Mead, one of the three opening speakers, replied 'This is a black city. There's something wrong with this audience. Some people are not here.'[4] The audience, it appeared, apart from Mr Washington himself, was almost entirely white.

The idea of national cultural institutions as synthesising and levelling forces goes back at least to the early nineteenth century when, following the Napoleonic wars and Napoleon's unprecedented looting of art-works in the interests of establishing a national museum (now the Louvre), many countries in Europe began to build and equip imposing national galleries as potent symbols of cultural ascendancy and as a means of distracting a restless populace from its discontents. Sir Robert Peel, addressing the House of Commons in July 1832, declared:

> In the present times of political excitement, the exacerbation of angry and unsocial feelings might be much softened by the effects which the fine arts had ever produced on the minds of men ... The erection [of the National Gallery] would not only contribute to the cultivation of the arts, but also to the cementing of the bonds of union between the richer and poorer orders of state.[5]

Margaret Mead's words 'there's something wrong with this audience' were directed to those attending the opening of the American National Portrait Gallery; they might equally well have been applied to the museum's contents which, as we shall see, were contentious. National portrait galleries – also a nineteenth-century invention – are understood to enshrine national identity through the representation of national heroes (and very rarely heroines). Who should be included is a crucial question. To open a national portrait gallery in 1968 seems on the surface to have been an extraordinarily rearguard and retrogressive piece of cultural management. It followed the London National Portrait Gallery which had been established a hundred years earlier with Thomas Carlyle – for whom historic portraiture permitted an almost magical access to the past – as one of its first trustees.

Portraiture as a genre holds, then, a special place in the discursive formations that serve to define national identity; in the USA the national portrait gallery as concept was mobilised at one and the same time both to protect the state against revolutionary social change and to symbolise the progress of culture in a nation perceived as owing its origins to revolutionary social transformation. The American National Portrait Gallery is a fundamentally English-speaking concept (only Edinburgh, London, Dublin and Washington have national portrait galleries) and the difficulties surrounding its evolution as an institution relate to the problematic process of defining national identity in relation to the histories of the colonised as well as the colonisers. In this

chapter I shall look at how portraiture is deployed to maintain a status quo against the threat of revolutionary social transformation in the late 1960s.

Portraiture is ostensibly concerned with the individual rather than the collective, and portrait galleries have tended to be associated with times of stability and prosperity.[6] If history painting appears to address politics and society, portraiture for the most part is regarded as deeply conservative and appears to be concerned with continuity and with the confirmation of societal norms. Moreover, since likeness has tended to be regarded as a prerequisite of portraiture, despite some celebrated exceptions, portraiture as an art form tends to be associated with mimetic forms of representation and hence with the reactionary rather than the avant-garde. The year 1968, in myth if not in fact, might be said to be a year of the collective, a year of revolution and the year which saw the beginning of the postmodern. It is this disjuncture which is both interesting and instructive.

So what has portraiture to do with 1968? The gallery that opened in Washington at 9th and F streets that year was the culmination of over fifty years of negotiation; its origins lie, however, in the eighteenth century. Charles Willson Peale in 1788 introduced into his museum of natural history 'the Portraits of Illustrious Personages distinguished in the late Revolution of America, and other paintings'.[7] If this was an embryonic portrait gallery, a further interest in the idea can be identified with George Healy's commission in 1858 to paint a series of whole length portraits of presidents for the East room of the Executive Mansion. Healy was an American artist who had spent a great deal of time in England and in Paris where Louis Philippe had sat for him for the Versailles Gallery; the commission included translating Gilbert Stuart's unfinished portrait head of Washington into a respectable whole length.[8] This event raises, again, the question of the relationship between private collecting and national (public) galleries but in a somewhat different form. Whilst portrait galleries were in the first place private collections, they always implied a public function. Thus Pliny's account of Athenian statuary explicitly affirms the elision of public and private: 'the rooms and halls of private houses became so many public places, and clients began to honour their patrons in this way'.[9] Paolo Giovio's celebrated sixteenth-century gallery in Florence was a private concept with a public function and the series of national portrait exhibitions set up in London in the 1860s at the instigation of the Earl Stanhope specifically aimed to transfer private objects (representations of people's ancestors) into a national space, first in the refreshment rooms built for the 1862 international exhibition at South Kensington and later at the purpose-built National Portrait Gallery at St Martin's Place.[10] Peale's museum was also his own studio; Healy's commission for the White House recognised both the private space of home (the East room of the

Executive Mansion, the 'natural' location for such objects) and the public space of power in which portraiture signified continuity of state apparatus. The model was not that of the (English) Elizabethan long gallery but that of the Athenian halls and rooms of private houses which Pliny had described as places for the public display of statuary.[11]

II

The Smithsonian Institution administers the National Portrait Gallery. At its foundation in 1846 it was charged with the encouragement and promotion of art. By 1910, long before it had any designated location, the National Portrait Gallery was already recognised as an entity at the Smithsonian.[12] The Smithsonian itself, poised between state institution and private benefaction, was ideally equipped to maintain the dual function of the portrait gallery.[13] The Portrait Commission, established in the late 1950s, consisted of a group of individuals deemed to come from the very 'top drawer', a phrase later used in connection with the search for a suitable director.[14] As with the trustees of the London National Portrait Gallery, it was as much their expertise as private collectors as their disposition to act as public servants that qualified them for the task. And when Wilmarth Sheldon Lewis, the Walpole scholar and leading member of the Commission, left his collection to Yale rather than to the newly fledged Portrait Gallery, there was considerable disappointment. James C. Bradley, under secretary at the Smithsonian in the late 1950s, couched his description of the deliberations of these latter-day Medici princes in terms of frontiersmanship:

> I would like to say that it was a privilege and a fascination to be present at these early meetings when a group of far-sighted men . . . gathered to explain the possibilities of an idea, a concept, . . . of memorializing through portraiture the men and women who had contributed significantly to the history, development and culture of this country. It is necessary in visualizing the setting and conduct of these early formative meetings [to recognize] that . . . these men of accomplishment were meeting to forge a national historical program of this special character without benefit of staff, funds, authorizing legislation or precedent on a national scale in this country.[15]

The discourses of Medicean patronage and American independence came together around the debates concerning the building that was eventually transferred by Congress from the Civil Service Commission to the National Portrait Gallery Commission. Designed and built (1837–67) by Robert Mills in Greek revival style, the Old Patent Office was a building whose history, it was claimed, 'runs deep in the American consciousness' (fig. 3.1).[16] The fact that President Lincoln's inaugural ball had been held there rendered the Old Patent

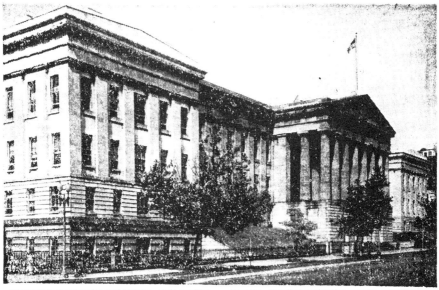

3.1 The Old Patent Office, Washington DC, by Robert Mills, photographed by the *Washington Star* and published 3 June 1956

Office a symbolically appropriate Pantheon, a suitable home for a collection which 'should have a great influence in fostering patriotism and in educating the coming generation in a knowledge of American history'.[17]

If Thomas Jefferson epitomised America's 'new man', he was also, as his legacy of architectural purism to Washington DC still testifies, a Renaissance prince and a classical hero all rolled into one. It seemed to the Smithsonian's secretary in the early 1960s that the National Portrait Gallery would be the rightful consummation of the marriage of old Europe and new America that Jefferson exemplified:

> It is deeply moving to see a noble building achieve its true destiny by serving a noble end. For me this meaning is all the more exquisite because the architect who produced this masterpiece received his first 'idea of the position and effect of those Greek temples which are the admiration of the world' when, coming to the south bank of the James, he saw on the opposite eminence Thomas Jefferson's translation of the Maison Caree [*sic*] at Nimes. Robert Mills, as you know, was given free access at Monticello to the finest collection of architectural works in America and was a beneficiary of Jefferson's patronage. While there he saw a portrait gallery that was probably also without a rival in the nation. It is not at all unlikely that Jefferson remarked to young Mills as he once did to another in explaining the purpose of this gallery: 'While I resided at Paris,

knowing that these portraits, and those of some other of the early American worthies were in the gallery of the Medicis at Florence, I took Measures for engaging a good artist to take and send me copies of them. I considered it as even of some public concern that our country should not be without the portraits of its first discoverers.' The purpose for which this building is now destined is one that Thomas Jefferson, perhaps the first in this country to build a gallery of portraits of historic personages as a matter of 'some public concern', would most assuredly approve.[18]

Thus, in 1963, the secretary to the Smithsonian charted a direct chain of connection from Athenian culture through Florence in the sixteenth century to a founding father of the USA and thence to the National Portrait Gallery under construction in Robert Mills's Old Patent Office.

<center>III</center>

The legislative history of the National Portrait Gallery dates from 1935 when Senator Walsh introduced a bill to create a National Portrait Gallery.[19] By 1937 this had become subsumed through several other bills into the National Collection of the Fine Arts.[20] Serge Guilbaut has described how this was the year of the Popular Front's greatest success in the USA, the year of the second American Artists' Congress, to which Picasso sent greetings.[21] The National Collection of the Fine Arts stood in opposition to the left international avant-gardism which is Guilbaut's concern. However, I want to suggest here that state cultural institutions like the National Collection of the Fine Arts and the establishment cultural lobby produced imperatives, and negotiated territory, that have been underestimated by Guilbaut in his concern with events which to us, fifty years on, appear more spectacular perhaps than arguments about national portraiture. Today the National Collection occupies the other half of the Patent Office building, an arrangement that reflects the relationship that underpinned the planning process, for, if America was to exhibit a national school of historic painting, it must, by its very nature, encompass its national portraiture. In 1936 Andrew Mellon made his arrangements with the Smithsonian regarding the foundation of a National Gallery of Art in the capital city but this was to house a collection of European painting and, in his discussion with the secretary of the Smithsonian, Andrew Mellon declared his intention also to bequeath a gallery specifically for national portraiture:

> Mr. Mellon inquired as to the status of a Portrait Gallery for which he understood Senator Walsh had introduced a bill last year. I told him that the Smithsonian Institution had a great many portraits of Americans of distinction for one reason or another. He suggested that, in connection with the gallery which the Mellon Trust would erect, a portrait gallery might be provided which

would include portraits, carefully selected, from those owned by the
Smithsonian Institution but not include any person who have not been dead
for some time, so that their status in the life of America could be judged without
prejudice.[22]

The Mellon collection included the Clarke collection of one hundred and
seventy-five portraits by American artists as well as the famous portrait of
Pocahontas which now serves (beneath an emblem incorporating the sil-
houette of Washington) as an advertisement for the National Portrait
Gallery.[23] David Finley later recalled that his close friend Andrew Mellon
believed that 'such a gallery would encourage the study of American history
and promote patriotism among the American people'.[24] But Mellon's idea
was not realised in his lifetime and the fact that the grand premises of the
National Gallery of Art housed European painting rather than native art did
not escape censure. The American Art League Inc. campaigned in the early
1960s on behalf of the National Collection of the Fine Arts and, when the
announcement of the Patent Office transfer came, a reviewer welcomed 'a
rare opportunity to watch the unfolding of American style in painting [that]
will be given in the array of American portraits from the seventeenth century
to today'. At the same time the writer sees the twinning arrangement as cor-
recting a shameful national neglect: 'There is now, in the capital of one of
the two great world powers, no rational and reasonably complete permanent
exhibition of that Nation's art. This is a striking contrast to just about every
country in the world.'[25]

From the cold war period of the mid-1950s, explicit references to the fos-
tering of patriotism through national portraiture are commonplace, not only
in journalism but also through official correspondence and congressional
speeches. Portraiture can here be seen to play a particular role in the cultural
propaganda campaigns. The idea of a national portrait gallery offers, at this
level, a muted and more elevated form of what is already inscribed in popular
culture in halls of fame and flag-waving ceremonies. Like them, it would serve
to reinforce the rhetoric of the white male hero and the democratic tradition.
Thus Leonard Carmichael, secretary to the Smithsonian, writing to Hon.
Frank Thompson Jnr in 1956 with reference to his legislation for a building to
house the Fine Arts Museum,[26] says: 'I feel that the exhibition of portraits of
Americans who have played a role in making this country great would impress
millions who view this collection. It would aid in teaching American history,
foster patriotism, and encourage the growth of good citizenship.'[27] The recipi-
ent of his comments, a great campaigner for the arts, was even more explicit
about the propaganda value of culture, declaring at the reception of the
American Concert Choir and Choral Foundation at New York University
Club on 7 March 1957:

At last, after several years headstart by the USSR, we are beginning to correct the impression other peoples have of us as a result of our own hesitant action regarding our own art as well as Russian propaganda . . . Gradually the truth is dawning on official Washington that one of the major ways in which we can turn reluctant and uneasy military allies – and the 700,000,000 of uncommitted peoples – into friends is to earn their respect for our own cultural programs.[28]

The notion of cultural propaganda is, of course, a familiar one, particularly in relation to American foreign policy in the cold war and abstract expressionism in the late 1940s.[29] It is argued that the state sponsored abstract expressionism as a manifestation of the abstract concept of liberty which the USA enshrined and as an example of national tolerance. Portraiture as a representational art form played no part in this. None the less since portraits lend themselves to the narratising of national history, they might be seen as particularly powerful in propaganda campaigns. The fact that public response to the opening of the National Portrait Gallery was notably muted does not in any sense invalidate the argument. The portraiture campaign failed to fulfil aesthetic expectations formed by definitions of fine art that excluded popular culture and which were predicated upon a notion of an international avant-garde.[30] Thus a curator at the gallery was reported to have said, at the time of opening: 'You should see some of the stuff we've been offered . . . We've turned down an awful lot of Sunday painter stuff like the face of John Kennedy on the Liberty Bell.'[31] (That it is these popular art forms that in the 1980s and 1990s have been explored as embodying cultural identities should not go unnoticed.) The gallery none the less functioned negatively to define the patriotic as essentially American, figurative and high art. These were the criteria by which its contents were judged. If, as Guilbaut suggests, 'the avant-garde artist who categorically refused to participate in political discourse . . . was coopted by liberalism, which viewed the artist's individualism as an excellent weapon with which to combat Soviet authoritarianism',[32] then portraiture could be annexed to foster patriotism at home and maintain the kinds of traditional values necessary for the valorisation of the avant-garde and, ultimately, also for its dismissal. If portraiture was a truly American and patriotic art, then it stood as a testimony to the survival of revolutionary values within a state-sponsored system.

IV

The relationship between conservative art-forms and a state-sponsored avant-garde is demonstrably complex. The question then arises as to whether the sudden surge of interest in the early 1960s in the idea of a national portrait

gallery was one consequence of those constellations examined by Guilbaut. A further question might relate to the fact that Andrew Mellon allegedly placed a twenty-year limit on his offer in 1942 of portraits to the nation and time would have run out in 1962.[33] But neither of these appears to have been germane. There are, I suggest, other factors involved in the realisation in 1968 of a project that had been under consideration since the 1930s. To understand the structural relationship of the National Portrait Gallery to the social change of the 1960s, to recognise its emergence in the 1960s as the symbolic heart of American patriotism, we must look at the trajectory of another museum that had for an equally long time existed in the imagination and aspirations of members of the American ruling class. This was the National Museum of the Armed Services or the National Military Museum.

Following the signing of the peace treaty at the end of the First World War, an organisation was established called the National Art Committee. This had the endorsement of the Smithsonian Institution, the American Federation of Arts and the American Mission to Negotiate Peace. Its object was to send artists to Europe to secure a pictorial record of the war. Just as Sir Thomas Lawrence had been sent to Aix-la-Chapelle and Vienna in 1818 to paint the portraits of the allied generals following Napoleon's defeat, so a group of eight American painters were sent to produce a series of individual portraits and a painting of the signing of the peace treaty in 1919. They included Cecelia Beaux, 'probably our best known woman painter, especially for her lovely portraits of women and children'.[34] This collection was regarded 'as the nucleus of a National Portrait Gallery' and it was financed by the subscriptions of individual cities.[35] The exhibition opened in New York City on 17 January 1921 and then toured twenty-six cities coast to coast.[36] The exhibition was expected to 'do much both to arouse patriotism and to extend interest in American art'.[37] When the pictures returned to their permanent home in Washington in July 1923, *The Washington Herald* trumpeted: 'America's New Position in World of Art has Recognition in All Parts of Globe'. A journalist claimed 'Nowadays America is very much on the world map of art and literature and Europeans do not hesitate to express their admiration for our splendid portrait school.'[38]

This optimism seems rapidly to have died and there is virtual silence on the topic of the national portrait collection until the early 1940s. It was in 1944 that the first references to a military museum linked with the portrait gallery began to appear. An element of portraiture is generally implicit in commemorative military art, as for instance with Trajan's column or West's *The death of General Wolfe*.[39] It is interesting, however, in the case of this twentieth-century commemorative project that the military and the portraiture elements were kept separate but interdependent. They were frequently discussed in tandem, they were both planned under the aegis of the Smithsonian, and the same

people frequently advocated both museums. This structural relationship is apparent in the wording of David Finley's memorandum: 'President Truman appointed an Advisory Committee to make plans for a National Military Museum. The plans were never carried out, but they were in part responsible for the idea of a National Portrait Gallery which had been previously endorsed by the Commission of Fine Arts on 22 June 1944.'[40] Finley envisages the two museums sharing the same location but his plans for alternative use for the Old Hadfield Court House did not materialise.

The mid-1940s was characterised, according to Guilbaut, by a wave of internationalism, by the conviction that the centre of western culture would henceforth be in America.[41] The persistence with which plans for a military and/or portrait museum were pursued is, therefore, all the more notable especially as it appears to predate the intense patriotism that proscribed certain organisations from 1947. In 1958, President Eisenhower appointed a committee to look into the establishment of such a museum in the belief that it could 'make substantial contributions to our citizens' knowledge and understanding of American life'.[42] Still nothing concrete occurred until in 1961 the National Armed Forces Advisory Board was set up to assist the Smithsonian Board of Regents and possible sites were explored. The plans – debated at the height of the Vietnam war – were heavily criticised and Col. John H. Macgruder asserted 'every effort is being made to alleviate any possible accusation that the Smithsonian is a propaganda agency of the Department of Defense or a special pleader for current policies'.[43] John Nicholas Brown, the highly influential Smithsonian Citizen Regent and chair of the Advisory Board, was heavily committed to the idea. Brown, father of John Carter Brown, currently director of the National Gallery of Art, was a member of the wealthy Brown family of Providence, Rhode Island and was married to a military historian whose major collection of military memorabilia is now housed in a special museum at Brown University. In 1961 he was hawkishly pressing Senator Anderson with the twin causes of the Armed Forces Museum and the National Portrait Gallery[44] and was acquiring objects that were extremely difficult to store such as the bathyscape *Trieste I*, a vessel which allegedly pioneered underwater exploration.[45] Finally in 1974, Mr Brown was persuaded to drop the project and although the Board still exists, I was informed in 1988 that it had not met for eight years.[46]

A military museum in the late 1950s and early 1960s would have served to reinforce a view of the United States as adventurist and pointed up the divisions in American culture that were increasingly apparent as opposition to American foreign policy grew, particularly among the young. A portrait gallery could, however, serve the same symbolic function as a military museum but in a far more subtle manner. When Hubert Humphrey took up the cause of the portrait gallery in 1960, it was effectively as a weapon in the cold war:

Washington must have a cultural status at least equal to its position as the polit-
ical, military and economic center of the free world. It lacks such a command-
ing status at this time. In fact, the *New York Times* recently (12/27/59) compared
Washington unfavourably with the provincial city of Tiflis, USSR. A National
Portrait Gallery will make a major contribution to our national life, will foster
patriotism, and educate the coming generations in the high ideals which dis-
tinguish us as a nation.[47]

V

The National Portrait Gallery finally materialised through a bill (51057) which
went through the Senate on 17 April 1962. The act defines the gallery 'as a free
public museum for the exhibition of portraiture depicting men and women who
have made significant contributions to the history, development, or culture of
the people of the United States'.[48] During the debate, the National Portrait Gallery
was described as 'an outstanding educational, cultural and patriotic center for
the American people'.[49] As it passed through the House of Representatives, refer-
ence was persistently made to the frontier tradition and to the cold war. Mr
McDowell spoke of the connections between the present legislation and the
educational organisations fostered by President Lincoln 'during the darkest days
of the war between the States'. He expressed certainty that 'a people which could
build for the future in the midst of war, and express such faith in its own cultural
values, was worthy of its great destiny'. The National Portrait Gallery would add
to this great tradition and 'in this period of cold war, and revolutionary and
national aspirations of people everywhere, it behooves us to take those steps
which will aid in the proper development of our own culture'.[50]

For their part, the members of the Smithsonian Board of Regents were
more concerned about the political implications of their acquisitions policy.
Anthony N. B. Garvan was sent on a fact-finding mission to visit other coun-
tries' portrait galleries; he produced a report which gave clear recognition to
the political issues of a collection of national portraiture. Garvan argued that
there had always been 'a grave concern lest this Gallery lead to a kind of visual
social register which accepts the portrait of the social leader whose promi-
nence rests upon birth, inheritance or property on an equal footing with that
of the functional leader whose leadership comes from his accomplishment'.
Garvan expressed grave concern about 'the political pressures that may be
exerted to secure individual admissions to the Gallery'.[51] In fact, probably the
trickiest political problem faced in the 1960s was the row that developed in
1967 over a portrait commissioned of President Johnson to which the
President and the First Lady took an instant dislike. The artist was Peter Hurd
and his portrait of the President was allegedly described by the President as
'the ugliest thing I ever saw' (fig. 3.2).[52] The incident led the Smithsonian

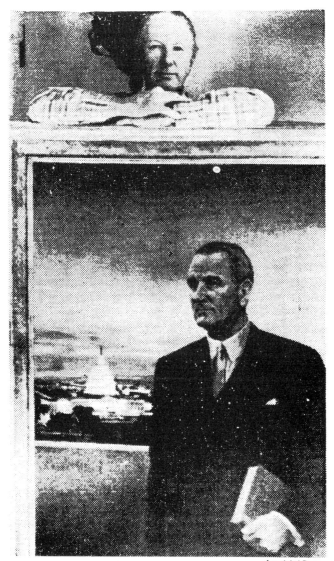

Associated Press

REJECTED: <u>Peter Hurd</u> with his portrait of the President. Mr. Johnson said that it was "ugliest thing I ever saw."

'Ugliest' Portrait of Johnson In Storage at the Smithsonian

3.2 Artist Peter Hurd with his portrait of President Johnson, intended for the Hall of Presidents but rejected by the President and First Lady, *New York Times*, 31 January 1969

secretary to warn the gallery's director on 14 August 1967 'to be very careful in making any offhand comments of a gratuitous nature . . . even to an old friend'. Their correspondence is labelled 'All material relating to the Hurd portrait of President Johnson must be held *very* confidentially'.[53] Throughout the mid-1960s portraits were being accumulated and by September 1966 it was announced that the Smithsonian had acquired 283 'major paintings' as well as 25,000 prints, drawings and book frontispieces. The ten-year rule, prohibiting the acquisition of a portrait of anyone who had not been deceased for at least ten years (a rule adopted following the precedent of the London National Portrait Gallery) was already being circumvented. Nagel had purchased portraits of Rachel Carson and Ernest Hemingway, put them on show for a period, then returned them to store until the ten years had elapsed.[54]

The Portrait Gallery of today offers the visitor a perambulation through the Early American Room, the George Washington Room, the Hall of Presidents, and the American Indian Room (which, until recently, was called the Native American Room and featured Henry Fiske's portrait of the artist/ethnographer, George Catlin, as a centrepiece), an untitled room containing portraits

3.3 *The expanding frontier*, a thematically arranged
room in the National Portrait Gallery, Washington DC.
The portrait represents Benjamin O'Fallon

of women reformers and an Explorer's Room. The Expanding Frontier Room (fig. 3.3) indicates the ceremonial approach to display – the portrait represents Benjamin O'Fallon. The shortfall of presidents was lamented – sixteen were missing when the gallery opened. The approach to the main galleries at upper floor level, reached via the elegant double staircase, is dominated by the Lansdowne portrait of George Washington; commissioned by Senator William Bingham as a gift for the Earl of Shelbourne, later Marquis of Lansdowne, it hangs in a recess flanked by columns, flags and potted palms in a discreet coffee and cream decor with carefully placed directoire style seating (fig. 3.4). In the Rockingham administration of 1782, Shelburne had agreed to take office on condition that the king recognised the United States. Gilbert Stuart's portrait is thus not only artistically significant as the only full-length original portrait of the first president of the United States by an American artist but also symbolically powerful as an emblem of the struggle for independence and as a sign of approval by the old European aristocracy for the 'new' American man. Prior to the opening of the gallery in 1968, the organisers searched Europe for a portrait of Washington and finally located this painting, the 'key centrepiece for the newly established gallery',[55] but it was the

3.4 The entrance to the main galleries of the National Portrait Gallery, Washington DC at upper floor level, Gilbert Stuart's Lansdowne portrait of George Washington on the end wall behind a cord

property of the eighty-six-year-old Earl of Rosebery who was unwilling to sell it. He was described by the Smithsonian Secretary as 'knowing virtually nothing about America and caring less'.[56] Through the good offices of David Bruce, the American ambassador in London (and ex-husband of Andrew Mellon's daughter, Ailsa) and Lord Mountbatten the loan of the painting was secured from the Earl's heir, Lord Primrose.[57] It is also perhaps significant that what was described by the Smithsonian secretary as 'the one portrait above all others which we would like to acquire permanently'[58] and as 'the most important portrait in the history of our nation . . .' and one which 'many of us are convinced . . . belongs in our National Portrait Gallery' remains to this day (despite talk of State Department negotiation with the British government) the property of a British nobleman.[59]

The Lansdowne portrait visually dominates the approach to the main floor of the Gallery (fig. 3.4). But textually it is two other portraits – the so-called Athenaeum portraits of George Washington and Martha, his wife, also by Gilbert Stuart – that take precedence. These hang to one's right as the landing is attained. Immediately opposite is a storyboard on the facing wall which reads: 'Stuart left the portrait heads of George and Martha Washington unfinished and kept them for the rest of his life. That of the President he used as the basis for all his subsequent images of Washington. No other likeness of Mrs Washington is known to exist.' The portraits were acquired from the Boston Athenaeum in 1980 and, it is claimed, together with the Constitution (displayed in the National Archive) 'constitute the most important of all American historical documents'. In this narrative the unfinished condition of the portraits and the fact that they served as matrix for all subsequent Stuart images of the president allows, by analogy, the sense of a continuing purpose (a task to be completed) and of a matrix, or a point of origin, not only for paintings but also for good government.

The hierarchy established by the organisation of the works displayed in the National Portrait Gallery is a hierarchy that articulates a highly structured view of American nationhood; this hierarchy tells a history of America as a nation of victorious adventurers and legislators. In the year of the Chicago riots and the uprising of young women and men demanding new forms of participation in government, the American establishment chose to assert the myth of the white American man. This history appeared to some no more than 'a magnificently packaged trifle . . . curious where it might have been awesome . . . everywhere dated, cautious and peculiarly bland'.[60] Born of the military aspirations of an influential class of American society, the American National Portrait Gallery worked to promote patriotic values in a non-militarist idiom; its very blandness and its very avoidance of the awesome served to reinforce a conservative politics in a period of intense transvaluation

of social values. The founding of the American National Portrait Gallery was a political event that presented culture as apolitical in a year marked by the revolutionary politicisation of culture.

Notes

1 I would like to thank the Smithsonian Institution for their generosity in awarding me a visiting fellowship in 1988 which enabled me to undertake the research for this paper. I am also grateful to the staff of the Smithsonian and the National Portrait Gallery for their advice and help. Special thanks are due to Robert Stewart and Ellen Miles for their encouragement, and to Vivien Hart for hospitality, and for her helpful scholarly advice. Versions of this paper were read at the Congress of the Comité International d'Histoire de l'Art in Strasbourg in 1989 and at the University of Sussex American Studies Research Seminar in 1992. This essay appeared first in the *Journal of American Studies*, 26, 1992.

2 A quotation from J. de Crevecoeur, *Letters from an American farmer*, 1782: 'What then is the American, this new man?'

3 *The New Yorker*, 19 October 1968, 'The talk of the town', pp. 50–51.

4 *Ibid.*

5 Hansard, quoted in G. Martin, 'The founding of the National Gallery in London, part 7', *Connoisseur*, 1974, p. 113.

6 The portrait cycle of illustrious men was a major theme in Italian art after the fourteenth century. See R. Starn, 'Renaissance heroes', in R. I. Rotberg and T. K. Rabb, eds, *Art and history: images and their meaning*, Cambridge University Press, Cambridge, 1988.

7 Advertisement in the *Pennsylvania Packet*, 21 July–1 September 1788, quoted in C. C. Sellers, *Mr. Peale's museum: Charles Willson Peale and the first popular museum of natural science and art*, Norton, New York, 1980, p. 38; for a full account of Peale's museum see L. B. Miller, ed., *The selected papers of Charles Willson Peale and his family*, vol. 2, parts 1 and 2, Yale University Press, New Haven and London, 1988.

8 The heads of George and Martha Washington by Gilbert Stuart now hang on the staircase in the Portrait Gallery. Copy of a draft letter from G. P. A. Healy to Congress, Washington, 1 January 1858, Healy Papers, Archives of American Art; V. L. Glasgow and P. A. Johnson, *G. P. A. Healy: famous figures and Louisiana patrons*, The Louisiana State Museum, December 1976–May 1977, p. 6; in 1950 while the White House was under repair, the presidential portraits were placed on show at the Smithsonian by courtesy of President and Mrs Truman as part of an exhibition 'Makers of history in Washington 1800–1950'.

9 Pliny the Elder, *The Natural History*, XXIV, ii, 17, *The Elder Pliny's chapters on the history of art*, transl. K. Jex-Blake, Ares, Chicago, 1976, p. 15.

10 See M. Pointon, *Hanging the head: portraiture and social formation in eighteenth-century England*, Yale University Press, New Haven and London, 1993, chapter 2 and postscript, for a fuller discussion.

11 Pliny the Elder, XXIV, ii, 17.

12 L. Carmichael, secretary to the Smithsonian to Dr D. Finley, director of the National Gallery, 2 December 1954, with reference to a bill introduced into 61st Congress, Smithsonian Archive, Office of Secretary, 50.

13 The Smithsonian Institution has a non-Federal entity and identity as well as taking on the appearance of a Federal agency through its acquisition of laws and Federal appropriations.

14 Charles Nagel, who in fact became the first director of the American National Portrait Gallery, wrote to the Secretary of the Smithsonian, Dillon Ripley from St Ermin's Hotel, London on 11 August 1964 about Andrew Oliver whom he wanted to recruit as director, saying 'he is right out of the top drawer and would give the NPG great cachet' (National Portrait Gallery Archive). Oliver was a lawyer and a member of the Commission for the National Portrait Gallery; he was an antiquarian and author of several scholarly books on American portraits.

15 James C. Bradley, oral history project, transcript, 62, Smithsonian Archive.

16 Mr Thompson of New Jersey speaking during the passage of S1057 through the House of Representatives, 16 April 1962.

17 Dr D. Finley, chair of the Fine Arts Commission, quoted in the *Washington Star*, 3 June 1956.

18 Dr L. Carmichael to Hon. Clarence Cannon, Smithsonian Regent, 9 April 1963, quoting Dr J. Boyd, editor of the papers of Thomas Jefferson, Smithsonian Archive, Office of the Secretary, 50, box 118.

19 S. J. Res. 132, 13 June 1935.

20 S. J. Res. 99, 11 March 1937; Public Resolution 14, 24 March 1937; Public Resolution 95, 75th Congress, 17 May 1938; Public Law 723, 25 June 1938.

21 S. Guilbaut, *How New York stole the idea of modern art: abstract expressionism, freedom, and the cold war*, University of Chicago Press, Chicago and London, 1983, p. 26.

22 Confidential minute of an interview between Dr Abbot and Mr Mellon, 8 January 1936, Smithsonian Archive, Record unit 46, box 143.

23 See D. E. Finley, *A standard of excellence: Andrew W. Mellon founds the National Gallery at Washington*, Smithsonian, Washington, 1973, p. 32; J. Walker, *Self-portrait with donors*, Little, Brown, Boston, 1974, p. 131.

24 D. Finley to the trustees of the A. W. Mellon Educational and Charitable Trust, 22 December 1953, Library of Congress, Finley papers, 36.

25 Unidentified newscutting, by F. Getlein, *Washington Star*, 1961; Smithsonian Archives, record unit 50.

26 H.R. 794, 3 Jan 1956 and S. 3471, 19 March 1956.

27 5 June 1956, Smithsonian Archive, record unit 50.

28 Transcript for release 7 March 1957, Smithsonian Archive, record unit 50.

29 This is the theme of Guilbaut's book; S. Guilbaut, *How New York stole the idea of modern art*.

30 There was much talk at the opening about the National Portrait Gallery being a hundred years too late; of photography having negated its purpose etc., e.g. Benjamin Forgey, *Washington Star*, 6 October 1968.

31 R. G. Stewart, reported in *The Washington Post*, 29 September 1966.

32 Guilbaut, p. 143.

33 I have been unable to see the official documentation of this condition but it is frequently mentioned, e.g. by Charles Nagel, interviewed by Russell Lynes in *Harpers Magazine*, June 1966, p. 28.

34 Cyntzon Borglum, *The Delineator*, June 1921.

35 *The National Art Committee exhibition of war portraits*, National Gallery of Art under the direction of the Smithsonian Institution, Washington DC, 5–22 May 1921, unpaginated; only

four of the portraits are now in the National Portrait Gallery because of the policy of accepting only American sitters. The artists were: Cecelia Beaux, Joseph du Camp, Charles Hopkinson, John C. Johansen, Jean McLane, Edmund Tarbell, Douglas Volk and Irving Wiles.

36 *Antiques Magazine*, July 1984, p. 150.

37 *The American Magazine of Art*, XII, March 1921, no. 3, p. 88.

38 Viktor Flambeau, *The Washington Herald*, 15 July 1923, p. 5.

39 For a discussion of the portrait element in Anglo-Saxon military painting, see J. W. M. Hichberger, *Images of the army: the military in British art 1815–1914*, Manchester University Press, Manchester, 1988, ch. 1; V. C. Purdy and D. J. Reed, in their Foreword to *Presidential portraits*, National Portrait Gallery, Washington, 1968, state 'In selecting the portraits, the staff has undertaken to represent the Presidents with likeness [*sic*] taken while they were in office or in some instances, as with military heroes, at the peak of their professional careers.'

40 Memorandum for the files, David E. Finley, Finley Papers, Library of Congress, Box 37.

41 Guilbaut, p. 63.

42 P. H. Oehser, *The Smithsonian Institution*, 2nd edn, Westview, Boulder, Colorado, 1983, p. 101.

43 *Ibid.*, p. 103.

44 J. N. Brown to Hon. Clinton P. Anderson, 20 February 1961, Smithsonian Archives, record unit 50.

45 Oehser, p. 103.

46 Conversation with James Hutchins, historian at the Museum of American History who persuaded Brown to drop the idea and was allegedly left to dispose of the stuff. The Board has not been repealed by Congress but it currently has no Chair.

47 Joint release, Senator Hubert H. Humphrey and Congressman George M. Rhodes, 3 February 1960, Smithsonian Archive, Record unit 50.

48 51057, sec. 2(b).

49 Senate report on S 1057, 26 July 1961 . . . 8.

50 Passage of S 1057, 16 April 1962 . . . 13.

51 A. N. B. Garvan, National Portrait Gallery: Background Studies, part II, MS., Smithsonian Office of the Secretary, 50, Box 117.

52 *New York Times*, 31 January 1969. See also *The Washington Post*, 1 January 1967.

53 The correspondence between Hurd, Nagel and Ripley is held in the National Portrait Gallery archive; see also correspondence between Nagel and Mrs Johnson, 17 January 1967, Smithsonian Institution Archives, Office of the Secretary Record Unit 99, Box 69.

54 National Portrait Gallery Press releases, 28 September 1966, National Portrait Gallery Library.

55 Charles Nagel, first director of the Portrait Gallery to Dillon Ripley, secretary to the Smithsonian Institution, 7 December 1966, National Portrait Gallery Archive.

56 In a letter that mentions the need to involve the State Department (Dillon Ripley to Charles Nagel, 27 January 1967), Portrait Gallery Archive.

57 Sir John Rothenstein had also been approached by Charles Nagel (letter of 11 December 1967, Portrait Gallery archive). Matters were not advanced by various blunders on the American

side like the misspelling of Lord Rosebery's name and the sending of important communications by surface mail. By the time the gallery opened, the Earl had died and Lord Primrose had inherited the painting. Through his generosity, it has remained on loan to the National Portrait Gallery. Charles Nagel wrote to thank Earl Mountbatten on 7 June 1968 shortly before the opening (Portrait Gallery archive).

58 D. Ripley to David Bruce, 2 February 1969, Portrait Gallery archive.

59 D. Ripley to O. Steiner, secretary to the George Washington Memorial Foundation, 20 February 1969, Portrait Gallery archive.

60 Paul Richard, 'A national family album', *The Washington Post*, 6 October 1968, p. K1.



THE SOUTH KENSINGTON MUSEUM: THE BUILDING OF THE HOUSE OF HENRY COLE

ℰ

Louise Purbrick



'AT THE SOUTH KENSINGTON MUSEUM,' explained Henry Cole, its general super-intendent, 'the State is the proprietor simply of art objects.'[1] It was not, however, simply art objects which were exhibited at South Kensington. The museum collection was divided into nine categories: Objects of Ornamental Art, as applied to manufactures, with an Art Library; British Pictures, Sculpture and Engravings; Architectural Examples; Appliances for Scholastic Education; Materials for Building and Construction; Substances used for Food; Animal Products; Models of Patented Inventions; Reproductions by means of Photography and Casting. Thus, the collection comprised art objects and other things. But, it was the art objects, or rather, the category of objects called Ornamental Art, which were the most important. They had cost more money. They were, for the most part, purchases, rather than gifts or loans, and the state was their proprietor because it had paid for them. The state had also paid for the building in which all the objects, purchased art or other-wise, were housed and had paid for the land on which it was built.

The South Kensington Museum opened in 1857. It was a state museum. It was owned by and administered through the state. It was part of a department of government: the Department of Science and Art. But responsibility for the management of the museum did not rest here. A Select Committee appointed in 1860 to inquire into South Kensington clarified the question of command. 'Authority for every measure is obtained direct from the Lord President of the Council, or the Vice-President of the Committee of Council on Education.'[2] How high office in the state became so intimately involved in making museum policy has a history. A question about its history had been put by the

chairman of the 1860 Select Committee to Henry Cole. 'What', he asked, 'was the origin of the collections at South Kensington?' And Cole replied with a warning. 'I hope', he said, 'I shall not weary the Committee with a long story, which must be a long story to enable them to judge of the facts.' Then he told the story. 'The year before the Queen came to the Throne,' he recalled, 'a Committee of the House of Commons . . . inquired into the promotion of art in this country.'[3]

1836: the first beginning

Henry Cole referred his audience to an earlier Select Committee which had sat in two sessions, from 1835 to 1836, and which had actually been appointed to 'inquire into the best means of extending a knowledge of the ARTS and of the PRINCIPLES of DESIGN among the People (especially the Manufacturing Population) of the Country'.[4] Thus, this Select Committee was particularly concerned with some of the 'People of the Country', with a section of the population, with a specific class: manufacturing workers. Their inquiry assumed that they required an arts education, or, more precisely, that there was something which was already known about the arts which should be made known to them. Diffusion was the description of this process: education as spreading, reaching, or in their words, 'extending a knowledge' outwards or downwards to some of the working class. The Select Committee was required to investigate appropriate methods of diffusion, to find 'the best means' of art education. In 1836, they published a Report and this began with a statement about why art education was necessary:

> from the highest branches of poetical design down to the lowest connexion between design and manufactures, the Arts have received little encouragement in this country . . . In many despotic countries far more development has been given to genius, and greater encouragement to industry, by a more liberal diffusion of the enlightening influence of the Arts. Yet to us, a peculiarly manufacturing nation, the connexion between art and manufactures is most important; – and for this merely economical reason (were there no higher motive), it equally imports us to encourage art in its loftier attributes; since it is admitted that the cultivation of the more exalted branches of design tends to advance the humblest pursuits of industry, while the connexion of art with manufacture has often developed the genius of the greatest masters in design.[5]

That knowledge of the arts was being diffused elsewhere was one reason to diffuse it in Britain, but this was not reason enough. Diffusion elsewhere does not explain the importance of the arts or the necessity of knowledge. So the Select Committee offered two other reasons: the arts had an 'enlightening influence' and they had an effect on the economy. The arts were generally

progressive, widely beneficial and vaguely benign and they had a specific func-
tion in a country whose economy was based on the international competitive-
ness of its industry. The arts, according to the Select Committee (and liberal
theory), had the special power to improve and, specifically, to improve design.

The Select Committee, however, did not separate art and design. The
'ARTS' and the 'PRINCIPLES of DESIGN' were coupled together in the same
educational project. But they did recognise two forms of design. They recog-
nised a difference in design constituted by the different processes of its pro-
duction. There was design which was individually created and that which was
collectively produced. There was the work of genius and the work of industry.
There was art and there was manufacture. The Select Committee, therefore,
could not separate art and design, since, for them, art was one form of design.
Another form was manufacture and it was art and manufacture which were
clearly separate: the distance between them displayed through and by their
design. A work of art and work of manufacture were both designed objects;
they were differently designed objects produced by different design processes:
individual and artistic or collective and industrial. And it showed. The differ-
ent processes of production were evident in the appearance of the object, in
the shapes and the surfaces of art and of manufacture.

For the Select Committee, art was clearly superior to manufacture. Evident
in the object and obvious to them, art was better than manufacture. So, as they
explained, 'to encourage art in its loftier attributes' was necessary because, as
they put it, 'the cultivation of the more exalted branches of design tends to
advance the humblest pursuits of industry'. Their claim, then, is not simply
that art had a particular power to improve design. It is still more specific. It is
that art as an object with a superior appearance and a better design had the
power to improve inferior manufacture, to improve its appearance and its
design. This notion of the excellence of art and this theory of its influence is
important. It underpinned one of the Select Committee's recommendations
regarding the 'best means' of educating manufacturing workers: the forma-
tion of museums. Since the appearance of art could exercise influence, all that
was required was to make it available to them by putting it in places accessible
to them. Educating manufacturing workers required the exhibition of art.

But there were two problems which were identified by the Select
Committee in their Report and which, in combination, rendered art unavail-
able and inaccessible to manufacturing workers, preventing their attendance,
and therefore education, at exhibitions. There was the restrictive practice of
art exhibition and the poor circumstances of manufacturing workers. 'Our
exhibitions', they stated, 'are usually periodical'; it was the practice to make art
available only for a limited time. Moreover, there was a price. 'A fee', they
noted, 'is demanded for admission.' Manufacturing workers had little time

and little money. So for them, as the Select Committee recognised, even a 'small obstruction is frequently a virtual prohibition'. They offered one solution to two problems. Increasing the time and money of manufacturing workers, paying them more money for fewer hours, was beyond the terms of their inquiry and out of the question. So they suggested removing the obstacles to art, implementing its unrestricted exhibition. They argued that art should be available all the time, exhibited permanently instead of periodically and, furthermore, available at particular times. Exhibitions should be open when workers could attend: 'accessible after working hours'. Open for longer and later, exhibitions should also be free: 'admission . . . gratuitous and general'.⁶ To argue that art exhibitions should be permanent, open and free was, of course, to argue that there should be public museums.

But, there was another problem: the exhibited art itself. Not only were there restricted terms of entry into art exhibitions, their content was also restricted. 'Modern works only', stated the Select Committee, 'are exhibited.' A limited audience, then, had access to a limited collection of art. Exhibited art collections were thus far too exclusive and should be expanded. The Select Committee set out some specific suggestions. They stated that:

> If the recommendation of the Committee were adopted, – that the opening of public galleries for the people should, as much as possible, be encouraged . . . casts and paintings, copies of the Arabesques of Raphael, the designs at Pompeii, specimens of the era of the revival of the Arts, everything, in short, which exhibits in combination the efforts of the artist and the workman, should be sought for in the formation of such institutions. They should contain the most approved modern specimens, foreign as well as domestic, which our extensive commerce would readily convey to us from the most distant quarters of the globe.⁷

Collections should comprise the whole of manufactured material production: objects which combined art with industry and which came from all over the world. The Select Committee apparently preferred the Renaissance and Raphael, but clearly considered that collections should be inclusive. So, their Report recommended that there should be museums and recommended what they should contain: almost anything from anywhere. This was how to exhibit art and educate manufacturing workers.

It took a long time for the Select Committee's recommendations on museums to become policy and to be put into practice. It took twenty-one years. The opening of the South Kensington Museum occurred in 1857. Yet, there was another recommendation for Schools of Design which was almost immediately implemented, and as Adrian Rifkin points out, 'represented the only systematic response to the terms of the Parliamentary enquiry'.⁸ Arguably, the establishment of the South Kensington Museum was equally

systematic but simply more slowly established. The Select Committee's 1836 Report had set out a recommendation which did not put a museum into immediate effect. Something else did: the Great Exhibition of 1851.

1851: the second beginning

The Great Exhibition of the Works of Industry of All Nations comprised a collection of over one hundred thousand objects from thirty-four countries divided into four classes: raw materials, machines, manufactures, fine arts. The collection was assembled in Hyde Park, London, and put inside a purpose-built, prefabricated building made of glass and iron: Crystal Palace (fig. 4.1). It opened on 1 May 1851, stayed open for six months, and closed on 31 October. Then the collection was dispersed and Crystal Palace dismantled. The Great Exhibition was a temporary affair, but one of lasting significance. The first *Guide to the South Kensington Museum*, published for the museum's official opening on 20 June 1857, explained its significance:

> In 1851 the Great Exhibition took place, and a favourable opportunity was afforded for instituting a comparison between our manufactures and those of foreign countries. The result showed that, although English productions were fully equal to those sent over to compete with them, as regarded workmanship and material, the public felt that much for the improvement of public taste was still to be accomplished.[9]

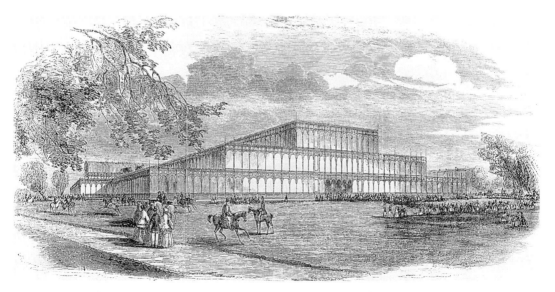

4.1 The Crystal Palace, from the *Official descriptive and illustrated catalogue of the Great Exhibition of the Works of Industry of All Nations*, London, 1851

The Great Exhibition, according to the *Guide*, was an international experiment. Comparisons were made between the manufactures from different countries and a conclusion was drawn from these comparisons: manufactures made in England lacked 'taste', a quality evident in foreign manufactures from foreign places. Thus, the Great Exhibition as experiment increased knowledge about manufactures, about the differences between them and their places of production. It also (and this is consistent with other kinds of experiments) revealed a law or principle of manufacturing. 'The Exhibition', the *Guide* continued, 'taught that art is the parent of design, and that design is the essence of successful manufactures.' So the relationship between art, design and manufactures set out in the 1836 Select Committee Report was on show at the Great Exhibition. And here it had more impact: an immediate effect. The 'lesson' of the Great Exhibition 'was not thrown away'.[10]

The *Guide* testifies that these things happened, that the Great Exhibition took place and taught a lesson. But it does not explain how. It is often assumed that there were two men responsible for the Great Exhibition: Prince Albert and Henry Cole. Prince Albert held all the prestigious positions and Henry Cole was the author of the official version of events. He wrote the 'Introduction' to the *Official descriptive and illustrated catalogue of the industry of all nations* (1851) which set out how he thought it happened. He claimed that 'wide moral agencies' had contributed to the Great Exhibition, one of which was Prince Albert. Cole described how the Prince 'took the subject under his own personal superintendence'.[11] The Prince was President both of the Society of Arts, the organization which promoted the idea of the Exhibition, and of the Royal Commission of 1851, the official body which carried it out.

The Royal Commission was 'issued' by the British government on 3 January 1851. Its purpose was 'promoting Arts, Manufactures, and Industry, by means of a great Collection of Works of Art and Industry of All Nations, to be formed in London, in 1851'. The Royal Commissioners included members of the Society of Arts and members of the British government and their powers included 'the definition of the nature of the Exhibition'.[12] So the state supported the principle of exhibiting, but its actual practise was to be carried out by another organisation which was obviously official, properly public, but usefully independent because it was somewhat separated from the state itself.

The Royal Commissioners executed the Exhibition. The Royal Commissioners, undertook, according to Henry Cole, 'individually and personally the whole responsibility . . . both pecuniary and executive'. They made a series of decisions which determined the form of the Great Exhibition and which,

therefore, defined its 'nature'. They decided how it should be financed; it was funded by public subscription. They agreed its location: the south side of Hyde Park, between Kensington Drive and Rotten Row. They chose a design for the building: Joseph Paxton's Crystal Palace. They set the terms of the collection of objects and their terms were not all-inclusive: not quite anything from anywhere was acceptable as the Exhibition's title 'Works of Industry of All Nations' suggests. The inclusion of objects from foreign nations required the approval of foreign governments. 'No articles of foreign manufacture . . . can be admitted for exhibition,' the Royal Commissioners stated, '*unless they come with the sanction of the central authority of the country of which they are the produce.*' They also excluded other objects: perishable goods, livestock, gunpowder, alcohol, portrait busts and all two-dimensional forms of fine art except, in their words, 'as illustrations or examples of materials and processes'.[13] The Royal Commissioners, furthermore, devised the system of classification, the division of the collection into raw materials, machinery, manufactures and fine arts, and they decided the arrangement for its display, unequally allocating the exhibition space by reserving half for objects from Britain.

For Cole, the work of the Royal Commissioners was an achievement in itself. 'It may be the boast of our countrymen', he writes, 'that the Exhibition was originated, conducted, and completed independently of any Government aid whatsoever, except its sanction.'[14] Exactly what the government sanctioned, precisely the part performed by the state, needs some clarification. The issuing of a Royal Commission was the ratification, by the state, of a group of individuals as a decision-making body and, therefore, the ratification of their decisions. The state sanctioned both the Royal Commission's practices of collection, classification and display of objects and, significantly, the practice of exhibition itself. It authorised an exhibition as a method of 'promoting Arts, Manufacture, and Industry'. Henry Cole's unspecified 'wide moral agencies' which, he claimed, 'contributed' to the making of the Great Exhibition can be more precisely defined. There was Prince Albert, an individual man. There was the Royal Commission, an organisation of individual men, and there was the state.

But Cole also claimed that the Great Exhibition was inevitable; it was bound to happen at a particular time and at a particular place: in 1851 and in London. The Great Exhibition, then, was bound to happen without Prince Albert or Henry Cole, without the Society of Arts, the Royal Commission, or the state for there was, according to Cole, another kind of agency at work. He suggested that the Exhibition was, quite simply, a sign of the times; it was related to the commercialisation of industry. He stated that:

The activity of the present day chiefly develops itself in commercial industry, and it is in accordance with the spirit of the age that the nations of the world have now collected together their choicest productions. It may be said without presumption, that an event like this Exhibition could not have taken place at any earlier period, and perhaps not among any other people than ourselves. The friendly confidence reposed by other nations in our institutions; the perfect security for property; the commercial freedom, and the facility of transport which England pre-eminently possesses, may all be brought forward as causes which have operated in establishing the Exhibition in London.[15]

Here it is capitalism which created the Great Exhibition. Its time and place, in 1851 and in London, was caused by the dominance of capital in the English economy and polity. The Great Exhibition happened because both economic and political spheres had developed according to the principles of political economy; the liberalisation of the market and the liberalisation of the government had taken place. In England, there was 'commercial freedom' combined with 'security for property' and London (thanks to the unrestricted financial speculation of the railway boom) was easy to reach. The notion that the Great Exhibition was thus a sign of the times, or as Cole put it 'in accordance with the spirit of the age', locks it into an unfolding narrative of the progress of capital and liberal reform.

The Great Exhibition made a profit of £186,000 and inevitably the narrative continues, or rather, the involvement of Cole's 'moral agencies' in exhibiting objects does not immediately end. The profit became the responsibility of the Royal Commissioners. On 2 December 1851, barely a month after the Exhibition was over, a Supplemental Charter was issued which required them to dispose of its 'surplus'. Still their President, Prince Albert produced a plan which promised to spend the profit pursuing the aims of the exhibition. According to the Prince that was 'the promotion of every branch of human industry by means of the comparison of their processes and results as carried on and obtained by all the nations of the earth'. He wanted another international experiment and this he insisted had already been agreed. 'We have', he referred to the Royal Commissioners, 'distinctly pledged ourselves to expend any surplus which may accrue towards the establishment of future Exhibitions or objects strictly in connection with the present Exhibition.'[16] But the Prince's plan was not for a repeat performance. He proposed something more permanent: the purchase of land. 'I am assured', he began:

> that from twenty-five to thirty acres of ground nearly opposite the Crystal Palace, on the other side of the Kensington Road, called Kensington Gore (including Soyer's Symposium), are to be purchased at this moment for about 5 000l. I would buy that ground and place on it four institutions, corresponding to the four great sections of the Exhibition – Raw Materials, Machinery, Manufactures, and Plastic Art.[17]

This was a plan to buy land and build museums. The Royal Commission set up a Surplus Committee which completed the purchase of the Gore House estate, paying £60,000 for 21½ acres. Then, with the permission and partnership of the government, they bought its adjoining land.

Money which bought land was not the only material legacy of the Great Exhibition left with the Royal Commissioners. They also acquired some of its exhibits. Henry Cole recalls how exhibitors 'presented various articles' to them: 'raw materials, models of inventions, and objects useful in scientific instruction'.[18] However, their own *First report* makes clear that they were actively engaged in the acquisition of Great Exhibition objects, in considering 'several suggestions to form and preserve a record of those articles . . . calculated to be of use for future consultation'.[19]

Thus, one immediate effect of the Great Exhibition was the continuing responsibilities of the Royal Commissioners. They held land, objects and a plan to build museums. Another immediate effect was the creation of a new government department, constituted within the Board of Trade. The Department of Practical Art was established in February 1852 and Henry Cole was appointed its General Superintendent.

Almost South Kensington

When the Department of Practical Art was established the exhibition of objects was no longer a policy simply sanctioned by the state; it became the policy of the state itself. The department had a number of policy aims, one of which was the formation of museums. All its aims were educational and were numbered and detailed in its *First report* presented to the President of the Board of Trade, Edward Cardwell, in 1853:

> The proposed objects of the Department were classed under the respective divisions of – 1st, General Elementary Instruction in Art, as a branch of national education among all classes of the community, with a view of laying the foundation for correct judgment, both in the consumer and the producer of manufactures; 2d, Advanced Instruction in Art, with a view to its special cultivation; and lastly, the Application of the Principles of Technical Art to the improvement of manufactures, together with the establishment of Museums, by which all classes might be induced to investigate those common principles of taste, which may be traced to the works of all ages.[20]

So the Department of Practical Art had three aims or 'proposed objects', plus the formation of museums. In effect, it had four aims; it had a programmic arts education policy divided into four parts. But its first three aims were different from the fourth, from the formation of museums, for they related to

teaching art in schools. The kind of teaching and the kind of student constituency differed, but the site remained the same: some sort of school. Intended also as sites of education, museums were similar to schools, but they were not the same. Significantly, they had a special place, or they were a special place, within the overall arts educational policy of the Department of Practical Art; they would perform a particular part of that policy: teaching everybody aesthetics through the exhibition of objects from all times. 'With the establishment of Museums', in the words of the department's *First report*, 'all classes might be induced to investigate those common principles of taste, which may be traced to the work of all ages.' What the department assumed, then, was the existence of a law of aesthetics, a set of rules or 'common principles of taste', which resided in objects, which everybody needed to learn and would learn in museums. Museums would be the place where they could look at the objects and learn the law.

The year that the Department of Practical Art was formed, 1852, it formed a museum: the Museum of Manufactures in Marlborough House. This was the place where policy would be put into practice, where 'all classes' would find in 'works of all ages' a law of aesthetics. To enable all to enter the museum the department instituted free or cheap admissions and long, late opening. To ensure that objects from all times were available it aimed to institute inside the museum an inclusive collection. Thus, the policy of the place was an obvious reiteration of the recommendations of the 1836 Report. But there was a difference between policy and practice; there was a discrepancy between the intended, inclusive collection and what the museum actually contained. Even the museum *Catalogue* began with a statement which described the intention of the museum and not the actual objects. '*The Museum is intended to contain not only works selected as fine examples of design or art workmanship, but others chosen with a view to an historical series of manufactures.*'[21] The intention is, of course, important in itself. The aim was to exhibit excellent objects, 'fine examples of design or art workmanship', and all objects, 'a historical series'.

The Museum of Manufactures in fact contained a composite collection of unconnected objects. Queen Victoria had loaned forty-two pieces of Sèvres porcelain. Space had been set aside for a gallery of objects illustrating 'false principles'. There was an art library of books, prints and drawings. There were reproductions of what could be called 'works of all ages', casts of ornamental art inherited from the Schools of Design and classified by period and subject: 'Ancient Greek and Roman; Medieval or Romanesque, Saracenic or Gothic; Renaissance; Figure, busts, masks; and Animals'. And there was a collection of objects from the Great Exhibition of 1851. These objects more than the others displayed the aim of the department and the intention of the museum, for they were selected rather than inherited and paid for rather than permanently on loan.

Purchasing Great Exhibition objects was a priority, at least for Henry Cole. When he was appointed General Superintendent of the Department of Practical Art, one of his 'first recommendations for immediate adoption' was the acquisition of items from the Crystal Palace. Paliament agreed a sum of £5,000. The Board of Trade requested that a committee select the objects and set out in a catalogue 'the prices of the various articles' and 'the reasons for purchase'. The selection committee consisted of four people: two superintendents from the department, Henry Cole and Richard Redgrave, and two others, Pugin and Owen Jones. Their catalogue contained a description of their selected objects and, significantly, their selection processes. This began with the disposal of their personal preferences:

> As a first principle in making the selections, the Committee felt it to be their duty to discard any predilections they might have for particular *styles* or ornament, and to chose whatever appeared especially meritorious or useful, if it came within the limits of the means at their disposal, without reference to the style of ornament which had been adopted. The collection accordingly possesses specimens of many European and several Asiatic styles. Yet each specimen has been selected for its merits in exemplifying some right principle of construction or of ornament.[22]

For the committee, it was the price of, and not a predilection for, Great Exhibition objects which set limits on the process of selection. It was within the price limit of £5,000 set by Parliament that they made their choices based on the object's merit or use and not, importantly, its particular style. The particularities of objects were rejected as a premise of suitable selection in favour of their principles. The selected object's 'style of ornament' was far less important than its 'principle of construction or of ornament'. So, the selected collection contained various unspecified styles which were categorised only according to continent of origin: Europe and Asia. But, as the committee went on to point out, European and Asian objects differed not only in their particularities of style but in their principles. 'Examples . . . from the East', they stated, 'illustrate the correct principles of ornament . . . whilst others, chiefly European specimens . . . are often defective in the principles of their design.'[23] The committee did not, however, specify which principles were 'correct' and which 'defective'. They did not need to. The question of principles had already been sorted out and settled by one of the committee's members, Richard Redgrave.

Richard Redgrave, at the request of the Royal Commissioners of 1851, wrote a 'Supplementary report on design'. Intended to evaluate all ' "Designs" ' in the Great Exhibition and to 'have regard to the general state of design', his report formed a critical commentary on the exhibited objects. It analysed their appearance and determined the principles of their design.

Redgrave provided a definition. '"Design"', he stated, 'has reference to the construction of any work for both use and beauty, and therefore includes its ornamentation also.' The design of the object was the whole of the object; its use and ornament, its function and form. The 'correct' principle of design of the object was established by ordering the relationship between use and ornament: form should follow function. Or, as Redgrave put it, 'ornament . . . cannot be other than secondary, and must not usurp a principle place'. And, he continued, 'if it do so, the object is no longer a work ornamented, but is degraded into mere *ornament*.'[24] 'Defective' principles, then, were the disordering of the relationship between form and function, distorting the object by putting its ornament before its use. This was bad design and was, for Redgrave, all too prevalent in the Great Exhibition. There were too many exhibits which were 'mere ornaments', objects without the right principles which were reduced only to the particularities of their style.

So the selection committee did not have much to chose from. They nevertheless spent the money that Parliament had provided. They bought 'the nucleus' of what they hoped would be a much more 'systematic collection'. For whatever their defects, the selected Great Exhibition objects were an 'effectual beginning' of an art collection which could achieve an important departmental aim:

> Notwithstanding the indifference to principles of Ornamental Art which is too prevalent in the present age – and even the variety of style and character in the works of this Collection afford proof of such indifference – there are signs that the existence of laws and principles in Ornamental Art, as in every branch of human science, is beginning to be recognized. Indeed, without a recognition of them, we feel that the Schools of Art can make no progress. Collections of Art will, we think, be most instrumental in helping to form a general belief in true principles.[25]

Objects of art were attributed with the power to achieve the department's aim. In the appearance of objects of art lay a law of aesthetics which was waiting to be learnt. Rules were not written on the objects, but as revealed by Richard Redgrave, they were discernible in some designs, in forms which followed functions. What he and Henry Cole wanted was everybody to look, learn a law, and like the art of utility (fig. 4.2).

More on the achievements of art objects will be said later, for in the meantime the Department of Practical Art acquired other than Great Exhibition objects: the Bandinel collection of ceramics, the Bernal collection of *objets d'art*, the Soulages collection of Italian and French art. They now needed another museum.

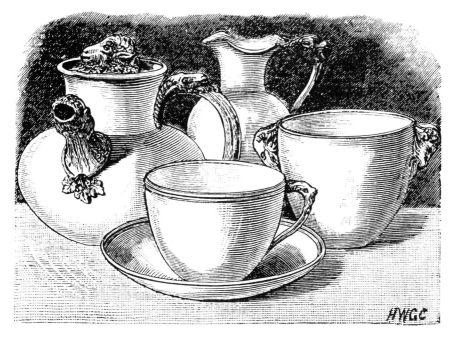

4.2 Utilitarian objects: a tea service designed by Henry Cole using the alias 'Felix Summerly'

Eventually at South Kensington

In 1853 the Department of Practical Art became the Department of Science and Art. Three years later it was moved from the Board of Trade to the Committee of Council on Education. Some things stayed the same: Henry Cole retained control; he remained the general superintendent of the Museum of Manufactures and was made joint secretary of the new, and now enlarged, department. It was under his control that the department's museum continued to acquire objects. An art collection was expanded which could not be kept on public display. There was a problem with Marlborough House. It was a provisional place, a Royal Palace property made temporarily available for exhibition use. Furthermore, there was the Royal Commissioners' collection of objects packed away in Kensington Palace, never yet put on public display. According to Henry Cole, what both collections required was a permanent place of public exhibition, or as he put it, 'a home'.[26] Land was available, that purchased by the Royal Commissioners with the Great Exhibition profits, and only a building was needed. In 1855 Parliament voted £15,000 for what it called 'covered space' and on 20 June 1857 Queen Victoria opened the South Kensington Museum (fig.4.3).

The building was unsuitable, ugly and made of metal. It let in the rain. It

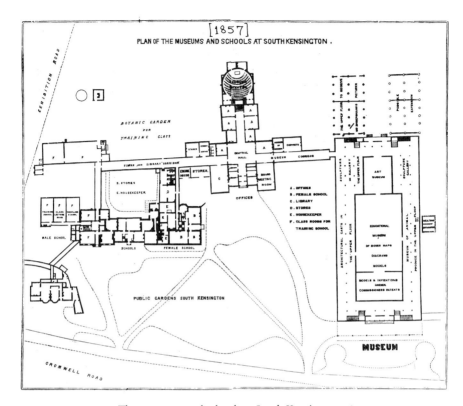

4.3 The museums and schools at South Kensington, 1857.
© The Board of Trustees of the Victoria & Albert Museum

was leaky and it was not made to last. A company called Charles Young had erected at South Kensington an impermanent and economical structure, an 'iron museum'. Henry Cole described it as simply a place of shelter for objects that had nowhere else to go. It was, he said, 'a temporary refuge for destitute collections'.[27] Dismantled in parts in 1867, the building was demolished in 1899. But before the dismantling, other building work had begun. Francis Fowke, a captain of the Royal Engineers, designed the permanent parts of the South Kensington Museum: the Sheepshanks Gallery, the Vernon and Turner Galleries, the Eastern Galleries, the North Court, the South Court, the Lecture Theatre. While these parts were permanent, there was no time when all the buildings which comprised the South Kensington Museum were complete. Francis Fowke carried out a programme of continuous construction.[28] Permanent is, therefore, a poor description of the South Kensington Museum as a physical building. Given its unfinished condition, South Kensington could not achieve the solid structural form considered to be

consistent with the state museum.[29] But, its form did not detract from its function.

The South Kensington Museum operated as a work of art. Unsuitable in parts and unfinished in form, it functioned like one of the objects of art it contained; it had an enlightening influence. Attendance at the South Kensington Museum, as described by Henry Cole, was an experience of entering an environment of enlightenment. In his *Introductory address on the functions of the Science and Art Department*, he offered an account of a museum visitor and his museum visit:

> The working man comes to this Museum from his one or two dimly lighted, cheerless dwelling rooms, in his fustian jacket, with his shirt collars a little trimmed up, accompanied by his threes, and fours, and fives of little fustian jackets, a wife, in her best bonnet, and a baby, of course, under her shawl. The looks of surprise and pleasure of the whole party when they first observe the brilliant lighting inside the Museum show what a new, acceptable, and wholesome excitement this evening entertainment affords to all of them. Perhaps the evening opening of Public Museums may furnish a powerful antidote to the gin palace.[30]

To be allowed to go inside South Kensington was to be enabled to undertake a journey from darkness into light, from drunkenness to temperance, from poverty to pleasure. It was the museum's admissions policy, open and free to a public which included the poor, which ordered an experience of enlightenment. This was Henry Cole's assumption and others agreed. The Select Committee on the South Kensington Museum which sat in 1860 'arrived at the opinion' that it was 'exercising a beneficial influence'. It had achieved the general aim of art; it was progressive, beneficial, benign.

Yet, the significance of the South Kensington Museum is its specific aim, an aim that was also attributed to objects of art: improving manufacture. It becomes difficult to distinguish between the museum and the objects it contained for specifically, as well as generally, it operated as a work of art: it had an effect on the economy.

Henry Cole explained how this happened. He appeared as a witness before the 1860 Select Committee and answered questions on the economic function of the South Kensington Museum. Key questions were asked by one Committee member, Mr Kinnaird. He began by establishing the nature of the institution. 'I think you said', he addressed Henry Cole, 'that the character of the South Kensington Museum is essentially practical?' Cole said, 'Yes'. To clarify the meaning of 'practical', Mr Kinnaird asked another question. 'It is conducted', he enquired, 'with a view of benefiting art and manufacture?' Again, the reply was affirmative. 'Especially',

Cole elaborated, 'ornamental art manufacture.' Well, so far, so good. Henry Cole's evidence had simply set out state policy since 1836: the exhibition of art eventually improved manufacture. This was the South Kensington Museum's purpose. Cole had yet to explain how it performed its purpose and how economic effects were accrued by the exhibition of art. Mr Kinnaird altered his questions. Instead of asking Cole about the museum, he enquired after particular objects:

> [Mr Kinnaird] Has not pottery within the last few years increased very much as an article of export from this country?
> [Henry Cole] I have not any precise facts as to that, but I believe so.
> [Mr Kinnaird] Are you of opinion that in pottery the models in the last few years have very much improved?
> [Henry Cole] Yes.
> [Mr Kinnaird] Do you attribute that to the exhibition of these objects of art?
> [Henry Cole] Certainly.[31]

So, the economic effects of exhibition was an increase in exports and the increase in exports was apparently related to improvements in actual designs. Or at least, in the opinion of Henry Cole. He testified to a relationship between the exhibition of art and the economy of manufacturing where the public appearance of art altered one part of the process manufacturing: making the 'model', producing the pattern, designing the design.

Another Committee member, Mr Blackburn, took over the questioning of Cole. He wanted to know more about the mechanics of the relationship between exhibition and economy, art and manufacture. 'How do you think', he asked, 'the manufacturer of china is affected by the exhibition of the South Kensington Museum?'. Not quite effusive, Cole responded to this question with more than a simple sentence:

> I think that the first result of this kind of exhibition is to make the public hunger after the objects; I think they go to the china shops and say, 'We do not like this or that; we have seen something prettier at the South Kensington Museum;' and the shop-keeper, who knows his own interest, repeats that to the manufacturer, and the manufacturer, instigated by that demand, produces the article.[32]

The South Kensington Museum, then, operated according to the liberal laws of supply and demand. The museum made accessible objects of art which were ultimately unavailable. Cole claims it created an urgent desire, a 'hunger', which had to be fulfilled elsewhere, outside the museum, in the market. This was the influence of art objects and South Kensington. Thus, a state museum diffused knowledge through a market mechanism. South Kensington taught its visitors to be knowing shoppers; it educated them to go out and buy only objects of utility.

There are now cash registers at South Kensington. Since 1899 the South Kensington Museum has been known as the Victoria and Albert Museum. Since 1988 there have been cash registers positioned at its entrances. They were placed, and strategically placed, inside the museum to encourage all visitors to give a donation, but they have been criticised for ensuring that most visitors pay. The cash registers appeared to mark the departure from the nineteenth-century liberal project of South Kensington: the education of everyone through the unrestricted exhibition of art. Their introduction into the museum provided the proof of a political intrusion: the economy broke into and entered a place of education. But the cash registers are not so completely out of place at South Kensington, for economic imperatives were always an integral part of its educational project.

Notes

1 British Parliamentary Papers, *Report from the Select Committee on the South Kensington Museum; together with proceedings of the Committee, minutes of evidence, and appendix, 1860*, Reports from Committees, 1860, XVI, p. 11.

2 *Ibid.*, pp. vii–viii.

3 *Ibid.*, p. 2. J. Minihan, *The nationalization of culture*, Hamish Hamilton, London, 1977, and N. Pearson, *The state and the visual arts*, Open University Press, Milton Keynes, 1983, contain histories of the South Kensington Museum. It should also be noted here that in 1899 its artistic and scientific collections were divided to establish two museums: the Victoria and Albert Museum and the Science Museum.

4 British Parliamentary Papers, *Report of the Select Committee on Arts and Manufactures, 1836*, Irish University Press, Industrial Revolution, Design, I, p. iii.

5 *Ibid.*, p. iii.

6 *Ibid.*, p. v.

7 *Ibid.*, p. v.

8 A. Rifkin, 'Success disavowed: the Schools of Design in mid-nineteenth-century Britain. (An allegory)', *Journal of Design History* I, 1988, p. 91. For other histories of the Schools of Design see: Q. Bell, *The schools of design*, Routledge & Kegan Paul, London, 1963; S. Macdonald, *The history and philosophy of art education*, University of London Press, London, 1970.

9 *Guide to the South Kensington Museum*, 20 June 1857, p. 1.

10 *Ibid.*, p. 1.

11 *Official, descriptive and illustrated catalogue of the industry of all nations*, Spicer & William Clowes, London, 1851, pp. 1–3.

12 *Ibid.*, p. 6.

13 *Ibid.*, p. 15.

14 *Ibid.*, p. 2.

15 *Ibid.*, p. 1.

16 'Memorandum by the Prince Consort as to the disposal of the surplus from the Great Exhibition of 1851', T. Martin, *The life of His Royal Highness the Prince Consort*, vol. II, Smith, London, 1877, p. 569.

17 *Ibid.*, p. 570.

18 H. Cole, *Fifty years of public work*, vol. I, George Bell, London, 1884, p. 317.

19 *First report of the Commissioners for the Exhibition of 1851*, Clowes, London, 1852, p. 165.

20 British Parliamentary Papers, *Reports and papers relating to the state of head and branch schools of design together with the first report of the Department of Practical Art*, 1850–3, Irish University Press, Industrial Revolution, Design, IV, p. 2.

21 *Ibid.*, p. 233.

22 *Ibid.*, p. 229.

23 *Ibid.*, p. 229.

24 R. Redgrave, 'Supplementary report on design', *Reports by the juries on the subjects in the thirty classes into which the Exhibition was divided*, William Clowes, London, 1852, p. 708. For a summary of Redgrave's writings on design see: G. R. Redgrave, *Manual of design compiled from the writings and addresses of Richard Redgrave, R. A.*, Chapman & Hall, London, 1876.

25 *First report of the Department of Practical Art*, 1853, p. 230.

26 H. Cole, *op. cit.*, vol. I, p. 322.

27 H. Cole, *op. cit.*, vol. II, p. 292.

28 For a detailed history of the building of the South Kensington Museum see: J. Physick, *The Victoria and Albert Museum: the history of the building*, Phaidon, Oxford, 1982.

29 C. Duncan and A. Wallach, 'The universal survey museum', *Art History*, III, 1980.

30 H. Cole, *op. cit.*, vol. II, p. 293.

31 *Report from the Select Committee on the South Kensington Museum*, 1860, p. 10.

32 *Ibid.*, pp. 10–11.

II

Artefacts, identity
and nationhood



THE BATTLE OVER 'THE WEST AS AMERICA' 1991

Alan Wallach



Critical exhibitions

IMAGINE AN EXHIBITION of classical Greek sculpture or Roman Baroque painting but not in the usual manner: not an exhibition devoted to the contemplation of 'masterpieces', not a demonstration of the evolution of a period style or a grouping around a familiar theme (Athenian democracy, the glories of papal patronage) but an exhibition that attempted to reveal the works under consideration as ideological.[1] You might object that such an exhibition would be virtually impossible to mount. To begin with, a critical examination of ideologies would probably require more in the way of written materials than an art exhibition could easily bear. Moreover, the type of historical criticism that now routinely occurs in academic settings would very likely encounter grave difficulties in a museum. For example, puncturing the myth of Athenian democracy would no doubt arouse the ire of a public – or at least its self-appointed representatives in the press – habituated to celebrations of 'the Greek miracle'. Finally, an exhibition that rigorously avoided the familiar affirmative discourses focusing on 'treasures', 'masterpieces' and 'genius' and instead submitted its materials to critical scrutiny would almost inevitably run into opposition from institutional and corporate backers as well as from potential lenders. How likely is it, after all, that the Vatican would send paintings to an exhibition that linked Baroque religious imagery to the seamier side of papal ambition, or dealt with religious faith as ideology *tout court*?

The critique of ideology strikes at the very heart of the museum's traditional function, its capacity, in Walter Benjamin's words, to produce 'an

eternal image of the past'.[2] Consequently, proposals for what might be called critical exhibitions more or less inevitably meet with institutional resistance since they pose the threat of undermining the museum's authority and thus adversely affecting the various elite, corporate and government interests which that authority normally serves. Yet such exhibitions are at least becoming more imaginable. The rise of critical and revisionist art histories has resulted in withering criticism of traditional museological approaches and has thus made it more difficult for museums to ignore the nature and effects of their habitual practices. Still critical exhibitions remain a rarity. With one crucial exception (which forms the subject of this essay), the few American examples that come readily to mind have occurred at experimental and non-mainstream institutions: 'Art/artifact' at the Center for African Art in New York City (1988); 'Winslow Homer's images of blacks' at the Menil Collection in Houston, Texas (1988–9); 'Mining the museum' staged by the Baltimore Museum of Contemporary Art at the Maryland Historical Society (1992). Of course it might be argued that these exhibitions failed to realise very much in the way of a thoroughgoing critique of ideology and that in the case of the Menil Foundation's 'Winslow Homer's images of blacks', what critique there was did little more than flatter that particular institution's liberal, upper-class pretensions. Still, these small exhibitions represented a deliberate break with past practices.

Rhetorical inventions

The same may be said of 'The West as America', a large-scale exhibition dedicated to 'reinterpreting images of the frontier' (as the exhibition's subtitle proclaimed), which opened at the Smithsonian Institution's National Museum of American Art in Washington DC on 15 March 1991. In the preface to the catalogue, William H. Truettner, curator for 'The West as America', asserted that ideology 'is the embracing factor of our investigation',[3] and in the exhibition itself he attempted to put this claim into practice. The exhibition contained 164 paintings, prints, sculptures, watercolours and photographs, which Truettner divided among six thematic sections. The section titles underscored the idea that what was on display was a culturally-constructed pictorial rhetoric: 'Repainting the past', 'Picturing progress', 'Inventing the Indian', 'Claiming the West' – a deliberate pun since painting claims its subject as surely as settlers claim the land – 'The kiss of enterprise' (another pun) and 'Doing the "Old America"'. Works in the exhibition ranged from long-neglected academic exercises such as Emanuel Leutze's *Departure of Columbus* of 1855, an elaborate costume picture featuring a heroically resolute Columbus bidding farewell to his son while melodramatically gesturing westward, to

Henry Farny's, Frederic Remington's, Charles Russell's and Charles Schreyvogel's retrospective evocations of a lost frontier world of troopers, cowboys and Indians.

Yet this was not simply another line-up of western art. In the context of the exhibition paintings, drawings, photographs and sculpture began to shed something of their status as major or minor works of art and take on the qualities of historical artefacts: objects created to achieve particular aims. As Bryan J. Wolf observed in a perceptive review, the central point of the exhibition was that in conquering the West palette and paint brush played as much of a role as instruments of domination as Colt revolvers or the pony express.[4] 'The West as America' thus attempted to instil in the viewer a sense of the works' utility, the way they addressed often pressing (ideological) needs. Consider, for example, the exhibition's presentation of Frederic Remington's well-known *Fight for the water hole* of 1903 (fig. 5.1), one of a number of 'last stand' paintings executed around the turn of the century. Like other paintings by the artist, *Fight for the water hole* has long been considered a documentary work, an accurate or realistic representation of an event that occurred in the Texas Panhandle in 1874 when a band of Comanches and Kiowas attacked a group of soldiers. The wall text that accompanied the painting took a different position:

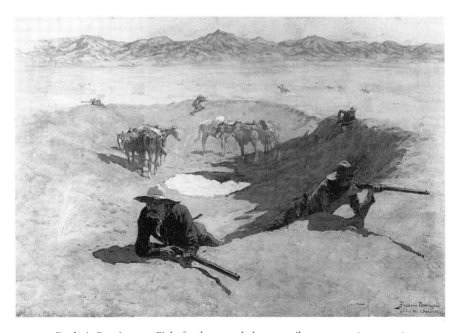

5.1 Frederic Remington, *Fight for the water hole*, 1903, oil on canvas, 69.2×101.6 cm. The Museum of Fine Arts, Houston; the Hogg Brothers Collection, gift of Miss Ima Hogg

Few scenes have come to represent nineteenth-century frontier America more than the 'last stand' and other images of battle. Yet by 1900, newspapers in the industrialized eastern United States referred to immigrant laborers as 'savages' or 'redskins' and the 'last stand' itself came to symbolize the plight of an embattled capitalist elite in an era of strikes, violence, and widespread immigration.

Although their paintings were not deliberate allegories, artists represented the West as if it were an urban situation. In Remington's *Fight for the Water Hole*, an outnumbered group of cowboys fights desperately to preserve a dwindling commodity – literally even a way of life – from a ruthless enemy 'strike.'[5]

In sum, the exhibition did almost everything in its power to frustrate a reading of western art as simple reportage or as a reflection of the real, and emphasized, instead, the role of constructed images within particular histories. Yet it may have done too much since it overlaid its rhetorical subject-matter with a far too insistent rhetoric of its own. Much of the controversy over 'The West as America' revolved around the exhibition's wall texts which were frequently condemned for talking down to a supposedly benighted audience. The texts quite properly underlined the idea that 'images are carefully staged fictions', that they 'are contrived views', that 'seeing is not believing', and emphasised the way an elaborate pictorial rhetoric of westward expansion helped to sanctify Manifest Destiny. For example, a wall text placed next to George Caleb Bingham's *Daniel Boone escorting settlers through the Cumberland Gap* (1851–2) – a painting featuring a mother and child on horseback at the head of a line of settlers (fig. 5.2) – read as follows: 'Such images persuaded Americans that migrating west was a peaceful mission, accomplished by "Holy Families" who courageously settled new territory.' Elsewhere wall texts made worthwhile and even daring political points: 'One of the most insidious aspects of white privilege historically has been its unquestioned claim to be standing at world center, measuring culture in terms of difference and distance from itself.' (Ten weeks after the opening, when several wall texts were revised, the words 'white privilege', deemed offensive by a panicky museum staff, disappeared.) In several instances, wall texts assumed a politically aggressive stance: 'doomed Indians' and 'the white man's Indian' were subsumed under the heading 'wishful thinking'. Other texts belaboured the more or less obvious: 'these images teach us more about the feelings and ideas of those who paid for them and made them than they do about the Indians whose lives they represent.' Or they adopted a self-righteous tone: 'What's Wrong with the Language We Use?' one wall text asked and went on to spell out the 'racial attitudes' of the 'words we use' to describe Native Americans, perhaps a necessary point but made in a manner that could only inspire in the visitor powerful twinges of guilt – or as often happened angry rebellion. 'A relentless sermon, phenomenally condescending to both the painters and the

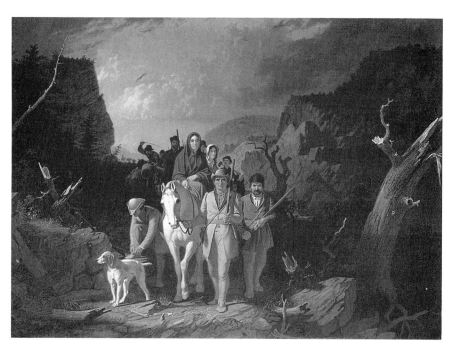

5.2 George Caleb Bingham, *Daniel Boone escorting settlers through the Cumberland Gap,*
1851–2, oil on canvas, 92.7×127.6cm. Washington University Gallery of Art, Saint Louis;
gift of Nathanial Philips, 1890

painted', the Harvard historian Simon Schama wrote of 'The West as America'
in the exhibition's comment book.[6] Other viewers, perhaps with less political
animus, arrived at similar conclusions: 'How nice!' wrote one visitor.
'According to your commentaries the world is filled with racist white males
and their hapless victims. Grow up!'

The West of the neo-conservative imagination

The wall texts were a serious tactical miscalculation and hostile commentators
made the most of them. At the exhibition's opening historian and retired
Librarian of Congress Daniel Boorstin wrote in the comment book: 'a per-
verse, historically inaccurate, destructive exhibit. No credit to the
Smithsonian.'[7] Within days 'The West as America' was engulfed in contro-
versy. Taking a cue from Boorstin (a repentant 1940s leftist who made his rep-
utation during the McCarthy period as a leader of the consensus school of
American history), neo-conservative reporters and columnists sprang to the
attack. *The Wall Street Journal* published an editorial entitled 'Pilgrims and

other imperialists' in which it displayed its usual subtlety in defence of capital-
ist values: 'Only in the land of the free, of course, is it possible to mount an
entirely hostile ideological assault on the nation's founding and history, to
recast that history in the most distorted terms – and have the taxpayers foot
the bill'.[8] (A later report in the *Journal* stated otherwise.[9]) Nationally-
syndicated columnist Charles Krauthammer labelled 'The West as America'
'the most politically correct exhibition in American history . . . tendentious,
dishonest and, finally, puerile'.[10] The controversy soon reached the halls of
Congress where Republican Senator Ted Stevens of Alaska, incensed over 'The
West as America' and reports of 'leftist' influence at the Smithsonian, publicly
humiliated Smithsonian secretary Robert McC. Adams at an Appropriations
Committee hearing – 'You're in for a battle', Stevens rumbled ominously. 'I'm
going to get other people to help me make you make sense' – and threatened
to cut the institution's funding.[11] (Loath to make waves, three weeks later
Adams humbled himself in front of the assembled editorial staff of the ultra-
rightwing *Washington Times*, a newspaper owned by the Reverend Sun Myung
Moon's Unification Church.[12])

The controversy was in some respects very much a product of its historical
moment. The exhibition opened during the period of official euphoria over
the United States and its allies' 'victory' in the Gulf War. In an atmosphere of
supercharged patriotism, the exhibition's critical assessment of manifest
destiny and related expansionist myths seemed downright subversive to those
celebrating the demise of 'the Vietnam syndrome'. In addition, 'The West as
America' coincided with the opening rounds in a far-reaching debate over
'PC' or 'political correctness', a term of leftist self-mockery co-opted by neo-
conservatives to disparage what they saw as plots and conspiracies hatched by
left-leaning humanities professors to undermine the values of western civil-
isation, do away with notions of truth and objectivity, and brainwash students
with Marxist and feminist 'propaganda'.[13] To the ideologues of the Reagan
right, who displayed a curious *Schadenfreude* in piling up examples of 'PC'
outrages, 'The West as America' looked like a ripe target. In a pamphlet enti-
tled 'Telling the truth' – her parting shot as chairperson of the National
Endowment for the Humanities – Lynne Cheney cited 'The West as America'
as proof that the 'PC' contagion had spread from university campuses to cul-
tural institutions and berated the exhibition for such crimes as its 'aggressive
lack of objectivity'.[14] Cheney's argument, like so much of the 'PC' debate,
represented a shift of focus for the neo-conservative right. With the end of the
cold war and the crumbling of the 'Evil empire', a new demonology was
needed and conservatives and neo-conservatives quickly settled for a domes-
tic culture war which suddenly became 'as critical to the kind of nation we will
one day be [thus proclaimed the unspeakable Patrick Buchanan] as was the

cold war itself'.[15] Charles Krauthammer made explicit the connection between neo-conservative cold war nostalgia and the new culture war agenda when he began his attack on 'The West as America' by imagining 'a party museum' thirty years ago in Moscow planning 'an exhibit of American art depicting the Western frontier as a chronicle of racist capitalist rapacity and call[ing] it 'The American West: The Origins of Imperialism''. 'Alas, they don't do it that way in Moscow any more,' lamented Krauthammer, 'but they do it that way in Washington.'[16] Krauthammer's inadvertent 'alas' was, of course, the tipoff.

Yet for all their dark talk about political correctness and the politicisation of cultural institutions, the neo-conservative pundits failed to come to grips with the difficult issues the exhibition raised. For the most part, they resorted to familiar tactics, castigating revisionist historians for failing to appreciate the 'tremendous adventure' of westward expansion and filling their columns with patriotic boilerplate.[17] An exception, however, was Richard Grenier, a writer for *The Washington Times*, who mounted an argument to the effect that 'Indians came into dominance in their respective regions by methods far worse than any the white man ever used against them' and then went on to cite Alexis de Tocqueville in defence of the idea that the destruction of 'inferior' native cultures was perhaps tragic but none the less inevitable, an argument, he claimed, 'most sane people' would agree with.[18]

To subtler ideologues, Grenier's argument would be embarrassing in its explicitness. Yet once you strip away the adventure tales, the cowboys-and-Indians myths that Remington *et al.* did so much to propagate, the history of the American West becomes from a variety of traditional viewpoints – e.g., Boorstin's consensus paradigm – deeply problematic. That history is in its main outlines inescapably a brutal story of expansion and conquest, of ruthless efforts to destroy Native American populations and cultures, of the merciless exploitation of industrial and agricultural labour – cowboys, railway workers, miners, itinerant farm hands – and of bloody labour strife. Not only neo-conservative pundits but more traditional scholars have attempted to keep this nightmare aspect of western history at bay. This probably accounts for the abusiveness, the rhetorical violence and evident sense of panic that characterised the hit-and-run responses to 'The West as America' from three well-known historians of the American West: William H. Goetzmann of the University of Texas, his son William N. Goetzmann and Gerald D. Nash, Distinguished Professor of History at the University of New Mexico. The elder Goetzmann accused Truettner of failing to credit the two Goetzmanns' *West of the imagination* as the basis for 'The West as America' (a charge that seems a little odd given the irreconcilable differences between the two projects) and faulted the exhibition for adhering to a 'conspiracy theory' and 'an outmoded Marxist interpretation'.[19] Nash in a furious

diatribe maintained that revisionist historians along with the organisers of 'The West as America' were simultaneously promoting Fascism and Stalinism.[20] William N. Goetzmann added the following to the exhibition comment book:

> If American whites were so bad, is it possible to picture Indians (Native Americans) paddling across the Atlantic to stop Hitler and other totalitarians. The curator [Truettner] should spend more time in what used to be the U.S.S.R. and learn what 'political correctness' means and has meant. The trendy 'screaming weenies' are at it again – but the pictures, all works of imaginative *art* (the definition of art) are wonderful.

A desire to steer clear of the painful contradictions of western history probably also explains the more cautious but still basically hostile response from traditional scholars of western art. These scholars remain deeply invested in the notion that representations of the American West possess documentary as well as artistic value and they thus raised objections to interpretations of such works as Remington's *Fight for the water hole* as anything other than literal accounts of historical events. For example, B. Byron Price, executive director of the National Cowboy Hall of Fame in Oklahoma City, a major repository of western painting, informed a correspondent from *The Washington Post* that *Fight for the water hole* was in fact nothing more than 'basic reportage': 'Remington just painted the scene as he'd heard about it.'[21] (Price went on to assert that revisionist critics were 'not like real people. They're uncomfortable with the sense of wonder that's in many of these paintings.') In a similar vein, Ron Tyler, director of the Texas State Historical Association and a recognised authority on western art, maintained that Alexa Nemerov's discussion of *Fight for the water hole* in the exhibition catalogue was based upon a misunderstanding of the reasons why Remington created such works. 'Nemerov misses because he goes for what, in the revisionist canon, is the easy, politically correct conclusion.' And the difficult conclusion? 'Remington chose to paint the Old West and its characters because it was what he knew best.' Thus 'the cowboy in *Fight for the Water Hole* is not the embattled capitalist, as Nemerov suggests, but embattled mankind struggling against ultimate destiny'.[22]

To their credit, a number of traditional art historians made efforts to come to terms with the implications of 'The West as America' and revisionist western history in general. Yet their attempts remained inconclusive, reflecting the fundamental impossibility of reconciling, or compromising between, traditional and revisionist approaches. For example, in a recently published essay, B. Byron Price worked out the following argument based on the 'interpretive conclusions', as he put it, of 'The West as America':

> If the art condemned in this exhibit is indeed flawed by racism, gender bias, and
> imperialism, then it follows that the museums exhibiting such works without
> caveats or as unbiased historical narrative, must also be guilty of promoting
> these concepts. Should these same institutions now don sack cloth and ashes,
> repent, and proclaim themselves museums of the western holocaust?[23]

Not a bad idea, especially in light of the opening in 1993 of the United States
Holocaust Museum in Washington DC. But the vision of the National
Cowboy Hall of Fame transformed into a museum of the western holocaust
proved too much for Price who beat a quick retreat to the notion that
museums of western art should in the future take an 'art history approach' that
would 'stress the universal and aesthetic qualities of the work rather than its
transient and ideological traits'.[24] Not for the first time, art history rides to the
rescue.

'The labour, patience and suffering of the negative'

For all their hysteria over 'The West as America', the neo-conservative opponents
of the exhibition failed to develop a serious appreciation of its problems and
shortcomings. Their myopia resulted from an inability to conceive of the exhibi-
tion as anything other than an art-historical morality play, a 'perverse' effort to
force 'imaginative works of *art*' into a procrustean bed of politically correct atti-
tudes. But 'The West as America' dared to aspire to an overall historical critique
of the art of the American West. That it ended up far short of its goal resulted, in
part, from too great a reliance upon conventional art historical methods – from
in effect attempting to do battle with the enemy on the enemy's turf. Thus in a
pinch, the exhibition fell back on traditional iconographical analysis, at times
somewhat pointlessly finding crosses, Judas's kiss, and Last Supper imagery in
scenes of western discovery and conquest. For example, in a wall text, Charles
Russell's *Carson's men* (1913) became a subliminal crucifixion:

> The three men, with their halo-like hats, are situated above a bison skeleton that
> recalls the skulls at Golgotha. Russell may also intend a play on Carson's first
> name, *Christ*opher, and on his crossing of the river, to convey the Christian
> meaning of the explorer's mission . . .

The text brings to mind the ennui peculiar to a certain type of art history
lecture, but this is not to say it is entirely wrongheaded. Indeed, this sort of
analysis worked well enough in the wall text accompanying Bingham's *Daniel
Boone escorting settlers through the Cumberland Gap* where the links to tradi-
tional Christian imagery were more readily apparent. But without providing
a more developed critical framework, the discussion of *Carson's men* could
only strike most visitors as arbitrary and purely speculative.

These difficulties are symptomatic of the exhibition's inability to carry through in any sort of developed or consistent way its programme of historical criticism. From the viewpoint of ideology critique, the exhibition's main flaws resulted from the organisers' failure to consider the problems inherent in the museum context, their failure to develop a concept of ideology sufficient to the materials on display, and, finally, their failure to prepare for the inevitable clash of viewpoints over a subject that for most Americans remains compelling and highly controversial.

As has often been observed, museum spaces are productive of what western culture recognises as high art. In these spaces historical artefacts acquire an aura of timelessness and universality – Benjamin's 'eternal image of the past'. Of course the authority of any given museum is relative. For example, the Washington National Gallery carries far more authority than the National Museum of American Art. But in the end that authority depends entirely upon a museum's capacity to produce timelessness and universality. Thus already inscribed in any given museum space is a set of meanings that work against any sort of critical narrative. Consequently, while museums present sacralised histories of cultural and artistic triumph, they are as if by design conceived to frustrate the sort of dialectical engagement with history that is, as Benjamin wrote, 'original to every new present'.[25] Instead, visitors are virtually compelled to approach the museum with a sense of reverence, to anticipate that at the museum they will encounter once again The Vindication of Art.

Consequently, the first serious difficulty with 'The West as America' was that it in no way attempted to undermine or contradict the museum's usual authority. Instead it tried to adapt to its own purposes the museum's traditional, hegemonic voice. But the ahistorical or anti-historical could not be so readily converted to the historical: the museum space could not without massive i0ntervention lose its aura of timelessness. Although the exhibition's neo-conservative critics objected to the injection of 'politics' into the hypothetically neutral space of the museum, they failed to note that the 'politics' on view were for the most part made to seem as authoritative and eternal as the 'politics' that usually inhabit such a space. The difference in the end came down to very little: museum visitors long accustomed to being patronised by, as it were, a traditional museum voice (the artificial, self-consciously superior voices of Philippe de Montebello and Carter Brown come immediately to mind) objected to being patronised in a new way.

The second difficulty followed on the first, since the exhibition organisers' neglect of the ideological character of the museum space was symptomatic of their limited comprehension of ideology as a category of historical criticism. In the exhibition, and also to some extent in the catalogue essays, ideology was

something added to, or only occasionally present in, works of art, the subject-matter of works, perhaps their content but almost never their form, never the way they shaped or represented or constructed a world. Ideology very often boiled down to a (usually erroneous) viewpoint, to a limited set of ideas or presuppositions. Thus there were few occasions in which visitors to 'The West as America' encountered something of the force of ideology, its power over perception, its intimate relation to social practice. Nor was there much sense of the contradictory ways ideologies function, their ceaseless interplay and opposition. Instead, the exhibition often adopted a superior tone as if what was wrong with the terrible things done to Native Americans or with the expropriation of Mexican-American territory was transparently self-evident – as if modern reason now triumphed over the partial and limited views of earlier Americans. But this was to miss the point entirely, to underestimate vastly the force of now discredited ideologies, the power they once possessed to constitute and at the same time naturalise a set of assumptions so that those assumptions seemed to go without saying, or vanish into the real (as was the case with so many western paintings). In other words, the exhibition contained almost nothing to suggest what Hegel called 'the labour, patience and suffering of the negative' but rather too happily advanced to its enlightened conclusions. Thus even sympathetic critics longed for a greater variety of materials in the exhibition, for examples of Native American and Mexican American artefacts, and for more attention to the question of high and low art forms. Such variety would at least have provided a greater sense of an inter-play of rhetorics, of the clash of antagonistic discourses, and would have made it more difficult to subject everything in the exhibition to the same blandly normalising viewpoint.

This brings us to the final difficulty. Because the exhibition was conceived in terms of a single, authoritative voice – a voice that drew upon the tradi-tional, institutional authority of the museum – the organisers of 'The West as America' proved unprepared for the uproar that followed in the wake of the exhibition's opening. This lack of preparation was probably no more than a result of a certain institutional insularity, an inability to recognise the histor-ical and political context in which the exhibition would occur. But it also pointed to a failure to conceive of the exhibition in terms of a range of clash-ing or opposing viewpoints. Controversy is the lifeblood of democratic culture (although perhaps for this reason art museums avoid it like the plague); only through argument and debate can genuine historical engage-ment occur. 'The West as America' took a step in the direction of this sort of engagement but because of its insistence upon a single, controlling voice it did not go far enough. Instead it drew back from the implications of its own pro-gramme. This was perhaps its worst shortcoming. To unfreeze 'an eternal

image of the past' requires more than simply pronouncing that image 'ideological'. Certain preconditions must be met since the ideological most fully reveals itself only when it encounters the diverse, living energies of the present.

Notes

My thanks to my research assistant, Anjeanette C. Rose, for bibliographical help; to William H. Truettner of the National Museum of American Art for his openness, his willingness to answer questions and his unstinting sharing of materials from 'The West as America' archive; and, as always, to Phyllis Rosenzweig for her critical insights.

1 This is not the place for a discussion of ideology but for a lucid summary of what I take to be the crucial meanings associated with the word, see T. J. Clark, *The painting of modern life*, Knopf, New York, 1985, p. 8; for a historical account, see Raymond Williams, *Keywords*, Oxford University Press, New York, 1976, pp. 126–8.

2 Walter Benjamin, 'Eduard Fuchs, collector and historian', in *One way street and other writings*, trans. Edmund Jephcott and Kingsley Shorter, Verso, London, 1985, p. 352.

3 William H. Truettner, 'Preface', *The west as America, reinterpreting images of the frontier, 1820–1920*, Washington and London, The Smithsonian Institution Press, 1991, p. 40. The catalogue contains essays by Truettner, Nancy K. Anderson, Patricia Hills, Elizabeth Johns, Joni Kinsey, Howard R. Lamar, Alex Nemerov and Julie Schimmel.

4 Bryan J. Wolf, 'How the West was hung, or, *When I hear the word 'culture' I take out my checkbook*', *American Quarterly*, 44: 3, September 1992, pp. 418–38.

5 Wall text copy on file in 'The West as America' archive at the National Museum of American Art. This abbreviated analysis of *Fight for the water hole* derived from a more extended discussion in the exhibition catalogue. See Alex Nemerov, ' "Doing the 'Old America,' " the image of the American west, 1880–1920', in Truettner, ed., *The west as America*, pp. 285–343.

6 All citations are from the exhibition comment books, now in the National Museum of American Art's 'West as America' archive. Selections from the comment books appear in 'Showdown at "The West as America" ', *American Art*, 5:3, summer 1991, pp. 1–11.

7 Cited in Ken Ringle, 'Political correctness: art's new frontier', *The Washington Post*, 31 March 1991.

8 'Pilgrims and other imperialists', *The Wall Street Journal*, 17 May 1991.

9 James M. Perry, 'Washington art exhibit is criticized for stance taken on Western frontier', *The Wall Street Journal*, 31 May 1991. The exhibition was financed with private funds.

10 'Westward hokum', *The Washington Post*, 31 May 1991. Krauthammer's column appears in over seventy newspapers in the United States and 'Westward hokum' surfaced elsewhere under such inventive headlines as 'If this is the American West, Sioux me' (*New York Daily News*, 2 June 1991).

11 Kim Masters, 'Senators blast Smithsonian for "political agenda" ', *The Washington Post*, 16 May 1991.

12 Alan McConagha, 'Smithsonian chief admits exhibit error', *The Washington Times*, 6 June 1991.

13 For an overview, see Paul Berman, 'Introduction: the debate and its origins', in Berman, ed., *Debating P.C.*, Laurel, New York, 1992, pp. 1–26; see also Pat Aufderheide, ed., *Beyond P.C.*, Graywolf Press, Saint Paul, Minn., 1992.

14 Lynne V. Cheney, *Telling the truth*, The National Endowment for the Humanities, Washington, 1992, pp. 37–8.

15 Cited in Norman Mailer, 'Republican convention revisited: by heaven inspired', *The New Republic*, 12 October 1992, p. 26.

16 Krauthammer, 'Westward hokum', *The Washington Post*, 31 May 1991.

17 See, for example, Ken Ringle, 'Political correctness: art's new frontier', *The Washington Post*, 31 May 1991.

18 Richard Grenier, 'Sentimental frenzy posing as history', *The Washington Times*, 29 May 1991. Grenier seems to have become the neo-conservatives's specialist on the Indian question. See his 'Indian love call', *Commentary*, 91:3, March 1991, pp. 46–50.

19 William H. Goetzmann, review of 'The West as America', *Southwestern Historical Quarterly*, 96:1, July 1992, p. 130.

20 Gerald Nash, 'Point of view: one hundred years of western history', *Journal of the West*, 32:1, January 1993, pp. 3–4.

21 Cited in Ringle, 'Political correctness: art's new frontier', *The Washington Post*, 31 March 1991.

22 Ron Tyler, 'Western art and the historian, *The west as America*, a review essay', *Arizona History*, summer 1992, p. 220; see also William H. Truettner and Alexander Nemerov, 'More bark than bite: thoughts on the traditional – and not very historical – approach to western art', *Arizona History*, fall 1992, pp. 311–24.

23 ' "Cutting for sign": museums and western revisionism', *The Western Historical Quarterly*, 24:2, May 1993, p. 232.

24 *Ibid.* For another example of this sort of tortuous and ultimately failed struggle with the implications of 'The West as America', see the essay by James Ballinger, 'Frederic Remington's Southwest', *American Art Review*, 5:1, summer 1992, pp. 90–5, 164. Ballinger is the director of the Phoenix Art Museum.

25 Walter Benjamin, 'Eduard Fuchs, collector and historian', p. 352.



BLINDED BY 'SCIENCE':
ETHNOGRAPHY AT THE BRITISH MUSEUM

℘

Annie E. Coombes



> Perhaps the hilarity with which the ordinary visitor regards the object lessons of ethnography arises from his overweening conceit of the value and importance of his own particular form of civilisation. No doubt he has much in common with that traveller who lost his way on his journey and described the climax of his experience in these words: 'After having walked eleven hours without having traced the print of a human foot, to my great comfort and delight, I saw a man hanging upon a gibbet; my pleasure at the cheering prospect was inexpressible for it convinced me that I was in a civilized country.'[1]

IN THE LATE 1980s and the early 1990s, the British Museum has had its fair share of coverage in the national press. Two issues have come to dominate discussion on the museum's future in the popular imagination: the return of cultural property (much, though not all, of which falls within the domain of the Ethnographic Department) and the dimensions and completion date of the new national library which already looks set to break the record for built-in obsolescence. Both issues are extremely controversial and although on the face of it they bear little relation to one another, the fate of each has long been inextricably entwined in the history of the institution.

It was the delay in plans to move the British Library in 1966 which resulted in the Ethnographic Department of the British Museum being 'hived off' (an expression taken from the Report of the Trustees, which already tells us something of the 'pragmatic' attitude of the administration to this aspect of the collections) to the present site of the Museum of Mankind at Burlington Gardens, in an effort to 'relieve congestion' in the Museum. Today it is the impending removal of the existing Library to its new home in Euston

which has provoked discussion about the reintegration of the ethnographic collection back into the main body of the British Museum in Bloomsbury. Significantly, such disruption and mobility is by no means an unusual occurrence in the history of the British Museum's ethnographic collection.

From the founding of the British Museum in 1753 it is clear that the administration was unsure about the most appropriate 'home' for those objects deemed 'ethnographic'. The complicated trajectory of the collection is instructive and worth outlining in brief. The Department of Antiquities, in which the collection was originally housed, was divided into three new departments in 1860: Greek and Roman Antiquities, Coins and Medals and finally Oriental Antiquities (which included what were known as the British, Medieval and Ethnographic collections). In 1866 a further shift occurred when these latter collections became a Department in their own right, known as the Department of British and Medieval Antiquities (which included ethnography although this was not recognised in the official name). Some years later the Department of Ceramics and Ethnography was formed out of the ceramics and ethnographic collections in the British and Medieval Antiquities collections. In 1933 yet another new department emerged called the Department of Oriental Antiquities and Ethnography. Over the years 1933–8 a new sub-Department of Ethnography was formed and finally in 1946 Ethnography acquired its own departmental status.

There are of course a number of serious questions raised by the evidently peripatetic nature of the ethnographic collections of the British Museum. Clearly there is historically some confusion over the classification of those objects which none the less apparently shared enough identifiable features to be unanimously categorised as 'ethnographic'. Part of this confusion lies evidently in the kind of relationship that could be posited between this apparently discrete group of objects and the rest of the collections in the museum. More than any other collection then, the ethnographic collections were historically endlessly recuperable by various disciplines and curatorial interests but never quite at home in any. It is a situation which is no less the case today and is one of the circumstances which makes the Ethnographic Department, the Museum of Mankind, potentially such a rich resource for the disruption and interrogation of so many of the criteria for cultural value which are so often assumed in relation to Museum collections, particularly where they form part of a universal survey institution like the British Museum. The fact that such challenges to the hegemony of bourgeois values have traditionally been less rather than more likely to have taken place in ethnographic collections is partly a product of the ambivalent and difficult relationship which ethnography and its sister science, anthropology, have historically negotiated with the state. In order then to appreciate fully the significance of the neurotic

mobility of the Ethnographic Department of the British Museum and the cav-
alier ease with which it was shunted from one place to another, both within
and without the museum, we should look a little more closely at the kinds of
values historically attached to the ethnographic object and the object of
ethnography and at its designated roles within the museum.

Firstly it might be important to recognise that it was more through an acci-
dent of fate than by design that the British Museum contained any 'ethno-
graphic' items in its collections at all. One of the historians of the collection,
himself a curator of ethnography in the museum, H. J. Braunholtz, makes it
clear that it was only because the original bequest which formed the basis of
the British Museum contained some items mainly from autochthonous
(indigenous) communities in North America, Latin America and the West
Indies that there was an opportunity later to incorporate other ethnographic
material from, for example, Captain Cook's collection from the South Pacific.[2]
The original bequest from Sir Hans Sloane, the antiquarian and medic
President of the Royal Society and of the Royal College of Physicians, included
a typically catholic collection of items which fell into the categories of natural
history, numismatics, antiquities, fine art and ethnography. William Fagg,
another keeper of the ethnographic collections, emphasises the significance of
such collections at the time as 'Providing a shop window in English society for
the exotic objects brought back by mariners and others from their travels and
by their own attitude to them, helping to mould the attitude of society itself'.[3]

And of course a number of other national institutions based in London,
which were established in the eighteenth and nineteenth centuries, such as the
Imperial Institute (the forerunner of the contemporary Commonwealth
Institute) and the Royal Society itself, were founded with the express desire to
'showcase' products (raw and otherwise) from the colonies, in an effort to
expand business investment and increase demand. Immediately this signals
one of the dilemmas of the ethnographic collection, shared to an extent, but far
less explicitly, by other departments. While it may be true that 'what we know
of [Sloane] suggests that his attitude was liberal, unprejudiced and enlightened',
the liberal intentions of the collector may not always be uppermost in the
institutions that inherit the collection, nor in the visitors who passed through
the exhibition galleries.[4] In the case of ethnography, its dependence on imper-
ial and colonial expansion makes this dilemma particularly acute.

And what exactly was the assumed significance of this category which
included such a motley selection of objects, from weapons to clothing and
personal ornament? Happily we are provided with a statement from the donor
who was to become one of the benefactors most responsible for the building
up of the collection: Henry Christy, philanthropist, antiquarian, leading
member of the Ethnological Society and director of the London Joint-Stock

Bank. Christy, whose own private collection prioritised prehistoric and ethnographic material, proclaimed in a statement which was to find an echo in almost every ethnographic collection set up across the country, that his objective had been to use the surviving cultures of autochthonous peoples to illustrate and supplement the gaps in European prehistory. More to the point it was important to him that these two branches of science should be permanently and physically linked. On his death in 1865 four trustees were appointed to oversee his collection and in the same year it was given to the British Museum and finally housed there in 1883. In 1886, thanks to the consistent expansion of the ethnographic collection due primarily to the funds available from a bequest by Christy, a newly reorganised ethnographic gallery was at last opened to the public.

The date of any sizeable ethnographic presence in the British Museum is conspicuous. It corresponds to the concerted expansion of the British Empire and by the 1890s, to what has since become known as 'the scramble for Africa' – a phrase which fittingly describes the European colonial powers' rampant and indiscriminate grab for more territory in that continent. For the museum it coincided with a moment when those entrusted with the care of the ethnographic collections had a particular interest in things African. And of course since the museum came more and more to rely for material on those individuals in active service in the colonies, the expansion of colonial activity in Africa contributed to the growth of those collections in particular over this period.[5] The character of the ethnographic collections' acquisition policy changed to reflect the imperial obsession with the new territories to be gained in Africa and shifted from a predominantly Melanesian and Oceanic focus to an African emphasis. The names of the new donors reflect the constituency which more than any other was responsible for the rapid expansion of ethnographic collections in Britain in the nineteenth century – the missionary and the civil servant.[6] To explain this dependency, where we might expect the protagonists of anthropological investigation to figure as prominant donors, we need to understand something of the status of anthropology at the turn of the century.[7]

The opening of the new gallery in 1886 coincided with something more than colonial expansion. It also occurred at a moment when anthropologists were starting to make demands for the recognition of the science as a discipline and at a time when certain persistent and prestigious spokespeople were beginning to formulate a public case for the necessity of anthropology in arguments which were to remain the stock-in-trade justifications for the new discipline for far longer than they warranted. More to the point, these two factors – colonial expansion and the case for the new discipline – more than any others, clinched the possible range of meanings which could be produced

through ethnographic displays. Where then are the anthropologists' names on the roll call of donors and vendors? In the first place, the infamous debate between the defenders and antagonists of Darwinian evolutionism in the 1860s had certainly put the two main positions – the Darwinian evolutionist tradition of the Ethnological Society and the racist conservatism of the break-away Anthropological Society – on the intellectual map of the public imagination. Secondly, by 1871 an amalgamation of both societies resulted in the founding of the Anthropological Institute which later had its headquarters in Great Russell Street, opposite the British Museum itself, a factor which certainly facilitated a close and enduring relationship between the ethnographic curators and the Institute. Many, including Charles Hercules Read, who did so much to upgrade the status of ethnography within the museum, went on to hold the Presidency of the Institute, in conjunction with their curatorial activities.[8] In addition, the more general public was bombarded with a confusing array of popular texts in the form of colonial novels, often serialised in cheap magazine editions, and huge regional and national colonial and missionary exhibitions, all of which presented the spectacle of the colonies and the colonial subject in a way which purported to derive authenticity from the assimilation of what was constantly cited as anthropological truth.[9] Evidently then, anthropology was confusingly perceived as the 'property' of a fairly broad educated public by the 1890s while none the less deriving its scientific authority from its supposedly specialist character.

Part of the reason for the museum's reliance on various civil servants and military personnel of the colonial administration stemmed from precisely the fact that anthropology may well have been on many people's lips, but it did not yet exist as an accredited discipline and had no academic or institutional training ground. Hence the familiar term, 'armchair anthropologist'. As the phrase suggests, this meant that most fieldwork to furnish the 'evidence' required for the many hypotheses on the origins and diffusion of art, culture and 'man' may have been directed by the likes of E. B. Tylor (often called the father of modern anthropology) from his Oxford study, though it was carried out for the most part by a band of enthusiastic amateurs involved in the colonial bureaucracy with disparate and often diametrically opposed objectives.

This is one of the reasons why, as much today as in the heyday of the ethnographic collections' expansion, we have to look somewhere other than the supposed intentions of the donor or vendor, however 'liberal' or 'enlightened' he or she might have been, in order to get some idea of the meanings produced through ethnographic collections. Already we can appreciate how the curators of the collection inhabited an indeterminate terrain in an amorphous and constantly shifting set of departments. We also know that both Augustus Wollaston Franks and Charles Hercules Read, responsible for the collections

at different periods in its early history, were particularly committed to building up the ethnographic collections and both publicly proclaimed their belief in the power of the ethnographic galleries to draw the public in statements which were reiterated in a number of prestigious publications. These statements give voice to the frustration and irritation at the lack of space and funds and at a general failure of recognition for the department both at the level of the museum administration and at the higher level of government and state patronage. In fact the public statements produced by the beleaguered curators justifying ethnography's value should be understood dialogically and recognised not only as a set of philosophical positions but also as a set of strategic arguments to prove ethnography and anthropology's indispensability to both the museum and the state.

Perhaps one of the most telling instances of the ways in which the institutional and disciplinary politics and pressures shaped the kinds of knowledge produced through the ethnographic collections is to be found in the history of the acquisition of what have become known as the Benin 'bronzes'.[10] I have dealt elsewhere with the complexities of the colonial narratives of Benin culture in West Africa in what is now Nigeria, but it is worth re-capping briefly here.[11] In 1897, a group of British officers had been killed after attempting a diplomatic mission against orders and in direct opposition to the wishes of the Oba (King) of Benin.[12] In response to both public outrage and the trading communities' opportunistic desire to break the back of the Oba's lucrative trade monopoly, the British government sent a punitive expedition to destroy the ancient kingdom of Benin. One of the results of this action was the wholesale plunder of the regalia and other objects from the royal court. These objects, many of which were of carved ivory and bronze and dating back to the fifteenth century, were brought back and some were sold at public auction in order to raise money for the administration of the Protectorate. Far fewer of these objects than expected remained either in the hands of the British or in the collections of the British Museum where they had originally been exhibited to the public.

Meanwhile the same objects had been the topic of intense debate both amongst that group who fancied themselves as part of the 'scientific' community and by the more general public, who had been regaled throughout the campaign with lurid descriptions of an apparently gratuitously violent society. For the most part the controversy revolved around the apparent anomaly of a material culture of evident antiquity and technical competence produced in a naturalist idiom not usually associated with Africa. The question which dominated discussion was the issue of origin. How could a violent and barbaric society like Benin be responsible for creating works of such technical and formal quality? As many West African commentators pointed out at

the time, there were plenty of historical precedents for such apparently mutually incompatible characteristics in European society.[13] The British, as one might expect, were reluctant to engage with this line of argument.

C. H. Read and O. M. Dalton, the ethnographic curators at the British Museum, had themselves been in the forefront of the debate over the origin of the Benin bronzes and had originally argued the case for an Egyptian origin. Meanwhile Dalton made an official visit to colleagues in ethnographic departments in Germany and used the resulting official report to argue the case more forcefully for government support for ethnography in Britain and in particular for the work of the ethnographers in the British Museum. He argued that the German Kaiser had the foresight to recognise the value of ethnography for German imperialism and that government funds had consequently resulted in magnificent ethnographic museums which were effective in promoting public interest and support for German imperialism in a way that the British government was unable to guarantee. Furthermore, he recounted the numbers of Benin bronzes and other artefacts from the British punitive raid which were now in German museums as resulting directly from this aggressive policy of government support.

Swallowing the chauvinistic bait, the national press took up the cry of British 'heritage'. As an ironic consequence, national pride became intimately linked with the fate of the Benin bronzes, which now became the symbols of British manhood as opposed to Edo barbarity. How could the government allow the valuable loot from the punitive raid, the reprisal for so many British deaths, to go to that other repository for British xenophobia, the Germans? At this point a radical revision occurs in the British Museum curators' scientific account of the origin of the Benin bronzes and ivories. No longer necessarily either of Egyptian origin or of Portuguese origin, it was now suggested that the bronzes could very well be of independent African origin.

What interests me here is the coincidence of a heightened public interest in the affairs of the British Museum and in particular a group of objects associated with the ethnographic collection; the constantly repeated desire for recognition and support both within the museum and from the government, of the ethnographers at the British Museum; and the revised account which, by assigning them African origins, now placed the contested and highly desirable objects squarely in the domain of the ethnographic department rather than ambiguously positioned between Egyptology and European Antiquities.

How far such a hypothesis was a deliberate strategy for more recognition on the part of the ethnographers remains a matter of conjecture. As we shall see, the foregrounding of certain selective aspects of African culture from Benin and, later, from the then Congo becomes a persistent policy on the part of the museum's ethnographic curators.[14] One thing is sure however: this

history is instructive of the kinds of negotiative processes by which 'scientific' knowledge of the culture of the colonies was produced, and gives the lie to a simplistic empirical account which takes such narratives at face value, without taking into account the institutional and other political factors at play. These, then, were just some of the complex interests at stake in the production of ethnographic 'meaning' at the turn of the century.

Given the ambiguous status of ethnography within the British Museum and the ambivalent relation of anthropology to the colonial government and to the accredited seats of scientific learning, the universities, we might expect to meet with similarly ambiguous and shifting narratives played out in the organization of the material culture on public display in the ethnographic galleries themselves. Unfortunately, despite the 'liberal . . . and enlightened' personal disposition of some donors, there was little evidence of this once their donation found its way into the public domain as part of the museum's ethnographic display. Organised geographically but along evolutionary lines which reinforced some of the most problematic aspects of social Darwinism, the collection remained in the kind of time-warp which it initially attributed to the culture of most of the colonies. Because of the British Museum administration's ambivalent attitude towards its ethnographic collections and the state's reluctance to invest in the 'science', the more complex and contradictory developments in the science of anthropology did not transform the narratives of the ethnographic galleries until long after *they* had transformed the discipline.

Instead it is the more defensive element in the discourse of the emergent science which comes to the fore and remains a dominant feature of the ethnographic curators' public presentation of the collections. And it is this defensiveness which contributes to the characterisation of the material culture of the colonies as prehistoric 'survivals' in the Tylorian (and, as we've seen, in Christy's) sense, long after this was current thinking amongst anthropologists. For example, the museum thoughtfully provided its public with a series of guides to the collections and through these we can see the recurrence of certain themes: the importance of the collections as a way of explaining Europe's own missing prehistory – as contemporary 'survivals'; their usefulness for the prospective colonial administrator; their function in providing enough knowledge of the 'mores and customs' of colonial peoples to enable more 'efficient' colonial government; and the importance of the collections in preserving the traces of 'dying' cultures for (a European) posterity. The 1899 *Guide to the exhibition galleries of the British Museum* explained the significance of ethnography in relation to the other collections: 'Ethnography is the name given to the scientific study of the manners and customs of particular peoples and of their development from savagery towards civilization; and it

more especially concerns itself with those races which have no written records.'[15]

The emphasis on the 'scientific' and 'modern' nature of the collection was further reinforced through the injunction that 'An ethnographical collection is not to be regarded as a mere haphazard gallery of native curiosities without educational value'.[16] Instead, 'the primitive races with which modern research has made us acquainted ... represent stages of culture through which our own ancestors passed on their upward path; in all probability the implements and weapons and utensils which they make and use are similar to those made and used in Europe thousands of years ago'.[17]

Having ascended the principal staircase to the upper floor of the museum, the numerical sequence of the plan (fig. 6.1) suggests that the visitor would have entered the Pre-historic Saloon and from there the Mediaeval Room and the Asiatic Saloon. The visitor could then either make a circuit taking in the various rooms devoted to ceramics and prints and drawings back to the Asiatic Saloon or could strike left and visit the Ethnographical Galleries which took up the whole of the east side of the upper floor in rooms 12 to 16. From here on, the guide reads like the inventory of some vast arsenal, the visitor bombarded with weapons first from Asia, then Australia and Melanesia, Polynesia and Micronesia and finally different regions of Africa. While there is little sense of distinction between most of these geographical regions in terms of degrees of what are termed 'primitiveness' and 'savagery', it is clear that parts of Asia received special treatment. Here the role of the ethnographic display was to exhibit (and thereby differentiate) material culture from what were termed the 'wild tribes' from the islands adjacent to India.[18] The visitor was exhorted to visit the Indian Museum at South Kensington, 'for a better study of the civilised products of India, Burmah and Siam.' While the guide's explicit references to violence and 'barbarism' are few and far between, we can perhaps assume that the spears, shields and other weapons ranged around the walls of the galleries would have suggested such categories with striking eloquence. Religion is the other important category which informs the explanations in the guide. As the text went on to explain:

> The purpose for which a collection such as the one here exhibited is brought together, is to enable us to understand by what methods man, in his earlier efforts of development towards civilization, supplies the wants of existence, protects his life, expresses his religious idea, and gradually advances towards the cultivation of the industrial and ornamental arts.[19]

Consequently, the other category which preoccupied the British Museum's ethnographic curators was that of decorative art and personal ornament since 'his clothing and ornament for the body will indicate the stage of savagery or

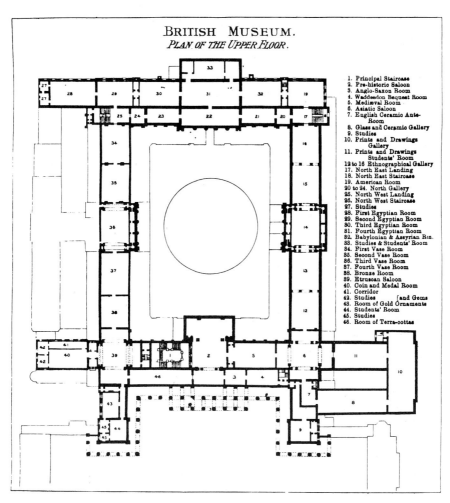

6.1 The upper floor of the British Museum, from *Guide to the exhibition galleries of the British Museum*, London, 1899 © British Museum

of primitive civilization in which he exists'.[20] These were not haphazard choices. To a certain extent they reflect the kinds of interests which the anthropologist 'at home' wished to foster in the colonial administrator and missionary – the primary donors to the museum's collections in this department. Since the early nineteenth century there had existed a conveniently pocket-sized questionnaire entitled *Notes and queries on anthropology*, specifying the kinds of observations with which the lay person in the field could satisfactorily supply the house-bound anthropologist with the field data for his (or her) research.[21] Far from being exclusively the domain of anthropology however,

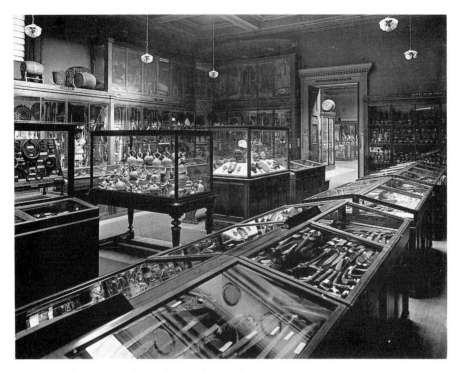

6.2 The Ethnographic Gallery at the British Museum, *c.* 1890. © British Museum

such 'aids' to research were rather the order of the day in the nineteenth century in a variety of 'sciences' which relied on the observational skills of the ordinary traveller. In 1890 the Folklore Society published their *Handbook for folklore*, and the Royal Geographical Society's *Hints for travellers* was in its sixth edition by 1889. What this suggests of course is that a far broader middle-class public than is generally recognised was directly implicated in the production of ethnographic 'meaning' and its members were sufficiently aware of the categories through which this was constructed (even while they may not have been aware of the more subtle nuances of meaning in the differentiation that they described), to recognise the ethnographic collection as something much more than a mere jumble of curiosities. In addition this kind of 'audience participation' would have sealed the sense of innate superiority of the European viewer since even the amateur was given the power of description and therefore, especially in the positivistic climate of Victorian Britain, the power of knowledge, over the colonial subject.

Over the period of 'armchair anthropology' in Britain, the *Notes and queries* series went through a number of editions. As we might expect, the categories which are best represented are those dealing with decoration and

ornament which is also a feature of the sections dealing with almost every aspect of material culture such as pottery, basketwork, metallurgy and habitation. In addition each questionnaire was prefaced with a page documenting the ornamental motifs 'employed by savages'. By 1905 in addition to the preoccupation with ornamentation, those sections with the largest quota of questions were devoted to religion, sacred animals, music, war and reproduction.[22] In other words, art, religion, war and sex were the primary means by which the European could 'know' the colonised subject.

By 1910 the importance of ethnography as an integral part of the colonial process is no longer merely implicit. *The handbook to the ethnographic collections*, a detailed and substantial volume of some three hundred pages, was published during a period when the ethnographic curators of the British Museum were engaged in a concerted drive to popularise the science of anthropology and, one imagines, by so doing, to enhance the appeal of the ethnographic collections. The handbook coincided with the publication, by the British and other museums' ethnographic curators, of a number of lavishly illustrated compendiums with titles such as *The races of mankind* and *Women of all nations*, designed in an accessible but identifiably 'scholarly' tone to introduce a comparative study of material culture worldwide. Meanwhile the *Handbook* stressed the links between its ethnographic collections and 'British enterprise and exploration', a fact which 'added considerably to their interest', and proceeded to introduce the collections with a detailed history of European travel and exploration. By now the desperation for official recognition of the discipline and the importance of the collection coloured the handbook from the outset:

> At no point in the world's history has any one nation exercised control over so many primitive races as our own at the present time, and yet there is no institution in Great Britain where this fact is adequately brought before the public in a concrete form. Meanwhile civilization is spreading over the earth, and the beliefs, customs, and products of practically all aboriginal peoples are becoming obsolete under new conditions which, though interesting from an economic point of view, have only a secondary importance for the ethnologist. In proportion as the value of Anthropology is appreciated at its true worth, the material for anthropological study diminishes; in many cases native beliefs and institutions described in the book have already become obsolete, though it has been found convenient, in mentioning them, to use the present tense. Such facts alone enforce the necessity for energetic action before it is too late.[23]

The *Handbook* is a useful instance of the way in which anthropological knowledge and the series of contradictions which it comprised was disseminated amongst the museum-going public. For example, in many ways it reproduces a fount of interesting detail and observation on art and culture and

its significance to the various peoples represented in the collections. And yet, despite the glowing descriptions of the art of, for example, the BuShongo from Zaire, as 'remarkable', and the declaration that 'the art of portraiture is prac- tised amongst them, and the wooden statues of their early kings are the most striking products of indigenous African art', such observations are ultimately to be understood as referring to the product of 'primitive man'.

> The mind of primitive man is wayward, and seldom capable of continuous attention. His thoughts are not quickly collected, so that he is bewildered in an emergency; and he is so much the creature of habit that unfamiliar influences such as those which white men introduce into his country disturb his mental balance. His powers of discrimination and analysis are undeveloped, so that distinctions which to us are fundamental, need not be obvious to him. Thus he does not distinguish between similarity and identity, between names and things, between the events which occur in dreams and real events, between the sequence of ideas in his mind and of things in the outer world to which they correspond. His ideas are grouped by chance impressions, and his conclusions often based on superficial analogies which have no weight with us.[24]

Such a historical precedent should perhaps forewarn us against attaching too much weight to the easy suggestion that prejudice and stereotype are immedi- ately disbanded through the process of attributing cultural and aesthetic value to material conventionally categorised as 'ethnographic' by the West. Perhaps most striking of all about this brief history of the development of ethnogra- phy at the British Museum is the fact that by 1910 the general *Guide* to the exhibition galleries of the British Museum replicates almost word for word the 1899 version and that by 1925 the new edition of the *Handbook to the ethno- graphic collections* is virtually indistinguishable from the 1910 version. And this, despite the fact that British anthropology had moved from a primary engagement with the evolutionary theory of social Darwinism to an interest in functionalism and diffusionism by this same date.[25]

By 1962 on the eve of the Ethnographic Department's move to its present location in Burlington Gardens, the *Guide* to the museum was still defining Ethnography in developmental terms as 'concerned with primitive peoples and their cultures in various stages of development', and furthermore stated that 'the Museum collections illustrate the cultures of those races which have no written records and are practically unknown to history'.[26] Evidently, while these collections no longer serve as 'survivals' of Europe's prehistory – the 'missing link' of Darwin's hypothesis – the department retained remnants of its earlier incarnation and by 1966 its role continued to be defined in terms of preserving 'specimens from still under-developed peoples of the world before they are submerged by the advance of industrial civilisation'.[27] Consequently, although by this date the language is no longer the evolutionary rhetoric of

the late nineteenth century, time (and with it, history) are still crucially elusive components in any analysis of the material culture in the department's collections.

Today, the Ethnographic Department of the British Museum lies sandwiched between on the one hand the exclusive shopping precinct of the Burlington Arcade at the Fortnum & Mason end of the couture boutiques of New Bond Street and, on the other, the equally exclusive international art market represented by the galleries of nearby Cork Street. Initially an accident of fate, the relocation to this particular site in 1969 nevertheless marks a transformation in the public profile of the Ethnographic Department as a more autonomous unit whose agenda was now more clearly differentiated from the main body of the British Museum while remaining tied to it in some often indefinable relationship. Though not intended, the Museum's proximity to London's commercial art centre and to the exclusive design outlets and auction houses of nearby Bond Street coincided with a renewed public fascination with the 'tribal' and the 'exotic' and with the marketing and consumption of such categories. In fact by 1976 the room dedicated to the aestheticised showcasing of individual pieces and known as 'The Treasures of the Collection' room, had already been inaugurated. This kind of emphasis by no means adequately reflects the more diverse concerns of the curators over this period.[28] However, the fact that it was in the historical conjuncture of the department's relocation and the auction houses' renewed interest in its collections that the trustees could report a sharp increase in the number of visitors to the Museum, more than doubling between 1974 and 1976, does tell us something about the shifts in the more general public's expectations of the material in the Museum of Mankind's collections and consequently signals another aspect of ethnographic 'meaning'.[29]

As a department of the British Museum, the Museum of Mankind is still funded and governed, as it was in the early twentieth century, by the same combined private and public resources managed by a group of trustees, appointed in varying proportion by different learned societies, the trustees themselves and the prime minister of the day.[30] The Museum remains accountable to the public through Parliament for the way in which the government grant is spent over the year. Increasingly, however, the clawing back of public subsidies for most cultural activity in Britain has meant that the museum has had to develop a more aggressive policy of private subsidy. Sponsorship, amongst other considerations, has inevitably meant some degree of either self-censorship on the part of the curators or more interventionist direction from sponsors in what is increasingly emerging, largely as a result of vocal opposition and criticism from those groups supposedly represented by such displays, as a highly politically sensitive arena for cultural (mis)representation.[31]

Despite the increasing awareness of, and participation from, museum professionals in the debates concerning the politics of representation in museums, the narratives played out in the Museum of Mankind's displays raise a number of issues which still resonate with the legacy of the colonial past which made them possible. The colonies once represented by the material culture in the museum's collections are of course independent nation states today. And yet these same objects remain, in some senses, the symbolic repositories of a set of cultural and social relations to the West. We need look no further than the British Museum's controversial retention of contested cultural property such as the Benin 'bronzes' or the Parthenon marbles and the institutional justification that the museum's role is to hold 'material in trust for mankind throughout the foreseeable future.'[32] Such paternalism remains the guiding principle in the face of considerable opposition. Nevertheless the displays' relation to colonial discourse is by no means simple. Although the museum is predicated on the production of cultural difference, it is not the monolithic and homogeneous difference reproduced in the spotlit grandeur of, for example, the Rockefeller collection at the Metropolitan Museum in New York, with its universalist aesthetic. In the Museum of Mankind, despite the internal logic of each of the exhibition rooms, in combination they defy coherence. And this incoherence, which might plausibly be experienced as contradiction by the viewer, may in fact produce surprising results, not all of which are negative or demeaning.

In the first place, the Introduction to the Collection room seems to contain a series of objects from a vast range of countries and peoples organised in a way which reproduces the comparative and typological taxonomy associated with many large ethnographic collections of the nineteenth century such as the Pitt Rivers Museum. The emphasis here is on form and function: the only information accompanying these objects is provenance and date, and it is a date which indicates the time when it was acquired by the museum, rather than when it was manufactured. On the face of it this represents another instance of the timeless 'ethnographic present' reincarnate. But further on in the display there is an interesting anomaly. An intricately embroidered and appliquéd man's vest from Peru, embellished with a portrait of the Cuban leader Fidél Castro – a clear indication of the use and transformation of a moment of more recent history – announces a society which is clearly living in a historically identifiable present. What this narrative omits, however, is the process whereby the museum acquired this material in the first place. The often violent and always invasive history of western intervervention which made such collections possible is absent as usual. The museum's own place within this colonial history remains unspoken and our 'introduction' produces the institution as unproblematic and benevolent custodian of these artefacts.

Upstairs the visitor encounters the universalising aesthetic of the 'Treasures of the Collection' room. But here too there is an interesting twist to the conventional narrative. The inclusion of ivories from the royal court of Benin from the sixteenth century illustrate the colonial Portuguese presence and locate the history of an ancient African civilisation. In another corner of the room an intricate carving by a contemporary Maori artist raises questions about history, tradition and continuity.

Although none of the rooms so far has directly addressed the political implications, conflicts and transformations which come with the recognition that all the societies represented in the museum are constantly in transition through contact with western capitalism, these issues are sometimes signalled in the museum. However, it is often left to the temporary exhibitions to elaborate these explicitly. In the 'Palestinian Costume Exhibition' of 1989–92, for example, the contemporary political context formed an integral part of the display. Much of the Palestinian culture shown was indeed alive but is found now in the refugee camps set up after the establishment of the state of Israel in 1948. The exhibition made explicit not only the problems of cultural erosion and destruction but also of the resilient transformation of Palestinian culture even in the face of the continuing Israeli/Palestinian conflict.

Clearly these rooms invite comparison and to engage in the sense of one of these spaces the visitor must identify the narrative structure which provides meaning in each case. Since few of them share the same organising paradigm it might become apparent that each display is responsible for providing a 'meaningful' context and that in no case do the objects radiate an immanent meaning. Such demystification, it seems to me, could well be one of the more positive and productive outcomes from visiting an institution which in many ways continues to occupy an anachronistic position in a contemporary multi-ethnic society. Meanwhile the Ethnographic Department of the British Museum will soon be on the move again. Perhaps the forthcoming reinstatement of the Ethnographic Department into the main body of the museum will do more than herald a 'homecoming'. After so much interrogation of ethnography and anthropology both within and without these disciplines, perhaps the limited challenges which both could offer to the hegemony of western culture will finally emerge.

Notes

1 H. C. Shelley, *The British Museum: its history and treasures*, Boston, 1911, p. 299.

2 H. J. Braunholtz, *Sir Hans Sloane and ethnography*, London, 1970, p. 19. Much of the historical detail on the early development of ethnography in the British Museum is taken from this source.

3 Braunholtz, p. 8.

4 *Ibid.*

5 See R. Robinson, J. Gallagher and A. Denny, *Africa and the Victorians*, London, 1967; M. Crowder, *West Africa under colonial rule*, London, 1968; V. G. Kiernan, *European empires from conquest to collapse 1815–1960*, London, 1982.

6 See Annie E. Coombes, *Re-inventing Africa: Museums, material culture and popular imagination in late Victorian and Edwardian England*, New Haven, 1994.

7 See Adam Kuper, *Anthropologists and anthropology: the British school 1922–1972*, Harmondsworth, 1975; G. Stocking, 'What's in a name? The origins of the Royal Anthropological Institute', *Man*, VI, 1971, pp. 369–90.

8 Braunhltz, p. 42.

9 See Coombes, *Re-inventing Africa* and J. MacKenzie, *Propaganda and empire: the manipulation of British public opinion 1880–1960*, Manchester, 1984. For a discussion on the representation of the colonies in French and US World's Fairs see W. H. Schneider, *An empire for the masses*, London, 1982 and Robert W. Rydell, *All the world's a fair: visions of empire at American international expositions 1876–1916*, Chicago and London, 1984.

10 Technically speaking the term 'bronze' is a misnomer. Analysis has shown that these objects are not always bronze but may be zinc brass or leaded bronze and are generally an alloy of copper, zinc and lead in varying proportions. The term 'bronze' is used here as a shorthand.

11 Annie E. Coombes, 'The recalcitrant object: culture contact and the question of hybridity' in F. Barker, P. Hulme et al eds., *Colonial discourse/postcolonial theory*, Manchester, 1994.

12 For a history of British interference in Benin City see Philip Aigbora Igbafe, *Benin under British administration 1897–1938*, London, 1979; Alan Ryder, *Benin and the Europeans 1485–1897*, New York, 1969.

13 See Robert W. July, *The origins of modern African thought*, London, 1968.

14 See John Mack, *Emil Torday and the art of the Congo 1900–1909*, London, 1990.

15 *A guide to the exhibition galleries of the British Museum*, London, 1899, p. 89.

16 *Ibid.*, p. 99.

17 *Ibid.*

18 *Ibid.*

19 *Ibid.*

20 *Ibid.*, p. 89.

21 James Urry, 'Notes and queries on anthropology and the development of field methods in British anthropology 1870–1920', *Proceedings of the Royal Anthropological Institute*, 1972, pp. 45–57.

22 C. H. Read, *Anthropological queries for Central Africa*, London, 1905–6.

23 C. H. Read, *Handbook to the ethnographic collections*, Oxford, 1910, p. VI.

24 Read, *Handbook*, p. 31.

25 Kuper, 1975, p. 17.

26 *Guide to the British Museum*, London, 1962, p. 38.

27 *Report of the Trustees of the British Museum*, London, 1966, p. 47.

28 Some examples of exhibitions put on over the period include: 'The tribal image'; 'Gamelan: a Javanese orchestra'; 'Yoruba religious cults'; 'Manding: focus on an African civilisation'. Few of these were concerned with simply an aestheticising project, and were, for the most part, far broader in scope.

29 *Report of the Trustees of the British Museum*, London, 1975–8, p.22.

30 See David M. Wilson, *The British Museum, purpose and politics*, London, 1989, p. 14, where he specifies how the Board of Trustees is selected and by whom.

31 Jean Fisher, 'The health of the people is the highest law', *Third Text*, 2, winter 1987, pp. 63–75; Annie E. Coombes, 'Inventing the "post-colonial": hybridity and constituency in contemporary curating', *New Formations*, 18, winter 1992, pp. 39–52.

32 Wilson, p. 116.

THE POLITICS OF DISPLAY: A 'LITERARY AND HISTORICAL' DEFINITION OF QUEBEC IN 1830s BRITISH NORTH AMERICA

Karen Stanworth

IN HIS TOURIST TRACT *The Picture of Quebec and its Vicinity* (1831), George Bourne advised his readers to follow his itinerary through the city if they were to understand correctly the plethora of visual stimuli presented there. To calm a 'temporary mental excitement' evoked by the novelty of the city – the glittering spires, the features and foreign language of the *habitants*, the dog carts and the military apparatus which continually pass before him – the tourist was urged to accept the authoritative representation of the city contained in the guide.[1]

Bourne's itinerary commences in the Upper Town; strategically located atop a natural escarpment, the Upper Town was the site of military, ecclesiastical, political, and social activity, undertaken by the dominant groups. The Lower Town, the slim band of land below the cliffs, was the focus of commercial enterprise and working-class domiciles (see map, fig. 7.1). Starting from the Market House, Bourne's tourist ascends literally and metaphorically from the centre of the *ancien régime* (signified through such institutions as the Catholic Cathedral and the former Jesuit college which had been converted by the British for use as a barracks), up the street to the present fulcrum of Quebec society, the Place d'Armes.[2] Literally a crossroads (fig.7.2),[3] the square was surrounded by visual markers of the dominant culture: the Castle of St Lewis, the governor's residence; the Episcopal Church, the seat of the lord bishop of Quebec; the Court House; and the Union Hotel containing the municipal government offices. In particular, Bourne draws the attention of the visitor to the Union Hotel, noting that 'strangers ought especially to recollect that the front room on the first story contains the Museum of the "Society for promoting Literature, Science, Arts, and Historical Research in Canada"'.[4]

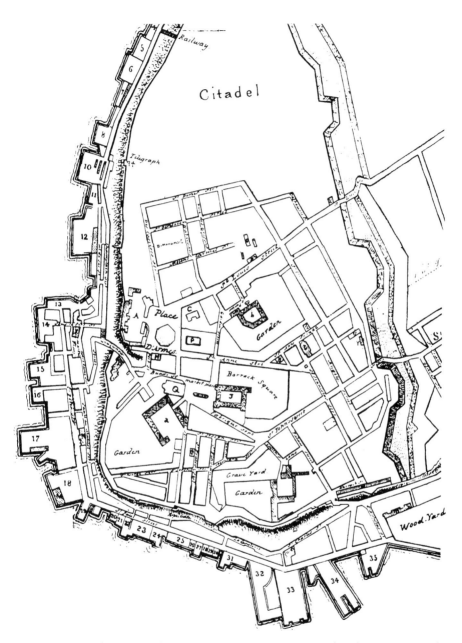

7.1 Quebec City, 1829, adapted from a map in G. Bourne, *A picture of Quebec*, 1829, A=Castle of St Lewis (Governor's residence); B=Parliament House; C=Court House; H=Public Offices (Union Hotel); J=Jail; P=Episcopal Church;Q=Catholic Church; a=seminary; b=Ursaline Convent. Numbers 5–35 indicate quays jutting into the St Lawrence River which surrounds the city on two sides of a triangle. The third side is enclosed by the gated stone wall running north-west from the cliff above the Wood-Yard

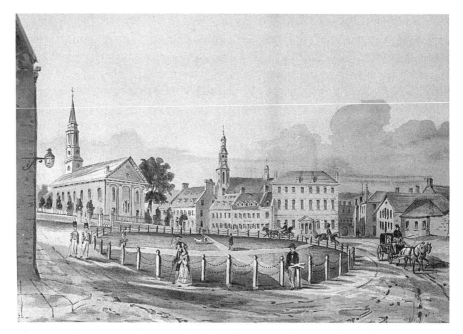

7.2 Robert A. Sproule, *View of the Place d'Armes, Quebec*, 1832, chromolithograph,
35.5 × 47 cm. Musée du Quebec. Photo: Neuville Bazin, courtesy of the Musée du Quebec.
The Union Hotel is the large three-storey building at the centre

It is this museum and the collecting strategies of its proprietary society which provide the impetus for this chapter. Although the contents of the museum were dispersed just over a hundred years ago (1890) and its activities quickly faded from the public conscience, I will argue that, both for the stranger to Quebec and for the city dwellers who daily passed its prominent façade, the museum, as a repository of 'literary, historical, and scientific' objects, held a strategic position of both geographic and socio-political significance in the colony in the 1820s and 1830s.[5] Before attempting to open up the hermeneutic of the 'literary and historical' representation of Quebec as mediated through the society and its museum, I will briefly outline the historical, financial, and physical dimensions of the museum.

The museum – foundation and direction

Assiduously promoted by Bourne's tourist guide,[6] the museum was the product of two learned societies amalgamated in 1829: the Literary and Historical Society of Quebec (LHSQ), founded in 1824, and the Society for the Encouragement of the Sciences and the Arts in Canada (SESA), founded in

1827.[7] United in 1829 under the temporary name of the Society for promoting Literature, Science, Arts, and Historical Research in Canada (shortly thereafter reverting to the name of the LHSQ), this merger was a significant factor in the decision to display publicly what had been essentially a private collection of artefacts assembled for the benefit of the societies' respective membership.

The moment of public incorporation of these objects arrived with the Charter of the society in 1831. The society received royal approval for:

> The prosecution of researches into the early history of Canada, for the recovering, procuring, and publishing of interesting documents and useful information, as to the Natural, Civil and Literary History of British North America and for the advancement of the Arts and Sciences in the said Province of Lower Canada, *from which public benefit may be expected.*[8]

Although exactly what constituted 'public benefit' was not outlined, such benefit was clearly a requirement of incorporation. The united society conceived of it as being at least partially met by the decision that the 'Society's Room should be open to the public on Thursday in each week from the hour of Twelve at noon until four in the afternoon'. 'Strangers and others' could be admitted during regular hours if accompanied by a member, 'and the name of every person who shall be admitted not being a member shall be inscribed in a Book to be kept for that purpose'.[9] Carefully delimited, access was to be controlled through stringent admittance procedures. However, as a necessary concession to incorporation, 'public benefit' was conceived of in larger terms than the invasion of the society by strangers. Open lectures and the irregular publication of the society's *Transactions* extended the LHSQ's public accessibility to members' friends, associates and interested lay persons.

The society generally confined its attentions to a local audience, although knowledge of its activities filtered outwards to various learned societies in the United States and Europe. Likewise, although 'strangers' visited the library and museum, the audience for the visual artefacts gathered in the Society's Room was primarily an informed, resident population concentrated in the city of Quebec but extending across a wide geographical scale, encompassing Lower and Upper Canada, and the eastern United States.[10] The categories of associate and of corresponding members were introduced in 1829, making possible active participation by those unable to afford the proprietary fees, and encouraging visits from corresponding members living up to several hundred miles away. Honorary memberships were extended to visitors to Quebec of high profile, such as Commander H. W. Bayfield, Royal Navy, member of the Astronomical Society of London, who gave a paper on the 'Geology of Lake Superior'.[11]

The collection comprised:

> About fifteen hundred mineralogical and geological specimens from foreign
> countries – about two hundred of the same genera from Lakes Huron and
> Superior – with a diversity of native samples. There are also a few subjects of
> Natural History in ornithology and zoology – seventy different indigenous
> woods – twenty mathematical models – a bowl from Herculaneum – some
> entomological species – a rich botanical variety – a select scientific library – The
> collection also comprises a number of conchological specimens, both pro-
> vincial and exotic. The room is adorned with paintings.[12]

Bourne included details of the fifty-three pictures, primarily copies of well-
known European paintings, which adorned the museum walls. In addition,
there were a folio of engravings, a massive volume of plates, and various other
printed images.[13]

Donations to the society's Library and Museum from 4 June 1829 (immedi-
ately after union) to 26 December 1830 (before the Charter was received)
included ninety-two separate contributions. These were detailed in local
newspaper accounts of the society's meetings and in the *Transactions*.[14]
Careful attention was paid to matching the object given to the name of the
donor. The Reverend G. Bourne (our tourist guide author) donated a German
Atlas by Homana (1789). Sir John Caldwell gave 'a basket of Insects'. Dr Lyons
deposited 'Twenty-five Engravings of newly discovered Plants'.[15] The library
was augmented by ninety-three additions in the same period, including
multi-volume sets of transactions from other societies (e.g. the Society of Arts,
Manufactures, and Commerce in London, England). In March 1829, the
society accepted the proposal of a Mr De Garris to lodge his pictures in the
rooms of the Society in exchange for the society promising to insure them.[16]

In addition to donations and loans, the Society solicited funds with which
to purchase desired objects. While the society was patronised privately by the
governors,[17] no funding from the public purse was received until the societies
amalgamated in 1829. Their petition to the new governor, James Kempt,
requesting a grant for the purchase of 'philosophical and chemical appara-
tus'[18] resulted in the receipt of a $1,000 (£250) legislative grant in 1830.[19] On a
nearly regular basis, the LHSQ received an annual grant of £50 from the
government.[20] Requests for funding emphasised that the society rooms were
maintained for 'the Benefit of all, who in the execution of any literary work;
or in the course of their studies, may wish to avail themselves of either [the
library or museum]'.

The three managers of the collection were designated as 'curators' of
the museum, the library and the 'apparatus', respectively. They were enjoined
to 'class and arrange them in scientific or methodical order'; the museum
curator was given additional leeway to organise the objects 'in the best manner

possible according to his judgement'.[21] The curators were also responsible for arranging the recently donated articles in the society's room before the next monthly general meeting, and for submitting in writing at the general meeting a report of all transactions in their 'respective departments' occuring between meetings, thus ensuring prompt recognition of the act of donation.

All donations were divided into four 'Classes':

I. The Class of Literature and History – to comprehend Moral Philosophy, Philology, Polite and Fine Arts, Literature generally, Civil History, Antiquities, Geography, Statistics, Political Economy

II. The Class of Natural History – Zoology, Geology, Mineralogy, Meterology, Botany, Dendrology

III. The Class of Science – Astronomy, Mathematics, Chemistry, Natural and Experimental Philosophy

IV. The Class of Arts – Agriculture, Commerce, Trade, Manufactures, Mechanics, Domestic and Useful Arts[22]

Kept under lock and key, the room's contents were preserved in suitable cases and cabinets. In the five-year period between 1833 and 1837, £80 was spent on 'specimens in Natural History' and £65 for 'Book Case, Glass Case & other Carpentry'.[23] 'Admirably arranged and scientifically classed',[24] the collections were arranged according to systems proposed by various authors. Commander Bayfield referred his readers to 'Professor Jameson, 3rd edition, 1820' when outlining his geological survey of Lake Superior.[25] William Sheppard followed Frederick Pursh's *Flora Americae* (1814) in his description of the plants described in Charlevoix's *Histoire du la Nouvelle France*. The anonymously described mineralogical collection followed Professor Frederick Mohs's natural history system for distinguishing minerals.[26] Only Mrs Sheppard complained about the inadequacy of the classification system which she employed to order her collection of shells, remarking that she was 'frequently at a loss respecting the species' because De Lamarck 'gives only a part of each genus'.[27]

The artefacts were exhibited in a single, 'spacious and lofty' room in the Union Hotel.[28] With over fifty paintings also hanging on the walls, the room would have conflated the present-day discrimination between gallery and museum, presenting a wide range of visual objects for the contemplation of the discriminating observer.[29] As literary and historical artefacts, the 'Books, Manuscripts, Maps, Charts, Plans, Diagrams, Prints, Engravings, paintings, and other objects, deposited in the Library' occupied the museum space but were administered by the librarian.

These objects, carefully classed, named and ordered, presented the visual delimitation of a 'literary and historical' account of 'Canada' – a previously unknown entity being made visible for its new public. In examining the

constitutive elements of the two founding societies, I will be arguing that the seamlessness implied in Bourne's and in Hawkins's image of the 'admirably arranged, scientifically classed' museum collection needs to be opened up. How is it that there were two societies pursuing seemingly identical mandates, who was involved, and to what end were their attentions directed?

Marketing a history

The six years between the foundation of the Literary and Historical Society of Quebec (1824) and the reception of its public charter in 1832 were marked by increasing tensions in the socio-political environment of the capital of British North America. The *Canadiens*[30] (the 'Canadian Party') dominating the elected House of Assembly were constantly in conflict with the appointed members of the Legislative and Executive Councils (majority were of the 'English Party'), the representatives of the upper house of Parliament.[31] Lord Dalhousie, the governor-in-chief of Upper and Lower Canada (now roughly Ontario and Quebec) was often outraged by the Assembly's pretentions to full control of the civil list and public financing. Dalhousie espoused a singular form of authority in keeping with most colonial situations and argued that 'the King's Representative in these Provinces must be the guide and helmsman in all public measures that affect the public interests generally'.[32] While professing to maintain a disinterested separation from local politics, Dalhousie is known to have resorted to manipulation of official privileges in order to shape events according to his preferred course.[33] Thus his involvement in the foundation of the LHSQ deserves close scrutiny. Likewise, the role of his successor, Sir James Kempt, in the evolution of the literary society also suggests that the supreme political authority in the colony had traditionally held a vested interest in the activities and profile of these cultural societies.

In the year before the formal establishment of the LHSQ, Dalhousie was engaged in correspondence with several men who would be of assistance in founding the society.[34] Proposing 'the formation of a Society, not entirely "Antiquarian" but Historical rather and Canadian', Dalhousie enlisted the support of William Smith, the author of the recently distributed *History of Canada*.[35] Smith's *History* was the first in Canada to cover the period of English rule (after 1760). Strongly pro-British, he asserted that the *Canadiens*' dismal history under French absolutist rule proved that their future progress lay in swift assimilation.[36]

In Britain between June 1824 and September 1825, Dalhousie was not actively involved in the LHSQ's formative years, but his temporary replacement, Francis Nathaniel Burton, became its first president; Chief Justice Sewell and Joseph Remi Vallières de St Réal were the vice-presidents.[37]

Working from an apartment in the governor's residence, the society published their first '[A]ddress to the Public' in 1824. Signed by Dalhousie, Burton, Vallières, and Sewell, the address outlined their intentions to 'give to Literature in this Province a corporate character and representation by the formation of a Literary and Historical Society at the seat of Government'.[38] The 'corporate' nature of the society was reaffirmed by the publication in the address of their respective titles above each name. Clearly identified with the corporate hierarchy, the job titles of president, vice-president, etc. confirmed their authority within the society and distanced them from their political and judicial roles, while simultaneously confirming them, through the publication of their personal names. The legitimacy of the 'corporate character' of their institution was at least in part attained through their apparent replication of the mandate and structural hierarchy present in similar British and continental societies.[39] Citing 'patriotic feeling', they announced their intentions eventually to 'embrace every object of Literary interest and inquiry' but for the present they would 'confine [their] researches to the investigation of points of History, immediately connected with the Canadas'.[40] Mythologising this history before their research even began, the committee wrote in its first address:

> [I]t is conceived that the early History of Canada abounds in materials, full of striking descriptions and romantic situations. The very circumstance of civilisation transplanted from the old world, superseding the indigenous barbarism of the natives, and yet remaining long enough in contact with it to acquire even some degree of respect for the rude Tribes it subdued or converted, seems to present a strange and remarkable contrast, capable of exciting the utmost curiosity and interest.

Their primary object was the preservation of 'documents', in particular those respecting 'the decaying Indian Tribes'.[41] Additionally, information regarding the 'early Natural, Civil and Literary History of the British Provinces in North America' would be procured from various sources [private and public]. Documenting the past, the society would collate evidence of the civilising influence of the 'old world', establishing a history which naturally preceded the present institutional framework.

In response to publication of the LHSQ declaration of intent, the local opposition newspaper, *Le Canadien*, appended an equally lengthy editorial commentary. In evident sarcasm, the author questioned, 'what author would dare to raise his views in opposition to such an authority?'[42] Warning that nothing could be 'true and good' that was voiced by this society, it was emphasised that this history 'would be the history of the governors, *published by authority, at the seat of Government and by the beneficiaries of the Government,*

presided over by the Leaders of Government' (original italics, my translation). Although the author went on to deplore the current history being 'written' by the present administration, thus subverting the LHSQ's address published on the same page, it is apparent that there was no doubt as to how Canadian history would be shaped by the voice of authority.

Strategies for marketing that history were laid down in this first address – collecting, publishing and lecturing. In order physically to consolidate these practices into visible acts of representation – *Transactions*, Library and Museum – the society needed to reach a larger public. It was believed that this goal would be achieved through their amalgamation with the Society for the Encouragement of the Sciences and the Arts (SESA) whose larger, more socially diverse membership extended more liberally across the ethnic and class divisions in Quebec at that time. The union would in turn be legitimated through the supreme authority vested in a Royal Charter granted in 1831/2. It is probably not coincidental that the application for royal approval was submitted soon after the LHSQ formally amalgamated with the SESA.

Dissent, union and incorporation

The SESA was dominated by legal professionals; its directors for 1827 were the president, Joseph Bouchette (Surveyor General) and the four vice-presidents, Andrew Stuart (lawyer and MP in the Assembly for the 'Canadian party'), William Sheppard (wealthy merchant, married to daughter of king's notary), Vallières de St Réal (a lawyer and ex-speaker of the House, now an MP in the Assembly for the 'Canadian party'), and Louis Plamondon (also a lawyer).[43] Dr Xavier Tessier, renowned for having started the Quebec Medical Association a year earlier, was the general secretary. Michel Clouet, lawyer and MP, became the treasurer. Drawing largely on the elite of the *Canadiens* in Quebec, the SESA nevertheless attracted several leading members of the English professionals in the community.[44] It would appear that the initial impetus to form the SESA so soon after the foundation of the LHSQ originated largely from issues related to differences in the social, financial and political status of the SESA's members.[45] A member himself of the SESA, the Reverend George Bourne characterized the difference as one of class; LHSQ members 'were chiefly gentlemen of high official rank in the province', SESA members were 'persons professionally qualified'.[46] Indeed, with its high-priced subscription, the LHSQ seems to have intended to exclude all but the wealthy elite of the province. There appears to be no reason not to accept William Sheppard's account that the 'formation [of the LHSQ] was brought about indirectly by a political movement . . . The Society was in the first instance composed of high officials and courtiers . . .'.[47] In contrast, the SESA took form in opposition to the LHSQ. Far from echoing

the concerns of the governor's group, the SESA staked out an alternative territory with a somewhat different mandate.

The rules and orders for the SESA were printed in 1827.[48] The document reads as a manifesto which details in minute fashion the election and duties of officers. Inevitably posed in contradistinction to the rules and orders of the LHSQ, the SESA document welcomed women,[49] publicly disavowed all discussion on politics and religion (article VI), and restricted the annual membership fee to one guinea (in comparison to the LHSQ which required £5 proprietary fee and £3 annually.)[50] The constitutional differences in the official documents of the societies inevitably find resonance in the escalation of the simultaneous battle between Governor-in-Chief Dalhousie and the House of Assembly. Briefly stated, Dalhousie prorogued the Parliament on 7 March in response to the refusal of the Assembly to pass the governmental supply bill. 'The troubles in the two Canadas' were being heatedly debated in the local press, in Nova Scotia and the United States.[51] It was in March 1827 that the SESA first met. It was about this time that Andrew Stuart and Joseph-Remi Vallières de St Réal left the 'Canadian party', now known as the 'parti patriote' (renamed in 1826), seeking a moderate position as 'bureaucrats'. The formation of the SESA at this particular moment suggests that the group, while disavowing discussion of politics and religion, were seeking to establish a neutral ground between the governor's men and the radicals (Papineau's supporters, primarily located in Montreal).[52]

In the autumn of 1827, the SESA published a list of eleven questions regarding literary, philosophic and commercial issues which were designed to stimulate responses from the general public in the form of papers and works of art.[53] Those considered of merit were to receive a medal from the society. Of the five medals subsequently awarded in March 1828, three were for 'literary' productions and two for essays on agriculture.[54] Either no entry was received for the 'philosophic class' or none was deemed worthy. The three literary prize winners were as follows: first prize for an engraving by Joseph Smillie of a map drawn by William Henderson (a vice-president of SESA); an honorary medal went to J. Fr. Bouchette (son of the SESA president) for engraved lettering; a second honorary medal was granted to Joseph Légaré, a local artist and municipal councillor, for his oil painting of *Indian warfare* (now known as *The massacre of the Hurons by the Iroquois*, fig. 7.3).[55] The announcement for the prize competition included a notice of the society's intention to create a museum for the display of articles of natural history from Canada and other objects, useful and 'agreeable', pertaining to the fine arts and the sciences. Apparently, the SESA sought to operate upon a wider spectrum of socio-cultural activity than the LHSQ. While not ignoring natural history, their policy of 'encouragement' focused upon the arts and commerce.

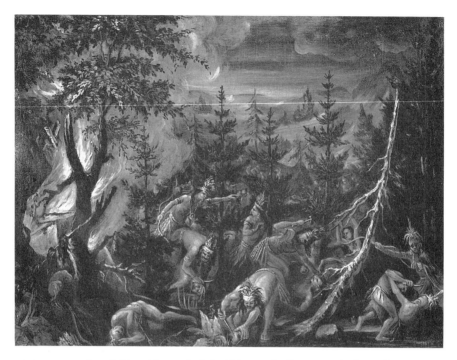

7.3 Joseph Légaré (1795–1855), *Le Mássacre des Hurons par les Iroquois*,
oil on canvas, 62.9×83.8 cm, *c.* 1828. Musée du Quebec.
Photo: Patrick Altman, courtesy of the Musée du Quebec

The union of the two societies was proposed within months of Dalhousie's departure from Canada in September 1828. His successor, Sir James Kempt, former lieutenant-governor of Nova Scotia, arrived armed with a mandate from William Huskisson, the colonial secretary, to repair the damage of Dalhousie's regime. Kempt attempted to 'carry on the Government if possible without a reaction of any kind'.[56] Considering that the proposal of union appears to have originated with the LHSQ, specifically with a letter to the SESA authored by Chief Justice Sewell, vice-president of the LHSQ, to the SESA,[57] it seems clear that the LHSQ was in agreement with Kempt's general policy of reconciliation. Bringing the predominantly *Canadien* membership and the nonconformist elements represented by the 'bureaucrats', Stuart and Vallières, into the LHSQ would confirm at least an appearance of a new co-operative spirit.[58] Given the ongoing pressure from various political factions to introduce a union of the two Canadas,[59] the achievement of a union between the two cultural organisations took on an elevated significance.

The SESA seemed to operate under the impression that the new name of the amalgamated would be the 'Society for promoting History, Literature,

Arts and Sciences in Canada' (thus truly amalgamating the titles of the LHSQ and the SESA). This is the name accredited to the society in Bourne's *Picture of Quebec* (Bourne was a member of the SESA). However, it appears that the LHSQ never had any intention of changing its name and that any suggestion of name changes was purely a temporary gesture. In the report of the committee concerned with the union, there was agreement with the 'title' of the society being the 'Society for promoting History, Literature, Arts and Sciences in Canada'. However, in the same set of resolutions, the LHSQ emphasised that the union would be 'mutually advantageous and beneficial to both [societies] and to the public, *provided it can be effected without abandoning the name and objects of this Society* (original emphasis).[60] Seemingly a trivial point, the name in fact brings a number of considerations to bear upon the received notions of what the society was meant to do and for whom. Furthermore, the receipt of the Charter in 1832 makes it clear that the initial request for incorporation made two years earlier was made under the name of the LHSQ. What was being subsumed by this act of naming was the difference signified by the procedures and structure of the SESA: its distinctive membership (predominantly professionals), its recognition of women members (the LHSQ did not admit women until 1923),[61] its disavowal of politics and religion, and its 'moderate' subscription fee (post-union fees were to be $5.00 or just over one guinea, i.e. a third of LHSQ's original fees, but only slightly more than the fees of the SESA). Clearly something was being sorted out here. The previously ineligible or uninvited (the professionals, both English and *Canadiens*) were now being brought into the LHSQ. The union of the two societies can be understood as a successful manoeuvre by the LHSQ which functioned to prevent the SESA membership from realising itself as a corporate body capable of using cultural definitions to challenge the 'history' of the colony being formulated by the LHSQ.[62] Curtailing in its infancy, the SESA's programme of prize-giving and museological interpretation, the formation of an extended LHSQ ensured the homogeneity of the 'historical' profile of the country.[63] The importance of the high profile members of the SESA to the LHSQ is signalled in the list of directors of 1830, the first year after their union, when half of the directors are former SESA members. Chief Justice Sewell becomes president, Stuart and Sheppard are vice-presidents, and Jonathan Wurtele, former secretary of SESA, is the new corresponding secretary.

History and union: representing statehood and identity

In describing the civic offices of the capital for his readers, Hawkins sketched a mental picture of the building, its site and its genesis. 'It is a large building, which stands on the north side of the Place d'Armes, and adds considerably

to its general appearance. It is a well proportioned and strongly built stone house, three storeys high, eighty-six feet in length, and forty-four in breadth.' Built in 1803, by The Union Company, a joint-stock company incorporated by an Act of Provincial Parliament, the building was originally designed as a grand hotel for the reception of 'strangers' visiting Quebec, under the title of the Union Hotel. As this was a financial disaster, the proprietors were obliged to sell the building in 1815. It was purchased by one of the major stockholders, Chief Justice Sewell. Hawkins noted that it was then rented from Sewell by the Province, 'it having been found most convenient to concentrate the offices of Government as much as possible under one roof'.[64] The offices of the civil secretary and his assistant, the Executive Council, the Commissioner of Crown Lands, the Inspector General of Public Accounts, the Surveyor General, the Royal Institution, the Adjutant General of Militia, and the Hydrographical Office were all in this building. Virtually every director of these offices was a member of the LHSQ. In the front of the principal storey were the rooms occupied by the LHSQ (rent free, 'with permission of the government').[65] Their museum/gallery came as close to being a publicly funded, publicly directed cultural institution as Canada would achieve before the official incorporation of the National Gallery of Canada in 1880.[66]

When Sewell bought the building from the Union Company of Canada, he added a third storey which raised its façade to a height en par with the Anglican cathedral, the governor's residence and the court house. As Hawkins noted, it added considerably to the 'general appearance' of Place d'Armes. Backed by the civic offices, and aligned physically and conceptually with the essential institutions of power in the colony, the room administered as museum, library and gallery was shaped as the primary site through which the visual, historical and literary past, and therefore, present, of the colony was expressed.

The negotiation of a union between the two societies, and the amalgamation of their membership lists, their 'rules and orders' and their collections represented a cultural triumph – the smoothing over of present differences designed to achieve an ordered and unified approach to Dalhousie's goal to 'rescue from oblivion and to collect into one Focus all that relates to the early history and natural productions of the Canadas'.[67] In a note of approval regarding the original foundation of the LHSQ, a contemporary journalist remarked that the importance of an 'Institution or Society' within a country affords 'a very sure criterion, whereby we may judge of the progress it is making in civilization, and of its remoteness from barbarism'.[68] Furthermore, it was clearly understood that in addition to being 'a proof of the civilised state of the country', such institutions also provided 'a means of judging of the stability of its political condition'.[69] The careful cataloguing of the donations

to the museum and library provides us with a retrospective means of judging just how that stability and progress was represented.

Joseph Légaré's loan of over fifty paintings, copies and originals, of mainly Baroque religious images literally framed the object collection.[70] Displayed on all four walls of the large former ballroom were the images of Saints Bartholomew, Catherine and Anthony; views of classic and modern Italy; replicas of Raphael's *The school of Athens* and Rubens's *Visitation*; and moral commentaries on drunkenness, despair and idleness. Thus the gamut of European civilisation was raised as the boundary within which the uncivilised past of the colony was neutralised and amended through scientific codification. While natural history tended to dominate quantitatively both the collection and the lecture schedule, the documentation of the Indian past was an ongoing concern.[71] Both these histories, the 'natural' and the 'Indian', were essential components of the desire to come to terms with Canada's 'barbarism'. Both the extensive, unmapped land and its equally unknown native inhabitants had to be charted in order to demonstrate the progress of civilisation in the young country.

In the first three volumes of the *Transactions*, there were inevitably maps, plans and diagrams of river beds, lakeshores, geological masses, etc. Detailed 'topographical notices' of different regions were read out at lectures, along with 'notes' and catalogues of various plants, shells, and insects. In addition to lectures, donations of rocks, birds, eggs, skins, etc. fleshed out the 'natural history' collection. Although Foucault's interpretation of the order of human sciences has become familiar in recent years, it is worth recalling again his arguments regarding the evolution of the domain of natural history. He suggests that in moving from describing the surface of natural objects to classifying the character of things in the late eighteenth century, the natural historian begins to relate the visible to the invisible, looking beyond surface distinctions to identify shared characteristics.[72] Drawing on Foucault's mode, I suggest that the LHSQ's concern for natural history is intrinsically related to the gathering of information about the Indians, the geological structure of the colony, etc. – which, when collated through the representational strategies of the museum, reveals the invisible 'organic structure' (the internal principle – more than the reciprocal interactions of the different elements) defining the history of the colonists, thereby placing the present in relation to a visible past.[73]

The history of the native populations was approached in three ways. Artefacts such as arrowheads, battle axes and a hatchet were donated to the museum collection.[74] Papers read to the public and then published in the LHSQ *Transactions* ranged from a report of a 'journey across the Continent of North America by an Indian Chief' to observations of contemporary Huron practices. 'Christianised' by the French and decimated by disease and wars with the Iroquois (the allies of

the British during the Seven Years War', the few surviving members of the Hurons were living at Lorette, a reservation about twenty miles outside Quebec City, close enough to serve as living specimens. The third form of documentation was history painting. In 1828, the SESA gave Joseph Légaré a silver medal for his depiction of *Indian warfare*. Ten years later, the LHSQ awarded a medal to Antoine Plamondon for his image of *The last Huron*.[75] Although these images did not become part of the museum collection, they were well known in the community and were associated with the awarding body.

This overriding concern for documenting and 'scientifically classifying' specimens of natural and native history dominated the activities of the LHSQ. The collected artefacts, displayed in glass cases in the society's room, were juxtaposed with the European images on the walls and the odd assortment of objects representing the civilised world (Roman vase from Herculaneum, antique Roman coins, box Italian Marbles . . .).[76] Located at the focal point of government activity, the museum can be understood as the visual manifestation of a unified notion of what constituted Canada's past. Contained and codified, the unknown and ambiguous terrain of history was represented as curious and unfamiliar; the terror of the unnamed was refuted through museological practices which 'scientifically' placed the past at a distance while defining the contemporary nation as the consequence of British colonisation.

The invention of nationhood during this period has been of historiographic concern for over a century. Eric Hobsbawn has suggested that the modern state 'was defined as a (preferably continuous and unbroken) territory over all of whose inhabitants it ruled, and separated by clearly distinct frontiers or borders from other such territories'.[77] The shift from various forms of autocratic rule to democratic institutions of government raised questions related to administration and to citizen loyalty. Such loyalty could be effectively shaped by uniting people in opposition to others. On a federal level, this can be seen to have been played out in Canada in the identification of the 'Americans' as disloyal (the loyalists having fled to Canada or back to Britain), in the figuring of the Indians as a pre-colonial 'other', and in the efforts to indirectly anglicise the *Canadiens*.[78] These were only some of the manifestations of a developing sense of nationhood. As an 'invented nation', Canada needed a history against which contemporary representations of identity could be conceived.[79] It was, I believe, in the rooms of the Literary and Historical Society of Quebec that these historicising tendencies were represented 'for Public benefit'. The visual confirmation of the physical fabric of the nation and its constituent elements (human, animal, mineral, and vegetable) in the museum was an essential to the process of national realisation – 'proof of the civilized state of the country' – as were the lectures and publications.

That this museum took form during the two decades of intensive negotiation around the idea of the political union of the two Canadas, that its rooms were located in the government-occupied Union Hotel, that its foundation was secured through the union of two competing learned societies, must not be a matter of chance. Although never formally a public institution, the museum was conceived and realised by people very much in the public domain and funded on an annual basis from the public purse. For the period up to the Act of Union (1840/1), the museum represented the idea of a people unified in its notion of self-indentity as expressed through 'literary and historical' artefacts.[80]

Today, the Union Hotel building functions as the main tourist bureau for Quebec City. Centrally located on Place d'Armes, the building's occupants continue to assist strangers to understand the province's capital city correctly. Across the street is the premier tourist and convention hotel, the Chateau Frontenac, standing on the site of the former Governor's residence. The Anglican church still provides the right flank, while tourist shops and the boardwalk define the opposite perimeter. The Union Hotel continues to represent to the stranger and locals alike a source of tourist maps, guides and information, that is, a fount of knowledge about the city and its place in the scheme of things.

Acknowledgements

I would like to thank Professor Marcia Pointon for her unreserved support and critical assistance in editing this and previous writing. Many thanks also to Gillian Poulter, Fernand Ouellet and Richard Jarrell for their generosity in reading the drafts of this article. I am indebted also to Sylvianne Dubois, the archivist at the Literary and Historical Society of Quebec, and to Cynthia Dooley, the librarian of the LHSQ.

Note on sources

The detailed descriptions of the archival sources at the LHSQ have not been included in each note in order to reduce their length. References to minutes or letters currently in the archives of the LHSQ will be understood to derive mainly from L1/B, 16 (Reports of the Treasurer); L1/B, 18 (Union with the SESA: extracts of minutes and letters); L1/E, 1 (Correspondence); L1/D1, 1 (General Accounts); L1/E, 1 (Correspondence); L1/B, 16 (Reports of the Treasurer); and L1/G2, 7 (Correspondence of Lord Dalhousie).

Notes

1 George Bourne, *The picture of Quebec and its vicinity*, P. & W. Ruthven, Quebec, 1829; 2nd edition, revised and corrected, 1831, p. 26. Pagination drawn from second edition. The second edition is virtually identical to the first.

2 The French surrendered Canada to the British in 1760. This was ratified by the Treaty of Paris which ended the Seven Years War in 1763.

3 In 1830, the square, actually closer to octagonal in form, had a single path across its enclosed space leading from the church to the Governor's residence. In 1832, the square was levelled and the chain fence installed (*Québec trois siècles d'architecture*, Quebec, 1979, p. 410).

4 Bourne, *The picture of Quebec* (1892 edition), vol. 4, p. 3–6. Alfred Hawkins, author of another tourist publication, imagined his tourist to be a discriminating and disinterested male, 'a philosophic spectator' (p. 458). Hawkins also advised this tourist to visit the society's rooms (p. 257) (Hawkins's *Picture of Quebec; with historical recollections*, Neilson, Quebec, 1834, with A. Thom and J. C. Fisher.

5 My conception of the role of the museum has been influenced by the writing of Annie Coombes, in particular, 'Museums and the formation of national and cultural identities', *Oxford Art Journal*, 11:2, 1988, pp. 57–68.

6 Bourne mentions the museum location three times in the guide in addition to his detailed catalogue of the museum's paintings: see below.

7 An overview of these and other societies expressing interest in the sciences which developed in nineteenth-century Quebec can be found in L. Chartrand, R. Duschesne and Yves Gingras, *Histoire des sciences au Québec*, Montreal, 1987. Earlier studies include G. Bernatchez, *La Société Litteraire et Historique de Québec*, M.A. thesis, University of Laval, 1979; R. A. Jarrell, 'The rise and decline of science at Quebec, 1824–1844', *Histoire Sociale*, 10, 1977, pp. 77–91.

8 *By-laws of the Literary and Historical Society of Quebec to which is prefixed a copy of the Royal Charter of Incorporation of the Society*, Quebec, 1832, p. 3. Emphasis added. The charter was granted 5 October 1831.

9 Article 17, 'Report of the Committee [examining several questions including that of public admittance to the Rooms of the Society]', 15 January 1829. By the time the by-laws were formalised in 1832, the hours of public opening were reduced to 1:00 to 3:30 p.m. *By-laws*, 1832, article 54.

10 Public lectures were popular and well attended by the 'better' classes. It is impossible to ascertain from extant data if the labouring classes were welcome. So-called middle-class institutions such as the Mechanics Institute and the Canadian Institute did not begin to appear in Canada until a decade later.

11 Published in *Transactions*, vol. 1, 1829, pp. 1–42.

12 Bourne, *The picture of Quebec*, pp. 104.

13 *Ibid.*, 105–10.

14 The first volume of the Society's *Transactions* was published in 1829 and included papers given before the members during the years 1824 to 1829.

15 *Transactions* (of the Literary and Historical Society of Quebec), 11, 1831, p. 433.

16 Extracts of Council's minutes 1829–39, 1 March, 1829. The name appears to read: 'De Garris'. However, Joseph Légaré, a local artist and city counsellor, is known to have 'loaned' his collection to the LHSQ for exhibition. It is possible that 'De Geggie' is the recording secretary's rendition of Légaré (Le Gare/Gagge?). It is also possible that a Mr Geggie, a donating member in the 1830s, was the lender.

17 For example, Dalhousie donated £100 annually while he was governor-in-chief.

18 'Apparatus' referred to various types of 'scientific' instruments, some of which was donated, some purchased.

19 Letter to Sir James Kempt from LHSQ, no date, *c.* 1829, cited in Laura Bancroft, *The Literary and Historical Society of Quebec*, M.A. thesis, University of Laval, 1950. £250 was granted by Kempt's successor, Lord Wittworth Aylmer. *Les Status provinciaux du Bas Canada*, 9–11, Geo. IV, vol. 9, 1829–30, pp. 767–9, cited in Bernatchez, *La Société Litteraire*, p. 7. Funds were often referred to both in Sterling [or *livres courants*] and in dollars. The exchange rate seems to have been approximately $4.00 to the pound.

20 Future funding included the exceptional Legislative grant of £100 on 10 May 1831. No funding was received in 1835 and 1836 according to M. Douglas, 'A history of the Literary and Historical Society of Quebec', *Transactions*, NS,4, 1865, pp. 4–15.

21 *By-laws*, 1832, article 8.

22 *By-laws*, 1832, article 39.

23 'Synopsis of the finances of the LHSQ 1833–1837', [LHSQ archives]. £102 was spent on books.

24 Hawkins, *Picture of Quebec*, p. 257.

25 Presumably referring to Robert Jameson, Regius Professor of Natural History at the University of Edinburgh, author of a *System of mineralogy*, 3rd edition, Edinburgh, 1820.

26 F. Mohs, *Treatise on mineralogy, or the natural history of the mineral kingdom*, Edinburgh, 1816, or possibly his similar 1820 publication.

27 These are all in *Transactions*, 1, 1829. Bayfield, pp. 1–42; Mrs (Harriet) Sheppard, pp. 188–97; William Sheppard, pp. 218–30; Mineralogical collection, pp. 265–88. Mrs Sheppard appears to have been using Lamarck's *Animaux sans vertèbres* (1801) which was in the LHSQ's library at the time.

28 Description of the rooms found in Joseph Bouchette, *A topographical description of the province of Lower Canada, with remarks upon Upper Canada*, London, 1815, p. 449.

29 A similar hierarchical arrangement of paintings (in this case, solely portraits) and artefacts was evident in Charles Willson Peale's Philadelphia Museum (1790–1820).

30 '*Canadien*' is used here to retain contemporary usage of a term employed to describe those born in British North America of French heritage. The children of English colonists were referred to as being English. The present-day notion of 'French-Canadians', 'English-Canadians', etc. was not popularised until the latter half of the nineteenth century.

31 Major issues developed around funding of governmental expenditures delimited by the Assembly's control of revenues, the governor's right to prorogue Parliament, and the proposed Union Act of 1822. The latter bill advocated the political union of Upper and Lower Canada which would have reduced the representation of *Canadiens* in the Assembly through increased requirements for franchise and increased the percentage of English-speaking members. Unionism remained a divisive issue throughout the 1820s and 1830s. See F. Ouellet, *Lower Canada 1791–1840: social change and nationalism*, Toronto, 1980 for discussion of political and economic situation (1815–37), especially chapters 5 to 10.

32 Peter Burroughs, *Dictionary of Canadian Biography*, VII, p.726. George Ramsay, 9th Earl of Dalhousie, was the governor-in-chief of British North America from 1820 to 1828.

33 As when Dalhousie brought a Dr Fisher from New York to assume the editorship of the newly-created *Quebec Gazette, by authority*, established by Dalhousie specifically to compete with the longstanding, oppositional *Quebec Gazette* – despite acknowledging that, as governor, he should 'avoid . . . appearing to interfere in the conduct of the periodical press in any way whatever' ('Letter to Mr. Buchannan, H.M. Consul at New York', [LHSQ archives]).

34 Bancroft, *The Literary and Historical Society of Quebec*, appendix B.

35 Smith, son of an American Loyalist, was the brother-in-law of Jonathan Sewell. Sewell, chief justice of Lower Canada, was one of the four primary figures involved in the founding of the LHSQ.

36 See summary of Smith's text in *La Vie litteraire au Quebec*, vol. II, 1806–34, Sainte-Foy, 1992, pp. 271–6.

37 Burton, lieutenant-governor of Lower Canada, resided in Canada only between 1822 (the year he was knighted) and 1825. Vallières, speaker of the elected House of Assembly in 1824, quickly moved from Dalhousie's good graces, assuming a position within the opposition by 1826.

38 Literary and Historical Society of Quebec, *Address to the public*, Quebec, 1824; copy in the 'Correspondence of Lord Dalhousie' [LHSQ archives].

39 For example, the Society for the Encouragement of Arts, Manufactures, and Commerce founded in London in 1760 also had a library, collected 'models and machines', gave prizes (premiums), and published their *Transactions*.

40 The LHSQ stated that they owed their origin 'to the patriotic feeling and anxiety for the honor, welfare and interest of the Province, which characterise the present Governor in Chief (LHSQ, *Address to the public*, unpaginated).

41 'First Nation peoples' is the currently preferred appellation for those heterogenous peoples resident in North America 'before contact' with Europeans. They were referred to by the Europeans as Indians, 'Savages', 'Natives'. The term 'Indian' is used here to reflect contemporary usage which homogenised the disparate peoples of the First Nations.

42 *Le Canadien*, 31 mars 1824.

43 The names of the officers were published in 1827 in X. Tessier, *Rules and orders of the Society for the encouragement of Sciences and Arts in Canada*, Quebec, 1827. The pamphlet was published simultaneously in English and in French. Vallières de St Réal, one of the original officers of the LHSQ, was not likely to have stayed involved in the society after he lost the speaker's position: see note 37.

44 Unfortunately I was unable to find any extant archival material remains from the SESA with the exception of some of their correspondence with the LHSQ which remains in LHSQ archives. This was carried on in English. It is worth remarking that an extant prize medal given to Joseph Légaré, a *Canadien* painter, was engraved entirely in English (including the name of the society), which suggests that the SESA prioritised English, although their meetings appear to have been bilingual. This refutes the notion that the SESA was posited as a French group in opposition to an English group; rather, the distinction is primarily one of class difference: the liberal professions and well-placed merchants opposed to the governmental elite.

45 There is not sufficient space here to examine each participant but further biographical information can be found in *Dictionary of Canadian biography* (DCB) which contains references to both recent and contemporary sources.

46 The SESA appears to have more closely paralleled the demographics of other contemporary learned societies. For an American example, see S. Baatz, 'Philadelphia patronage: the institutional structure of natural history in the new republic, 1800–1833', *Journal of the Early Republic*, 8, 1988, pp. 111–38.

47 Cited in J. Douglas, 'Opening address [on the history of the LHSQ]', *Transactions*, NS, 5, 1865–6, p. 6. Sheppard is referring to Dalhousie's appointment of John Fisher (member of the Literary and Historical Society of New York) as the editor of the official government gazette in a move to counter opposition papers.

48 *Rules and orders . . .* (SESA). Also published simultaneously in French.

49 Article VIII, 4. As with the clergy, women were admitted without the potential humiliation of the public ballot. Women were automatically accepted when supported by three members (potential male members required two members' support), and were allowed to vote, but only by proxy.

50 Fees cited in Douglas, 'The history of the LHSQ', p. 7.

51 See M. Whitelaw, *The Dalhousie journals*, vol. 3, Toronto, 1982, pp. 101–2, for Dalhousie's views of the 'troubles' in May 1827.

52 It is important not to limit the differences between the LHSQ and the SESA to ethnic opposition. There was definitely a third position here between the *Canadien* radicals and the British governors. See G. Carr, Imperialism and nationalism in revisionalist historiography', *Journal of Canadian Studies*, 17:2, 1982, pp. 91–9, for an introduction to the massive Canadian historiography of French–English nationalism.

53 *La Bibliothèque Canadienne*, V:5, October 1827.

54 *La Bibliothèque Canadienne*, VI:4, March 1828, pp. 158–9.

55 It has been suggested recently that Légaré received an honorary medal not because of his work being judged inferior to Smillie (as suggested by Trudel) but because of his status as a full member of the SEAS (the first prize being used to 'encourage' non-members) (J. Porter in *La Peinture au Québec, 1820–1850*, Quebec,1991). This distinction is not tenable, as Sheppard, a full member, received both an honorary and first prize medal the following year. The medal, engraved in English, referred to 'An Oil Painting of Indian Warfare' (see figs. 1 & 2 (for reproduction of medal) and fig. 3 (for reproduction of painting), in Porter, 'La Société Québecoise et L'"Encouragement" aux artistes de 1825 à 1850', *Journal of Canadian Art History*, IV:1, 1977, pp. 15–16. The French-language press referred to the painting as 'representant le caractère barbare des combats sauvages entre les Hurons et les Iroquois' (*Bibliothèque Canadiene*, VI:IV, March 1828, p. 159).

56 P. Burroughs, 'James Kempt', *DCB*, p. 463. Kempt confirmed Papineau in his position as speaker of the Assembly. Vallières was appointed as the provincial judge in Trois-Rivières. Chief Justice Sewell, whose prerogative as speaker of the Legislative Council was the privilege of exercising two votes, assisted Kempt to pass the long overdue money bill. Sewell's multiple roles as chief justice, speaker of the Legislative Council and vice-president of the LHSQ placed him in a position of questionable neutrality.

47 'Union with the SESA', letter of 15 January 1829, [LHSQ Archives].

58 Members of the 'bureaucratic party', Vallières and Stuart posed a significant threat to the English party elite who were in disarray after the 1824 election – both were elected to the Assembly in 1827, dividing the two Quebec city seats between themselves. The divisiveness of the English-speaking population in Quebec City at this time has been underrated in historical analyses which focus on the division between the English- and French-speaking

populace. Ouellet discusses the specifics of the loss of cohesion in the English-speaking population in *Lower Canada*, pp. 257–9.

59 Questions concerning the political union of Upper and Lower Canada were raised in 1822, in 1826 and throughout the decade. See F. Ouellet, *Economic and social history of Canada*, Gage, Ottawa, 1980, p. 325 and passim. The physical union through canals was an issue throughout the 1820s and 1830s. *Ibid.*, pp. 370–6 and passim. Dalhousie constantly supported the unionists.

60 'Union with the SEAS', Report of 26 January 1829, [LHSQ archives]. Signed J. Sewell, Chairman [of Committee for investigating union].

61 Significantly, women were politically enfranchised in Quebec until disqualified in 1834 (the bill of 1834 did not receive royal assent until 1840, but the politicians acted as if it had). Andrew Stuart seems to have been the first to challenge propertied women's right to vote in 1832 – the year he became the president of the LHSQ.

62 Although the 'authorised' history was being challenged by Michel Bibaud in his 'Histoire du Canada' published in weekly instalments in his journal, *La Bibliothèque Canadienne*, this was the work of an individual as opposed to the institutionalised 'history' of the LHSQ.

63 Although the Musée Chasseur, a natural history museum featuring birds, reptiles and mammals, was founded in 1824 in Quebec City, it did not engage in any 'literary or historical' pretensions. Experiencing financial difficulties, it was taken over by the government in 1837, and its contents were 'given' to the LHSQ in 1840. For a complete account, see R. Duchesne, 'Magasin de curiosités ou musée scientifique? Le Musée d'historie naturelle de Pierre Chasseur à Québec (1824–1854)', HSTC Bulletin. *Revue d'Histoire des Sciences, des Techniques au Canada*, VII:2, mai 1983, pp. 59–97.

64 Hawkins, *A picture of Quebec*, p. 256. A very 'convenient' source of extra income for Sewell.

65 *Ibid.*, pp. 256–7.

66 See M. Tippett, *Making culture: English-Canadian institutions and the arts before the Massey Commission*, Toronto, 1990, for a history of Anglophone cultural institutions in Canada. Also note that R. Duchesne unconvincingly argues that the Musée Chasseur was 'the only true public museum [in Canada] in the first half of the nineteenth century'. However, Chasseur received only two loans from the Assembly and was not favoured with free rent, governor patronage, high-profile directors, etc. as was the LHSQ ('L'Ordre des choses: cabinets et Musées d'histoire naturelle au Québec (1824–1900)', *Revue d'Histoire d'Amérique Français*, 44:1, 1990, pp. 3–30, esp. pp. 10–11).

67 Address to Dalhousie, signed by F. Burton, chair of the LHSQ, *c.* 1825, [LHSQ archives].

68 Signed 'P.', *Canadian Magazine*, II:8, February 1824. 'P' is responding to the declaration in the LHSQ address that 'civilisation transplanted from the old world, supersed[es] the indigenous barbarism of the natives . . .'.

69 *Ibid.* This alignment of a society's cultural progress with its political stability took on added resonance in the aftermath of the bitter political confrontation in 1822 over the Union Bill (which proposed a parliamentary union of the two Canadas intended to diminish Canadien representation in the Assembly and to foster the anglicisation of the French-speaking community).

70 It is not clear that loans from other members did not occur. Certainly members such as William Sheppard had extensive personal art collections and may have augmented Légaré's loan. See John R. Porter, *The works of Joseph Légaré 1795–1855*, Ottawa, 1978, p. 14, for details of Légaré's collection.

71 Four of the seventeen lectures in volume II (1831) of the LHSQ's *Transactions* dealing with lectures given after the merger dealt with Indian topics, i.e. a Huron grammar, a description of the 'Tête de Boule' Indians, 'on textile substances' used by North American Indians, and on 'processes used in dyeing' by the Hurons.

72 M. Foucault, *The order of things: an archaeology of the human sciences*, New York, 1973, pp. 132–44, 226–32. Although Foucault later reassessed much of *Les Mots et les choses*, the differences between Linnaeas and Lamarck, for example, remain of interest here. It may be that Mrs Sheppard was unhappy with Lamarck's *Animaux sans vertèbres* (1801) as a consequence of that difference in 'surface versus character'.

73 What I understand by this is that Foucault argues that the organic structure implies a living character in things, a pre-evolutionalism, which suggests that natural sciences not only denominate the human world but define the implication of humans within those things.

74 *Transactions*, I [1829] and II [1831]. Both contain lists of donations and transcriptions of papers read.

75 See F.-M. Gagnon, 'Antoine Plamondon *Le dernier des Hurons* (1828)', *Journal of Canadian Art History*, XII:1, 1989, pp. 68–81, and J. Trudel, 'Joseph Légaré et la bataille de Sainte-Foy', *Journal of Canadian Art History*, VIII:2, 1985, pp. 140–75. Both illustrated.

76 'List of donations to the Library and Museum since June 4, 1829', *Transactions*, II, 1830, pp. 433–9.

77 E. Hobsbawm, *Nations and nationalism since 1780: Programme, myth, reality*, Cambridge, 1990, p. 80.

78 The *Canadiens* expressed 'unshakable devotion to the British Constitution' at least until the 1820s. See F. Ouellet, *Lower Canada*, pp. 70–1, for full citation and pp. 74–5 on admiration of British institutions.

 For discussions of Indians as 'other' see Gillian Poulter, *Visual representations of native peoples in Quebec 1760–1840*, M.A. thesis, York University, 1992; Maureen Ryan, 'Picturing Canada's native landscape: colonial expansion, national identity, and the image of a "dying race"', *Revue d'Art Canadienne/Canadian Art Review*, XVII, 1990, pp. 138–49. Note that Ryan focuses on the period after 1870.

79 Linda Colley discusses Britain as an 'invention nation that was not founded on the suppression of older loyalties so much as superimposed upon them' ('Britishness and otherness: an argument', *Journal of British Studies*, 31, October 1992, pp. 302–29; esp. p. 327). Her work on the re-fashioning of alliances and culture of the four nations of Britain to create a common Britishness united against various others is, I believe, useful way of conceiving the multiplicity of Canadian-ness. The Constitutional Act of 1791 safeguarded *Canadien* rights to French laws and customs. It also granted them the political rights of British subjects – a move which resulted in little cultural disruption yet a willingness to abandon loyalties to the French crown.

80 Little is known of the museum's status during the years after the rebellion of 1837 (when the capital was moved away from Quebec City, after which the LHSQ were forced to give up their premises in the Union Hotel). As the capital was shifted several times, the government-dominated membership of the LHSQ ebbed during the periods of absence. The museum was actively supported between 1865 and 1882 (interestingly the years around confederation 1867–73). In the 1860s, the LHSQ was established in the Morin College building – its present site. The natural history collection was sold to the High School of Quebec in 1890 for $200.00.

NORMAN ROCKWELL AND THE *SATURDAY EVENING POST*: ADVERTISING, ICONOGRAPHY AND MASS PRODUCTION, 1897–1929

C. E. Brookeman

IN HIS CRITIQUE of the two-volume definitive catalogue of Norman Rockwell's work that appeared in the *New York Times Book Review* of 12 December 1986, Arthur C. Danto drew attention to a lack of learned articles on Rockwell: 'So where are the monographs, the iconographic studies, the densely hermeneutic *Artforum* essays, the Frankfurt School-inspired poststructuralist analyses in *October*, the brilliant retrospective at the Beaubourg or the Palazzo Grassi?'[1] This absence is noteworthy particularly when one considers the quantity of Rockwell's public image-making, from the 321 covers that he produced for the weekly *Saturday Evening Post* (hereafter the *Post*) between 1916 and 1963 to his host of calendar and encyclopaedia illustrations, and the wall posters that have been made from his images. The definitive catalogue numbers some four thousand items. However, America's best-known artist is not exactly about to disappear. A new museum on route 183 in Stockbridge, Massachusetts devoted entirely to Rockwell opened on 13 June 1993, the result of a ten-year $9.2 million project. Hail Rockwellworld! For the record Arthur Danto has missed a celebrated piece of Frankfurt School criticism entitled 'The triumph of mass idols' by Leo Lowenthal that analyses the *Post*'s ideology.[2] Rockwell's covers played a part in the process by which the *Post* became an American institution. Behind this rise to success in the new mass market was the Curtis Company, one of the first advertising-driven media corporations.

Lowenthal's essay develops an interpretation of the ideology of the *Post* through an investigation of the occupations of those exemplary Americans who were the subjects of the biographies that had become a standard feature of magazines like the *Post* and *Colliers*. The *Post* that had achieved a circulation

of one million by 1908 was one of a new type of weekly magazine based on a subject-matter of business, current affairs, fiction and an ever-increasing proportion of advertising. The success of this formula among an audience made up largely of the white middle class can be measured by the circulation figures of the *Post*. By 1929 the average weekly circulation had reached 2,865,996.[3]

The short biography of famous Americans became a standard part of the *Post*'s formula which was designed to win a large-scale readership. The genre of biography often followed an Horatio Alger 'rags to riches' narrative and morality. Another device that was geared to create a mass readership was that the fiction was often serial, based on a recurring character like the Chinese detective Charlie Chan. The *Post* also published G. K. Chesterton's tales of deduction that featured the repeated presence of a Roman Catholic priest who was also an amateur detective, called Father Brown. This evolution of a formula based on repeated forms such as the short biography enabled Lowenthal to compare biographies from different eras. Lowenthal concluded from his analysis that, whereas at the beginning of the century the majority of biographies were based on the lives of exemplary American businessmen – a group he called 'heroes of production' – from the 1920s onwards businessmen were steadily replaced by what Lowenthal calls 'heroes of consumption' such as movie and sports stars. Andrew Carnegie gave way to Clark Gable, captains of industry like John. D. Rockefeller gave way to baseball stars like Babe Ruth.

Lowenthal argues that this change in the nature of hero figures marks a shift from an economic system based on the energies of individual entrepreneurs, who were often the heads of family firms, to a faceless system of large-scale corporations. This tendency towards monopoly capitalism was in part a response to an industrial system based on the mass production of consumer commodities such as movies, sewing machines and automobiles. Lowenthal's argument is that the traditional virtues of the Yankee businessman – thrift, frugality and deferred gratification – visible in such national character models as Benjamin Franklin and Henry Ford, were not designed to generate the high-level volume of consumption demanded by the system of mass production. From his study of the *Post* Lowenthal argues that the new consumer values were attached to and mediated by a fascination with the extravagant lives and lifestyles of heroes and heroines from the entertainment industries: film stars, boxers, baseball players and singers. In particular the lifestyles of Hollywood stars, with their palatial homes, swimming pools and chauffeur-driven limousines, symbolised a world of glamour and pleasure in which, in line with the new consumer values, gratification was satisfied not deferred. An important part of this new culture was the use particularly in advertising of images that integrated sexual desire into the process of stimulating consumption.

The genre of the 'celebrity' biography was a particular interest of George Lorimer, the *Post*'s editor from 1899 to 1936. The *Post*, for example, from the 1920s followed the personality and career of Mussolini who was tracked for the *Post* by the former US ambassador to Italy, Richard Washburn Child. The Italian Fascist party was seen by the *Post* as a necessary bulwark against the spread of Bolshevism. The ghosted 'Memoirs' of Mussolini appeared in the *Post* alongside those of boxing great Jim Corbett, musician and composer John Philip Souza and the singer and entertainer Fannie Brice.

The success of the *Post* was masterminded by Cyrus Curtis who had bought the moribund *Post* in 1897. Curtis had already made a success of the monthly *Ladies' Home Journal*, mainly by being able to deliver a large group of readers-cum-consumers to the advertisers. In the case of the *Journal* the bulk of the readership was made up of middle-class women. With the *Post* the market that Cyrus Curtis promised to deliver to the advertisers was predominantly that of the male middle class, living in the suburbs of large cities, or in small-town America, a target group that included well-to-do farmers. With the advertising company N. W. Ayer & Son, Curtis organised a national campaign to promote the *Post*, buying cards in railway and elevated cars and space in newspapers and magazines. The two thousand subscribers that Curtis had inherited in 1897 had become a circulation of 193,544 by the year ending June 1900.

A major part of the *Post*'s developing appeal was that in a time of rapid change it explained how modern society worked. The rate and nature of the changes in this era that straddled the nineteenth and twentieth centuries are described in an article on 'Grandparents' that Margaret Mead, the American anthropologist, wrote for *The Saturday Evening Post Norman Rockwell book* in which she observed, apropos of her grandmother: 'When my grandmother died in 1928 at the age of eighty two, she had seen the whole development of the horseless carriage, the flying machine, the telegraph and Atlantic cables, telephone, radio, silent films.'[4]

Not only did the *Post* serve the needs of its middle-class market by explaining how a modern consumer society of mass production functioned, it also reassured its readers that such core American values as self-reliance, hard work and prudence were not incompatible with the values of a consumer society. This was achieved by editorials stressing that self-help, industriousness and self-reliance were valuable national American characteristics in themselves, regardless of any particular mode of production. The consumer society was seen in a positive light as a democratic open society in which an abundance of commodities enabled more people to achieve a comfortable standard of living. Advertising was integrated into this seamless process by claiming it as a democratic way of directly informing citizens of the American dream that was in the grasp of every immigrant. The spirit and promise of this

society was expressed in an advertising slogan of 1887 used by Macy's department store: 'Goods suitable for the millionaire, at prices in reach of the millions.' Alongside editorials on character were articles that explained how America had harnessed Niagara to produce electricity, what the role of advertising was, and discussions about America's world role.

The *Post* through its advertising was a vehicle for a new kind of mass production and distribution of standardised commodities to a nationwide market. A typical example of this process was the rise of Coca-Cola. Invented in 1886, it was first distributed to a local market centred on Atlanta and the southern states. In the catalogue that accompanied an exhibition at the Boilerhouse Museum entitled 'Coca-Cola 1886–1986: designing a megabrand', the transformation of Coca-Cola into a mass commodity was described as follows: 'It was the initiative of putting Coca-Cola into bottles together with the development and refinement of the franchise system that turned Coca-Cola from a Southern curiosity into a world product.'[5]

Another example of this process was the creation of a nationwide movie culture. In her study of American youth culture in this era *The damned and the beautiful: American youth in the 1920s*, Paula Fass comments as follows on how cinema contributed to the formation of a shared national culture within one segment of the mass market, native, white, middle-class college students: 'Most students regularly attended one movie per week, and students were especially interested in the personalities, tastes, and interests of movie stars who were given full coverage in columns, reviews, and interviews.'[6] The film industry was a prime model of this trend by which advertising, publicity and mass production had, by the 1920s, created large consumer audiences. The depth and scale of the economic and social impact of Hollywood film can be seen by the fact that between 1930 and 1945 the movies attracted 83 cents of every American dollar spent on recreation.[7]

A further example of the arrival of this consumer culture can be seen in the transformation of the cosmetics industry into a mass industry, sweeping aside the traditional Puritan disapproval of the 'painted woman'. Richard Corson in his book *Fashions in makeup* quotes the following analysis by an advertising agency that calculated that by the end of the 1920s:

> American women were using three thousand miles of lipstick a year, 375,000,000 boxes of face powder, and 240,000,000 cakes of dry rouge. American cosmetics manufacturers, in 1928, spent more than 16 million dollars . . . in advertising their products . . . making them the third largest industry in the country in volume of magazine advertising . . . The cosmetics produced had risen in value . . . to $191,039,469 . . . a year. This does not include imported cosmetics, which in 1920 were valued at more than six million dollars, exclusive of toilet soap.[8]

The promoters of this new society of consumption relying heavily on the purchasing power of the middle class needed to adapt an inherited traditional belief system of thrift, frugality and deferred gratification that had enabled a society of immigrants to rise to economic security, to one in which the desired lifestyle was achieved and measured by the acquisition and display of material things. The world of mass production and mass advertising targeted the nuclear household as a unit of consumption that needed to be persuaded to purchase those goods that were seen as essential to the affluent modern home – Hoovers, cars, fridges, radios, sewing machines, etc. Instead of saving to purchase essentials outright, the consumer citizen was offered a growing range of commodities that could be purchased if necessary with the aid of credit schemes. The Singer sewing machine was among the first products to be made available in this way. Beginning in 1856 with an industrial machine, Singer's partner, lawyer Edward Clark, then introduced a hire-purchase scheme whereby a Singer which cost $50 outright could be bought for $5 down and $3 per month for a total sum of $100. The same credit facility was then extended to the purchase of the lightweight 'family' machine, introduced in 1858. By 1926 instalment sales accounted for about two-thirds of all new car sales. The credit buying of expensive items thus became an established part of American life by the mid-1920s. Magazines like the *Post* which carried Singer's advertising became through their advertising a major means by which the consumer was made aware of the products of mass production.

Cyrus Curtis, the *Post*'s owner, was in no doubt as to the importance of advertising. A 1915 brochure that the *Post* produced to launch a major initiative to increase advertising carried under a photograph of the Curtis company headquarters in Philadelphia the following caption: 'An Institution Built on Faith': 'This building in Independence Square represents an institution built on faith – faith in the power of advertising.'[9]

This new company headquarters completed in 1911 not only symbolised the power and authority that befitted the status of the Curtis Company as a national enterprise and institution, the imposing building was a model of enlightened working conditions and amenities for its 3,500 workers. It included a small hospital. The Curtis company, according to an article in the *Architectural Review*, provided safeguards against what it called 'the formation of class-feeling, institutional-hatred, envy, malice and all uncharitableness'.[10] The building was yet another American neo-classical icon in praise of an American civilisation of business whose grandeur and stability were expressed by the paired marble columns of the entrance, and the imposing lobby faced with marble from the ancient quarry of Mount Pentelicus which supplied the stone for the Parthenon in Athens.

One of the important consequences of the growth of this advertising-

driven sector within the economy was a great increase in the demand for advertising copy and imagery from commercial artists like Rockwell, whose first cover for the *Post* dates from 1916. The world of mass-produced commodities that ranged from model T Fords to canned foods, from small electrical appliances to cosmetics, and materials and substances for cleaning and hygiene, increasingly employed national advertising through such mass circulation media as the *Post* in order to bring the abundance of commodities to the attention of the American consumer. By 1927, when the *Post* had reached a weekly circulation approaching three million, advertising revenues were in excess of $50 million. This reliance on advertising revenue can be seen in the arrival by 1929 of a *Post* which often contained over a hundred pages of advertising in an average total of 160 pages. This advertising-driven formula, which had made Curtis's other magazine, *The Ladies' Home Journal*, into the most profitable magazine in America, was successfully applied to the *Post*. Curtis's belief in the values of a consumer society of abundance and the major role of advertising is illustrated by his address to a meeting of advertisers in which he argued that the idea that *The Ladies' Home Journal* was published for 'the benefit of American women was an illusion of the editors'. He went on to identify his own marketing strategy: 'But I will tell you the real reason, the publisher's reason, is to give you people who manufacture things that American women want and buy a chance to tell them about your products.'[11]

The *Post*'s acknowledgement of the major role of women not only as having a considerable say over the purchase of household commodities but as consumers in their own right, was reflected in the contents of the *Post* by the inclusion of articles that were specifically directed at women. In the 28 June 1908 issue the *Post* announced two upcoming articles: one entitled 'The complexities of the complexion' by medical writer Woods Hutchinson, and another entitled 'Frauds and deceptions in precious stones' by Tiffany's expert in precious stones. Ahead of these articles the 20 June 1908 issue of the *Post* had carried the following announcement: 'Who says that *The Saturday Evening Post* is for men only? . . . We number women readers not by tens of thousands but by hundreds of thousands.'[12]

The interest in the woman reader was not confined to her role as a consumer. From 1909 Maude Radford Warren began publishing articles on the increasing presence of women in the workforce. In a series that charted the rise of the career woman particularly in the professions, she surveyed the history and current status of women in law, teaching and the arts, concluding with the following look to the future: 'Perhaps it is not a Utopian dream that the professional woman of today is blazing a trail for that possible woman who, in a readjusted world, may have not only a profession, but a husband and children too.'[13]

However, there was one major visual space in the *Post* that was untouched by this positive reception to the emergence of 'the professional woman': the front cover, where the *Post* continued to depict women as alluring passive objects of desire, becoming, like the commodities displayed in the adverts, fetishes of consumerism. In the six years from 1908 to 1913, when covers became entirely independent and no longer tied to the lead story or article, 142 of 313 covers were of this type. Two artists, Harrison Fisher and Henry Hutt, specialised in providing the *Post* with elegant and alluring images of femaleness, through an iconography of sirens and coquettes (fig. 8.1). The development of an iconography in the *Post*, not only on the front cover but throughout the magazine, attests to the increased importance of visual display. By the mid-1920s a normal issue would include a front cover image in two colours. Inside, the reader would find articles and stories stylishly illustrated by commercial artists like J. C. Leyendecker. Another expanded area for visual imagery was the whole pages devoted to single commodities that appeared on the inside front cover and on the back cover. These full-page adverts went far beyond statements of a product's properties or uses. The acquisition of a particular commodity like a car was seen as a passport to desirable modern middle-class lifestyle of affluence, pleasure and security. As the caption to a 1920s Packard Motors advert of people in evening clothes getting into a limousine concluded: 'a man is known by the car he keeps'.

However, the most important new ingredient in this advertising culture was a recognition of the purchasing power and consumer influence of women. As has been pointed out, Cyrus Curtis made his first fortune in the magazine business out of a woman's magazine, *The Ladies' Home Journal*, which was seen as a market leader for the rest of the field. It was the *Journal* that became the first magazine of its type to achieve a circulation of a million. Of the eight American mass-circulation magazines of the 1920s with circulations of a million or more, six were women's magazines based on the advertising revenue from mass items such as clothes. By 1928, according to one advertising executive, 97 per cent of all advertising was directed at women, and 67 per cent of all consumer items were purchased by women.[14] For a magazine like the *Post* the problem was how to appeal to the wives and daughters of its main audience of upwardly mobile businessmen without sacrificing its patriarchal ideology. It achieved this by coming out in favour of a selective modification of the traditional nineteenth-century notion that women should be confined to the role of domestic housewives and mothers. An editorial of 19 July 1913 entitled 'A woman's sphere' typifies this selective process of modification by arguing that women did have the right to find

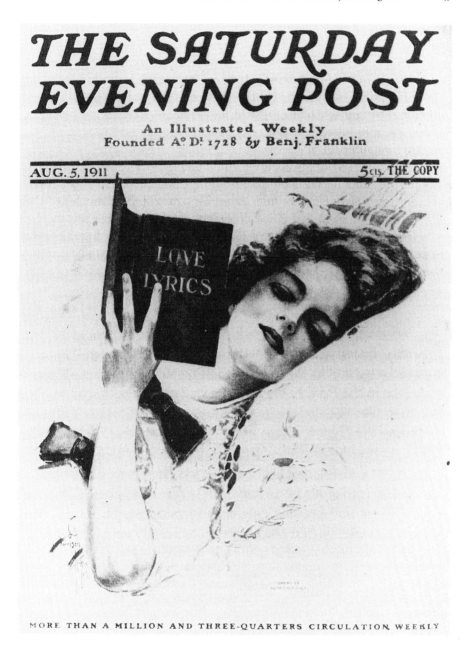

8.1 *Saturday Evening Post,* cover by Harrison Fisher, 5 August 1911

interests outside the home but only after the dishes had been washed. As the article stated:

Food must be cooked, floors mopped, dishes washed, stockings darned. When this dull work falls to the wife it is adding insult to injury to tell her she should never think of doing anything else – that performing labor the relative value of which is measured by a wage of about six dollars a week is the highest usefulness she can possibly find. When the dishes are done she ought to have interests outside the house, as different and as stimulating as possible.[15]

On the issue of women's suffrage the *Post* saw it as a necessary modern reform. An editorial of 14 February 1909 entitled 'Why women shouldn't vote' satirised some of the absurd arguments against female suffrage and by 1913 editorials were arguing for an increase in the wages of women workers. There was a contradiction in the notion that the power of the American middle-class woman who had gained the vote in 1920 was increased by her enhanced status in the eyes of the advertisers. The idea that the labour-saving household gadgets of the consumer revolution inevitably led to a decline in the amount of women's housework has been challenged.[16] If anything, it increased the number of duties and responsibilities that advertisers discovered for the housewife. She was now judged against an image of the improved perfectible efficient world made possible by consumer gadgets. This advertising vision of the good life, suggesting that society was perfectible, was a double-edged sword. The woman consumer not only had the opportunity to achieve, with the help of advertising, the perfect figure, the perfect kitchen, the perfect marriage and the perfect children, she had the duty to do so. The modern house and the modern body in a consumer society were threatened by such dangers as germs and physical deterioration that could only be kept a bay by the purchase of cleansing products and a whole range of cosmetics and pills. This kind of advertising, aimed at exploiting the anxieties of women consumers is exemplified by the following copy from the 1920s:

Health authorities tell us that disease germs are everywhere. Door-knobs, chair-arms, banisters – a hundred places around the home that big and little hands must touch daily – carry the germs of illness. 3,000,000 people in the United States are sick every day. And yet much of this illness is preventable.[17]

One of the effects of a consumer society was to widen the gap between a female culture of domestic and nurturing roles within the modern suburban home and a culture of the breadwinning male who left the home to work in the competitive capitalist city, which was the source of real power and prestige. This represented a change in the work and lives of women who, for example, in the era of western settlement:

bore a wide range of responsibilities. The women of the wagon trains made substantial preparations for the journey. They wove the cloth top for the wagon, prepared food, medicines and clothing for the trip and managed the cooking

and cleaning en route. Once they arrived at their destinations, women frequently helped to build their new homes, break the soil, and harvest the crops. Their own cash crops, butter, eggs or lard, could be vital to sustaining their families in the early days.[18]

A mythology was created out of these historical experiences in which a virtuous heroic figure of the pioneer women of northern European Protestant stock became part of America's myth of creation in which a chosen people of Wasp men and women laid the foundations of the USA by turning a wilderness into a productive garden. Critics of the consumer society often turned to this model of an earlier rural America of thrift, self-reliance and deferred gratification when pointing to the hedonistic enervating culture of modern consumer society. Whatever freedoms and new roles women demanded from a reluctant patriarchal America, they had to continue to be mothers and housewives. This was the ambiguous message contained within the *Post*'s acknowledgement of the consumer power of women.

This acknowledgement had a substantial influence on the contents of the *Post* and its use of its advertising space. By 1929 the *Post* devoted about 60 per cent of its pages to advertising. The allocation of space within this proportion reflected a recognition and consolidation of the consumer power of women. Products that appealed to men such as industrial and business goods accounted for about 50 per cent of the total advertising space, with automobile-related products accounting for about 25 per cent of that 50 per cent. Household products aimed at women such as vacuum cleaners, refrigerators, dishwashers and toothpaste were the largest single category, occupying 40 per cent of the advertising space. The inclusion of women in the *Post*'s view of the world was part of an economically necessary strategy to maximise circulation and create a large-volume national market. By 1908 Cyrus Curtis and his editor George Lorimer had increased the *Post*'s circulation to a million from a figure of 250,000 in 1898. Lorimer, who had been hired in 1899, had previously worked as a manager in the canning department of Armour, the Chicago meat packing firm, so he was familiar with the techniques of mass production. The *Post*'s success depended on its ability to reach, expand and satisfy an ever-increasing mass national consumer market for the standardised products of industrial society. By 1894 the USA had created a level of industrial production that almost equalled that of Great Britain, France and Germany combined.

The formation of a national consumer market based on industrial mass production is often cited as a development particularly associated with America. The emergence of a mass society with national markets depended on the convergence of a number of factors that have been usefully summarised by Thomas Cochran:

These include the electrical devices of telephone, light, and power machinery; the automobile and interurban highways; oil as a major source of energy; better alloys and specialised tools; an easier capital market helped by the huge reserves of insurance companies; a mature system of investment banking; trade, employer, and civic associations; chain stores and mail-order houses; more specialised wholesale and retail distributors; nationwide advertising; direct factory marketing of branded products to retailers; and increasing federal and state regulation of business practices.[19]

Magazines like the *Post* were not the only means by which the advertising messages of the consumer society were disseminated. Another new institution based on mass production and the purchasing power of the American middle-class woman was the department store, first developed in Paris in the 1850s by Aristide Boucicaut with his Bon Marché store. American versions of these storehouses of consumer commodities soon followed with Macy's, Wana-makers and Marshal Fields. They transformed the shopping habits of the American middle-class woman as profoundly as the coming of the shopping mall. Woolworths catered for the lower end of the market. Stores with their palatial interior design also played a part in reshaping the look and function of the central business districts of such cities as New York, Boston and Philadelphia. In the late nineteenth century the city centre with its towering skyscrapers, served by new electric city transport systems, became the symbol of American modernity. Within this context the downtown department store with its well-lit and airy spaces, restaurants and rest rooms, became a female equivalent of the men's club. Women could meet there without any obligation to buy. Department store owners saw the affluent middle-class woman as their main market and created their corporate identity in the exclusive image of the native-born white middle-class woman which meant that they refused to hire foreign-born or African-American women as sales staff.[20]

The development of nation-wide patterns of consumption and taste within the main social and economic unit upon whose purchasing power an industrial consumer society depended, namely the affluent middle-class nuclear family, was the basis of the market for both the *Post* and the first department stores like Macy's. In the case of the *Post* this economic system of consumer consensus was complemented by a similar aspiration towards a shared ideological world view, mediated through the editorials and articles on business and public affairs that, along with fiction and advertising copy, constituted the contents of the *Post*.

In the eyes of George Lorimer, who was the *Post*'s editor from 1899 until 1936, the core of the *Post*'s market was the young, upwardly mobile white Anglo-Saxon Protestant businessman and his family. In articles and fiction the *Post* encouraged the idea of the businessman as the model American. One of the ways Lorimer constructed an ideological model for his readership was

through a celebration of Benjamin Franklin as a type of national character that was not subject to the vagaries of fashion or revision (fig. 8.2). The first

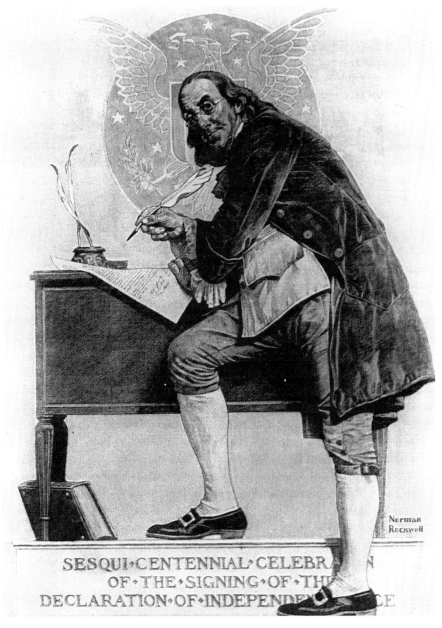

8.2 Norman Rockwell, *Franklin's sesquicentennial*, original oil painting for cover of *Saturday Evening Post*, 29 May 1926

step was the appropriation of Franklin as the founder of the *Post*. The 22 January 1898 issue of the *Post* cited its founding date as 1821. The next issue announced that the *Post* had been 'founded A.D. 1728 by Benj. Franklin'. Franklin had founded the *Pennsylvania Gazette* with Samuel Keimer in 1728 but there was no real continuity with the *Post*. However, Franklin did have the correct mix of self-interest, opportunism, and thrift to serve as the *Post's* model American man of business. In his self-reliant rise to political and economic success that is the main theme of Franklin's *Autobiography*, he achieves wealth and status by pursuing his economic self-interest. This involves the breaking of the contract of apprenticeship he had entered into at the age of twelve with his half-brother, the printer James Franklin. Ben then moved to Philadelphia as a free agent where he made a fortune out of the printing and publishing trade. Franklin's life was also exemplary for the part he had played in ridding America of the hereditary restraints on trade and political freedom imposed by what the American colonists saw as the despotic rule and feudal economic controls of George III. The use of the historical figure of Franklin as a role model was also based on his period as the Congress's representative in France where he was an astute guardian of America's foreign policy interests. Although one is dealing with myths of national hero types rather than realities, Franklin's famous practicality and pragmatism is often a euphemistic cover for Machiavellianism. Indeed when one adds to the Franklin myth his mythic, prodigious extra-marital sexual appetites, Franklin becomes a prototypical J. R. Ewing figure rather than a sober honest Quaker statesman and model of deferred gratification. The qualifications for inclusion in the national pantheon of exemplary Americans were fairly broad but it was fundamentally a tradition of virtuous men like 'honest Abe' Lincoln, Henry Ford and Charles Lindbergh whose lives are seen as a narrative in which upright, honest, plaindealing bearers of the Protestant ethic ascend to success through industry and self-reliance. There is another repressed narrative and tradition in which guileful smooth-talking opportunists on the make – the carpet bagger, the Yankee pedler, the sly backwoodsman, the hustler, the religious demagogue and the conman – succeed by exploiting the gullible masses.

Lorimer projected the self-reliant Franklin as the representative American in a number of his editorials, a theme that he continued in a series entitled 'Letters from a self-made merchant to his son' which appeared anonymously in the *Post* from 1901 to 1902. These letters, based on the style and content of Franklin's own 'Poor Richard's almanac' (1732–58) that had offered pragmatic practical and moral advice to eighteenth-century Americans, extolled the values of thrift and moderation to a wayward undergraduate son of the twentieth century. The letters were published as a book that was eventually translated into more languages than any American work since *Uncle Tom's*

cabin. In editorials, interviews, fiction and biographies the *Post* constructed an ideology of an entrepreneurial business culture that would serve America into the twentieth century. This Franklin-like national type of success had another important role as a figure that could transcend and weld together the diverse nationalities, regions and cultures of the United States. Unlike 'highbrow' magazines like *Harpers* and *The Atlantic* that catered for elite minorities, the *Post* sought a national market united not only by similar patterns of consumption but also by a set of consensual beliefs. The *Post* in this era before radio and television was instrumental in identifying and mediating a set of attitudes and beliefs that aimed to unite an American society in the image of a Wasp middle class. By the 1920s under Lorimer's editorial control the *Post* had developed a linked set of attitudes to domestic and foreign policy issues.

A version of this set of attitudes can be seen in an editorial Lorimer wrote for the 22 May 1920 edition of the *Post*:

> We have really been living in a semi-socialist state, and it has half-ruined us. To finish the job we have only to perfect our socialistic system of confiscatory taxation; to further increase our governmental activities in restraint of trade and liberty, so that nobody can do anything without a license and a passport; to continue our policy of regarding destructive alien reds as wronged innocents, and constructive American businessmen as suspicious characters . . . If the United States is going to remain a going concern, it must discard this soft, lie-abed, sugar-teat socialism, this asking-papa-for-anything-you-want theory of life, and begin to practice self-denial and self-help.[21]

In the *Post*'s world view the virtues of the Protesant ethic provided a model of social and economic behaviour against which the ills of America could be measured. According to this view the American republic was threatened by a series of enemies such as socialists, Bolsheviks and a variety of subversives. The fear of alien outsiders and un-American collectivist beliefs came together in Lorimer's mind over the issue of immigration control. In a series Lorimer commissioned from William Roberts that began with a lead article entitled 'The rising Irish tide' of 14 February 1920, the *Post* campaigned for new immigration controls. The article raises the spectre of a mass invasion of illiterate Roman Catholic Irish peasants who would destroy America's Protestant foundations. The *Post* mounted a campaign to control immigration and discredit the pernicious liberal image of America as a haven for refugees. Lorimer in particular attacked 'the rose-colored myth of the all-powerful melting pot' in which the mixing of different races was seen as a positive process.[22] Having raised a generalised fear of alien outsiders, Lorimer in the 21 May 1921 issue of the *Post* directed his readers to the ideas of racial degeneration that had been developed in two books, *The passing of the great race* by Madison Grant (1916) and *The rising tide of color* by Lothrop Stoddard (1920). The books predicted the

defeat of the white race by non-white people, which would be followed by a descent into savagery. F. Scott Fitzgerald made these anxieties part of his portrait of Tom Buchanan in his 1926 novel *The great Gatsby*. Tom Buchanan, who represents the voice of a troubled Wasp America, has read this pseudo-scientific racist literature in a book by a writer called Goddard whose name recalls that of Stoddard. Tom Buchanan comments as follows: 'Civilisation is going to pieces . . . I've gotten to be a terrible pessimist about things. Have you read *The Rise of the Colored Empires* by this man Goddard . . . It's up to us, who are the dominant race, to watch out or these other races will have control of things.'[23]

Lorimer made the *Post* a vehicle for fears that the stability of America was being threatened by an ever-increasing number of immigrants who were, in his view, importing un-American ideas such as socialism, Bolshevism, labour unions, and class conflict. The *Post* continued to raise the spectre of racial degeneration as part of a generalised fear of alien outsiders with such pseudo-scientific articles as the series on 'races' that Lorimer commissioned in 1924 from Stoddard. In the illustrated article Stoddard explicated the strengths and weaknesses of the several European races, complete with a map of the 'Present distribution of European races', supplied by Madison Grant. The argument within the article was supported by photographs of Nordic, Alpine and Mediterranean types. The series concluded with a fear that the supremacy of the Nordic types was being eroded to the detriment of western civilisation. This kind of pseudo-scientific theorising and appeals to nativist resentments and red scares were part of the successful campaign that led to the enactment of the controls of the 1924 Immigration Acts.[24]

By the end of the 1920s the *Post* had reached a circulation of 2,865,999 and a readership of three times that number. It had also carved out a recognisable ideological message. The *Post* and its readers voted Republican, feared a rising tide of foreign-born immigrants and disliked government interference and regulation in the nation's life. This largely negative combination of prejudices and anxieties proved an attractive mix for the American middle class, and was an important factor in the success of the *Post*. Rockwell's cover images were part of this ideology.

The evolution of the *Post* into a major mass circulation magazine also saw the evolution of Rockwell into arguably America's best-known artist. Many years later Senator Edward Kennedy described Rockwell's contribution to American culture as follows:

> I have had the pleasure of meeting Norman Rockwell personally and of observing for myself that the warmth and sensitivity that emanates from the art of Norman Rockwell emanates from the great man himself. Norman Rockwell has enriched our national heritage by using his enormous artistic talent to preserve, for generations to come, meaningful moments in our life and in our time.[25]

The promotion of Rockwell as a major recorder of American's 'national heritage' has proceeded apace. The publication of *Norman Rockwell: a definitive catalogue* in two volumes in 1986 was an important step in the public relations exercise to establish a new museum for Rockwell. The discreet grey buckram binding and casing of the two-volume catalogue, which contains nearly four thousand entries, are those of the archival tool rather than the glossy allure of the *cappuccino* table book. The successful raising of some $5 million as an initial foundation for the new Rockwell museum in Stockbridge, Massachusetts, which opened on 13 June 1993, clearly benefited from the patronage of President Reagan. The President, according to a feature in *Time* of 20 January 1986 by Hugh Sidey:

> broke his White House rule and agreed to serve as honorary chairman of a $5 million fund drive for a new Rockwell museum being built just outside the artist's beloved Stockbridge Mass. This was too close to Reagan's heart. White House Counsel Fred Fielding said he would take the heat for turning down the request which came from Massachusetts Congressman Silvio Conte. But Reagan insisted: 'I want to do it. Norman Rockwell was wonderful.'[26]

It is not only politicians who are attracted to Rockwell. The best-selling novelist John Updike, chronicler of American suburban life and culture, and sometime student at the Ruskin School of Fine Art in Oxford, gave the following account of the pleasure he has derived from a poster-size reproduction of a 1950 *Post* cover by Rockwell, entitled 'Shuffleton's Barber Shop'. Updike tells us that the reproduction is 'hung over the water closet of my office toilet, where I cannot help but look at it several times a day. After perhaps 5,000 such absent-minded examinations, I am still finding new things to see in it.' Updike's appreciation, which appeared in the December 1990 edition of *Art and Antiques*, goes on to celebrate what he calls Rockwell's 'avid particularism' and concludes with this assessment of Rockwell's final period:

> As small-town America and its family magazines faded around him, his painterly excess became more apprehensive and lavish – a preservative varnish, a nostalgic greed, a self-satisfying perfectionism, an art for art's sake. Widely loved like no other painter in America, yet despised in high-art circles, he pushed on, into canvases that almost transcend their folksy, crowd-pleasing subjects.[27]

Rockwell's inauguration as an 'American old master' with a museum devoted exclusively to his work is an appropriate time for an analysis of Rockwell's iconography, style and subject matter. The mythology surrounding Rockwell's relationship to the success of the *Post* is described as follows in the introduction to the *Catalogue raisonnée*:

To many people *The Saturday Evening Post* and Norman Rockwell are syn-onymous. Without one another, it is doubtful either would know the lasting fame and popularity each has achieved. The notion that NR painted every weekly *Post* cover from his debut issue in 1916 to his last cover in 1963 is a not uncommon misconception. Were this true, his total collection of *Post* covers would approach twenty-five hundred, compared with his actual tally of three-hundred twenty-one covers. This averages out to seven and one half covers per year spread over a forty-seven year tenure with the *Post*. At less than one per month, this ratio has been powerful enough to dull the names and memories of the artists of the over two-thousand remaining covers published during the *Post*'s last half century.[28]

Rockwell had always wanted to do covers for the *Post*, which he considered the best showcase for a commercial illustrator. In the first sketches for the *Post* that he took to his fellow illustrator and friend Clyde Forsythe who had already worked for the paper, Rockwell attempted to reproduce the image of beautiful women and handsome men that Henry Hutt and Harrison Fisher had developed into a *Post* house style. Rockwell described these first sketches as follows:

> I had had my ideas ready for a long time; all I'd needed was the push that Clyde gave me. I set to work the next morning on a painting of a handsome Gibson man in evening dress leaning over the back of a sofa to kiss a gorgeous Gibson Girl in evening dress seated on the sofa. High Society, just the short of thing the *Post* was using at that time. The next day I left that painting to start another: a beautiful ballerina curtsying before a great curtain in the glare of a spotlight.[29]

The Gibson look was named after the artist-illustrator Charles Gibson, who had created an image of women as smiling, compliant beauties with long black skirts, a narrow waist, broad hips, tight white blouses that emphasised full breasts, long hair piled upon the head, and high brows. Forsythe took one look at Rockwell's attempts, and promptly advised him to stick to the subject-matter that he had already developed in his illustrations for childrens' magazines like *The American Boy*; the pursuits and activities of young teenagers. The following analysis of Rockwell's *Post* covers is based on the 122 covers from his very first of 20 May 1916 through to that of 7 December 1929. This length of run is extended enough to make a deconstruction of the imagery and ideology of a major commercial artist who provided narratives of American aspirations for a magazine its editor George Lorimor described as 'the greatest weekly maga-zine in the world'. This run of Rockwell covers is analysed according to the part they played in the emergence by the 1920s of the *Post* as, according to Lorimer, 'the greatest weekly magazine in the world'. Rockwell continued to produce covers for the *Post* until 1963, making a grand total of 321. Jan Cohn character-ises the era of the *Post*'s greatest success in the 1920s as follows:

Certainly the 1920s were the great heyday of the *Post*; circulation, advertising, profits – all rose like the stock market. The magazine itself seems to stand as a material representative of that buoyant time, with its Rockwell and Leyendecker covers, in its F. Scott Fitzgerald stories and Charlie Chan serials, and articles that appeared to cover all of the prosperous and frivolous American scene.[30]

The very first cover Rockwell did for the *Post* in 1916 entitled *Boy with baby carriage* (fig. 8.3) shows a grim-faced young teenager in a business suit and hat pushing a baby in a wicker pram to the obvious ridicule of two other boys who are off to play baseball. A baby's milk bottle protrudes from the top pocket of the boy in the suit. In style and content this is a representative example of Rockwell's covers and places him squarely in a nineteenth-century narrative genre tradition, established in America by painters like William Sidney Mount with such works of his as *Rustic dance after a sleighride* (1830), and Winslow Homer and his well-known picture of boys at play in a country landscape entitled *Snap the whip* (1872). Mount's genre works in particular were widely circulated as lithographs in Europe and America. Where Mount and Homer record the commonplace rituals of nineteenth-century rural America, Rockwell's covers for the *Post* that had consolidated its form and content by the 1920s focused on the culture of small-town America and of the suburbs, ideas of community that stood midway between rural and urban society.

Rockwell's definition of his aims and description of the categories that structured his work reflect his debt to the narrative realism of nineteenth-century genre painting:

> My life work – and my pleasure – is to tell stories to other people through pictures. *The Last Supper* is the most painted dramatic story-picture ever painted . . . People seem to be just six ages in story-telling pictures. They are babies, children, adolescents, lovers, middle-aged people or old people . . . A baby or child with an old person has many human interest possibilities and people love such pictures. They love children and they love old people who can understand and play with children.[31]

The quality of 'avid particularism' that Updike sees in Rockwell, his search to perfect a documentary verisimilitude in the spirit of nineteenth-century genre realists, influenced his mode of composition. Firstly he made a loose sketch of the idea, secondly he gathered models, costumes and background props (Rockwell eventually had a virtual museum of costumes and props), thirdly he made individual drawings of separate parts (after about 1937 he used photographs), fourthly he made a full-scale drawing in great detail, fifthly he made colour sketches, and the sixth step was to put all the parts together in a final oil painting. He often used the same model again and again. For example, he used a boy named Billy Paine as the model for all three boys in his first *Post* cover.

8.3 *Saturday Evening Post*, cover by Norman Rockwell, 20 May 1916

The covers that he produced for the *Post* between 1916 and 1929 can be divided into the following categories by subject-matter: teenagers of various ages on their own 50 per cent; teenagers with old people 25 per cent; old people on their own 20 per cent; miscellaneous (festive occasions such as Christmas)

5 per cent. The old people are usually grandfather figures, often named 'gramps'.

Rockwell's largest category, of young teenagers socialising with their peer group, is a sign of the growing autonomy of this new culture of youth and of an important change in the ways American society sought to manage the education and behaviour of young teenagers. The key institution for this new and powerful group identity was the high school.

By 1930 the high school had replaced the family as the main agency of education and socialisation for American youth. Prior to the twentieth century, high-school enrolment was limited to a small elite portion of the American population. In the first quarter of the twentieth century high schools and the newly-formed junior high schools became institutions for the mass of the youth population as the age limit for compulsory school attendance was extended to older and older ages. Child Labor Laws against the practice of employing children as cheap labour moved children out of the factory and into the school. In 1900 there were 6,005 public high schools with 519,251 students. By 1930 there were 23,930 with an enrolment of 4,399,422. By the early 1930s, 60 per cent of America's youths of high school age were in school.

Among the consequences of this opening-up of the schools were: the removal of youth from the world of the adult labour force; a massive increase in the role and influence of the adolescent peer groups; and a further challenge to the influence of the family. Parents and educators were thus faced with new problems of social control. By the 1920s middle-class high school students increasingly moved in a culture of their own that had quickly absorbed such features of the new mass consumer culture as movies and the automobile. One sample of Californian high school boys in 1925 found that more than 40 per cent of the boys had the use of the family car whenever they wished and almost one quarter owned their own car. Traditional forms of socialisation and moral education such as the church and the patriarchal family were now challenged by a self-contained, high-school-based teenage culture of movies, dating, riding in cars and parties, much of it based on an ad hoc co-educational socialising. The power of this high-school-based pursuit of leisure was recognised by the fact that many states felt the need to prohibit the formation of high school fraternities and sororities. Like the legislation prohibiting the sale and consumption of alcohol, this probably had the effect of increasing the power of such student organisations which became powerful underground secret societies.

Rockwell's covers for the *Post* in the period under review, 1916–29, were largely based on the activities of a teenage peer group, mainly boys on their own, or significantly with grandparent figures rather than with parents. Prior

to working for the *Post* Rockwell had specialised in illustrations depicting the world of teenage play for publications like *Boy's Life*, *St Nicholas*, *Youth's Companion* and *The American Boy* which were aimed at this new market of the young teenager.

Rockwell's cover for the *Post* of 16 June 1917 entitled *Measuring height* (fig. 8.4), depicting a boy scout measuring another boy who falls short of the required height of 5 feet, while acknowledging the arrival of a self-contained teenage culture also shows how an adult world of national responsibilities insinuates its values into this teenage boy scout world. The immediate historical context for the cover was the declaration of war by the USA against Germany on 6 April 1917. Up to this time the *Post* had consistently argued against America entering a European conflict and had supported Woodrow Wilson's policy of neutrality. Lorimer's views on the war during this period can be gauged from a letter he wrote to Senator Beveridge: 'In the event of war with Germany, I am preparing to enlist as Major-General of the artillery. I understand that the big guns are placed about twelve miles in the rear of the firing line, and that the Major-General stands twelve miles behind the big guns.'[32]

Once war had been declared the *Post*'s coverage changed to attacks not only on the 'fanatical, tyranical, power-mad, blood-and-iron Prussianized Germany of Bismarck' but also on the enemy within: 'professional pacifists . . . little brothers to the worm and the sheep and the guinea pig'.[33] *Measuring height* clearly distances itself from the rhetoric of government recruitment campaigns and posters which favoured the 'Your country needs you' type of poster in which an accusing, threatening finger is pointed at the civilian public. At the centre of Rockwell's image is the idea of 'joining up', that symbolic moment when individual rights are given up in favour of a group loyalty. Rockwell has chosen to depict this process in terms of a young boy being measured to see if he meets the requirements of admission to the boy scouts. It looks as if the would-be recruit will fail because he is not tall enough. The image dramatises a moment of uncompleted initiation into the paramilitary boy scouts whose values are prototypical of the responsibilities that will be imposed on the individual by an adult world in which soldiers are killed.

Rockwell's depiction of teenagers as members of a discrete youth culture bears witness to the change within the middle class from a belief that maintained that children were little men and women who just grew taller to a new culture in which there was an extended period of evolutionary growth from childhood through adolescence. This idea, which had developed within the culture of the nineteenth-century bourgeoisie, viewed childhood and adolescence as times when the individual child should be encouraged to explore and develop its own identity. The young child came to be regarded as a person with

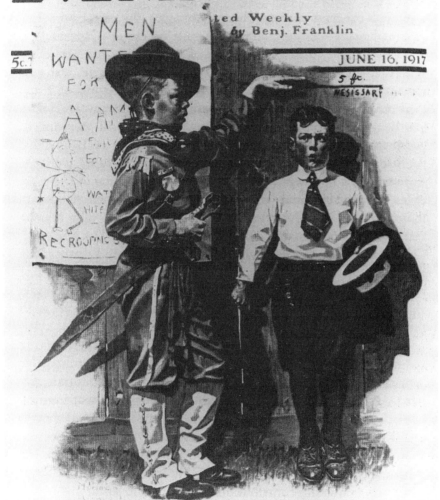

THE SATURDAY EVENING POST

MEN
WANT...
FOR
A AM...

RECRUITING

...ted Weekly
by Benj. Franklin

JUNE 16, 1917

5¢
NESISSARY

5c.

In This Number: Carl W. Ackerman — Maximilian Foster — Will Irwin — Basil King
Charles E. Van Loan — Elizabeth Jordan — Nalbro Bartley — Eleanor Franklin Egan

8.4 *Saturday Evening Post*, cover by Norman Rockwell, 16 June 1917

distinctive attributes – impressionability, vulnerability, innocence – which
required a warm, protected and prolonged period of nurture. Whereas
formerly children had mixed freely in adult society, parents now sought to

segregate them from premature contact with servants and other potentially harmful adult influences. Liberal educators and moralists began to stress the child's need for play, for love and understanding, and for the gradual, gentle unfolding of his or her nature in line with the liberal romantic view of the child. Rockwell's young teenagers are the product of this liberal, child-centred culture.

This new idea of the nature of childhood also reinforced the bourgeois idealisation of family life in which the home became a refuge from a brutal outside world of industrial capitalism, a haven in a heartless world. This liberal ideology was resisted by the development in the period between 1890 and 1920 of a number of paramilitary organisations like the boy scouts and other voluntary organisations such as the YMCA which saw boys as miniature warriors, needing to be trained by military discipline and a Spartan ideal of muscular Christianity to mould and protect their maleness. The YWCA also provided a range of community service activities and safe housing for young women.

Rockwell's 1917 cover *Measuring height* belongs to this period when the whole question of the rights of children is being negotiated. The date of the cover is only a few years after the Boy Scouts of America had been formed in Febuary 1910 with the aid of William D. Boyce, a Chicago publisher. The US Congress gave the organisation a charter in 1916. How then are we to read this image? First of all the boys are playing a game called 'soldiers'. The sense in which it is a game is conveyed by the misspelling; army is *aarmy*, recruiting is *recrooting*, necessary is *nesissary*. The uniformed boy scout is seen as a scout rather than a soldier. Rockwell is referring us here to the iconographical tradition of the trapper from James Fenimore Cooper's novels, the figure who stands between wilderness and civilisation, linking the two. The ideology of the boy scout movement included a conservationist dimension, a Wordsworthian belief in the importance of contact with nature. The boy scout curriculum was strongly in favour of what was known as wood craft, the training of the boy scout in such skills as the ability to follow a trail, read a map, trap game, imitate animals, pitch camp, play the harmonica and sing songs round a campfire. The endless drilling and shouting of a professional army was kept to a minimum and replaced by ideals of service to the community. This formula attracted large numbers of American boys with its frontier mythology. Rockwell's figure of the boy scout with his flowing kerchief and rakish hat is a study in the picturesque, that visual space which civilisation has not penetrated, an area of undomesticated male freedom where all the Natty Bumpos gather. The boy scout's less than fitting uniform recalls Natty Bumpo's fringed leather skin costume and shaggy Gothic outline. He is a reluctant soldier often at odds not only with the discipline codes of a

professional army but also with the whole idea of urban bureaucratic civilisa-tion. The trapper also trusts his instincts rather than the rational codes and protocols that govern the military mind. Rockwell supported and helped to popularise the boy scout movement throughout his life. The main attraction of the boy scouts for Rockwell was that a voluntary association like the scouts helped to bond America's youth together and condition them to 'be prepared', if required, to make the transition from boy scout to soldier, willing to kill or die for the country.

Another Rockwell cover for the *Post* which constructs a similar narrative, in which a teenager is being initiated into an adult world of duties and responsibilities that curbs the freedom of the individual, is the cover of 20 May 1916 already mentioned, entitled *Boy with baby carriage* (fig. 8.3). Rockwell described the action in this cover as: 'Two boys in baseball uniforms scoffing at another boy who was dressed in his Sunday suit and pushing a baby car-riage'. The grim-faced boy is a reluctant manikin in an adult's uniform of a three-piece business suit complete with hat and buttonhole. He is clearly embarrassed to be seen performing a child-care role normally carried out by a female adult. The sense of being caught up inappropriately and prematurely in the cares and culture of an adult world is heightened by two other boys who raise their baseball caps in mock salutation as they pass by on their way to enjoy themselves playing baseball, the American national game for young males. The boy pushing the pram will have to transgress the gender line even further by feeding the baby its milk from the bottle that protrudes from the boy's top pocket.

The response of the viewer to this image depends on an explicit culturally determined contrast between the free and the unfree, between a world of child-care and parental responsibility involving a considerable loss of indi-vidual freedom normally only demanded of women, and a world of sport in which boys could develop a traditional type of warrior maleness, modified by codes of gentlemanly fair play, through the pursuit of athleticism and indi-vidual excellence, all conducted within a general framework of co-operative team-building. Organised team sports such as baseball were, like the boy scouts, introduced into the culture of young teenagers and supervised by adults in order to produce muscular Christians with a strong sense of com-munity values. Baseball and the baseball mitt in Rockwell's iconography denote childhood freedom, away from adult supervision and cares (the figures of grandfathers who often accompany the boys playing baseball are clearly in their 'second childhoods').

A distinctive element within the increasingly autonomous culture of American youth were the courtship rituals of teenagers which are a favourite subject for Rockwell. As well as romantic scenes of teenagers in the throes of

puppy love reading books together or pulling a Christmas cracker, Rockwell also documents some of the contradictions inherent within the bourgeois invention of this long period of extended adolescence, education and freedom from the world of work that by the 1920s in the middle class lasted from high school to college.

One activity that expanded into a major activity was dating the opposite sex. In a cover of 1917 entitled *Two men courting girl's favor* (fig. 8.5), the teenager holding his dance card at one end of the sofa is attempting to claim his pre-arranged dance with the girl in the middle. She is clearly more interested in the worldly young male, elegantly and confidently perched at the other end. The boy with the card is wearing the formal attire of the young middle-class American boy, knickerbockers and a wide Eton collar. He is clearly no match for the sophistication of the modern young man in white-tie evening-dress with his hair fashionably 'slicked' down. The girl is wearing the modern shift dress that was an intermediate stage in the evolution away from the elaborate petticoats, bustles and hourglass shape of the nineteenth-century and towards the flapper of the 1920s who flattened her chest, dieted away her hips, raised her hemline and bobbed her hair. In the contest for the attention of the young woman, the boy at the knickerbocker end of the scale was clearly no match for the sophisticated college man whose angularity anticipates the streamlined aesthetic of such fashions of the 1920s as Art Deco. The young woman, particularly in the way her waist line is moving down to her hips, and the emphasis that is being directed on to the long line and graceful contours of her arms and legs, is clearly on her way to a fully-fledged flapper. This modernist emphasis on an unencumbered sweeping contour downgraded an interest in details in favour of curvilinearity. Despite research visits to Paris in the 1920s in pursuit of the avant-garde, Rockwell chose to paint in the style and conventions of picturesque realism.

Rockwell, unlike the modernists, liked to call attention to virtuoso details and flourishes such as the quill pen with which Benjamin Franklin signs the declaration of American Independence in the *Post* cover of 29 May 1926 (fig. 8.2), marking the sesquicentennial celebrations of the signing. The version of the picturesque aesthetic with which Rockwell frames his human figures is derived from a style that was historically used to evoke a particular perception of nature in which the human figure was usually a marginal decorative smudge within a gaze that was focused on effects of erosion in the landscape. Man-made monuments such as cottages, haywains and milestones, and natural objects such as ancient trees, meandering paths and streams, are all weathered into a single mood which is tranquil, reflective and leisurely. Roland Barthes's essay on the picturesque in the tourist guides known as *The blue guide* argues that the commentary in the guide suggesting which places

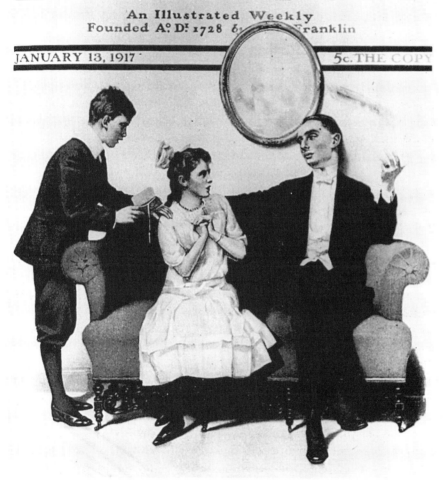

*THE SATURDAY
EVENING POST*

An Illustrated Weekly
Founded A° D! 1728 by ... Franklin

JANUARY 13, 1917 5c. THE COPY

8.5 *Saturday Evening Post*, cover by Norman Rockwell, 13 January 1917

to visit 'hardly knows the existence of scenery except under the guise of the picturesque. The picturesque is found any time the ground is uneven.' The picturesque, Barthes argues, is another example of 'this disease of thinking in essences which is at the bottom of every bourgeois mythology'.[34] Rockwell constructs his picturesque vision out of children whose laces are undone, with

unkempt hair, well-worn patched trousers, and dogs with shaggy coats. He combines the realism of genre painting with the picturesque and fashions an alternative to the new metropolitan fashion of the streamlined early twentieth-century modernist aesthetic that aspired to smooth out nature's bumps, not to highlight them. This new style was known as Art Deco Moderne, whose advocates saw themselves as the exponents of modern design and illustration. They wanted a style without historical precedent. However, they were confronted by a contradiction in the taste of their main market, the middle classes whose houses, furniture, gadgets, clothes, etc. constituted the raw material for the designer. The correct modern image, of the ideal home were the new suburban family homes that Le Corbusier called 'machines for living'. In plan the new house of the 1920s organised its internal horizontal and vertical communication around a tight core for service areas and stairwells, with axial passageways for internal and external traffic flow. In this mode of convenience-living the garage interlocked with the main body of the living area to house the two automobiles that were essential to modern living. However, when it came to surface decoration, consumers often desired a historical rather than a contemporary look for furniture, curtains, etc. The range of 'looks' that were on mass production offer at the beginning of the twentieth-century included American Colonial, Federal, English Tudor, French Norman, Mediterranean (Italian), and Spanish or Mission (so called after the Spanish Mission buildings of New Mexico and California). There were subdivisions within these broad categories such as Cape Cod, Dutch Colonial, and Chippendale. The contradiction can be clearly seen in an advert in *Country House* that announced its 'new Edison, the phonograph with a soul'. The machine was to be housed in handcrafted historic cabinets. The ad copy noted further that 'The new Edison instruments are equipped with electrical motors, electrical automatic stops, and complete electrical lighting systems, thus combining the historic design of the cabinets themselves with the most modern and convenient equipment'.[35] All these pastiche 'looks' gave the American bourgeoisie a sense of being connected to an historical idea of the past. The logo of the *Post*'s front title, with its suggestion of the antique, made the magazine a fit object to sit on a Colonial or Federal table alongside *Country Life*. Rockwell's *Post* covers often directly evoked a picturesque period in America's past. In the same way that eighteenth-century aestheticians of the picturesque preferred the mazy convoluted design of gnarled trees and the irregular shape and outline of a donkey's features to the sublime columns of Greek architecture, Rockwell's preference is for casually dressed Tom Sawyers with patches on their clothes and chewing on straws. The designer modernism of such icons of the streamlined Art Deco Moderne style as the liberated flapper of the 1920s are not part of Rockwell's iconography.

Rockwell's covers for the *Post* in the period under review are a version of that fantasy world which is such a powerful element in American commercial popular culture. It is a world that, like Disney's full-length animations such as *Bambi*, can bring together a mass audience of children and adults. In this vision social relationships or ideas of conflict are avoided in favour of a magical Disneyland of children, nature, and animals. Rockwellworld is constructed with the same verisimilitude as Disneyworld to create an audio-animatronic, life-size model of Abraham Lincoln giving his Gettysburg Address. The repressive nature of this fantasy world is examined by Ariel Dorfman and Armand Mittelart in their study of the impact of Disney comic books on Latin America. They find that half the stories occur in extraterrestrial places, the other half in foreign lands where the people are generally primitive. They are all non-white. Only men are shown, and they are predominantly enormous and muscular, except when they are pygmies. 'They are like children. They don't need to produce to live. They are model consumers.'[36]

The image of America that Rockwell constructed for the *Post* has many of the characteristics that appear in Disney's anthropomorphic vision of an America of children and middle-class animals. Rockwell expressed his own version of this fantasy world in his following manifesto-like statement:

> Maybe as I grew up and found that the world wasn't the perfectly pleasant place I had thought it to be, I unconsciously decided that, even if it wasn't an ideal world, it should be and so painted only the ideal aspects of it – pictures in which there were no drunken slatterns of self-centered mothers, in which, on the contrary, there were only Foxy Grandpas who played baseball with the kids and boys fished from logs and got up circuses in the backyard. If there was sadness in this created world of mine, it was a pleasant sadness. If there were problems, they were humorous problems. The people in my pictures aren't mentally ill or deformed. The situations they get into are commonplace, everyday situations, not the agonizing crises of life.[37]

Rockwell's 122 covers for the post in the period 1916 to 1929 depict a Wasp world of benign grandparents and cheerful teenagers. His image of the America that lay beyond the secure cultural homogeneity of suburb and small town, is of a frightening nightmare world peopled by 'drunken slatterns of self-centered mothers' and 'the mentally ill or deformed'. Rockwell associated this 'other' America with the ethnic ghettos of the city whose degraded social conditions he had seen in such illustrated publications as *How the other half lives* by Jacob Riis (1890). An ardent social reformer, Riis had lived in and photographed the squalor of the lower East Side of New York where incoming immigrants – the Irish followed by Germans, Chinese, Jews and Italians – were crowded into slum tenements. The original photographs taken by Riis were not reproduced in the 1890 version of *How the other half lives* owing to

the fact that printers had not yet perfected the halftone process of reproducing photographs. As a result the illustrations that accompanied the prose commentary by Riis were not photographs but line illustrations based on the photographs. The original photographs conveyed more documentary detail than the stylised drawings which exaggerate a caricatured sense of national and racial stereotyping.

This reliance on national stereotyping and a belief in the supremacy of white Protestant Christian culture were marked features of the prose commentary by Riis in *How the other half lives*. This, for example, is Riis's dismissal of Chinese culture: 'Ages of senseless idolatry, a mere grub-worship, have left him without the essential qualities for appreciating the gentle teachings of a faith whose motive and unselfish spirit are alike beyond his grasp.'[38]

The immigrants in Riis are threatening and criminal. Riis's message is that if they aren't controlled and reformed, they will become a permanent underclass threatening the security of Wasp America. There is the sense of a recoil from the alien 'otherness' of the non-Wasp immigrant in both Riis and Rockwell, a fear of America being subverted by un-American outsiders. The social vision and iconography within Rockwell's covers for the *Post* in the period from 1916 to 1929 were part of a successful marketing and editorial campaign to make the *Post* a major vehicle for the transmission of an ethnocentric vision of America, created in the image of a Wasp middle class. His later work included some images that acknowledged that there were conflicts in American society, such as his sympathetic portrayal of the struggles of the Civil Rights Movement in his 14 January 1964 cover for *Look* magazine, entitled *The problem we all live with*. It depicts a young African-American girl being escorted into high school by four civilian US marshals who are protecting her right to have as good an education as her fellow white Americans. However, the rhetoric of the fundraising drive to establish a Rockwell museum has led to a presentation of Rockwell's images as conflict-free commodities, investments in a national heritage. A fundraising leaflet of 1991 for the Rockwell Museum entitled *Corporate membership program: an investment in America's heritage* makes the following pitch for Rockwellworld;

> When you become a business friend of the Norman Rockwell Museum . . . You help preserve a tradition of excellence and American values captured by Rockwell for nearly a century . . . You inherit a competitive edge by your association with an American Legend . . . You gain visibility which enhances your corporate image by linking it with a national treasure . . . You continue the partnership started by Rockwell early this century.

The image on the leaflet's front cover is taken from a painting entitled *A scout is loyal* which Rockwell did for the 1930 Boy Scouts of America Calendar.

It depicts a boy scout standing in front of George Washington who holds the Bill of Rights. Behind Washington stands the gaunt stooped figure of Abraham Lincoln. This iconography of the American past is completed by an American eagle in flight and an American flag. The leaflet continues to celebrate an American nation based on images of great Wasp heros with further Rockwell images such as his 6 March 1943 *Saturday Evening Post* cover entitled *Freedom from want* in which a Wasp family prepares to celebrate Thanksgiving. The painting captures the moment of the arrival of an enormous turkey which Grandma is about to lower on to the table, around which a three-generation extended family is gathered. A smiling patriarchal Rockwell grandfather presides over this scene of American abundance. The message of this image is spelled out by the following accompanying prose commentary: 'Norman Rockwell's themes are rooted deeply in American values and our pride in those values . . . a pride Rockwell shared. The American family was the core of his work, and his view of family life remains compelling to us, even today.'

The last phrase, with its suggestion of an earlier era of familial stability that has disappeared from the contemporary world but which can nevertheless be revived, was an essential theme in the Reagan administration's vision of America. Reagan and his allies of the New Right saw the society they had inherited from the Carter administration as a failed liberal experiment. The Republican Party asked for a born-again crusade against a general moral decline. It was in this atmosphere that ideas of salvation and crusade were inserted into the discussion of domestic and foreign policy. In reality, this led to an attack on what was considered to be the welfare dependency of the poor who were exhorted to rise up and achieve affluence by the practice of self-reliance, frugality and hard work. A similar narrative shaped Reagan's foreign policy in which a courageous Christian nation battled on a global scale with a godless Russian 'evil empire'. This was the time when the President often likened himself to Rambo and promised to ensure American victory over the Russians by the laser-gun technology of 'Star wars'. The reshaping of an heroic America by the Reagan administration and its New Right allies after what was continually stressed as the humiliation of the Carter years was often based on a promise to restore an idealised past when authority was securely vested in white, male, middle-class America. The association between Rockwell's vision of America and Reagan's became official when the President broke his own house rule that prohibited the White House from forging any formal presidential association with voluntary organisations and agreed to serve as honorary chairman of a $5 million fund drive for a new Rockwell museum. This quasi-official federal patronage was duplicated at the state level. In the credits section of the leaflet is an acknowledgement that the leaflet was 'funded in part by the Massachusetts

Cultural Council, a state agency'. One wonders whether the non-Wasp citizens of Massachusetts would agree to the use of public money to add yet another shrine to the achievements and power of Wasp America. The presence in the leaflet of Rockwell's multi-racial image of a world of diversity entitled *Golden rule*, over which was printed the biblical homily to 'Do unto others as you would have them do unto you', might suggest that the Rockwell Museum had a commitment to a multi-cultural America. However, if we look carefully at this cover that he did for the 1 April 1961 *Saturday Evening Post*, we will discover that this apparent celebration of facial, racial, and cultural diversity does not include any indigenous examples of American diversity. Diversity is something that exists outside America.

The leaflet has no information about Rockwell's techniques or artistic qualities. He is described as Rockwell the 'Portrayer of the American Way of Life,' a theme which is illustrated by the family celebrating Thanksgiving. In another section he is seen as 'Norman Rockwell – American Historian'. His virtues are entirely based on an interpretation of the social and historical content of his imagery. We are told in the manner of a newsreel that 'Rockwell's illustrations capture the drama and pride of significant events from the early twentieth century right through to the day America puts its first man on the moon'.

In an interview that George Lorimer gave in 1928 to a magazine called *The World's Work*, he described the *Post* as an 'enormous engine of publicity [employed] consistently as a power for good, espousing causes or the public weal'.[39] In Lorimer's case these causes the *Post* espoused included the promotion of ideas of racial purity, and support for immigration controls to protect the supremacy of Wasp America from the invasion of foreign-born Irish Catholics, Chinese and Russian Jews whom Lorimer smeared with charges of fomenting Bolshevik unrest particularly among labour unions. In the same interview, Lorimer also identified the audience that constituted the main supporters of the *Post*'s ethnocentric message. Using a phrase that has become a standard description of the conservative mainstream in American society, Lorimer argued that the *Post* represented the world view of 'the silent majority'. It is thought to be the first use of the term. The 'silent majority' for Lorimer is a shorthand way of describing the conservative majority of the American middle class who in the 1920s voted Republican and believed in the supremacy of a white Anglo-Saxon Protestant America based on the monocultural values of a racially homogenous population. Rockwell's vision of America provides a set of reassuring images of an earlier America in which the American heroes of such national sports as baseball were Wasps, and young Americans were patriotic members of the YMCA and YWCA, or of the boy scouts.

This fantasy land has none of the conflicts and contradictions of the real world. The Rockwellworld museum inaugurated in Stockbridge, Massachusetts on 13 June 1993 exhibits an abundance of benign, white Anglo Saxon Protestant, monocultural images of nation, race, gender, class, family and childhood. It also represses all other traits. In Rockwell's own words his ideal world will not be blighted by the presence of 'drunken slatterns of self-centered mothers' and people who are 'mentally ill or deformed'.

Notes

I would like to thank Martin Pumphrey for sharing his insights into American consumer culture with me, Malcolm Judelson for his exacting proof reading, Tom Putt for his help with economic theory, Bill Stott for his close reading of Rockwell's *Post* covers, and Hazel who showed me how to 'read' women's magazines.

1 Arthur C. Danto, 'Freckles for the ages', *New York Times Book Review*, 12 December 1986, pp. 10–11.

2 Leo Lowenthal, *Literature, popular culture and society*, Pacific Books, Palo Alto, 1968, p. 116.

3 All details on circulation are those established by Jan Cohn in her book *Creating America: George Horace Lorimer and The Saturday Evening Post*, University of Pittsburgh Press, Pittsburgh, 1989, pp. 292, 301. My reading of the ideology of the *Post* is largely based on her findings.

4 Jean White, ed., *The Saturday Evening Post Norman Rockwell book*, Curtis, Indianapolis, 1977, p. 90.

5 Stephen Bayley, *Coke!*, The Conran Foundation, London, 1986, p. 22.

6 Paula Fass, *The damned and the beautiful*, Oxford University Press, New York, 1977, pp. 206–7.

7 Cobbett Steinberg, *Reel facts: the movie book of records*, Vintage, New York, 1987, pp. 47–9.

8 R. Corson, *Fashions in makeup*, Universe Books, New York, 1972, pp. 491–3.

9 Curtis Campaign Materials, Curtis Archives, Indianapolis, 1915.

10 Montgomery Schuyler and Thomas Nolan, FAIA, 'A modern publishing house: the construction and equipment for the New Curtis Publishing Company, Philadelphia, P.A', part 1, *Architectural Record*, 31 March 1912, p. 281.

11 James Playsted Wood, *The Curtis magazines*, New York, 1977, pp. 66–7.

12 Editorial, 'Not for men only', *The Saturday Evening Post*, 20 June 1908.

13 Maude Radford Warren, 'Petticoat professions', *The Saturday Evening Post*, 5 November 1911.

14 C. Naether, *Advertising to women*, Prentice Hall, New York, 1928, p. xiii.

15 Editorial, 'A woman's sphere, *The Saturday Evening Post*, 19 July 1913.

16 R. S. Cowan, 'The industrial revolution in the home', *Technology and Culture*, 17 January 1976, pp. 1–23.

17 E. R. Jones *Those were the good old days: a happy look at American advertising 1880–1930*, Simon & Schuster, New York, 1959, p. 437.

18 Jay Kleinberg, *Women in American society 1820–1920*, British Association for American Studies Pamphlets, 1990, pp. 10–11.

19 Thomas C. Cochran, *200 years of American business*, Basic Books, New York, 1977, p. 114.

20 Susan Porter Benson, *Counter cultures: saleswomen, managers, and customers in American department stores, 1890–1940*, University of Illinois Press, Urbana, 1988.

21 Editorial, 'Fiddling', *The Saturday Evening Post*, 22 May 1920.

22 Editorial, 'The great American myth', *The Saturday Evening Post*, 7 May 1921.

23 F. Scott. Fitzgerald *The great Gatsby*, Penguin, Harmondsworth, 1968, p. 19 (first published in 1926).

24 Lothrop Stoddard, 'Racial realities in Europe', *The Saturday Evening Post*, 22 March 1924.

25 Jean White, ed., *The Saturday Evening Post Norman Rockwell book*, Curtis, Indianapolis, 1977, p. 11.

26 Hugh Sidey, 'Rockwell was wonderful', *Time Magazine*, 20 January 1986, p. 20.

27 John Updike, 'Seeing Norman Rockwell', *The Wilson Quarterly*, spring 1991.

28 From Introduction by David. H. Wood in Laurie Norton Moffat, *Norman Rockwell: a definitive catalogue in two volumes*, University Press of New England, Hanover, 1986.

29 *The Saturday Evening Post Norman Rockwell book*, pp. 3–4.

30 Cohn, *Creating America*, p. 166.

31 Norman Rockwell, *How I make a picture*, Watson Guptil Publications, New York, p. 50.

32 Lorimer to Beveridge, 11 June 1915, Beveridge Papers, Library of Congress, Washington DC.

33 From essay in *Post*, 21 April 1917 by Irwin S. Cobb entitled 'Thrice is he armed'.

34 Roland Barthes, *Mythologies*, Paladin, London, 1973, pp. 74–5.

35 Lisa Phillips, *High styles: twentieth-century American design*, Whitney Museum, New York, 1985, pp. 48–81.

36 Ariel Dorfman and Armand Mittelart, *How to read Donald Duck: imperialist ideology in the Disney comics*, International General Publishers, New York, 1974.

37 Jean White, ed., *The Saturday Evening Post Norman Rockwell book*, Curtis, Indianapolis, 1977, p. 10.

38 Jacob Riis, *How the other half lives*, Dover, New York, p. 77.

39 Walter Tittle, 'The editor of The Saturday Evening Post', *World's Work*, New York, January 1928, p. 307.

III

A proper place
for the modern



CULTURED INTO CRISIS:
THE ARTS COUNCIL OF GREAT BRITAIN

℮

Jonathan Harris



Introduction

IN AUGUST 1976 what was then called the Art Department of the Arts Council of Great Britain organised an exhibition in London concerned with books produced by artists. Amongst those who had been invited to take part was the American feminist artist Suzanne Santoro, whose book *Towards new expression* (1974) dealt with images of women's genitals. Based in Rome from the late 1960s Santoro's work, on the cultural meanings attached to representations of the vagina, had formed part of a longstanding debate within the Italian feminist movement on sexuality and social relations within patriarchal societies. Santoro visited the show at the Institute of Contemporary Arts to discover not only that her book had been left out of the catalogue, but that it was also not on display.

When the British feminist magazine *Spare Rib* asked the Arts Council why the book had been suppressed, even though Santoro had been invited specifically to take part a few months earlier, the organisation responded that it had been omitted 'on the grounds that obscenity might be alleged'. It stated: 'We are willing to defend obscenity on the grounds of artistic excellence but considered that in this case the avowed intention of the book was primarily a plea for sexual self-expression'.[1] Although Santoro's book was omitted from the exhibition and catalogue, the Arts Council decided that Allen Jones's *Projects*, a collection of sketches and ideas for stage, film and television shows, such as *Oh! Calcutta* and Stanley Kubrick's *A clockwork orange* – including images of shiny cat suits, bare buttocks and leatherwear – was, in contrast, legitimate artistic expression.

In considering the history and current purpose of the Arts Council of Great Britain, and in particular its provision for the visual arts, this anecdote raises most of the questions that a critical analysis should address. In an adequate account of the Council it is important (1) to determine *what* functions (both general and specific) the organisation was intended to carry out, (2) to establish *where* the Council should be located in relation to the organisation and function of central and regional government within Great Britain, and (3) to examine *who* made (and now makes) decisions regarding such questions as the definition of legitimate artistic expression. It may be the case that, whatever the *stated* intentions of the Arts Council, the organisation can be seen to have acted in a specific way – in accordance with a set of assumptions and values – that was unrecognised or unadmitted by the members and officers responsible for policy and operational control.

The Santoro case and other accountable instances of the Council's treatment of the work and interests of women artists *may* lead an observer to the conclusion that an unacknowledged prejudice or set of prejudices regarding the status of women *as* artists had influenced the decisions made by those in power, who in most cases can be shown to have been men. More generally, the Arts Council's explicit or assumed definition of culture, along with its sense of cultural value, requires critical interrogation. In relation to 'visual arts' in particular, the Council's historical inclusion and exclusion of certain media and producers within this category can be shown to demonstrate the partiality of its definitions, selections and evaluations.

It is also important to ask how the Arts Council has fared under successive Conservative governments, in office since 1979, which have called – at least in their political rhetoric – for greater efficiency in public spending, for the judicious withdrawal of the state from involvement in non-essential areas of public life, and for individual citizens to take prime responsibility for the quality of their society and culture. On all three counts, the Arts Council was perceived to be a likely target for major reorganisation, reduction and even abolition.

Although the latter issues may seem relatively novel, given the longer history of the Council, it is important to recognise that several features of this recent debate – carried out in governmental, academic and popular arenas (for instance, partially on television and in the press) – actually recapitulate problems of definition of purpose and decision-making which beset the founding of the organisation in 1945 and the history of its operation during the 1950s and 1960s.

In a wider sense, the Arts Council's problems of identity, situation and function may be typical of those encountered by agencies and authorities of central states in contemporary western societies. Two factors are partic-

ularly significant here. Firstly, whatever the claimed independence of the Council, historically it has functioned as part of a *state apparatus*, reliant on the government of the day for funding, selection of senior executive staff and general policy direction. Secondly, although formally responsible for arts development and provision throughout the country, the organisation has always been based in London and drawn on officials and advisers predominantly from the south-east of England. The name itself is extremely confusing as the Arts Council of Great Britain has been responsible only for provision in *England* since 1967. Separate provision exists for Scotland, Wales and Northern Ireland. This account is concerned only with the English situation.

Subject to sharp criticism in recent years over its organisation, location and policy decisions, from both the left and right in Britain, each with their own agendas for reform or transformation *and* from artists who see themselves as the clients of the organisation, the Arts Council has faced and continues to face a *crisis of legitimacy* regarding its role and value in contemporary society. This chapter examines some of the roots of the crisis and considers recent attempts by Council officials concerned with visual arts to meet the criticisms levelled at the organisation.

State patronage: the English 'half-baked' method

'Half-baked' was how Maynard Keynes, the first chairman of the Arts Council, described the organisation soon after its formation at the end of the Second World War.[2] In contrast to continental European states' recent attempts to organise artistic production which had resulted in the perceived reduction of culture to propaganda and consequent mediocrity – Keynes had in mind the fate of culture within Nazi Germany and Fascist Italy during the 1930s and the war years – the Arts Council of Great Britain had, he said, avoided the creation of *l'art officiel*. Instead, its elaborate committee structure, involving both professional administrators employed by the Council and a set of 'lay panels' consisting of 'private' individuals with amateur or informal interests in specific arts, would ensure that the Arts Council *facilitated* rather than dictated artistic production. Set up as a 'quango' (quasi-autonomous non-governmental organisation), the Council received public funding but had operational autonomy guaranteed through its award of a royal charter by the monarch, the formal head of the British state. This, at least, was the claim.

The Arts Council's charter, granted in 1946, affording the organisation independence and protection under the Crown, defined the Council as being:

For the purpose of developing a greater knowledge, understanding and practice of the fine arts exclusively, and in particular to increase the accessibility of the fine arts to the public throughout Our Realm, to improve the standard of execution of the fine arts and to advise and co-operate with our Government Departments, local authorities and other bodies on any matter concerned directly or indirectly with those objects.

No definition of 'the fine arts' was made, nor any description given of 'the standard of execution of the fine arts' that the Arts Council intended to improve. The charter subsequently was to be amended and a new declaration issued in 1967. A restatement of the objectives occurred, with important changes in terminology. The Council was now intended:

(a) to develop and improve the knowledge, understanding and practice of the arts ['fine' is omitted];
(b) to increase the accessibility of the arts to the public throughout Great Britain ['Our Realm' is omitted]; and
(c) to advise and co-operate with Departments of Our Government, local authorities and other bodies on any matters concerned whether directly or indirectly with the foregoing objects.

Such changes in the terminology of the account of the function of the Council, along with the omission altogether of the phrase 'to improve the standard of execution of the fine arts', indicate that between 1945 and 1967 the Arts Council had faced a variety of criticisms and been subject to governmental attempts at reform and modernisation of principle and policies. These will be discussed later. The shift from 'fine arts' to 'arts' seems particularly significant though, again, the change lacks any specificity of description or explanation.

Indeed, given the absence of any initial *detailed* account of Council policy, in relation to any of its fields of cultural subvention, including the visual arts, the organisation's general statements of values and tasks were opened to inevitable debate and opposing interpretations. However, rather than this being an essentially narrow or academic discussion concerned only with categories such as 'fine arts' or 'arts', it can be shown that these terms have formed part of a wider problem to do with definitions and evaluations of *culture* and their relationship to *whole ways of life*. This involves, therefore, the complex relationships between cultural activities, social class, gender, ethnicity and political values and beliefs. The Santoro case might illustrate, amongst other things, the gulf between official – and relatively liberal – notions of culture and the values and interests of women (and women artists) committed to feminism. It is for this reason that the organisational structure and membership of the Arts Council requires careful scrutiny.

Perhaps one main difference between pre-1979 debate over and in the Arts Council and more recent reconsideration has been the relatively greater open,

public discussion initiated by both government and Council members and staff. In particular, since about 1987 staff with responsibility for visual arts provisions have made consistent attempts systematically to describe their policies.

Before examining elements of this discussion in some detail, it is important to consider the specific place of the visual arts within the Council as a whole. A recent Arts Council guide set out the activities of the Visual Arts Department:

> The Visual Arts Department aims to extend the understanding and appreciation of the visual arts and to support the full range of contemporary practices. The Department is principally concerned with the promotion of painting, sculpture, photography, printmaking, installation work and performance. It is also interested in the relationships between these and other arts practices such as architecture, design, film, video and craft, and with other cultural sectors including education and publishing.[3]

It is important to bear in mind that, in proportion to public money spent by the Arts Council on other art forms – for example, opera, music, drama and dance – the visual arts have always received a very small amount. This situation may be taken to reinforce the argument that, historically, the visual arts in Britain have had a relatively marginal place compared with, for instance, dramatic, literary and musical forms of cultural production. In 1977–8 visual arts spending was 2.1 per cent of all Council money allocated, although the National and Tate Galleries traditionally have been funded directly by central government.[4]

Visual arts funding *has* increased slightly in recent years although the establishment of a department concerned with film, video and broadcasting – extending the Council's 'visual arts' provision beyond the traditional medium-based definitions restricted to painting, sculpture, printing and drawing – was actually created by dividing the original Art Department. No *increased* financial provision was made. Similarly, although photography was recognised as a substantial field of professional and popular practice when it was given a separate lay panel of advisers within the Council in 1990, it has not received any additional funding over and above that allocated to the Visual Arts Department.[5]

In contrast with other departments within the Arts Council which distribute a very high proportion of their expenditure in the form of grants and guarantees to other independent arts groups, such as touring companies and orchestras, up to the mid-1980s the department concerned with visual arts spent about half of its budget on activities which it *directly* controlled or organised. This was in the form of touring exhibitions of individual and group work, along with the direct management, for a time, of two exhibition spaces in central London: the Hayward Gallery on the South Bank and the Serpentine Gallery in Hyde Park. These are now managed independently. The

department also makes large revenue grants to about fifteen independent galleries, to visual arts support organisations such as magazines and newspapers and to schemes involving the commissioning of works for public buildings. In the early 1990s the Visual Arts Department started the national campaign for 'Percent for Art', which advocated the employment of artists and craftspeople in any public building, architectural or environmental scheme.[6]

It is arguable that, until very recently, the organisation of visual arts provision within the Council adhered to an essentially idealist and elitist notion of state patronage, rooted in an amalgamation of nineteenth-century aristocratic and high bourgeois values. This position, set out in the royal charters, may be characterised as an assumed (and not specifically argued) belief in a singular 'high culture'. Concomitant with this was the duty to ensure the 'maintenance of standards' primarily through lending support to leading metropolitan (London-based) galleries and museums seen by the Council – the representative of the state – as exemplifying these standards and values. Notice also that standards here are understood in the singular, without the possibility that a *variety* of kinds of evaluation may be possible. Further, by making grants available to approved provincial institutions the Arts Council reproduced a nineteenth-century *central* state patronage which, for example in the field of education, had yoked regional art schools to the authority of the metropolitan Department of Science and Art and the National Art Training School in London (now the Royal College of Art).[7]

Along with all the other departments within the Arts Council up to 1987, staff responsible for visual arts had no *articulated* philosophy or policy to guide their allocation of resources, nor any detailed analysis of national or specific regional needs. Given this state of affairs, it is not surprising that many felt that the Arts Council appeared to act arbitrarily in its decisions or arrogantly refused to involve itself in any kind of public or self-scrutiny.

The election, in 1979, of the Conservative Party led by Margaret Thatcher, brought the prospect of a return to nineteenth-century *laissez faire* economics and government in Britain. Rhetorically based on notions of 'rolling back the powers of the state', reinstating entrepreneurial capitalism as the force for social innovation, and subjecting public institutions to rigorous 'value for money' audits, the change in government might not have seemed to establish a propitious climate within which the Arts Council could operate. However, it is arguable (and perhaps ironic) that the opening up of a space for wide-ranging discussion *about* and *within* institutions of the state – in this case the Arts Council, though it was a situation which faced all public bodies – radicalised debate into the purpose and nature of the organisation with *potentially* very different political and intellectual consequences from those envisaged by the government of the day.[8]

'Administered consensus by co-option'

In an abstract sense, attacks on the Arts Council from the left and right have commonly been made in the name of 'democracy' and public accountability. However, the specific meanings of these terms within actual political discourse turn out to be very different.

Prior to the election of the Conservatives in 1979 right-wing policy review groups associated quite closely with the Thatcherite wing of the party called for the abolition of the Arts Council, partly on the grounds that it supported radical *left-wingers* who, it was claimed, were simply using visual art, theatre and other activities as vehicles for their political activities. It was also argued by the Adam Smith Institute and the Federation of Conservative Students that the role of financial sponsorship for the arts should pass into the hands of private citizens who could, if they chose, make charitable tax-deductible donations to arts organisations which they wanted to support. The incoming, explicitly *non-interventionist* Tory government, such groups argued, should have no role at all in the subvention of cultural production which, they claimed, was a private field of activities outside the legitimate concerns of the political state.[9]

At about the same time that this attack on the Council was made by the right, a representative of the left in Britain initiated a critique of the nature and function of the Council which linked the operation of the organisation to the historical nature of the British state, its ruling class and traditional cultural values.[10] Raymond Williams argued that without the existence of any formal structures explicitly intended to make possible and require a democratic decision-making process in the Arts Council, the body – typical in many ways of the British state as a whole – was *administering consensus by co-option*.

By this he meant that the Council worked through recruiting members likely to have the same values, interests and attitudes as those of the chair and the minister of state in the government responsible for selecting that executive officer. A true diversity of opinion was *never* likely to occur because this process of organisation and selection, half-baked or not, efficiently worked to reproduce a specific and narrow set of cultural traditions, prejudices and preferences. Kept at the level of informality and shared enthusiasms, it was not surprising then that the Arts Council's own organisational culture was dominated by male, middle-class English, 'Oxbridge' or London University educated arts lovers working in 'amateur' or professional roles (either sitting on the Council or its departments' lay panels as *advisers* or administrating as paid officers).[11]

Since the organisation's inauguration in 1945, the Arts Council's lay membership has always consisted of what may be described as 'private' individuals acting in 'public' roles. Lord Keynes, the first chairman, or Sir Kenneth

Clark, chairman from 1953 to 1960, personified this operative notion of public service, centred on the stewardship of persons whose precise *lack* of professional (and particularly pecuniary) interest in the arts was taken as a guarantee of both their altruistic commitment to cultural activities and their independence of judgement in matters of principle and policy relating to Council work.

Such figures as Keynes and Clark, usually successful and renowned as professionals in fields such as law, academic research or financial management, have traditionally been invited by Government ministers – who were themselves in many cases probably also friends or acquaintances from public school, university, or the professions – to take charge or advise bodies such as the Arts Council because they are believed to share the interests and values held by the government of the day. In this respect, whatever the *claims* to independence, the Arts Council, because the government chooses the chairman (and it has *never* been a woman), is directly, though in an organisationally complex way, yoked to that government's political and ideological principles and policies. The government minister also chooses *all* other members of the Council (both lay and paid) and so the body maintains itself throughout the derived component committees and subcommittees.[12]

Given this pattern of membership, its highly homogeneous social character, and the Council's persistent defence of such 'informality' within the committee structure – that is, its opposition to any commitment to a comprehensive process of *formal consultation* or *representation* in respect of decision-making – it is not surprising to find that the organisation has, until comparatively recently, predominantly focused its activities on the south-east of England, and London in particular. Given also the Council's original metropolitan, 'high-culture' definition of the arts – including the visual arts of painting and sculpture – it was predictable that the executive officers and lay panel members would decide to concentrate resources in London where most of the expensive and prestigious 'national' companies, galleries and museums have been located. Indeed, as noted earlier, the Arts Council directly added to this preponderance by taking charge – for a period – of the Hayward and Serpentine Galleries.

In 1984–5 the Arts Council spent the equivalent of 224 pence on cultural patronage for every person living in the south of the country compared with 105 pence for those living in the north.[13] It could be argued, however, that the Arts Council, a body through its charter explicitly committed to encouraging and facilitating artistic production rather than *initiating* it, has simply followed the long history of political and cultural centralisation in Britain. The national state governmental administrations, along with the national press and publishing industries, and the national institutions for the display of

artistic, scientific and archaeological artefacts (that is, major elements of the *official* cultural character of the nation) have been located in the capital city for well over a hundred years.

During the late 1940s and 1950s the Arts Council actually *retracted* much of its activities outside of the metropolis, partly because there had never been a policy for the whole country and partly because the Council decided to concentrate almost entirely on what it deemed 'professional' cultural activities. This excluded from benefit millions of people whose interest in a wide variety of arts occupied time outside their working lives and those for whom artistic practices were a marginal part of their economic activity. The latter situation was, and still is, the case for a large proportion of visual artists in Britain and North America.

By the mid-1950s, according to one commentator, 'the Arts Council had become a heavily centralised body. It had reasserted a tradition of art expressed through exemplary standards as recognised by the cultivated few, in opposition to the diversity of practices, activities and audiences.'[14] Outside the south-east, however, groups and individuals active within the visual and other arts were not prepared to accept the effective metropolitan prejudices of the organisation. During the 1960s and 1970s a number of regional organisations were established which began to seek funding from the Arts Council. These groupings were amalgamations of local government bodies, specialised arts clubs and other associations of people with interests in a wide variety of cultural activities.

By demonstrating specific regional interests and needs and through enlisting the political influence of local government politicians and officials who were capable of putting pressure on the central government (and through that on the Arts Council officials in London), these alliances caused the Council to recognise officially what it was later to call Regional Arts Associations. Though ad hoc in composition – in one sense an extension of the 'half-baked' method of subvention favoured by Keynes – the RAAs grew during the 1960s and 1970s into a fairly comprehensive network, although their operation in Scotland and Wales, not to mention Northern Ireland, was different from their status in England. The Arts Council of Great Britain, based in London, began to work with the Regional Arts Associations and through this contact, in the political climate of the 1980s, appeared to come to a further, and more radical, revaluation of its aims and methods.[15]

Culture and democracy

During the early 1980s the Arts Council extended its involvement with the English regional network into a process of devolution of resources. The then

chairman, William Rees Mogg, referred to this, in Georgian aristocratic terms in keeping with the class profile of the Council's typical leading executives, as recognising 'the glory of the garden'.[16] Once again, this change *may* be explained in relation to the stated aims of Conservative government policy (the party was re-elected in 1983). If the future of the Council's existence under the *rhetorically* non-interventionist Conservatives appeared to be no longer in doubt, partly at least because the government had recognised the financial significance of arts activities to the nation's economy as a whole, then decentralisation, the cutting-back of public money spent on bureaucracy and the rationalisation of resources were putatively all policy objectives to be furthered within organisations such as the Arts Council.

The Council's *Annual Report* for 1984–5 stressed the significance of the devolution plan which, it was claimed, strengthened partnerships in fundings, particularly with local government authorities, which were asked to play a greater role in local arts development. Extra money allocated from central government to the Arts Council included sizeable grants made to local authorities working with the Council's officials. By the beginning of the 1990s the Regional Arts Associations were replaced by a lesser number of bodies which were renamed Regional Art Boards, as part of an attempted unified planning process. Along with central government's introduction of three-year funding packages for the Council, also intended to aid a planning process for cultural funding, and the creation of incentive funding schemes intended to get visual and other arts organisations to plan the economic dimensions of their activities, such devolutionary changes may appear radically to have altered the Council's profile and function.

Is it the case, however, that the objections raised by those disturbed by the Santoro case (and other controversies) have been dealt with and that the Arts Council should now be considered a more responsive and open organisation, willing and able to respond to the diversities of people and cultural practices and values present in British society in the 1990s?

It could be argued that simply the *recognition* by the Council of its historically inherited and maintained cultural prejudices may be taken as an indication of the change that the organisation has undergone. The status of photography within visual arts provision is perhaps symptomatic of struggle around meanings and values in and of the contemporary culture, both *inside* the body and in the society at large. In the Council's 1991 *National arts and media strategy discussion document*, Visual Arts staff begin their account of photography by saying:

> During the second half of the twentieth century the major part of Arts Council and R.A.A. spending has been on traditional art forms and their institutions – fine art galleries, opera houses, concert performances, theatre and so on. Very

little support or recognition has been offered to those art forms mediated by mass production through publishing, broadcasting and the twentieth century technologies. Thus leaving those recent cultural forms that have most impact on the lives of most people open to the largely uncontrolled exploitation of profit seeking companies.[17]

Though presented diplomatically, and with the hint of a nineteenth-century state philanthrophy ('helping the people'), the writers invoke questions of classes, cultures and the context of an urban industrial–capitalist society in which diverse cultural practices and values have survived, or developed, and are subject to powerful economic forces with significant social and ideological consequences. The Arts Council, presumably because of its set of governing assumptions and values, related to its social membership, the writers say, has been relatively blind to this actual variety of activities and interests within late twentieth-century British culture. This is not simply a question of cultural preference or the vagaries of subjective taste. It centrally concerns the issue of the control of the material and institutional means through which artists (though many producers shunned that term because of its traditional connotations) have been able to initiate and pursue their particular interests and values.

The head of the Visual Arts Department, introducing the discussion document, is careful to define 'visual arts', saying, 'in a general sense, including visual art of all traditions and in all media'.[18] It is clear then that this part of the Arts Council *has* responded to the kinds of critique made by Williams and others. Since 1987 the Visual Arts Department extended Council activities in a variety of ways related to popular access and provision for a variety of producers, processes and products. It demonstrated a commitment to education, through its involvement with the Curating and Commissioning MA programme at the Royal College of Art. It attempted to support regional provision through its development programme for local authority galleries and to support practising artists through the assertion of an Exhibition Payment Right. It has endeavoured to recognise the plurality of contemporary practices and mixed-media activities through the establishment of the Institute of New International Visual Arts.[19]

It was not until 1985 that the Arts Council formally instituted a programme designed to facilitate what it called 'ethnic minority arts', along with an attempt to respond to the needs of disabled people in society. This was partly an imitative response to the structures and policies put in place by those who had worked for cultural services provided by the Greater London Council, the regional government authority for the capital which the Conservatives were to abolish in 1986.

However, these programmes have been seen by some as partly the development of a kind of 'cultural surveillance' by the state, appropriating and

domesticating the activities of artists from the Afro-Caribbean and Asian populations in Britain.[20] The same criticism could be made of the Arts Council's attempts to incorporate women and feminist artists, because modification of their work and values occurs once the possibility of funding (or support of some other kind) becomes available provided that artists can meet Council criteria. From this perspective, though, the Arts Council can *never* win: it either excludes or it manipulates. This is the view of those who say that state institutions can never be reformed and simply must be bypassed or opposed. It relies on the assumption that it is possible to reduce the variety of interactions between, say, Visual Arts Department support programmes and its clients to a form of simple manipulation or censorship.

If one rejects this position and advocates involvement in the state institutions, then questions of membership and representation become crucial. The issue of the predominance of middle-class men in positions of authority within the Council cannot be ignored as a factor influencing decision-making. The Visual Arts discussion document offered the view that:

> Despite the demise of the liferoom, the depiction of women in western society has remained such a fetishized subject, . . . for many years women artists were directed towards 'feminine' subjects, [so] it is not surprising that the position of women artists and issues of gender (and sexuality) in art should remain contested and fraught.[21]

Any fundamental review of the Arts Council, and of the place of the visual arts within it, must address the culture and society at large within which, for example, such ideologies of gender have been created. However, issues such as the status of photography, or 'ethnic arts', or of the value of women artists and feminist art, will not be resolved through debate or committee restructuring, although the organisation could take a role in attempting to change attitudes. As part of the state, the Council's place and function is related to its *representativeness*, of the culture(s), within the society. The question of its legitimacy is thus inseparable from the question of to what extent the state and government of the day can claim realistically to represent or to embody the interests of the people. A crisis in legitimacy occurs when it has become plain to enough people that their interests are not even recognised, never mind attended to, by the institutions which claim to represent them.

At the end of the twentieth century, at least *part* of the Arts Council – particularly that concerned with the visual arts – seems to have recognised that the narrow field of artistic practices valued historically by the Council should not be hived off from the whole gamut of processes, products and forms which constitutes the cultural terrain of contemporary society. There is now a sizeable 'cultural economy' generating a significant part of the country's wealth,

and its problems are not separable, finally, from those of the corporate capitalist economy as a whole. Roy Shaw, secretary-general of the Arts Council in the early 1980s, made this point, saying: 'The constant crisis in the arts can be dealt with only if there are radical changes in economic, social and educational policies as well.'[22] Subsidies and other support mechanisms may take many forms, and while the Arts Council has traditionally seen itself as the defender of the 'high arts', both broadcasting (through the television licence fee and advertising revenue) and the press (through its reliance on advertising revenue) have found themselves able to survive only through indirect means which arguably have come to determine much of the nature and output of these forms of cultural production. Commercial television is perhaps one of the most salient examples of a cultural form the character and development of which has been determined by its reliance on advertising revenue.

Should the fate of any or all of these specific cultural economies be left to the dynamics of capitalist development or should they rather be placed under some form of popular and democratic control? This question necessarily raises the issue of the limits of 'the public' and 'the private' in contemporary society, and the puzzle of what kinds of organisational structures may enable more effective representative and even participatory democracy to be achieved. In *this* sense, the idea of 'cultural democracy' is not essentially different from the idea of political or social democracy.

One traditional theory, associated with Marxism, is that the state can never *truly* represent or embody the sum of values and interests present in the society, not primarily because of the extraordinary diversity of which it is constituted but because those values and interests are, at root, actually in opposition: one value negates another and one interest must predominate. Within this view the state has grown up, in capitalist society, specifically to maintain the rule of the capitalist class, within an extending structure of oppressions and repressions which may also include institutions of patriarchy and racism.

Yet it is clear, historically, that organs of the state, like the Arts Council, *have* admitted people with views and commitments very different from those of the previously dominant aristocratic high bourgeoisie. Reforms have been made – piecemeal, usually against internal opposition – but they *have* registered something of the changes and struggles taking place in the wider society. In this sense it is perhaps not so strange for a partial 'opening up' to have occurred while the Conservatives have been in power in Britain, for their election and subsequent re-election has signalled, amongst other things, a crisis in the British political culture, a reorganisation of social and political groupings and forces, as well as the breakdown of labourist socialism, partly under the weight of its sexist and racist elements.

This is all to reiterate that the crisis of legitimacy is inside, as well as outside, the state, and in particular relation to the Council concerns the range of meanings and values for art within the culture (understood as a plurality of values, interests and ways of life). Struggles to reform or to transform the definition, place and significance of the 'visual arts' within the Arts Council of Great Britain are no more and no less than a specific embodiment and representation of that wider conflicted culture and society.

Notes

I would like to thank staff and students in the Department of Fine Arts at the University of Western Australia for their enthusiastic interest in this topic, which was the basis for a number of both informal and formal presentations. I would also like to thank Sandy Nairne who kindly read an earlier draft and made helpful suggestions for its improvement and historical accuracy.

1 For an account of the Santoro case, see 'Censored: feminist art that the Arts Council is trying to hide', *Spare rib*, 54, January 1977. This text is collected in the anthology *Looking on: images of femininity in the visual arts and media*, edited by Rosemary Betterton, Pandora, London, 1987, pp. 256–8.

2 See his BBC broadcast 'The Art Council: its policy and hopes', 1945, published in *The Listener*, 12 July 1945, p. 31.

3 *Visual arts*, Arts Council of Great Britain, London 1991, not paginated.

4 Source for statistics: *Arts Council of Great Britain: three year plan 1989/90–1991/92*, Arts Council of Great Britain, London, 1989, p. 5.

5 For an account of the principles and policy objectives of Arts Council staff and advisers concerned with photography, see the 'Photography discussion document', compiled by Barry Lane and Sue Isherwood, in *The national arts and media strategy discussion document*, Arts Council of Great Britain, London, 1991.

6 For a critical account of recent visual arts policy within the Arts Council, see Sandy Nairne's 'Art in a state: issues and politics in the arts funding system', *Art Monthly*, June 1992, pp. 3–9.

7 For an account of the continuities between nineteenth-century and twentieth-century state provision for visual arts in Britain, see 'The Arts Council of Great Britain', in Nick Pearson, *The state and the visual arts*, Open University Press, Milton Keynes, 1982, pp. 65–7.

8 For a wider analysis of the impact of Conservative policy on British social, political and cultural institutions, see Stuart Hall, *The hard road to renewal: Thatcherism and the crisis of the left*, Verso, London, 1988.

9 See *Mr Robinson's party, or the truth about the Arts Council*, Federation of Conservative Students and Adam Smith Institute, London, 1980 and the Conservative Party manifesto, 1979. By 1983, however, the manifesto for the Conservatives claimed that funding for the arts had grown under the Tory government.

10 See Raymond Williams's article 'The Arts Council', *The Political Quarterly*, 50:2, April–June 1979, pp. 158–71. Williams sat on the Council, as a lay member observer between 1975 and 1978, at the invitation of the then Labour government minister Hugh Jenkins.

11 For an interesting sociological analysis of the relations between class and cultural preferences, see Pierre Bourdieu's and Alain Darbel's *The love of art: European art museums and their public*, trans. Caroline Beattie and Nick Merriman, Polity Press, Cambridge, 1991.

12 For a historical account of the background of Arts Council personnel, see 'Profiles of Arts Council chairmen' and 'Background of Council members', in John S. Harris's *Government patronage of the arts in Great Britain*, University of Chicago Press, Chicago, 1970, pp. 45–55. Sandy Nairne, head of the Visual Arts Department between 1987 and 1992, has claimed that this situation has now ended: in his department, he stated, only three out of seven officers were white, male and Oxbridge graduates (letter to author).

13 Statistics from: *A hard fact to swallow*, Policy Studies Institute, London, 1981.

14 Pearson, *The state and the visual arts*, p. 58.

15 For an account of the organisation of RAAs, see *The state and the visual arts*, pp. 61–4. In 1981 there were twelve RAAs in England, catering for the whole country except Buckinghamshire. Wales had three, but of a different kind from those in England, while Scotland had none.

16 See William Rees Mogg, 'Introduction', *Arts Council of Great Britain Annual Report*, Arts Council of Great Britain, London, 1984, pp. 1–2.

17 Barry Lane and Sue Isherwood, 'Photography discussion document', *The national arts and media strategy discussion document*, p. 4.

18 Sandy Nairne, 'Visual arts discussion document', *The national arts and media strategy discussion document* (introduction).

19 See 'Visual arts', *47th Annual Report and Accounts 1991/92*, Arts Council of Great Britain, London, 1992, pp. 26–7.

20 Nairne, 'Art in a state', pp. 5–6.

21 Nairne, 'Visual arts discussion document', p. 7.

22 Roy Shaw, *The arts and the people*, Jonathan Cape, London, 1987, p. 147. Shaw disputed the Conservative claim that financial support for the Arts Council had grown during the early 1980s: 'No one believed this . . . the Arts Council delicately declared itself doubtful of the claim and calculated that its grant-in-aid from government had declined by 6% in the same period' (p. 147).

THE POLITICS OF PRESENTATION:
THE MUSEUM OF MODERN ART, NEW YORK

Christoph Grunenberg

In the history of art, as in more materialistic matters, money talks vividly.
Alfred H. Barr, Jr, 'A new museum', *Vogue*, October 1929[1]

The world center, institutionally speaking, of the modern movement in the fine
and applied arts is the Museum of Modern Art.
The New Yorker, 1953[2]

THE MUSEUM OF MODERN ART (MoMA) in New York is without doubt the
single most important institution devoted to the history of twentieth-century
art. It was the first museum to be exclusively concerned with modern art and
its collection is generally regarded as the most comprehensive in the world. In
the minds of many – historians as well as the public – the Museum of Modern
Art is virtually synonymous with the modern movement and, as such, has
been a target for attacks on modernism.

This chapter will investigate how the Museum of Modern Art achieved this
special status, how it came to be considered the archetypal modern art
museum and how it was able to sell the idea of modern art to a wide public.
Whereas previous studies of the museum have centred on the postwar years
my analysis will focus on the first decade of its existence.[3] The decade from
MoMA's foundation in 1929 to the opening of its permanent residence in 1939
was a crucial one in the institution's history. It was during this period that
MoMA established its organisational structure, formulated its basic policy
and developed strategies for the propagation and presentation of modern art.
The procedures applied by the museum in the transformation of European
modernism into an aesthetic conforming with the specific requirements of

America's culture, politics, capitalist economics and continuing Puritan tradition will be investigated. Through its foundation, programme, organisation, administration, departmental structure, as well as its institutional practices (such as acquisitions, exhibitions, publications and education), MoMA contributed to the redefinition of the concept of modernism. The second part of this chapter will focus on MoMA's establishment of a paradigmatic mode of display during the 1930s. The museum building, the decoration of its galleries, methods of installation and hanging were all crucial instruments in the Americanisation of modernism. In its 1939 building, the Museum of Modern Art seemed to have achieved a perfect harmony between art and its architectural container. An analysis of the museum's exterior and interior will reveal MoMA's adherence to the separation of art and life, its negation of avant-garde art's political potentials, and its restoration of the autonomy of the modernist work of art.

Foundation and early success

The foundation of most museums and other cultural institutions in the United States has been the result of the philanthropic activities of private individuals, rather than state or municipal initiatives as in Europe. The establishment of the Museum of Modern Art, likewise, developed out of the combined efforts of three public-spirited private collectors. In early 1929, Mrs John D. Rockefeller, Miss Lillie P. Bliss and Mrs Cornelius J. Sullivan discussed the idea of founding a museum in New York devoted to modern art. They all came from extremely privileged backgrounds, including some of America's oldest and wealthiest families.[4] In May 1929, the three women enlisted the help of A. Conger Goodyear, a collector and former President of the Albright Gallery in Buffalo. He was to become the first president of the museum, a position he occupied until his retirement in 1939. Goodyear organised an Advisory Committee which comprised, besides himself and the three women, Frank Crowninshield, editor of *Vanity Fair*, Professor Paul J. Sachs, director of the Fogg Museum of Harvard University, and Mrs Murray Crane.

However, the individual identified most with the museum and its programme was without doubt Alfred H. Barr, Jr (1902–81). It was Professor Paul J. Sachs who recommended Barr, then a young scholar, to the Advisory Committee. In July 1929, Mrs Rockefeller gave her seal of approval to Barr's appointment as the museum's first director: 'I liked Mr. Barr and felt that his youth, enthusiasm and knowledge would make up for his not having a more impressive appearance.'[5] Barr was trained as an art historian in Princeton and Harvard and had first-hand experience of the European avant-gardes. He

occupied the post of director until October 1943, and continued his influential work as director of museum collections from 1947 until his retirement in 1967.

MoMA's 'manifesto'

In August 1929 the seven founders of the museum issued a brochure drafted by Alfred Barr that described the function and programme of the new institution:

> [The] immediate purpose is to hold . . . some twenty exhibitions during the next two years. These exhibitions will include as complete a representation as may be possible of the great modern masters – American and European – from Cézanne to the present. The ultimate purpose will be to acquire, from time to time, either by gift or by purchase, a collection of the best modern works of art.[6]

The museum, as envisioned by its founders in 1929, was to limit its activities to painting and sculpture.[7] However, Barr had something very different and far more radical in mind. In 1929 the museum had announced a possible expansion 'beyond the limits of painting and sculpture in order to include departments devoted to drawings, prints and other phases of modern art'.[8] This was a toning down of Barr's bold proposal which had envisioned a much more complex and comprehensive approach to the presentation of modern art:

> In time the Museum would probably expand beyond the narrow limits of painting and sculpture in order to include departments devoted to drawings, prints, and photography, typography, the arts of design in commerce and industry, architecture (a collection of *projets* and *maquettes*), stage designing, furniture and the decorative arts. Not the least important might be the *filmotek*, a library of films.[9]

It was the attempt to provide a comprehensive survey of contemporary visual culture that made the Museum of Modern Art such an unique institution. Barr acknowledged a number of influences on his original conception of the museum as a multi-departmental structure, the Bauhaus being the most decisive: 'I read particularly about the Bauhaus, a fabulous institution, where all the modern visual arts . . . were studied and taught together in a large new modern building. Later, in 1927, I visited the Bauhaus for several days. Undoubtedly it had an influence not only upon the plan for our Museum . . . but also a number of its exhibitions.'[10] Elements of Barr's original plan were also retained in the Provisional Charter of the Museum, granted on 19 September 1929, which defined MoMA's mission as 'encouraging and developing the study of modern arts and the application of such arts to manufacture and practical life, and furnishing popular instruction'.[11] To the trustees,

Barr's plan seemed too ambitious and for the first two and a half years the museum exhibitions were limited to painting, sculpture, and occasionally some graphics. However, in early 1932 MoMA staged an exhibition of modern architecture (the epoch-making 'International style' show) that initiated an aggressive policy of expansion. An exhibition of photography followed in the same year; industrial design was presented for the first time in 1933; and in 1935 a film library was established. In 1940 all the media proposed by Alfred Barr in 1929 had featured in exhibitions or were represented by independent departments. Barr's vision of the penetration of all aspects of contemporary life by a modern style was best realised in his comprehensive survey exhibitions 'Cubism and abstract art' (1936) and 'Art in our time' (1939). Otherwise, the museum maintained the independence and autonomy of separate departments, and continues to do so.

In the early years of its existence, the Museum of Modern Art's activities were mainly restricted to exhibitions. This was partly due to its lack of a substantial permanent collection. The first two years were regarded as a provisional and experimental period in which the viability and public interest in a museum of modern art was to be tested through a large number of exhibitions. The institutional nature of art museums – based on sanctification and permanent preservation of masterpieces – was redefined by the Museum of Modern Art's deliberate concentration on temporary exhibitions. Eventually, the museum's activities were to be divided equally between exhibitions and the collection. This plan combined the functions of several types of European institutions, as Barr acknowledged: 'The balance between temporary exhibitions and "permanent" collection was a combination of the German *Kunstverein* exhibition gallery and the Luxembourg–Tate museums of contemporary art.'[12] Considering the novelty and unestablished nature of the art shown in the Museum of Modern Art, exhibitions seemed to be the most appropriate medium of popularisation.

'A torpedo moving through time': the permanent collection[13]

The status of the museum as a permanent institution was not confirmed until five years after its foundation. The Great Depression delayed the establishment of a collection and the generation of sufficient funds for an endowment. In a 1933 report to the trustees, Barr lamented the lack of progress: 'Of course the first two years were considered a period of trial. During this time temporary loan exhibitions were to indicate whether there was really sufficient interest in modern art to make a permanent institution advisable. But this policy was continued with little alteration during the third and fourth years and apparently will be during the fifth.'[14] It was only in 1934 that the museum's

permanence was confirmed through the acquisition of the Lillie P. Bliss collection and the establishment of an endowment of $600,000.[15] The permanence of the collection was envisaged to be very relative, as the museum's president explained in 1931:

> The permanent collection will not be unchangeable. It will have somewhat the permanence that a river has. With certain exceptions, no gift will be accepted under conditions that will not permit of its retirement by sale or otherwise as the trustees may think advisable . . . When a creative artist has not yet attained recognition from other museums, it should be the province of this institution to give him a full representation in its collection . . . The Museum of Modern Art should be a feeder primarily to the Metropolitan Museum, but also to museums generally throughout the country.[16]

In the first two decades of its existence, the museum understood itself primarily as a 'laboratory' for which the title of 'museum of contemporary art' might have been more appropriate. Barr defined the scope of the collection as a 'torpedo in motion', visualising the idea in a diagram which he described as follows:

> The blunt end pushes into the advanced field of art by means of the changing exhibitions. The bulk is made of 'accepted' modern art. The tail tapers off into art which has become 'classical' and is ready for the general museum. The torpedo moves forward by acquiring and retains its length of 70 years by giving to other museums. A strong and well proportioned permanent collection gives body to the Museum and supplies a background to any changing exhibitions.[17]

The museum's experimental period finally came to an end in 1953 when the Board of Trustees decided not to sell any longer any works from the collection considered 'classical'. The Museum's 1947 agreement with the Metropolitan Museum of Art regulating the sale of 'classic' paintings and sculpture was terminated. This indicated the end of MoMA's heroic period: modern art had become widely accepted and fashionable, and the Museum of Modern Art itself became part of the history of modernism.

The business of modern art

More than with most American museums, MoMA's trustees have always played an important role in the definition of the museum's policy as well as its daily affairs. Much of the institution's financial support during the early years was supplied by the trustees.[18] Though its benefactors and trustees (many of them collectors) have always been recruited from American's social elite, the interpretation of MoMA's success as the result of a high society conspiracy would be simplistic. The support of some of the most influential people in

business, politics and the media certainly contributed to MoMA's prominent position. However, a critical element in the establishment of the museum as the foremost institution in modern art was its continued insistence on high standards of excellence and professionalism. Especially during its early years, MoMA attracted a number of young and ambitious individuals, representing the most brilliant authorities in their fields.[19] The museum employed the most advanced marketing and publicity strategies in the propagation and dissemination of modern art. MoMA resolved the contradictions of capitalism and modernism by turning modern art into a business, promoting it just like any other commodity.

Likewise, the Museum of Modern Art's organisation and administration resembled more a business enterprise than an educational institution. It published annual reports with elaborate diagrams charting its income and expenditures, sales of publications and number of visitors. Its administrative structure resembled those of public companies, including a president, board of trustees, director and executive director, and a large number of committees.[20] It was run with the professionalism and efficiency of a company competing in the capitalist market economy. In an early, confidential report to the trustees Alfred Barr described MoMA's operations exactly in these terms:

> Analysis of the present organization of the Museum reveals two distinct types of work . . .
> 1. 'Production.'
> Basically, the Museum 'produces' art knowledge, criticism, scholarship, understanding, taste. This is its laboratory or study work . . . This preparation or 'production' work is the stuff of which the Museum's prestige is made.
> 2. 'Distribution.'
> Once the product is made, the next job is its distribution. An exhibition in the galleries is distribution. Circulation of exhibitions catalogs, memberships, publicity, radio, are all distribution.[21]

From its foundation in 1929, the Museum of Modern Art employed the most up-to-date methods of distribution. It used publicity to shock and to attract attention, to get its name into the newspapers and the public to visit its exhibitions. The museum's van Gogh exhibition of 1935 was promoted by an extensive publicity campaign and is one of the first instances of a blockbuster show. MoMA was also one of the first museums to use radio broadcasts for publicity and education.[22] For decades the museum's publications were unrivalled in their scholarship, size, quality of layout and illustrations. Similarly, the exhibitions established new standards of excellence, not only in their selection but also in their presentation and installation.[23] In the early years of its existence, MoMA transformed the definition and function of the museum as institution: the emphasis was no longer on collection, preservation and classification but

instead on education, communication and public participation, always with the insistence on the highest standards. The museum was selling a product – modern art – and this it did better than any other museum:

> Consider the Museum entirely as a *business. If the product is good its duplication and distribution can be endless.* There is no need for 'burning up' the product on hand by an extravagant policy of too rapid and too thin distribution and without studied replacement that should in any rate exceed the distribution . . . The distribution of the Museum's product will improve once it is looked at apart from its preparation. Just as it is unfair to judge preparation from a 'popular' angle, so it is unfair to make distribution a purely scholarly affair. It should be impossible to corrupt a good product by intelligent distribution.[24]

'A machine to show pictures in': the Museum of Modern Art's permanent home[25]

The announcement of the Museum of Modern Art's establishment in 1929 concluded with a prophetic statement: 'It is not unreasonable to suppose that within ten years New York, with its vast wealth, its already magnificent private collections and its enthusiastic but not yet organized interest in modern art, could achieve perhaps the greatest modern museum in the world.'[26] For the first decade MoMA occupied a number of temporary spaces, including a twelve-floor skyscraper and a former Rockefeller town house on the site of the present museum. By 1939 when its new building opened to the public the museum had already realised its ambitious goal of assembling a remarkable collection that included many icons of twentieth-century art (Picasso's *Les Demoiselles d'Avignon*, for example, had entered the collection the previous year).

After the museum became a permanent institution, a chronic shortage of space made the need for its own building increasingly urgent. In 1936 Philip L. Goodwin (1885–1958) and Edward D. Stone (1902–78) were commissioned to design a modern museum (fig. 10.1).[27] The final product of their collaboration fulfilled the demands for a material manifestation of MoMA's principles and ideology:

> [T]he design of the building became, in all truth, itself a part of the museum collection – the only part permanently and indefinitely on display. Whatever type of building was erected could not but be judged rigorously, by the outsider as part and parcel of the whole contemporary art movement, and by the insider according to the high criterion set by its own contents.[28]

An analysis of the building will reveal how the museum successfully accommodated a diversity of demands, balancing commercial display techniques

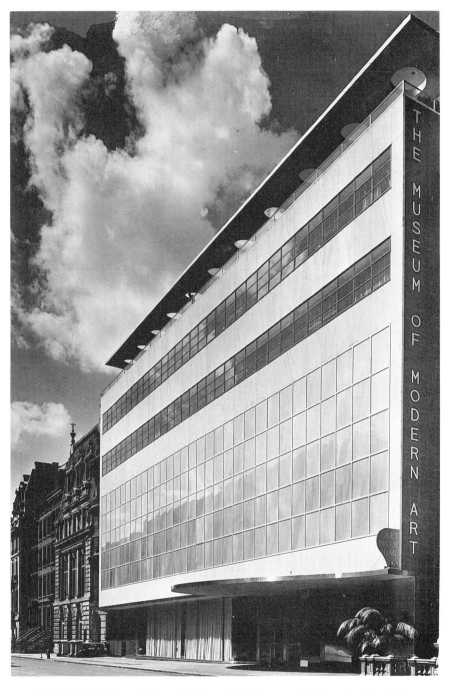

10.1 Philip L. Goodwin and Edward D. Stone, *The Museum of Modern Art, New York, 1939.*
Photo: Museum of Modern Art

with formalist aesthetics, intimacy with authority, and flexibility with an impression of permanence. As the building reached completion in the spring of 1939, New Yorkers were confronted by the museum's unadorned and resolutely modern façade:

> The façade has been disturbing New Yorkers, even the most up-to-date of them, during all the months of its construction, by its stark and machine-made simplicity. It contained nothing, so it was feared, that resembled architecture in any way, but now that the scaffoldings have been removed and the chromium and glass have been polished up the extreme cleanliness of the affair mitigates somewhat the nudity, although the unregenerate will doubtless insist that the front calls loudly for some flagpoles and other ornament.[29]

The museum's flat, white and polished façade anticipated the austerity of the galleries and the severity of the art historical judgement applied to modern art, or, as Barr defined it: 'the conscientious, continuous, resolute distinction of quality from mediocrity'.[30] The entrance was designed to ease the transition from the street into the museum (fig. 10.2). The ground floor opened in a floor to ceiling glass wall with curved entrance bay giving full sight of the entrance

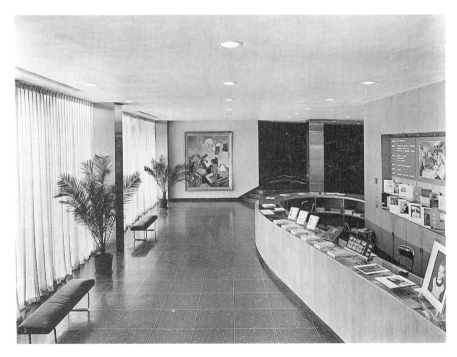

10.2 Philip L. Goodwin and Edward D. Stone, *Entrance hall, The Museum of Modern Art, New York, 1939.* Photo: Robert M. Damora, courtesy of Photographic Archives, Museum of Modern Art

lobby. The layout is reminiscent of commercial architecture, in particular department stores with their wide and visually accessible expanses of glass.

> The deep, recessed, curved loggia lined with metal opens invitingly from the sidewalk, and the column projecting through the open space gives a pleasant sense of the stability of the building; the whole hallowed form leads one inevitably into the building through welcoming glass doors. An imaginative feature is the way in which the curve of the counter of the entrance carries through the curve of the wall outside; the entire entrance and lobby are most interesting examples of that weaving together for outside and inside which is one of the great marks of best contemporary design.[31]

The museum's name on a background of blue tiles on the side of the building attracted visitors from Fifth Avenue, New York's most elegant shopping street. The prominent placement of the museum's name was a programmatic allusion to the Bauhaus in Dessau (Walter Gropius, 1925–6). The street façade of the museum conformed to all the requirements of contemporary shop-fronts:

1. Be sufficiently distinctive to be easily recognized from a distance.
2. Display name signs that are easily read from afar, from nearby and by those looking into windows.
3. Reflect, in character of design, the type and quality of merchandise sold inside the store.
4. Provide windows for most advantageous display of merchandise.
5. Provide an easy, direct and attractive entrance.[32]

The affinity of museum and department store continues in the twentieth century. Walter Benjamin has remarked on the strong affinity between the museum and the distribution and presentation of commodities: 'The concentration of works of art in the museum approximates them to commodities, which – where they offer themselves in masses to the passer-by – rouse the idea that he also must receive a share.'[33] The Museum of Modern Art effectively employed the most advanced presentation and display techniques, derived from American commercial as well as European architectural and artistic sources. On the entrance level the museum presented itself as an open and democratic institution. However, the austerity of the façade's central zone, with its polished steel and translucent glass grid, anticipates the authority and seriousness inside the galleries.[34]

In the art historical labyrinth

The interior of the museum repeated the play in the façade between organic and geometric forms. Decorative elements were restricted to the circulatory spaces, such as lobbies and staircases. The floor plan of the galleries possessed

all the elements of functionalist architecture: an open plan with steel post construction allowing complete flexibility in the division of the gallery space. An exhibition plan for the museum's opening exhibition, 'Art in our time', with the actual walls in place illustrates the spatial division of the galleries (figs 10.3, 10.4). The installation represents the result of the careful balancing of practical and didactic considerations:

> In the effort to gain the maximum wall space for the present very large exhibition, the space has been divided into a large number of small rooms, one entered from the other, and it is here perhaps that the sacrifices contingent upon the gaining of flexibility are most apparent. The screens run straight from floor to ceiling, and the effect is that of permanent rooms; and, where there are so many of them, with the circulation from one to another so irrevocably fixed, a rather disquieting feeling as of being in a *labyrinth* almost necessarily results.[35]

The spaces were surprisingly varied, many of them cut irregularly, with curved walls and oblique angles. This asymmetrical arrangement of spaces

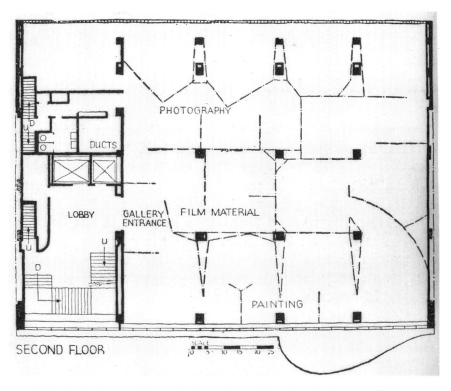

10.3 Philip L. Goodwin and Edward D. Stone, *Second floor plan, the Museum of Modern Art, New York, 1939.* Photo: Robert M. Damora, courtesy of Photographic Archives, Museum of Modern Art

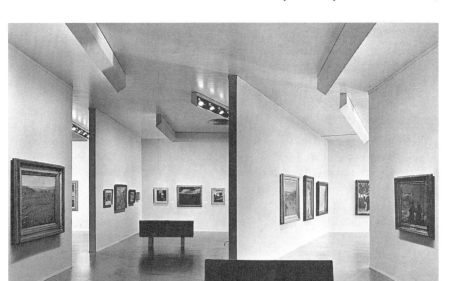

10.4 Upper floor gallery at the time of the 'Art in our time' exhibition,
Museum of Modern Art, New York. Photo: Robert M. Damora,
courtesy of Photographic Archives, Museum of Modern Art

fulfilled practical needs but also contributed to a sense of dynamic moder-
nity. The powerful appeal of asymmetry and its mixture of practical and
ideological foundations permeated the museum building on many levels.
This contrasts with classical architecture where symmetry denotes lack of
spontaneity, controlled regularity and defence of the status quo. In the
MoMA's spaces visitors had to progress through a series of galleries without
the danger of digression. In the labyrinth of MoMA's galleries, the visitor is
subjected to a compulsory course in recent art history following 'the
development of modern art in a clear logical sequence'.[36] Barr's attempt to
organise modern art according to the principles of traditional art history is
exemplified in the famous chart he created for the 1936 'Cubism and abstract
art' exhibition. This chart presented the evolution of modern art developing
towards two types of formal expression: 'Non-geometrical abstract art' and
'Geometrical abstract art'.[37]

The intimacy of modern art

After the simplicity and coldness of the façade visitors were surprised by the
intimacy of the museum's galleries:

> If the facade of the building confirms the suspicion that I have entertained this
> long while past, that New York simply cannot afford a curved line, the interior
> refutes the impeachment arrogantly, for the exhibition space is divided into
> innumerable alcoves that weave into each other like rose leaves on a larger scale.
> This provides the intimate approach to the pictures that is now deemed essen-
> tial.[38]

Everything in the design of the galleries was done to evoke a feeling of inti-
macy: the space was divided into small units with irregular plans and the
ceiling was kept deliberately low (12 to 14 feet). The domestic scale was not
restricted to the galleries but penetrated the whole building, beginning with
the entrance area: 'Burnished chromium doors open into a large foyer which
gives no idea of a museum but resembles a modernistic residence with loung-
ing chairs, a counter for catalogues and receptionists standing to offer
information.'[39] Other elements of the museum, such as its limited number of
floors, the penthouse and balcony, as well as the lack of representative spaces
and the extensive use of decorative plants, furthered the analogy to typical
New York residential buildings.[40] The gallery spaces were domesticated and
approximated to the private collectors' homes so closely associated with the
institution.[41] The galleries' intimate character facilitated the aesthicisation of
art, allowing the beholder to establish a personal relationship to the objects
exhibited. Walter Benjamin described the transformation occurring in the
collector's home:

> The interior was the place of refuge of Art. The collector was the true inhabi-
> tant of the interior. He made the glorification of things his concern. To him fell
> the task of Sisyphus which consisted of stripping things of their commodity
> character by means of his possession of them. But he conferred upon them only
> a fancier's value, rather than use-value. The collector dreamed that he was in a
> world which was not only far-off in distance and time, but which was also a
> better one, in which to be sure people were just as poorly provided with what
> they needed as in the world of everyday, but in which things were free from the
> bondage of being useful.[42]

MoMA reproduced the escapist strategies of the Victorian interior: the works
of art were detached from their original context of production and their social
and political implications were effaced in a fictitious process of appropriation
and domestication. In the Museum of Modern Art the Victorian profusion of
objects was replaced with modernist isolation and sterility. The negation of
the exterior world has become an essential part of MoMA's politics of
presentation, continuing to the present day: 'You won't know which building
you're in when you're in the galleries', William Rubin, curator of painting and
sculpture, stated in 1983.[43]

The 'white cube'[44]

The same critic, who above had praised the possibility of an 'intimate approach to the pictures', continued in his review to criticise the hostility and coldness of the galleries: 'I must also add that these picture alcoves disdain coziness. Apparently, in the new museums, we shall be expected to stand up, look quickly and pass on. There are some chairs and settees, but the machin-like neatness of the rooms does not invite repose.'[45] The paradigms of modern-ist aesthetics have penetrated not only the works of art but also their presentation – distance and autonomy is practised in art and in its installa-tion. The simple stereometric spaces, the white walls and the lack of orna-mentation present a conscious claim for the seriousness and relevance of modern art. The so-called 'white cube' liberated modern art from its common association with decadence, insanity, sensuality and feminine frivolity; simultaneously, it revealed the inherent masculinity and authoritarian char-acter of formalist aesthetics:

> [O]ne of the greatest barriers to the healthy development of Art interest in America is unquestionably the fact that it has been so largely cultivated hitherto as an interest peculiar to women. Whatever may have been the causes for this extraordinary fact in our national history and however deeply our society is indebted to women and women's organizations for the preservation of aesthetic interest during a century or more of cultural chaos, there are no good reasons at the present time for perpetuating the anomaly. On the contrary, we are con-fronted on every hand with indications that the time has come in America when Art is again taking its proper place among the normal interests of men. Indeed it may be said quite bluntly that no really significant development of contem-porary art can take place in this country without the whole-hearted participa-tion of men whose intimate relations with commerce, industry, and productive enterprise of all sorts makes them, rather than women, the immediate instru-ments for 'applying the Arts to practical life.'[46]

MoMA's policy represented a conscious attempt to resolve the ideological contradictions between modernism's political and social agenda within the American system of capitalism and the Puritan suspicion of the fine arts. The integration of modern art into the male sphere of production and economics transformed it into an aesthetic acceptable to American businesses without disturbing the social order. At the same time, modern art and design – abstract and simple – provided an outlet for philanthropic activities liberated from the dangers of extravagant ostentation:

> The [Protestant] campaign against the temptations of the flesh, and the depen-dence on external things, was . . . not a struggle against the rational acquisition, but against the irrational use of wealth. But this irrational use was exemplified

in the outward forms of luxury which their code condemned as idolatry of the flesh, however natural they had appeared to the feudal mind. On the other hand, they approved the rational and utilitarian uses of wealth which were willed by God for the needs of the individual and the community.[47]

The white, neutral and ideology-free gallery space constitutes the physical materialisation of MoMA's selective amnesia. More than anything else, the 'white cube' epitomised the attempt to escape from the realities of the external world, belying modernism's original claim for the integration of art and life. The museum's spaces functioned as a defence not only against the metropolitan cacophony of New York but also, and more importantly, against the material world of production and consumption, the contradictions of class society and political conflicts. The 'white cube' constitutes an ideological vacuum, an immaculate space in which art is restricted to the realm of ideas and pure aesthetics:

> The ideal, to be sure, was conceived in such a fashion that its regressive and apologetic, rather than its progressive and critical, characteristics predominated. Its realization is supposed to be effected through the cultural education of individuals. Culture means not so much a better world as a nobler one: a world to be brought about not through the overthrow of the material order of life but through events in the individual's soul . . . Culture belongs not to him who comprehends the truths of humanity as a battlecry, but to him in whom they have become a posture which leads to a mode of proper behavior: exhibiting harmony and reflectiveness even in daily routine. Culture should ennoble the given by permeating it, rather than putting something new in its place . . . The beauty of culture is above all an inner beauty and can only reach the external world from within.[48]

In the museum's galleries, modern works of art are implicitly defined as self-contained entities, limited in scale and demanding contemplative perception. The physical confinement and limitations imposed by the installation reveal MoMA's selective appropriation of modernism. There is no space for art transgressing the traditional separation of media into painting, sculpture, graphics, architecture, design, photography and film, as reflected in MoMA's departmental structure.[49] This automatically excludes large-scale murals, collaborations between architects and painters, environmental designs, and convergence of fine and industrial art. Above all, the Museum of Modern Art's politics of exclusion deliberately ignored or defused the penetration of art by social and political issues in the Soviet and German avant-gardes.[50] Despite the fact that Alfred Barr was one of the very few art historians with first-hand knowledge of Soviet art, which clearly fascinated him, it was to lead a rather subordinate role at the Museum of Modern Art.[51] The austere gallery spaces

with their pristine white walls epitomised MoMA's ambition for purity and neutrality, historical accuracy and objectivity: modernism became history. MoMA's politics of presentation replaced political engagement with formalist aesthetics, anarchy with rationalisation, internationalism with individualism, diversity with absolute purity, and fragmentation with aesthetic autonomy:

> [T]he *autonomy of art* is a category of bourgeois society. It permits the description of art's detachment from the context of practical life as a historical development – that among the members of those classes which, at least at times, are free from the pressures of the need for survival, a sensuousness could evolve that was not part of any means–ends relationships.[52]

Notes

1 Reprinted in I. Sandler and A. Newman, eds, *Defining modern art: selected writings of Alfred H. Barr, Jr*, New York, 1986, p. 73.

2 D. MacDonald, 'Profiles: action on West Fifty-Third Street – I', *The New Yorker*, 12 December 1953, p. 49.

3 The critical texts are: C. Duncan and A. Wallach, 'MoMA: ordeal and triumph on 53rd Street', *Studio International*, 194, 1978, pp. 48–57. A revised version of this article was published as 'The Museum Of Modern Art as late capitalist ritual: an iconographic analysis', *Marxist Perspectives*, 1, 1978, pp. 28–51. C. Duncan, 'MoMA's hot mamas', *Art Journal*, 48, 1989, pp. 171–8. The museum's role in the dissemination of abstract expressionism is investigated by E. Cockroft, 'Abstract expressionism: weapon of the cold war', *Artforum*, XII, 1974, pp. 39–41. A. Cox, *Art-as-politics: the abstract expressionist avant-garde and society*, Ann Arbor, MI, 1982. S. Guilbaut, *How New York stole the idea of modern art: abstract expressionism, freedom, and the cold war*, Chicago and London, 1983, M. Kozloff, 'American painting during the cold war', *Art-forum*, XI, 1973, pp. 43–54.

4 Russell Lynes gives an detailed account of the museum's founder's social background in *Good old modern: an intimate portrait of the Museum of Modern Art*, New York, 1973, pp. 3–8.

5 Letter from Abby A. Rockefeller to A. Conger Goodyear, 12 July 1929. MoMA Archives, NY, A. Conger, Goodyear Papers, vol. I.

6 Barr, *A new art museum*, brochure August 1929, reprinted in Sandler and Newman, *Defining modern art*, p. 69.

7 'Unless I am mistaken, the founders of the Museum originally intended it to be a kind of Luxembourg or purgatory for non-academic painting and sculpture, which in 1929 could rarely be seen in New York save at dealer's galleries.' A.H. Barr, Jr, *Notes for the reorganization committee*, typescript dated 23 February 1938, p. 5. MoMA Archives, NY, Alfred H. Barr, Jr. [AHB] Papers, Archives of American Art, Microfilm 2166, Frame 670.

8 Barr, *A new art museum*, p. 71.

9 A. H. Barr, Jr, 'Chronicle of the collection of painting and sculpture', in *Painting and sculpture in the Museum of Modern Art, 1929–1967*, New York, 1977, p. 620.

10 Alfred H. Barr, Jr, *The 1929 multidepartmental plan for the Museum of Modern Art: its origins, development, and partial realization*, typescript dated August 1941, p. 2. MoMA Archives: AHB Papers [AAA: 3266; 71].

11 Quoted in Barr, 'Chronicle of the collection', p. 620.

12 Barr, *Notes for the reorganization committee*, p. 6. MoMA Archives: AHB Papers [AAA: 2166: 676].

13 Quoted in Barr, 'Chronicle of the collection', p. 622.

14 *Ibid.*

15 Miss Bliss, who died in 1931, bequeathed her collection to the museum under the condition that within three years 'the Trustees of the Estate should be satisfied that the Museum of Modern Art is sufficiently endowed and in judgment of said Trustees on a firm financial basis and in the hands of a competent board of trustees.' Quoted in Barr, 'Chronicle of the collection', p. 621.

16 A. C. Goodyear, 'The Museum of Modern Art', *Creative Art*, 9, 1931, pp. 456–7.

17 Barr, *Present status and future direction of The Museum of Modern Art*, typescript dated 6 August 1933, p. 11. MoMA Archives: AHB Papers [AAA: 3266; 132]. In 1936 the time frame of the collection was restricted to 'works produced within the previous fifty years, with a smaller number of works of earlier periods to illustrate the sources and aid in the understanding of contemporary art.' Barr, 'Chronicle of the collection', p. 625.

18 In 1933 it 'was decided to abandon a public drive to raise endowment funds and depend entirely on the Trustees and friends of the Museum'. Quoted in Barr, 'Chronicle of the collection', p. 622. 'In the early years, the trustees financed the Museum of Modern Art almost entirely. Besides making generous annual gifts for running expenses – as late as 1944, the Rockefellers were reportedly giving $100,000 a year and Stephen Clark [Chairman of the Board] $25,000 – they raised an initial endowment of $630,000 (mostly out of their own pockets), provided the funds to erect the present building, on a site donated by the Rockefellers, and have given the Museum – either directly or by providing funds for their purchase – by far the greater part of the paintings and collection.' MacDonald, 'Profiles: action on West Fifty-Third Street – I', pp. 50–2. For an complete account of income and expenditures during the Museum's first decade, see A. C. Goodyear, *The Museum of Modern Art: the first ten years*, New York, 1943, appendix G.

19 The most prominent of the so-called 'young Turks' were Philip Johnson (later to become America's leading architect), Lincoln Kirstein (subsequently founder of the New York City Ballet) and Edward M. M. Warburg (also involved in ballet as well as a trustee of MoMA and the Metropolitan Museum of Art). Eminent art historians involved with the Museum in its early years were Henry-Russell Hitchcock, Beaumont Newhall, James Johnson Sweeney and James Thrall Soby.

20 For a diagrammatic representation of the museum's administrative structure see A. H. Barr, Jr, *The Museum of Modern Art, New York*, mimeographed fund-raising brochure, New York, 1936, p.16.

21 Barr, *Present status and future direction of the Museum of Modern Art*, p. 2. MoMA Archives: AHB Papers [AAA: 3266; 122].

22 In 1931 the Museum employed a public relations firm and from 1933 it employed a full-time Director of Publicity. For an account of MoMA's early use of publicity see Lynes, *Good old modern*, pp. 126–35. The 1932 opening of its quarters on West Fifty-third Street was accompanied by a radio broadcast.

23 A review of the opening exhibition 'Cézanne, Gauguin, Seurat, and van Gogh', praised: 'Never before, either here or in Europe . . . has the art of these men been more favorably shown, both as regards the excellence of the examples chosen and the way in which these are displayed . . . the pictures, widely spaced on walls covered with a fabric of becoming color and admirably lighted by lamps concealed in recesses of the rafters of the ceiling, show to

their best advantage.' B. Burroughs, 'The Museum of Modern Art', *Bulletin of the Metropolitan Museum of Art*, XXIV, 1929, p. 320.

24 Barr, *Present status and future direction of the Museum of Modern Art*, pp. 3–4. MoMA Archives: AHB Papers [AAA: 3266; 123–4] (my emphasis).

25 H. McBride, 'Opening of the new Museum of Modern Art', *New York sun*, 13 May 1939, p. 10. Reprinted in D. C. Rich, ed., *The flow of art: essays and criticism of Henry McBride*, New York, 1975, p. 370.

26 Barr, *A new art museum*, p. 72.

27 Alfred Barr favoured a prominent European as museum architect and consulted J. J. P. Oud, Walter Gropius and Ludwig Mies van der Rohe about a possible commission. Mies emerged as the most likely candidate, being both available and very interested in the project. However, the museum's president A. Conger Goodyear and most of the trustees thought an American more appropriate. They appointed Goodwin, who also was a trustee, and Stone while Barr was absent in Europe. For a complete account of the affair see R. Roob, '1936: the Museum selects an architect', *Archives of American Art Journal*, 23, 1983, pp. 22–30.

28 T. F. Hamlin, 'Modern display for works of art', *Pencil Points*, XX, 1939, p. 615.

29 McBride, 'Opening of the new Museum of Modern Art', p. 370.

30 Quoted in Macdonald, 'Profiles – action on West Fifty-Third Street – I', p. 49.

31 Hamlin, 'Modern display for works of art', p. 616.

32 L. Sukert, 'The retail shop: an opportunity for architect and merchant', *American Architect*, 142, 1933, p. 25.

33 W. Benjamin, 'Das Passagen-Werk', in *Gesammelte Schriften*, ed. Rolf Tiedemann, third edition, Frankfurt am Main 1989, vol. V:1, p. 522.

34 Rosalind Krauss has established the inherent authoritarianism of the grid in modernism: 'Surfacing in pre-War cubist painting and subsequently becoming ever more stringent and manifest, the grid announces, among other things, modern art's will to silence, its hostility, to literature, to narrative, to discourse . . . There are two ways in which the grid functions to declare the modernity of modern art. One is spatial; the other is temporal. In the spatial sense the grid states the autonomy of the realm of art. Flattened, geometricized, ordered, it is antinatural, antimimetic, antireal . . . In the flatness that results from its coordinates, the grid is the means of crowding out the dimensions of the real and replacing them with the lateral spread of a single surface. In the overall regularity of its surface, it is the result not of imitation, but of aesthetic decree . . . The grid declares the space of art to be at once autonomous and autotelic' ('Grids' in *The originality of the avant-garde and other modernist myths*, Cambridge, Mass. and London, 1986, pp. 9–10.

35 Hamlin, 'Modern display for works of art', pp. 618–20 (my emphasis).

36 H. A. Read, 'Art in our time,' *The American Magazine of Art*, 32, 1939, p. 339. For an analysis of MoMA's galleries (as they existed in the 1970s) as labyrinth see Duncan, Wallach, 'The Museum of Modern Art as late capitalist ritual: an iconographic analysis.'

37 For a discussion of Barr's chart and concept of art history see S. N. Platt, 'Modernism, formalism, and politics: the 'Cubism and abstract art' exhibition of 1936 at the Museum of Modern Art', *Art Journal*, 47, 1988, pp. 284–95; W. J. T. Mitchell, '*Ut Pictura Theoria*: abstract painting and the repression of language', *Critical Inquiry*, 15, 1989, pp. 348–71; R. Rosenblum, 'Foreword', in A. H. Barr,Jr, *Cubism and abstract art*, third edition, Cambridge, Mass. and London, 1986, pp. 1–4.

38 McBride, 'Opening of the New Museum of Modern Art', p. 371.

39 E. Shaw, 'New York's art galleries draw universal interest', *Spokane Spokesman Review*, 16 July 1939.

40 Cf. Ricciotti, 'The 1939 building of The Museum of Modern Art: the Goodwin–Stone collaboration', *American Art Journal*, summer 1985, pp. 57–9.

41 In the years 1929 to 1940, the insurance value of paintings and sculptures acquired by gift ($645,268) was more than ten times the value of the purchases ($62,396), (Barr, 'Chronicle of the collection', p. 628).

42 W. Benjamin, 'Paris – the capital of the nineteenth century', in *Charles Baudelaire: a lyric poet in the era of high capitalism*, London and New York, 1983, pp. 168–9.

43 M. Brenson, 'Modern museum closing until May', *New York Times*, 26 December 1983, p. C11.

44 Brian O'Doherty, *Inside the white cube*, San Francisco, 1976.

45 McBride, 'Opening of the new Museum of Modern Art', p. 371.

46 A. Packard, *A report on the development of the Museum of Modern Art*, typescript, New York 1938, pp. 88–9.

47 M. Weber, *The Protestant ethic and the spirit of capitalism*, London, 1985, pp. 170–1.

48 H. Marcuse, 'The affirmative character of culture', in *Negations: essays in critical theory*, London, 1988, p. 103.

49 'By distributing the work of the avant-garde to various departments . . . by stringently enforcing what appears to be a natural parceling of objects according to medium, MOMA automatically constructs a formalist history of modernism' (D. Crimp, 'The art of exhibition', *October*, 30, 1984, reprinted in A. Michelson, R. Krauss, D. Crimp and J. Copjec, eds, *October: the first decade, 1976–1986*, Cambridge, Mass. and London, 1987, p. 244).

50 For a discussion of MoMA's and in particular Alfred Barr's treatment of Russian constructivism see: Crimp, 'The art of exhibition', pp. 240–7; and B. H. D. Buchloh, 'From faktura to factography', *October*, 30, 1984, reprinted in Michelson, *et al.*, *October: the first decade*, pp. 77–9.

51 MoMA's first exhibition solely devoted to Russian constructivist artists was the 1948 'Gabo–Pevsner' retrospective (though selected constructivist works were featured in survey exhibitions, such as 'Cubism and abstract art', 1936). Other victims of the museum's discriminating construction of the history of modern art were Dada and much of radical German modernist architecture and design – neglected because of their attack on the autonomy of the modern work of art.

52 P. Bürger, *The theory of the avant-garde*, Manchester, 1984, p. 46.

Select bibliography

The excellent Archives of the Museum of Modern Art provide a complete documentation of the museum's history from its foundation in 1929. The most important source are the Papers of Alfred H. Barr, Jr which are also available on microfilm in the Archives of American Art. Useful information about the Museum's activities can also be found in the *Bulletin of the Museum of Modern Art* (published from 1933) and the irregularly published *Annual Reports*. The Museum of Modern Art's annual *Studies in Modern Art* (no. 1 published in 1991) deal with works in the collection and the Museum's history.

Barr, A. H. Jr, *Painting and sculpture in the Museum of Modern Art, 1929–1967*, New York, 1977.

Duncan, C., 'The MoMA's hot mamas', *Art Journal*, 48, 1989, pp. 171–8.

Duncan C. and A. Wallach, 'The Museum of Modern Art as late capitalist ritual: an icono-graphic analysis', *Marxist perspectives*, 1, 1978, pp. 28–51.

—'MoMA: ordeal and triumph on 53rd Street', *Studio International*, 194, 1978, pp. 48–57.

Goodyear, A. C., *The Museum of Modern Art: the first ten years*, New York, 1943.

Greenberg, R., 'MoMA and modernism: the frame game', *Parachute*, 42, 1986, pp. 21–31,

Hunter, S., *The Museum of Modern Art, New York: the history and the collection*, New York, 1984.

Legg, A., ed, *Painting and sculpture in the Museum of Modern Art: catalogue of the collection, January 1, 1977*, New York, 1977.

Lynes, R., *Good old modern: an intimate portrait of the Museum of Modern Art*, New York, 1973.

MacDonald, D., 'Profiles: action on West Fifty-Third Street – I', *The New Yorker*, 12 December 1953, pp. 49–82; 'Profiles: action on West Fifty-Third Street – II', 17 December 1953, pp. 35–72.

Mashek, J., 'Embalmed objects: design at the Modern', *Artforum*, XIII, 1975, pp. 49–55.

'The Museum of Modern Art at Fifty', *Art News* (special issue), 79, 1979.

Phillips, C., 'The judgement seat of photography', *October*, 22, 1982, pp. 27–63.

Platt, S. N., 'Modernism, formalism, and politics: the 'Cubism and abstract art' exhibition of 1936 at the Museum of Modern Art', *Art Journal*, 47, 1988, pp. 284–95.

Ricciotti, D., 'The 1939 building of the Museum of Modern Art: the Goodwin–Stone collabo-ration', *American Art Journal*, summer 1985, pp. 51–76.

Riley, T., ed., *The international style: exhibition 15 and the Museum of Modern Art*, New York, 1992.

Roob, R., 'Alfred H. Barr, Jr.: a chronicle of the years 1902–1929', *New Criterion*, summer 1987, pp. 1–19.

—'1936: the Museum selects an architect', *Archives of American Art Journal*, 23, 1983, pp. 22–30.

Sandler I., and Amy Newman, eds, *Defining modern art: selective writings of Alfred H. Barr, Jr*, New York, 1986.

Scolari-Barr, M., 'Our campaigns', *New Criterion*, summer 1987, pp. 23–74.

Wallach, A., 'The Museum of Modern Art: the past's future', *Journal of Design History*, 5, 1992, pp. 207–15.

INSIDE-OUT: ASSUMPTIONS OF 'ENGLISH' MODERNISM IN THE WHITECHAPEL ART GALLERY, LONDON, 1914

Juliet Steyn

TO DEFINE INVOLVES making categories, which entails drawing boundaries and differentiating. In 1914, the Whitechapel Art Gallery organised an exhibition called 'Twentieth century art (a review of modern movements)'.[1] This, a pivotal exhibition, was part of the processes through and in which a specifically 'English' account of modernism was created and installed. Its aim was to map out the development of modern art and, indeed, it occurred at a moment when, as Charles Harrison has suggested, 'the mainstream practice of modern art was defined and entrenched in England'.[2] Definitions create identities and produce hierarchies.

This chapter, through a study of the exhibition 'Twentieth century art', will examine the institution of the Whitechapel Art Gallery and its role in the formation of an identity for English modernism. It will explore also a web of shifting discourses which themselves constructed, and were constructed by, cultural boundaries and hierarchies. Furthermore, it will argue that distinctive categories, which situated an *inside* and an *outside* of and for accounts of modern British art, were produced in the exhibition. Here attention will be drawn to the formation of yet another category which occupied a space which is *outside* even when *inside* – that occupied by the 'alienised'. The special display of works by Jewish artists, in 'Twentieth century art', curated by David Bomberg, was important. For there in that place, (*outside* the *inside*), differentiation occurred and hierarchies were negotiated. The exhibition staged and was framed by a double strategy which could function only through inclusions and exclusions which were themselves set in motion through the shadowy presences of the alienised. Finally, I will discuss ways in

which critics represented the exhibition and argue that these not only articulated and installed dominant definitions of modern art in Britain but also replicated social categories.

The Whitechapel Art Gallery has an institutional history of which it is also a product. It was opened on its present site in east London on 12 March 1901. The gallery was the outcome of twenty years of exhibitions organised in St Jude's School by Canon and Henrietta Barnett. These events attracted an increasing number of visitors, from 10,000 in 1881 to 55,300 in 1886.[3] This success meant that extra space for exhibitions was needed. In 1897, Canon Barnett decided to purchase land to build, as he put it, 'a permanent Picture Gallery scheme'.[4] Within two weeks he had raised the estimated £6,000 necessary for the project and commissioned the architect Charles Harrison Townsend – who had established a reputation as architect of the Bishopgate Institute (1894) – to design the building. The location chosen was next to the Passmore Edward's Library[5] on Whitechapel High Street. The decision to build an art gallery next to a library was significant: their social roles were seen as compatible. It was considered that both provided the means for the social advancement of the working classes and for providing them with a respectable and sober form of recreation. Culture was intended to mould people: in the reproduction of social roles and in the productive processes.

By the late nineteenth century a transformation of the public and private spheres was occurring. Education, in a variety of sites, including the Whitechapel, strove to secure, sustain and legitimate itself as a 'body', and a 'voice' in the public domain. Art galleries were part of a larger project of social organisation and one in which culture was used to educate and morally uplift the public. Barnett saw 'art as a teacher' and pictures as 'preachers, as voices of God passing his lessons from age to age'. His language resonates with the zealousness of Christian socialism. Instruction through art, he believed, would lead to the improvement of the 'lower classes'. By teaching them to admire the beautiful, they would gain insights and understandings which would enable them to share the values of the classes above them. The gallery sought to inculcate in the local population a higher subjectivity which could transcend 'base nature' by offering experiences, feelings and pleasures that went beyond what were understood as the mindless routines of working-class lives. Furthermore, Barnett argued: 'There can be no real unity so long as people in different parts of a city are prevented from admiring the same things, from taking the same pride in their fathers' great deeds and from sharing the glory of possessing the same great literature.'[6] Education and art were considered as foundations through which social problems would be ameliorated, a 'common' culture created, and 'one' nation produced.

The Whitechapel Art Gallery addressed itself to culturally differentiated communities: foreigners (the Irish, the Jew, etc.), outsiders (the working classes, women, etc.) who needed incorporating into the evolving idea of the nation state. It has been argued, notably by Philip Dodd, that the years 1880–1920 entailed the invention, transformation and remaking of English identity. Its successful creation was both predicated upon and nourished by the illusion that 'everyone had a place . . . and had contributed to the past which had become a settled present'[7] – while at the same time, as David Feldman suggests, practices that departed from or did not fit in with the evolving national pattern and ideas about one nation were construed and represented as alien.[8] Increasingly since the 1880s, Jewish immigrants from eastern Europe were settling in east London, and the area of Whitechapel conveyed a sense of 'race', as well as class concentration. Indeed, for many contemporary observers the East End of London meant the Jewish East End. The Jews in Britain stood out as a disturbing alien presence who, it was thought,[9] hindered the construction and consolidation of the nation. Their assimilation to, and dissimulation from, English middle-class values was the necessary complement to the definition of the dominant English. Jews were subjects of, and subject to, the programme of exhibitions, lectures and guided tours organised at the gallery.

The 1906 exhibition 'Jewish art and antiquities'[10] shaped a Jewish identity, in relation to the wider issue of making a common, national identity defined as English. It sought to teach the 'foreign' Jew to assimilate and, at one and the same time, reminded Jews and non-Jews alike that this process had already been accomplished. The version of 'Jew' offered by the exhibition or adduced by the catalogue was predicated upon particular notions of assimilation, middle-class moral values, high culture, judgements on class and – in the wake of anti-alien agitation, which led to a Royal Commission whose findings culminated in legislation to restrict immigration[11] – a defence against anti-semitism.

The art history produced in the exhibition was that of the disinterested observer of 'truth'. The question of the display, which included paintings, decorative art, synagogue ornaments and manuscripts gathered from western Europe, was the problem of representing history and reality. Empirical methods, derived from the natural sciences, structured the form of 'Jewish art and antiquities'. Facts and 'data' were accumulated to give the exhibition the authority of science. The catalogue was at pains to point out that the show was not exhaustive or even representative in that it included just a few 'specimens'. The word *specimens*, with its scientific connotations, reminded the viewer that, in spite of the miscellaneous collection of objects on view, the items served as evidence of greater 'truths'. The chaos of miscellany was overcome

by the display of specimens. The exhibition ordered, channelled and con-
structed historical 'reality' and 'truth'. It offered as truth the pretence that what
was in reality an unceasing struggle over identity (Jewish and/or English) had
already been settled, and offered a version of 'Jew' compatible with an English
middle-class form of life and morality.

The social and ideological assumptions of the exhibition were legitimated
by discourses which provided and articulated the 'rules' for what was to be
apprehended as 'reality' and 'truth'. The instituting discourse, the exhibition
catalogue, was intended to be didactic. All catalogues at the Whitechapel, as
the Trustees' Report following the exhibition 'Jewish art and antiquities'
explained, were to describe 'the pictures in language which aimed at linking
the subject to the experience of the visitors, and at assisting their judgement
in appreciating the various merits'.[12] Yet, it seems from the tone of this
Trustees' Report that the value of art and the educative purposes of art exhibi-
tions was not taken as given. The text is a defensive attempt to fend off antic-
ipated criticisms. It suggests that the particular claims it wished to make, for
the value and uses of art, needed after all to be established, argued and
defended. The voice of the Report is assertive. Experience, it argued, had
taught:

> that with higher tastes people turn away from the things which make for
> poverty. A great love of beauty means, for instance, greater care for cleanliness,
> a better choice of pleasures, and increased self-respect. The use of the powers of
> admiration revealed new interests which are not satisfied in a public house but
> drives their possessors to do something both in their world and their play which
> adds to the joy of the earth. The sordid character of many national pleasures
> and the low artistic value of much of the national produce is due to the unused
> powers of admiration.[13]

The text opposed value to necessity. The need for 'beauty' was set against
the need for 'bread'. 'Admiration', which would transform individuals by
leading them away from 'base pleasures' characterised as 'sordid', would be
transmuted by the 'powers of admiration', as would the 'national produce'.
A choice was explicit: in this discourse high culture would rescue the
masses from all forms of poverty – social, economic, moral, intellectual and
spiritual. But perhaps the over-defensive tone signalled anxiety and suggests
that the efficacy or viability of the strategy was in question. Certainly by the
1890s, as Gareth Stedman Jones suggests, institutions in the public sphere
were changing their social roles. No longer were they seen as manor houses
from which a new 'squirarchy' would lead the poor to virtue. They were
increasingly perceived as 'social laboratories' where professional adminis-
trators could work out their new principles of social policy.[14] Here political

exigencies were transformed into rational authority which itself was meant to represent the general interest. This was also the moment when, according to Harold Perkin, the political extension of citizenship to the whole community began the processes of 'differentiating professional society from its predecessors'.[15]

The Whitechapel Art Gallery was a late venture. It was itself caught in a conundrum articulated by incompatible discourses: philanthropy versus professionalism. Over the next years, and certainly by 1914 in the exhibition 'Twentieth century art', a shift of paradigm is evident. There can be witnessed a battle of competing discourses, trustees (for whom the gallery was still a philanthropic venture) against curators (for whom art was a discrete practice, with its own discourses which were to be legitimated by the expert administrator). The form of artistic re-evaluation signalled by the exhibition and its catalogue is significant and made all the more so given the particular history and ideology of the gallery.

The paradigmatic change was made explicit in the catalogue which accompanied the show. It started with a short essay to frame the exhibition and continued with a list of artists' names, lenders or the title of the work. Authorship and ownership were given priority. There was no additional amplification or elucidation of works. Implicit in this schema is the idea that knowledge springs directly from the objects themselves. The exhibition employed a modernist approach to art which has now become the familiar discourse of professional art historical management. Art history is presented as a seamless chronology. Art works were to be 'read' through the text 'artist' and/or through the notion of 'style'.

The story mounted by the catalogue sought to make connections across a diverse range of art through identifying their stylistic similarities. In 'Twentieth century art' a broad range of works, from Impressionist to Cubist and Futurist, was shown. Vanessa Bell, Henry Lamb, Gaudier-Brzeska, Stanley Spencer, Paul Nash and Wyndham Lewis were amongst those who had work on view. In addition a large collection from Roger Fry and the Omega Workshop was displayed.[16] Separated from the rest and hung together in the Small Gallery were works by Jewish artists. A Jewish section within this exhibition did not, and indeed could not, conform to or fit in with the overall theme of the show with its aim to instate a modernist aesthetic into British art discourses. What bonded this section together was the Jewish origins of the participants. Fifty-three works by fifteen artists were displayed. These included Bomberg, Gertler, Kramer, Modigliani, Wolmer and Pascin.[17] However, before we examine the significance of this section the parameters of the exhibition as a whole will be considered.

As mentioned earlier, correspondences between styles formed the basis for

categorising the works and indeed the rationale for the hanging. The show was divided into four main groups. The first group showed the influence of Walter Sickert and Lucien Pissarro on modern art and stressed their use of ordinary subjects which, it was argued, were treated in a 'luminous' manner; the second constructed links between Puvis de Chavannes, Alphonse Legros and Augustus John whose works were characterised by their persistent use of decorative design and linear simplifications in the treatment of human types; the text argued that a third group had a debt to Impressionist painting and to Cézanne and suggested further that this work differed from the previous group in its use of volumetric drawing and its abandoning of perspective. The final group was characterised as having given up representation almost entirely. This group, it was pointed out, had recently established a Rebel Art Centre. Though not displayed in this context, the works of Bomberg were mentioned in the catalogue as if included in this group. His paintings and drawings were to be found in the Small Gallery with the works of other Jewish artists.

As a whole, the exhibition was conceived as a follow-on to a show staged in the Whitechapel four years earlier, called 'Twenty years of British Art'.[18] There, the intention had been to show what had happened in art since the 'absorbtion' (*sic*) of the lessons of French Impressionism: 'The Twentieth Century Art exhibition is concerned with the progress of art since the absorbtion of the Impressionist teachings, as shown in the work of Younger British artists.'[19] The 1910 exhibition was designed to show the impact on art of French Impressionism, which it considered to have moved art away from 'naturalism'. According to the 1914 catalogue the earlier exhibition had

> showed that artists had moved away from an academic treatment of history, anecdote, and sentimentality, and had gone in search of a more brilliant treatment of light in landscape, and of more truly decorative treatments of subject, and of a more intimate treatment of human life generally.[20]

Here the sketch is gaining priority over finished painting. Private expression is celebrated over academic skill, and French painting becomes the model for modern art. Explicit too is the notion of progress, which in art was taken to mean the assertion of the autonomy of aesthetic experience. Implicit also is the association of 'development' with an artistic language or style which now meant the avoidance of subjects which could be construed as morally charged. Moral incitements were being transmuted into progressive imperatives. Additionally, by creating a link between the two exhibitions, 'Twenty years of British art' and 'Twentieth century art', the notion of art as a continuously evolving process was installed.

The catalogue accompanying 'Twenty years of British art' did not have entries on each of the 569 items on display. It vacillated in its schema from one which would seem to let the art 'speak for itself' to another with an overtly didactic purpose. The commentary produced for *The convalescent* by Ambrose McEvoy is typical.

> This modest picture is a remarkable example of the attainment of the harmony necessary to make a painting into a fine work of art. The simple lines of the bare room, the sober colour scheme of ivory and brown and dim red, the quiet light falling on the sofa and its occupant, all combine to carry forward the expression of a gentle, homely beauty.[21]

This caption shows a critical discourse now mediated through particular understandings of French art. The form and the design both articulate 'gentle, homely beauty' which together evoke a scene of calm and simple domesticity. The text links form and content to produce a message which celebrates and idealises the virtues of home. But above all, it is the achievement of a particular aesthetic quality, 'harmony', which secures this picture as a modern work of art.

An uncharacteristically lengthy entry on Tonks's *Rosamund and the purple jar* (fig. 11.1) spells out the ways in which modern art was understood to be different and superior to Pre-Raphaelite art.

> Behind the work of the artist here one feels a wider culture, a mind that knows childish things for what they are. He can delight in them, and, when his theme, as here, enjoins, revel in their charm, but we feel that he can also put childish things away. He does not labour under the illusion, natural and even praiseworthy as it was in the case of the Pre-Raphaelites, that the only way of art lies in childish methods.[22]

The differences produced in and by the text between Tonks's picture and a Pre-Raphaelite painting established the ground for differentiating and classifying modern art. In this discourse modern painting is interpreted as more knowing, more intelligent, more discerning in concept and in the handling of paint. Modern art is produced as superior in so far as it demonstrates a greater understanding of the methods and procedures of art. Judgements on art are to be made in terms deemed intrinsic to art itself. Through this form of critical re-evaluation, the role of art and the artist's moral responsibility is redefined: modern art is identified and made.

'Twenty years of British art' was part of a process whereby the idea of art as a distinct culture demanding recondite knowledge was being formulated, articulated and promoted. The primary concern of art was to be aesthetic, and art history and criticism were constructed around the artist and his (*sic*) stylistic precedents. Or as the catalogue put it:

11.1 Henry Tonks, *Rosamund and the purple jar*, oil on canvas, 52.7×37.4 cm.
Tate Gallery, London

> A feeling common to the painters, sculptors, and designers represented in the exhibition is that of a compulsion on the artist towards a more personal state-ment of his relation towards his subject in particular and to life in general than has been expressed in the preceding phases of the development of art.[23]

The role of art is given a new formulation. The responsibility of art is rede-scribed through a notion of 'artist' whose work must be authentic (personal). The 'moderns' were drawing up a hermetically sealed account of art which increasingly becomes the domain of the 'expert', the professional curator and administrator of art.

In 1912 contemporary artistic theory had been polarised by the London launch of Post-Impressionism. The Royal Academy, attempting to maintain its prestige and power, closed rank against 'modern' art. The plutocratic regime of the Royal Academy was defending its own system of private commissions against the private galleries and market forces. These social and economic exigencies were transmuted into aesthetic debates, in which Post-Impressionism, through Fry's and Bell's aesthetic theory, was constructed as progressive (modern) and defined in opposition to the values of the Royal Academy in Piccadilly which were represented as reactionary.

By pitting the one institution against the other, the critics of *The Times* and *The Observer* recreated those polemics in the reviews of 'Twentieth century art'. *The Times* asserted:

> This exhibition in Whitechapel seems like a challenge to the other in Piccadilly. The Piccadilly artists would say, no doubt, that Whitechapel is the proper place for it and Billingsgate the proper language. Art, like life, is at any rate more exciting in Whitechapel than in Piccadilly. Something is happening there and nothing at all at Burlington House.[24]

Through the nature of the exhibition 'Twentieth century art', the Whitechapel presented a challenge to the prestige of the Royal Academy. The values espoused by the Royal Academy served as a negative foil against which 'pro-gressive' or 'advanced' art could be assessed and measured. In these dis-courses, the Whitechapel represented the modern, progressive culture of the market economy and the administrative state.

For *The Observer* the exclusion of works by Royal Academicians was at least as worthy of comment, as significant, as those works which were included in the show:

> There is scarcely an exhibitor at the Whitechapel who is represented at the Royal Academy. We are thus faced with the remarkable fact that the official guardians of the nation's art, the members of the Royal Academy, refuse to take any account of the vast movement, or succession of movements, which have led twentieth century art into new paths, and, on the other hand what pretends to

a representative exhibition of twentieth century art, organized by laymen who have no axe to grind and who have on previous occasions given proof of their liberal spirit, absolutely ignores the existence of the Royal Academy.[25]

A metaphorical battle – East versus West; administrative versus plutocratic culture; commissions versus market forces; progressive versus reactionary –was here being played out.

'Twentieth century art' was selected by the gallery director, Gilbert Ramsey, with the help of the previous director Charles Aitken who, in 1911, had been appointed director of the Tate Gallery. They had asked permission of one of the Trustees, William Dawson, to dispense with the usual practice of setting up an advisory committee for the exhibition. In a letter dated 5 February 1914 Dawson acceded to this request with the proviso that: 'we shall not have many examples of the "Cubist" and "Futurist" school, though perhaps we should have one or two as an example of what certain members of the public can be induced to tolerate.'[26] To whom was he referring? Whatever may be postulated as an answer to this question, Dawson's fears seem to have been well founded. The *Daily Express* asked what would be the consequences should 'a whole flood of *isms* be let loose like a cataract on the unprepared East End?'[27] The director of the National Gallery, J. B. Manson, had written to Ramsay express-ing his disquiet at the decision to include Cubist works in the exhibition.[28] On 15 May Dawson, in response to a letter from the chair of trustees of the Whitechapel, The Hon. Harry Lawson, MP, which alerted him to an article in the *Telegraph* by Sir Claude Phillips, agreed with the view that the trustees: '*assume a grave responsibility in opening the doors of such an exhibition without careful preparation and warning to the artistic youth and larger public of East London.*'[29] Thus for the trustees, if not the curators themselves, a paternalistic role for art exhibitions was still on the agenda. But if this entailed the 'careful preparation' of the public, many of the critics appear to have been ill-prepared for the exhibition.

The *Star*[30] began its review with a critique of the title of the show. The critic castigated the organisers for creating expectations which were misleading. Furthermore, the exhibition was 'bewildering'. *The Standard* saw it as an insane attempt to present a complete review of the whole evolution of modern art. Bomberg's *In the hold* (fig. 11.2), *Ezekiel* and *Racehorses* were singled out for comment.[31]

Moreover, a number of other newspaper reports completely misrepre-sented the exhibition. Out of 494 exhibits, a total of thirteen – by Nevinson, Roberts, Wadsworth, Etchells and Wyndham Lewis – could be described as Cubist or Futurist. Nevertheless, the headline in *The Observer* ran 'Futurist art in Whitechapel'[32] and a notice appeared in the *Daily Express*[33] under the title 'Futurist picture show'.

11.2 David Bomberg, *In the hold*, oil on canvas, 196.2 × 231.1 cm. Tate Gallery, London

The *Manchester Guardian* suggested that all Jewish artists were Cubists: 'The little gallery at Whitechapel is always made a particular feature of in these exhibitions. This year it will house the younger Jewish artists with Mr. Bomberg and other cubists as the nucleus.'[34] Yet Bomberg was the only artist in the Jewish section whose work could have been characterised in that manner. The way in which the press dealt with Cubism and Futurism served to associate those forms of modernism with Jewish artists. Or, if not with the Jews then with foreign or malign influences.

The message of *The Westminster Gazette* was as clear as a bell: modern art was infected by foreign influence. Commenting upon the works of Duncan Grant the reviewer argued: '[Grant] has surrendered the gift which enabled him to paint a picture so beautiful as the "Lemon Gatherers" for an apprenticeship in cabalistic decoration.'[35] The force of the reference to the Cabala is to intensify a specifically Jewish connotation, and in this case and this context suggests the idea of an occult, irrational world where reason has been lost. The language is emotive. The idea of Grant 'surrendering' his talent evokes the sense of the artist losing himself to an outside alien force. He is seduced by an evil influence (modern art). But the text goes on to argue that Grant could save himself through applying reason.

According to *The Westminster Gazette*, William Roberts was also in grave danger: he had overdosed on modernism. However, the text argued – following the rationale of the catalogue – that if an evolution such as Cubism was legitimately worked out, this evil influence need not be serious. None the less the article continued with further reproaches: 'and soon the individual artist finds himself out of sympathy with the Academy, yet believes that the language of art is a common speech based upon representation of reality, will be forced for his own life's sake to subscribe to a movement as to a trade union.'[36] Here, modern art is equated with trade union politics. And the power of this particular association also served to suggest that personal or artistic freedom is at stake. Artistic integrity and political conformity were posed in opposition. In this discourse, progressive art becomes unfree.

Whilst the catalogue argued that the development of modern art was evolutionary, the press tended to depict its nature as revolutionary. The term *revolutionary* had, by this moment, acquired quite particular meanings. It was represented in opposition to evolution. The former connoted violent change and the latter a planned or 'natural' transition. Charles Harrison[37] has traced the use of 'revolutionary' in the context of art to an article dating from 1910, by Frank Rutter. The article was a defence of Post-Impressionism. Certainly by 1914, if the reviews of the 'Twentieth century art' exhibition are anything to go by, it was seized upon with alacrity. Doubless, as Harrison also argues, 'revolutionary art' was not then a term applied casually.

The review in *The Star* displayed anxiety about thinking calmly and constructively about these 'artistic revolutionaries'.[38] Moreover, the *Observer*[39] described the exhibition as representing a revolutionary movement and again, taking up the theme in institutional terms, argued that the exhibition undermined and threatened the position of the Royal Academy. The text continued, commenting on Bomberg's *In the hold*, in the following terms: 'Here one young fellow with artistic if rebellious instincts exclaimed – I'm going home to buy a penny box of paints and do some of those pictures myself. That's what I'm going

to do.' Here two points were made: firstly, it is a rebellious young man who is drawn to modern art; and secondly, modernism invites the uneducated or unsophisticated to enjoy it. Rebelliousness and ignorance are represented as if inherent to the apprehension and appreciation of modernism.

The Morning Post[40] made an oblique, though immediately recognisable, reference to the Jewish East End. 'The Commercial Road ought to test their appeal to the love of bright colour an implicit grotesque humour, and the like.' The Commercial Road connoted 'Jewish' in terms of locality and – perhaps – also through the identification of Jews with commerce. Additionally, the love of bright colour suggested a lack of sophisticated taste and restraint, as indeed did the idea of 'grotesque' humour. This characterisation suggests children or 'primitive' peoples. In the art discourses of the time, 'primitive' was used to connote nature, truth and sincerity or to signify the barbaric and uncivilised. For a traveller in unknown London, like Charles Booth, the working classes had been perceived as leading lives which were understood as congruent with their physical nature: 'I see nothing improbable in the general view that the simple natural lives of working class people tend to their own and their children's happiness more than the artificial complicated existence of the rich.'[41] If working-class life was seen as uncomplicated or simple in contrast with the complexity of the life of the rich, it was also seen as more authentic, as more real. Indeed Mark Gertler, in a letter to Brett dated January 1914, appears to have shared this view: 'I was extremely fortunate to live in the East End amongst real people.'[42] A month before in a letter to Carrington, he had elaborated this notion in aesthetic terms:

> As for realism – my work is real and I wanted it to be real. The more I see of life, the more I get to think that realism is necessary . . . I was born from a working man. I haven't had a grand education and I don't understand all this abstract intellectual nonsense! I am rather in search of reality.[43]

His text was both a celebration of the 'authenticity' of Jewish working-class life and a defensive attempt to ward off criticisms of it. Indeed, if the lives and experiences of East Enders were deemed to be direct, unmeditated and natural, according to *The Morning Post*,[44] they could be expected to find pleasure in an art which was bold, bright in colour, emotionally simple and closer to nature. By inference this was an art devoid of skill, elegance or refinement. It was 'primitive'. And again it was Bomberg's work that was used to exemplify these traits.

The apparently anecdotal account of *The Morning Post* described the gallery as half filled with children, some brought in by parents. 'Stout, foreign mothers and dark sometimes ragged fathers.' These people were not just poor but alien too. *The Standard*[45] also suggested that children and foreigners could

understand these 'puzzle' paintings. Once more, it was Bomberg's work – *In the hold, Ezekiel* and *Racehorses* – which served as examples. *The Daily Telegraph* review explicitly mentioned the Jewish section: 'The small room contains a good collection from the brushes of Jewish painters. There are also a great many subjects that will appeal to children.'[46] Again the reference was to associate children and Jews.

The critical reception of the show created a version of modernism which it explicitly associated with evil. It constructed this modernism as repressive, as working against the freedom of the individual artist. It both linked modernism with revolution and trivialised revolutionary politics by characterising them as childish and unsophisticated. In short, this chain of associations and complicities anchored modernism to subversive, foreign, Jewish influences.

It is puzzling, given the anxieties voiced during the planning phase of the exhibition, as to what were the motives which led to the creation of a special display of work by Jewish artists. It is even more perplexing since this display did not fit with the overall theme and conception of the show. Its inclusion can be explained by local interests, that is to say, the Jewish constituency that the trustees of the Whitechapel sought to educate. But if the curators were intending to appease the trustees, then they failed to do so. William Dawson declared that the exhibition was 'a responsibility which I was not personally prepared to incur'.[47] And, if the special section of art by Jews had been devised to appeal to East End Jews in order to show to them and to others the success story of assimilated Jewry and its cultural achievements, it was a strategy which clearly backfired, as it was bound to do. To hang the works separately was a deeply ambiguous act; whilst they were in a position to be celebrated, they were also open to being reviled.

Judgements on art do not exist apart from the normative values of society. And for the press which produces and constructs, as well as mediating these values, the exhibition served to reinforce the myth of the Jew as a 'foreigner in our midst'. The hanging of the exhibition can be read as resonant with Simmel's idea of Jews as the very epitome of *strangers* – always on the *outside* even when *inside*.[48] Zygmunt Bauman has taken up this theme more recently in his book *Modernity and the Holocaust*, suggesting: 'The objects of anti-semitism occupy as a rule the semantically confusing and psychologically unnerving status of foreigners inside.'[49] Moreover, as the words of Edouard Drumont (a French MP and a noted anti-semite) suggest, the very absence of solid boundaries between hitherto separate groups could in itself be the cause of confusion and lead to fear and resentment. He wrote, 'A Mr. Cohen who goes to synagogue, who keeps kosher is a respectable person. I don't hold anything against him. I do have it in for the Jew who is not obvious.'[50] So even

the fact that some Jews assimilated was used against them by anti-semitic theorists. Their presence, now articulated as the not-quite-identical was a distorted, displaced image of themselves. Ambivalence moves to menace. No doubt, had the Jews not consented to assimilate they would also have been blamed for anti-semitism.

The liberal compromise had offered emancipation to the Jews in the expectation that they would move closer to British society. In this discourse it was argued that anti-semitism would only end when society tolerated the Jews, and this meant their assimilation. But this liberal creed allowed no place in society for Others. In Hannah Arendt's sharp words: 'Jews had been able to escape from Judaism into conversion; from Jewishness there was no escape.'[51] Equality of conditions, though certainly a basic requirement for justice, is nevertheless among the greatest and most uncertain ventures of modern society. The more equal conditions are, the less explanation there is for the differences that exist between people; and thus all the more unequal do individuals and groups of people become. Modernity was, as Bauman argued, simultaneously bringing about the levelling of differences and again creating boundaries and structuring further differences.

> Under conditions of modernity, segregation required a modern method of boundary building. A method able to withstand and neutralize the levelling impact of allegedly infinite powers of educatory and civilizing forces; a method capable of designating a 'no-go' area for pedagogy and self-improvement, of drawing an unencroachable limit to the potential of cultivation (a method applied eagerly, though with mixed success, to all groups intended to be kept permanently in a subordinate position – like the working classes or women). If it was to be salvaged from the assault of modern equality, *the distinctiveness of the Jews had to be re-articulated.*[52] [author's emphasis]

The Jews just did not fit in. But, paradoxically, that was their place. For although the category 'Jew' was ambivalent, there was no escape from it. Jews filled out and occupied the symbolically important place as *Other*. Cultural identity is always inseparable from the creation of boundaries. Furthermore, the cultural order is always constituted around the figures at its territorial edge which structure the relationships of *superior* and *inferior*. In Britain, Jews were installed at the extreme edge of social relations as *Others*, whereby they occupied both a cognitive and socio-economic position which secured and maintained them as different, distinctive and inferior. Correspondingly, in the exhibition 'Twentieth century art' the works by Jewish artists were constructed as *Other*. The terrain they occupied was literally and metaphorically *outside* the *inside* of modern art practices as they were being formulated in the exhibition.

In an argument which draws upon the work of Raymond Williams, Peter

Stallybrass and Allon White argue that a culture which is 'inherently domina-tive' (that is to say, constructed in a mode inclined towards domination), has access to power and prestige which enables it to create the definitions which come to dominate and form the *outside* and *inside*.[53] They continue:

> Bourgeois democracy emerged with a class which, whilst indeed progressive in its best political aspirations, had encoded in its manner, morals and imagina-tive writings, in its body bearing and taste, a subliminal elitism which was con-stitutive of its historical being. Whatever, the radical nature of its 'universal' democratic demand, it had engraved in its subjective identity all the means by which it felt itself to be a different distinctive and superior class.[54]

The democratic aims embedded in the particular aims of the 'Twentieth century art' exhibition were spelled out clearly in the accompanying catalogue which the authors ended with the following plea: 'They hope that all who are in sympathy with their conscious effort to introduce art to democracy will aid them in their endeavour to show that democratic feeling has been introduced in art.'[55] Democracy refers to an idea of open argument and equality amongst people who are all deserving of respect. But, as the press make plain, the aspira-tion to 'equality in difference' cannot stand up. It can only serve as an ideology of domination whose goal it is to hide that domination. The notion of rights in bourgeois democracy failed to erase Jew-as-other because the administra-tive state was based on a misrecognition of the relations of power in institu-tions and discourses through which social relations are mediated and regulated.

In its effects, the exhibition was to provoke and expose tensions between cultural differentiation and the formation of a national culture, and between cultural particularism and the totalising ambitions of the nation state. Nationalism depended increasingly for its definitions on criteria which were 'cultural', argues James Snead.[56] It was possible to classify national cultures through one culture projecting an image of its difference from another. In this way, superiority, deemed to be both natural and national, was established. Snead continues with reference to an argument mounted by Sigmund Freud in which Freud had opined:

> Closely related races keep one another at arm's length; the South German cannot endure the North German, the Englishman casts every kind of aspersion upon the Scot, the Spaniard despises the Portuguese. We are no longer aston-ished that greater differences should lead to an almost insuperable repugnance, such as the Gallic people feel for the German, the Aryan for the Semite, and the white races for the coloured . . . In the undisguised antipathies and aversions which people feel towards strangers with whom they have to do we may recog-nize the expression of self-love – of narcissism.[57]

We are in the unstable world of projection. When faced with non-British culture (and in particular the work displayed in the exhibition as Jewish art), the press, insensitive to nuances of desire, inevitably re-articulated difference to represent an inferior category: a modernism associated with subversion, foreignness, Jewishness. Modern art was here associated with malign influences. Some critics, seemingly blinded by fear, went so far as to explicitly connect Cubism and Futurism with Jewish artists. Furthermore, as we have seen, modern art was seen as part of the occult, irrational world of the *Other*, constructed as an alien force with an evil influence. But this art could be distinguished from another modernism, a superior modernism, which celebrated the notion of the purity of artistic expression. This was a modernism which could be legitimated as a democratic, progressive form of art. A version of modernism which sought to banish from the discourses of art, social, political, symbolic or ideological judgements, was being created. A place was made for art in which its ultimate value is 'aesthetic'. And aesthetic in a particular sense: one which banishes from its discourse any other deemed extrinsic to its own fantasy of purity.

The Whitechapel Gallery participated in the articulation, negotiation and administration of cultural identities national and/or *Other*. The chimerical place of the alienised was essential for the construction and articulation of the identity of a distinctively English account of modernism. No longer tempted to transgress, the modernism of British culture was rendered, for a moment at least, safe and pure, within such territorial pickets.

Notes

This text is an elaboration of an earlier article, 'Yids, mods and foreigners', published in *Third text*, XV, summer 1991. I am grateful to Andrew Brighton for his insightful comments which provoked me to rethink it and enabled another text to emerge and to Richard Appignanesi for generously giving his time proof-reading the text, for his helpful comments and encouragement.

1 'Twentieth century art (a review of modern movements)', summer exhibition, 1914, Whitechapel Art Gallery. The exhibition was from 8 May to 20 June and was open to visitors each day from 12 noon to 9.30 p.m.

2 Charles Harrison, 'Critical theories and the practice of art', in Susan Compton, ed., *British art in the twentieth century*, Royal Academy, London, 1986, p. 55.

3 Henrietta Barnett, *Canon Barnett: his life and work*, vol. II, London, 1918, p. 55.

4 *Ibid.*, vol. II, p. 154.

5 John Passmore Edwards was Liberal MP for Salisbury 1880–5. He gave grants of money to boroughs on the basis that libraries would be established.

6 S. and H. Barnett, 'Class divisions in great cities', in *Towards social reform*, London, 1909, cited in Frances Borzello, *Civilising caliban: The misuse of art 1875–1980*, Routledge, London, 1987, p. 32.

7 Philip Dodd, 'Englishness and national culture', in Philip Dodd and Robert Colls, *Englishness: Politics and Culture 1880–1920*, Croom Helm, London, 1987, p. 22.

8 David Feldman, 'The importance of being English: Jewish immigration and the decay of liberal England', in David Feldman and Gareth Stedman Jones, eds, *Metropolis London*, Routledge, London, 1989, passim.

9 See the Evidence taken by the Royal Commission on Alien Immigration cd. 1742, vol. II, 1903.

10 See Juliet Steyn, 'The complexities of assimilation in the exhibition 'Jewish art and antiquities' in the Whitechapel Art Gallery, London, 1906', *Oxford Art Journal*, 13:2, 1990.

11 Royal Commission on Alien Immigration, I, Report cd. 1742, 1903. The Bill was passed in 1905 and reached the statute books in 1906.

12 Trustees' Report, Whitechapel Art Gallery, 1907, p. 3.

13 *Ibid*, p. 3.

14 Gareth Stedman Jones, *Outcast London: a study in the relationship between the classes in Victorian society*, Penguin, Harmondsworth, 1984, p. 328.

15 Harold Perkin, *The rise of professional society: England since 1880*, Routledge, London, 1990, p. 9.

16 These works, listed in the catalogue nos 36–115, were all on sale. They included furniture and decorative items.

17 Fifty-three works by the following fifteen artists were shown: David Bomberg, Moses Kisling, Mark Gertler, Horris Brodsky, Isaac Rosenberg, Bernard Meninsky, Alfred Wolmark, Hubert Schloss, Morris Goldstein, Eli Nadelman, Pascin, Modigliani, Mark Wiener, Jacob Kramer and Clara Bernberg.

18 Twenty years of British art (1890–1910)', summer exhibition, Whitechapel, 1910.

19 'Introduction', 'Twentieth century art', catalogue, p. 3.

20 *Ibid.*, p. 3.

21 'Twenty years of British art', catalogue, p. 21.

22 *Ibid.*, p. 20.

23 *Ibid.*, p. 6.

24 Anon., 'Challenge of Whitechapel to Piccadilly: an exhibition in the East', *The Times*, 8 May 1914, Whitechapel Art Gallery archive. All press clippings have been taken from this archive and are unpaginated.

25 Anon., 'Twentieth century art at Whitechapel', *The Observer*, 17 May 1914.

26 Letter from William Dawson to Gilbert Ramsey, dated 5 February 1914, Whitechapel Gallery Archive.

27 P. K. G., 'Side-splitting-art', *Daily Express*, 8 May 1914.

28 Letter from J. B. Manson to Gilbert Ramsey, Whitechapel Art Gallery.

29 Letter from W. Dawson to The Hon. Harry Lawson, MP, dated 15 May 1914.

30 A. J. Finberg, 'The Whitechapel Art Gallery', *The Star*, 20 May 1914.

31 Anon., 'Cubists in East-End: picture-puzzles to be seen in Whitechapel', *The Standard*, 14 May 1914.

32 Anon., 'East End critics: Futurist art in Whitechapel', *The Observer*, 10 May 1914.

33 Anon., *Daily Express*, 11 May 1914.

34 Anon., 'Post-Impressionists for Whitechapel', *Manchester Guardian*, 9 April 1914.

35 J. M. M., 'Twentieth-century art', *The Westminster Gazette*, 21 May 1914.

36 *Ibid.*

37 Charles Harrison, *English art and modernism 1900–1939*, Allen Lane, London, 1988, p. 75.

38 Finberg, *The Star*, 20 May 1914.

39 *The Observer*, 10 May 1914.

40 Anon., 'Whitechapel Gallery', *The Morning Post*, 11 May 1914.

41 Charles Booth, *The life and labour of the People in London*, cited in Philip Dodd, 'Englishness and the national culture', p. 9.

42 Letter from Mark Gertler to the Hon. Dorothy Brett dated January 1914, Mark Gertler, *Selected letters*, ed. Noel Carrington, Rupert Hart-David, London, 1965, p. 63.

43 Letter from Mark Gertler to Carrington dated Sunday (December 1913), *op. cit.*, p. 60.

44 *The Morning Post*, 11 May 1914.

45 *The Standard*, 15 May 1914.

46 Anon., 20th century art: Whitechapel exhibition', *The Daily Telegraph*, 8 May 1914.

47 Letter from W. Dawson to the Hon. Harry Lawson, MP, *op. cit.*

48 Zygmunt Bauman, *Modernity and the Holocaust*, Polity Press, Cambridge, 1989, p. 53.

49 *Ibid.*, p. 34.

50 Drumont cited by Patrick Girard, 'Historical foundations of antisemitism', in Joel E. Dinsdale, ed., *Survivors, victims and perpetrators: essays on the Nazi Holocaust*, Washington, 1980, pp. 70–1, cited in Bauman, *Modernity and the Holocaust*, p. 58.

51 H. Arendt, *The origins of totalitarianism*, George Allen & Unwin, London, 1958, p. 87.

52 Bauman, *Modernity and the Holocaust*, p. 59.

53 Peter Stallybrass and Allon White, *The politics and poetics of transgression*, Methuen, London, 1986.

54 *Ibid.*, p. 202.

55 'Twentieth century art', catalogue, p. 5.

56 James Snead, 'European pedigrees/African contagious: nationality, narrative, and communality in Tutuola, Achebe, and Reed', in H. K. Bhabha, *Nation and narration*, Routledge, London, 1990, p. 235.

57 Sigmund Freud, 'Group psychology', *Civilization, society and religion*, Penguin, Harmondsworth, 1986, p. 131.

THE FRIGHTENING FREEDOM OF THE BRUSH: THE BOSTON INSTITUTE OF CONTEMPORARY ART AND MODERN ART

Serge Guilbaut

IN THE LATE 1940s during the first stages of the cold war, freedom of experi-
mentation was automatically equated in certain quarters with liberal freedom
and in opposition to totalitarianism. Any attempt to curtail the artist's
freedom of expression was seen as tantamount to treason. When America was
trying to lead the western world in a crusade against totalitarianism, American
culture itself had to reject isolationism and Americanism for a liberal interna-
tional language. Liberals who refused to see art production in political terms
were bound to make serious mistakes in this new, Manichean, international
postwar world.

It is against this backdrop that the controversy surrounding the 1948
publication of the ICA manifesto, *'Modern art' and the American public*,
should be seen and understood, if one wants to make sense of the hysterical
response it generated.

The 'Boston affair' developed in a very volatile historically painful
moment for the United States during which a total reorganisation of
American culture was attempted by a liberal elite who understood the
importance of modern culture in the symbolic struggle with Russia for world
hegemony during the cold war.

The 'Boston affair', starting with the publication in February 1948 of a man-
ifesto by the Boston Institute of Modern Art, was a response to this complex
political situation, as well as an attempt to define the Institute's position on
the general reorganisation of American culture after the Second World War.

In February, the Boston Institute of Modern Art, which had been established
in 1936 as a branch of the Museum of Modern Art of New York, decided to

change its name to The Institute of Contemporary Art. This apparently harm-
less one-word change sparked, not only in Boston but in the whole country, a
critical upheaval that would shake up the American art world for several years.

The issue, 'modern' art, was then so hot that the Institute felt the need to
make a public statement to publicise the move. This manifesto, *'Modern Art'*
and the American public, was signed by Nelson W. Aldrich (president) and
James S. Plaut (director) and was published with the intent of making a large
impact: ten thousand copies were printed and distributed internationally by a
professional firm from New York. This effort was carried out, no doubt, in
part, to respond to a growing concern in the press about the unintelligibility
of modern art, about its elitism and its foreign content.

Aline B. Louchheim, the art critic for *The New York Times*, wrote several
didactic articles about the history and meaning of modern art. In one article
she announced how delighted she was to report that elitist art (abstract and
Surrealist art) had finally been repelled:

> It would seem that one fight is won. Yesterday's advance guard in painting has
> been driven back, for nonobjectivists and surrealists are now waging a defen-
> sive warfare from the questionable vantage points of a few specialized galleries,
> a couple of English and American 'little' magazines, and one major museum.
> Those painters, modern in spirit and manner, who are turning to nature, seem
> clearly to have the offensive, bolstered by critics and public alike.[1]

The elitism of *Partisan Review*, *Tiger's Eye*, *Horizon* and the Museum of
Modern Art was clearly on target here. Around the same period Howard
Devree, another important art critic, discussed in *The New York Times* the dif-
ficulties involved in producing good modern art. He did not see the war over
modernism won yet. In fact, he saw many signs of future battles coming from
the right. Devree was aware that American culture needed some readjustment
after the war, and that it needed some calm after so much confusion. The point
of chief concern for him was to know 'how far to the right the pendulum may
swing'. Like Louchheim, Devree put the blame for the public disorientation
on the shoulders of the Surrealists and Abstractionists, who, along with their
young American friends, were called 'extremists':

> In the midst of so many uncertainties it is in the cards that people are likely to
> demand more affirmation from post war art and less of the seemingly passive,
> negative and unintelligible. Less of experimental surface pattern, less of non-
> objective posturing, less of escapism from life into sheer esthetic problems.[2]

These articles are interesting because they delineate the boundaries of what we
can call the aesthetic *juste milieu*: a tasteful aesthetic centre, without wild
experimentation but aware nevertheless of modern formal discoveries.

Devree, describing the swing of the pendulum, was referring to something

very real. Since the end of the war, groups on the right had often violently, and even in Congress, attacked modern art, which they often equated with Communism. Characteristic of this violence is this text by the conservative critic Arthur Craven, written 2 February 1948:

> The controllers of the art business still cling, for the sake of their prestige, to the cheapest interpretation of internationalism – not the honorable exchange of cultural goods but the servility of American artists to European models. There is the Museum of Modern Art, in New York, a Rockefeller plant riddled by cultural sicknesses. Its top intellectual, Alfred Barr, master of a style that is one part mock erudition and nine parts pure drivel, writes books on Picasso, the red idol deified by the Parisian bohemia which he rules, and other such deadly phenomenons [*sic*]. His museum is a glittering depot of exotic importations and the claptrap of a few culled Americans who have nothing American about them . . . The Fogg Museum of Harvard, rendezvous of an effeminate and provincial tribe, is still another such institution.[3]

Confronted with such attacks, many critics (including Devree, Louchheim, and Pearson) thought it was time to protect what was 'reasonable' in modern art from the fake, the unbaked, and the lazy in order to save the great tradition. As Devree wrote: 'It is the hope of many of us today, convinced that most of the modern movement is sound and forward looking, that the barricades may go up to protect the middle road before it be captured by forces of blind reaction who would swarm far beyond it once it was crossed.'[4]

The Boston manifesto was intended to be this roadblock to reaction: to function like a counter-fire in a forest blaze, sacrificing a few minor elements to save the rest. The problem was that the Boston institution had not studied closely enough the direction the wind was blowing. As a result, its entire strategy backfired, leaving the Boston Institute in the delicate position of having to take the heat.

While MoMA idolised Paris, Boston became interested in presenting the art of the northern European countries (Germany, the Netherlands, Scandinavia) as well; it organised exhibitions by Kokoschka, Ensor, Munch, Corinth, as well as the Mexican artist Orozco. In other words, the humanistic aspect of modern art, rather than its formal issues, was emphasised.

The ICA obviously did not have a direct political purpose in mind. But the attempt to redefine the modern paradigm, and the need to decree in the manifesto that the end of modern experiments dated from 1939, signalled (perhaps unintentionally) that the ICA no longer believed in the implications of internationalism, experimentation and progressivism that the term *modern* once carried. In the hot political debate of 1948, such a sign of retreat in the face of rightists who equated modern art with international conspiracy against American culture implied that a concession had been made to isolationism.

No matter what their interest in (non-Parisian) world artists, no matter what their humanist values, this move implied for many in the art world, in the complicated play of symbols at the beginning of the cold war, that the ICA was fearful of engaging in the cultural and political struggle for international supremacy. The move from Modern to Contemporary was, to put it simply, viewed as a step away from internationalism and one towards isolationism – indeed, a move from liberalism to conservatism. This was what triggered the angered wave of objections that came from many artists (many supported by the ICA), curators and art critics.

But what precisely was contained in the text – besides the title – that was responsible for all this uproar? Two sectons of the text constituted, in particular, the heart of the controversy. In one, the Institute attacked the so-called unintelligibility of modern art. As the public at large was unable to penetrate the esoterism of modern art, this had become in the manifesto's terms a general cult of bewilderment. 'This cult rested on the hazardous foundations of obscurity and negation, and relied on a private, often secret, language that required the aid of an interpreter. It became an attractive playground for double talk, opportunism, and chicanery at the public expense.'

In a sense, the manifesto was a compromise. It accepted the challenge to defend comprehensible art but did not totally reject the formal discoveries of past modernism. The ICA proposed a rational position, defending an art that showed a certain awareness of aesthetic experiments but without going too far. Modern art, then, was not rejected as a whole. Unlike reactionary diehards, the ICA did accept 'historic' modern art, that of the pioneers such as Picasso and Miró, but rejected in particular contemporary experiments resting on the hazardous foundations of obscurity and negation. The manifesto, then, was an attempt to establish the ICA as a liberal institution acting in defence of artistic pluralism as well as of a humanism that MoMA – too involved in international abstractions – seemed to have abandoned. By its move, the ICA thought to stop the wide-scale erosion of public interest in advanced art. While still protecting the modern tradition, this was a way to bring back into the liberal aesthetic fold that part of the public dissatisfied with the eccentricities of later modern artists, and consequently too ready to listen to conservative rhetoric.

By the same token, as some artists realised, the manoeuvre marginalised a nascent avant-garde whose aesthetic was based on automatism and chance, a type of art in which individual discoveries took priority over tradition, 'craft' and direct communication. It was this rejection of modern abstract art by an important institution dedicated to contemporary art which caused the furore.

The second passage in the ICA manifesto that created such a ruckus among artists and journalists was the following:

We enjoin the artist to exercise his historic role of spiritual leadership, and to forge closer ties with an ever growing public in terms of common under-standing. Nature and mankind remain an inexhaustible source of inspiration. World chaos and social unrest, which prompted many of the excesses of modern art, are still with us, but the artist should not take refuge in private cyn-icism. If he is to help build a culture able to counteract the trend toward world dissolution, he must come forward with a strong, clear affirmation of truth for humanity.

This passage rang lugubriously in the minds of many readers, as it pain-fully reminded them of the Nazi and Communist authoritarian regimes. It was also much more immediately reminiscent of the violent attacks lately launched by the right, not only against modern art but also against all forms of dissidence. The term 'enjoin' especially distressed many artists, who felt the text was an infringement on their liberties. They were quick to see – in the cold war atmosphere of hysteria – an authoritarian gesture. One must recall, of course, that in response to right-wing pressure President Truman himself had issued, in March 1947, an executive order that required an investigation of every person entering civilian employment in the federal government and that the 'Attorney General's list' was in full operation. For many, this text really sounded like the 'Loyalty Bill'. At the same time, it had the ring of the old Popular Front calls for social realist art, which were now totally discredited.

In the political climate of 1948, the ICA's criticism of modern art, its recast-ing of it in academic clothes, came to be perceived by the liberals who ran MoMA and the Whitney Museum in New York as an unprecedented and dangerous betrayal, for in recent months the right had been assailing modern art with a vengeance – often mounting the same arguments used by the ICA – and with a measure of success. We must remember that, supported by the Hearst press, Congress had called back, after a hard-fought battle, the exhibi-tion of paintings 'Advancing American art', which had received great acclaim in Prague in 1947. The fact that several artists had previously had ties with the Communist Party and that many artists represented in the exhibition worked in what may be called a 'diluted' modern style had been sufficient to trigger a virulent campaign against modern art. *The New York Journal-American*, for example, wrote

The paintings are not American at all. The roots of the State Department collec-tion . . . are not in America – but in the alien cultures, ideas, philosophies and sickness of Europe. Those paintings that try to tell a story at all give the impres-sion that America is a drab, ugly place, filled with drab, ugly people. They are definitely leftish paintings.[5]

When one realises that the exhibition had been put together by the State Department (a nest of Communists, as the right wing referred to it), one will understand that there was no room at the time for the ICA's semantic subtleties.

That is precisely what James Thrall Soby, director of the department of painting and sculpture at the Museum of Modern Art in New York, tried to explain in a letter written to James Plaut, director of the Boston Institute of Modern Art, soon to become the ICA, immediately after the publication of the manifesto. The letter was at once very lucid, analytical and prophetic. Soby was aware of the dangerous implications of the stand taken by the ICA. In his letter, after expressing his surprise and disappointment, Soby proceeded to describe what was, in his view, the true liberal stance. While he could appreciate Plaut's desire to seek a centrist position, he could also clearly see what was weak and ambiguous in the ICA's tactics:

> To begin with, I feel relatively certain that the name change will be construed as a sign of surrender to the immense forces of reaction which are gathering around us every day, in every sphere of life and the arts. Hence I think I object more to the timing of the announcement than to the change itself. I can imagine, for example, the comfort the Institute's statement will give to the conservative art magazines and to the daily press. They will never quote your sentence 'We are inalterably opposed to extremism of the die-hard conservative kind, which is a dangerous obstruction to creative progress' They don't consider themselves as conservatives – reactionaries seldom do. They will regard your statement as editorial meat – as the first and very important crack in the progressive facade.[6]

Soby was quite right. After the right wing's victory in recalling 'Advancing American art', the name change of an important institution clearly indicated that the right wing and nationalistic forces had the strength to effect a transformation of the American cultural milieu, pushing it towards populism. Soby was careful, however, to avoid totally alienating Plaut. He said that he thought he understood what the manifesto wished to explain, namely, that it aimed to obviate certain abuses and certain simplicities of modernism. At the same time Soby insisted that, in spite of certain deficiencies in modernism, for him there was no other way to express the contemporary era: 'It does not seem to me, frankly, that either President Truman's academic realists or Lincoln Kirstein's "neo-Humanism" offer a valid new direction.'

In February 1948 (before the publication of the ICA manifesto and in response to Boswell's criticisms), Daniel Catton Rich, the curator of the Art Institute of Chicago, published an article in *Atlantic Monthly* denouncing the dangers that accompanied a president's announcements concerning his artistic tastes and distastes.[7] That, he said, was the equivalent of the kind of

censorship already practised with horrifying results by the authoritarian regimes of Nazi Germany and Soviet Russia. Modern art was winning, in spite of the hysteria of the rightists, who labelled anything that they could not understand as Communistic. 'During a period when loyalties are under painful scrutiny', Rich pointed out, 'it is easy to dismiss what one does not like or understand, as subversive.' Nevertheless, modern art was asserting itself despite 'a growing pressure from reactionary sources to obstruct the freedom of the brush'.

It is this 'freedom of the brush' that was at the core of the new American culture that developed between 1947 and 1950. This celebration of freedom was fascinating because it unfolded in the manner of a mystery novel, with sudden turns and secret dealings and even occasional assassinations – but luckily only character assassinations. The violence of the debate and of the denunciations reflected only too well the atmosphere of the period. That is why the articulation of a manifesto at that moment was so perilous.

The centre position in the political spectrum was the choice position, as we have seen, but what kind of cultural equivalent was going to represent it? The populist centre desired by Boston was an attempt to occupy a liberal *juste milieu*. But this position was already strongly occupied by the new liberalism of the 'vital centre'. This solidified, anti-Communist, internationalist and elitist position did not leave much room for manoeuvre. The problem for the ICA was that there was no ideological space left for its toned-down liberal and populist brand of modernism. The aesthetic the ICA defended was much too bland to survive in the merciless cultural and propagandistic war waged by the two superpowers on the world stage. The ICA seemed to address the domestic debate, while the extremists of this new vital centre, supported by MoMA, were continuing on a most aggressive path, extending through automatism, European discoveries but with new American characteristics, thereby articulating an international discourse.

In this cultural war, no place was left for 'soft' liberalism, or, translated into art terms, for mild modernism even if the ICA was interested in work associated with liberalism such as the art of Ben Shahn, Philip Evergood and William Gropper. This humanist art had become too maudlin for the younger artists. As Schlesinger put it, the new liberalism was not a field for 'the sentimentalists, the utopians, the wailers'.[8]

Soby's letter was significant in that it managed to touch on all the most important points of the controversy, all the while attempting to keep Plaut in Soby's camp. Despite the evidence – the fact that Plaut could not bring himself to love what was being produced by the postwar modern artists, namely, an art based on pessimism, automatism and abstraction – throughout his letter Soby made every effort to bring their two positions closer together, unable as

he was to believe that his friend Plaut had changed his mind so quickly and so totally. The letter abounded with expressions such as 'I know you don't mean it that way', 'Of course, this is not what you mean', 'I'm sure you agree' as if Soby believed there was a text underlying the manifesto that he was going to exorcise. Nevertheless, it was quite obvious that the two men were no longer in agreement on many questions.

Plaut's and Soby's letters illustrate the sudden invasion of politics into the art world. Plaut's refusal to engage in a political as well as aesthetic debate did not save him from being dragged into the political arena not only by the conservative but by the liberal cold warriors as well. In 1948, it seems that no corner was left where one could hide from the cold war rhetoric. As a matter of fact, things went from bad to worse, as, on 25 March 1948, a group of Boston-based artists and critics held a meeting to censure what they regarded as 'the injurious meddling of The Institute in the affairs of creative artists'.[9] The fact that many of these artists had been supported by the ICA sorely demonstrated how misdirected the manifesto had been.

H. W. Janson, much like Soby, but this time in public, made the connection between the ICA's profession of faith and the concomitant political situation:

> To repudiate the term 'Modern Art' at this time cannot but give aid and comfort to all the protagonists of die-hard conservatism. The Institute's statement denies that it is 'an invitation to reaction'. Nevertheless, it is difficult to see how it can be anything else, under present circumstances. If the statement really means everything it says, the most we can expect of the Institute in the future will be the sponsoring of a 'safe and sane' middle of the road style, in which the ideas of modern art are sufficiently diluted to please the great mass of the public.[10]

The silence that the ICA kept in the face of the abuses to which it was subjected seems to indicate that the Boston institution found it preferable not to add fuel to the fire and to wait for the exhibition which was being prepared by Frederick Wight to demonstrate through examples what sort of contemporary art it was supporting. The public would then clearly see that their course was not reactionary. The result was unfortunately very different from what had been anticipated, and the ICA found itself once again with a controversy on its hands. A controversy, in fact, which broke out for much the same reasons and spread in much the same manner through the popular press.

The exhibition, 'American painting in our century', opened on 14 January 1949.[11] The exhibition and the accompanying catalogue – both the work of Wight – in a sense constituted a new manifesto. The text examined the history of American art and presented the contemporary options, favouring a style of painting that was humanistic, balanced, rational and a little romantic. The

language of the catalogue, however, had a certain bias, for it gave ammunition to those who wanted to see in it an anti-modernist attack and a pro-American position, while it gave hardly any to those who had hoped for a clear link with the modernist tradition.

Indeed, ostensibly written from a liberal outlook, the text was certainly attempting to consecrate modern art, but a modern art imbued with traditional American characteristics, a modern art with roots in the United States (i.e. Luks, Sloan, Davis, Marin). In essence, what was at the core of this new contemporary art discovered by the ICA was a form of neo-romanticism, detached from Parisian modernism. According to Wight, this romanticism, inherent to American culture, was the result of the United States' exceptional situation, of its landscape, of its legendary political institutions.

The catalogue as a whole attempted to define an aesthetic line that was connected with an academic modernism recognised by the large majority of American museums and art magazines as the best art produced in the land. The style of artwork Wight selected was American, liberal and populist. Nevertheless, it rejected the radical, experimental tendencies that had become extremely visible beginning in 1947 (Abstract Expressionism). It was this choice, and this discrimination, that again brought great acclaim from the right, again to the surprise of the Institute.

As the exhibition included art-work that contained a certain measure of social criticism, it distinguished itself from the right wing, while at the same time avoiding adherence to the traditional image of the artistic left. In Wight's opinion, in fact, militant art had to give up the propagandistic tones so characteristic of the art produced in the Depression era in favour of a more individualistic and more optimistic approach. Or, more precisely, he thought it should be more individualistic and at the same time, paradoxically, more universal. Wight seemed, therefore, to want to extricate contemporary art from the labyrinth of partisan politics and lead it toward the ethereal spheres of universality. The art that he considered authentic was an art that rejected the doctrinaire attitudes of the art of the 1930s, and its general content (which he refers to – characteristically for those cold war years – as 'collective art') in favour of a liberating individualism: 'The creative trend is toward individual expression and the functioning of individual conscience rather than toward collectivism.' The political innuendo was clear. Ben Shahn and Jack Levine were considered the best representatives of this category, most certainly because their work had by then become sufficiently general to avoid the conservatives' ire, in view of the fact that they spoke of the human tragedy rather than of the class struggle. Wight systematically insisted on the importance of the individual, in opposition to what he called 'types'. Accordingly, he included three naive painters in his exhibi-

tion. Their ingenuous – and therefore fresh and honest – spontaneity was put forward as a guarantee of individualism. Similarly, the abstract paintings included in the show asserted themselves for their anti-authoritarianism, their total independence and their freedom. These qualities, however, were subject to certain controls, for there was no question here of accepting every sort of freedom, nor every sort of abstraction. Alone among their generation, Adolph Gottlieb, Byron Browne, William Baziotes, I. Rice Pereira and Loren MacIver met with Wight's approval. Why? Very simply because their art, while abstract, was constructed, balanced, comprehensible and above all controlled. The introduction of these few abstract painters certainly distinguished Wight from the extreme right, but at the same time his refusal to include those who were technically more experimental separated him from MoMA. As we shall see, this precarious balance between the two cultural poles could not last, for the simple reason that the text of the catalogue unwittingly gave too much encouragement to those who could not abide MoMA and its new-wave liberalism. While writing the catalogue, Wight was looking too much over his left shoulder, trying to dissociate himself from the modern extremists. But in doing so he did not realise that it was then possible for the populist right to extract some elements from the text and herald them as theirs, as their own victory over modernism.

However, the bond that connected all these eclectic painters and made them at once American and contemporary was, in Wight's opinion, their romantic character which made them different from Parisian formalism. Wight's ideology was therefore such that it permitted easy differentiation between American art and Parisian internationalism. The latter was considered suspect because of its excessive formalism, rationalism and intellectualism.

For the ICA, modern art, as the 1948 manifesto had announced, had come to an end in 1939. The abstract expressionist art genre, based on Surrealist automatism, did not come within the Institute's parameters and was, therefore, not exhibitable. If the ICA rejected the Pollocks, the Rothkos and the Motherwells, it was because it regarded them – along with their aesthetic – as impostors, as anti-humanist manipulators, as a threat to modern art itself. The *juste milieu* wanted to be able immediately to recognise 'Man' behind the image, behind the technique.

On 21 February 1949, *Life* published a liberally illustrated article on the exhibition, which was at once very short and yet very ample in relationship to the space it occupied. The first page contained three black-and-white photographs of modern paintings by Paul Burlin, William Baziotes and G. L. K. Morris. The title, 'Revolt in Boston. 'Shootin' resumes in the art world', was catchy and recalled at the same time the good old days of the American

Revolution and hence independence from Europe, and the brutal force of the mythical Wild West, OK Corral style. The double connotation was explosive, and *Life* managed, in a few words, to extract and convey what the text of the catalogue subtly intimated. Leaving aside what was progressive and liberal in the exhibition, in a typical media hype, the meaning of the ICA show was hijacked. The works of Burlin, Baziotes and Morris were merely displayed there, defenceless and confronted with a text that vilified them. They were essentially put there as targets, as bait for the wrath and sneers of the readers, who, once they had released their anger, could proceed to the next pages, to cast their gazes with indulgence and approval on the colour reproductions of other works, which were both more accessible and more in harmony with the values held by *Life* and its readers. Furthermore, as the three had not been selected for the ICA exhibition, they then represented those famous examples of the 'cult of bewilderment'. Using the catalogue as a guide, *Life* explained – without acknowledging numerous more subtle passages – that Boston had 'assembled an exhibition to show the main trends in U.S. art of this century which they believe are chiefly rooted in native traditions that are romantic and realistic'.[12]

Thanks to a skilful and manipulative text (which referred to modern art as totalitarian), and to the overwhelming presence of several magnificent, often full-page, colour reproductions, modern art came out the loser. *Life* insisted on the realism, the violence and the rugged appearance of American art, as exemplified by Sloan and Bellows. It especially emphasised that Bellows had refused to study painting in Europe for the express purpose of preserving his American art from foreign influences. Wight had certainly put this theme forward in the catalogue, but *Life* made it the centre of the whole argument. Speaking about Burchfield, it said: 'His work, which first appeared in the late 1920s, helped to precipitate a decade of sporadic revolt against the new experimental isms from abroad.' Even Jack Levine was enlisted in the pro-American crusade. *Life* described his work as having undergone a conversion: 'One of Levine's early paintings, it is, according to the Boston Institute, his most individual work and belongs in the sturdy traditions of Bellows and Sloan. Levine's later paintings, showing heavy influences from Europe, are fierce comments on poverty and injustice.'[13] In other words, the later paintings were unexhibitable because they were un-American and, by association, 'Communistic'.

Yet Walt Kuhn was certainly the single artist who gave *Life* its best argument for anti-modernism. His painting *The blue clown* covered the entire last page of the article. What was all the more useful for the cause was the fact that Kuhn had been partly responsible for the introduction of the modern art virus in 1913, through his participation on the Armory Show committee. Now, at the age of sixty-eight, Kuhn had rejected his youthful indiscretions and painted in

a realistic style. As it was then fashionable to publicise the memoirs of intellectuals who had become disenchanted with Communism during the 1930s, it was ingenious for *Life* to exploit Kuhn's 'repentance' to promote the conservative cause.

'Oddly enough', the article stated, 'Kuhn himself stayed a realist and, in fact, has come to believe that extreme modernism has led art down a false and confusing path'.[14] This enlistment of Kuhn in the anti-modern battle would deeply hurt liberals such as Lloyd Goodrich of the Whitney Museum, who realised that such a manipulation of Wight's text for nationalistic purposes closely resembled totalitarian mass manipulations. He wrote a letter to Plaut on 23 February 1949 – immediately after the publication of the *Life* article – in which he explained his feelings about the article: 'The continual emphasis on supposedly "American" qualities, the hostility towards "foreign" influences, and the sneers at advanced trends are worthy of Dr. Goebbels.' James Thrall Soby had himself already reacted – without delay, according to his habit – by writing to Plaut on 21 February, not only to denounce the distortions in the *Life* article but also to demand a strong reaction on Plaut's part to set the record straight, since *Life* had relied on the catalogue of the ICA exhibition as a source to ridicule modern art. The tone of the ICA catalogue was possibly 'nonModern' but surely not 'anti-Modern'; the difference was fine but important and required a clarification:

> I strongly urge that the Institute dissociate itself from the *Life* article, publicly and preferably by an open letter to *Life*'s editors. I don't see how you can do anything else and have *American Painting in Our Century* mean anything. To allow both the article and your catalogue to stand, seems to me the very essence of 'double talk' – to use the word which *Life* quotes with such glee from your manifesto of last year. I hope you will agree; I feel certain you will.[15]

In fact, in spite of all the pressure that was brought to bear on him in the following days, James Plaut decided that the best course of action was silence.

A letter from Lloyd Goodrich, who considered himself betrayed by the use that had been made of Kuhn's painting, which he had loaned for the exhibition, as well as a pressing telegram from Alfred Barr, also were given no public reply. Barr's telegram read:

> May I urge that you publicly and in detail correct or repudiate the current article in *Life*, which by its use of the Institute's name and errant distortions of your catalog has greatly confirmed your institution's reputation as a compliant instrument of reactionary forces. Yours in an unofficial and friendly spirit.[16]

For the Institute to present Kokoschka, who had been opposed by the Nazis, was still the most progressive of stances. But for Barr, director of the Museum of Modern Art collections, New York, times had changed. What

he was pressing in his cold warrior fervour was that Kokoschka was of course a good symbol to use in opposition to Fascism, but because the new enemy was now Communism, a new cultural symbol of freedom was needed to combat it. The new American abstract artists, in their disregard for traditional rules, were in Barr's mind the perfect image of free America to project abroad. That is why he could characterise the new automatic style as 'free enterprise painting' with such assurance. Finally, the pressure against liberalism in art had become so strong – and the ICA's position so untenable – that the Institute came to realise that an alliance among progressive institutions was indispensable, even at the cost of a few ideological concessions. In a letter addressed to his colleagues from New York, Plaut proposed a liberal counter-attack. What perhaps brought him to this decision was a series of letters from Alon Bement, director of the Traphagen School of Fashion. What frightened James Plaut was that Bement was enthusiastic about the position supported by Wight's catalogue and that he wanted to launch his own anti-modernist manifesto with the ICA's blessings. Bement's membership in the National Board of the American Artists Professional League, an organisation very close to George Dondero, indicated to what extent the ICA had become enmeshed in the abhorrent schemes of the right wing. Clearly, the Institute had to part company with the rightists quickly or remain for ever tainted.

James Plaut and the ICA therefore sought a way to retreat without incurring too much loss:

> The Institute's officers, however, are in full agreement with me on one point: that it would be a very healthy thing indeed to attempt to clarify the whole issue of progressivism and reaction in the arts today through the medium of a joint statement of clarification issued constructively, and not in the spirit of negation and criticism, by the Museum of Modern Art, the Whitney and ourselves . . . In the last analysis, the relatively few people who champion a liberal point of view in the arts must stand together and present a common cause if the cause is not to suffer gravely.[17]

On 12 March, Alfred Barr answered brusquely and in a way that did not bode well at all for the ICA's earlier position. He wanted to emphasise his impatience with the ICA, which, after having plunged itself into this ideological and political mess, now wanted to head a renewed liberal cultural front. While agreeing to help save the situation, Barr at the same time laid down conditions that would put the ICA in a delicate position, since he was essentially proposing a complete disavowal – albeit with a few concessions in the interest of humanism – of the position initially taken in the famous 1948 manifesto. He told Plaut he thought the way open to some sort of joint statement

such as that suggested in his letter. Such a statement, Barr asserted, would however have to be a very positive affirmation of a shared belief in the validity and sincerity of modern art, and those who were seriously concerned with it, not only up to 1914 (as Plaut's manifesto implied) but right to the present as well.[18]

After the episode of the *Life* article, Barr made it clear that, this time, the common declaration would be mostly along the lines defined by New York:

> There is no reason to conceal from you that we have a certain skepticism about your position in view of the fact that you have not so far made any effort to correct *explicitly* either the statements or the implications of your manifesto . . . The *Life* article, however bad it is journalistically, is a natural consequence of your avoidance of real clarification in explicit verbal form . . . These observations are confirmed by the fact that you have since refused to raise a finger to correct the *Life* article, which has given the widest publicity to your current exhibition as a *confirmation* of the most regrettable implications of your manifesto. You have even exhibited a copy of this article at your entrance, and you have given the impression here in New York that you personally okayed the article. (I mention this to give you an idea of what your position is). However, I think we can arrive at some statement which will clear the air and to some degree consolidate once more those institutions and forces which favor a liberal and progressive policy toward the arts in this country.[19]

The door was still open, but the voice that was now coming to Boston was that of the father, and it was thundering. The New York people were clearly determined to take matters into their own hands again. The theory of the new liberal front was in fact going to be drafted by Goodrich and ratified by the ICA. As Barr and Goodrich had intimated, the manifesto was going to insist on the following: (1) modern art has 'continuing validity', contrary to the view expressed in the ICA's statement that it had run its course; (2) recognition of the diversity of contemporary art and of the freedom of the artist to express himself as he chooses; (3) recognition that advanced art necessarily has a small audience at first and that the size of an artist's audience is no criterion of the value of his work.

These three points, which lay at the very heart of the new manifesto, defined the 'advanced' liberal position, basically identical to that which the ICA had refuted in its manifesto of 1948.

The ICA maintained the right to introduce the importance of humanism in modern art, which, since the beginning of the controversy, had been one of its major interests. If it had to accept the validity of modern art in 1949 – an art that seemed too extreme, too abstract – it wanted at least to insist on the fact that modern art was not cut off from life. Unlike the earlier manifesto,

however, this one – undoubtedly drafted under MoMA's influence – sought to assert that not only modern art but also abstract art exuded humanism:

> We believe in the humanistic value of modern art even though it may not adhere to academic humanism with its insistence on the human figure as the central element of art . . . We recognize the humanistic value of abstract art, as an expression of thought and emotion and the basic human aspirations toward freedom and order . . . Contrary to those who attack the advanced artist as anti-social, we believe in his spiritual and social role.[20]

The discussion and the preparation of the text took the entire year of 1949, and it was not published until March 1950, owing to the prolonged negotiations among the three different institutions. It was by then high time for it, since on 9 February Senator McCarthy had delivered his famous Wheeling address, the beginning of his war against 'subversives'. Liberalism had yet much darker days ahead.

The text, in its final form, was a true liberal manifesto, which insisted on freedom of expression, on internationalism and on pluralism. It attempted to exonerate both modern art and abstract art from the attacks that had been levelled by the right-wing press. Art – said the manifesto – was neither socially nor politically subversive; neither was it 'un-American'. The proof which was put forth, and which was going to constitute the liberals' main line of defence to safeguard modern or abstract art, had been developed by Barr and amended by Nelson Rockefeller. The manifesto added a few details concerning the politicisation of modern art and especially emphasised to a greater extent the correlation between Nazism and Communism, both of which were violently opposed to the freedom of modern art.

> We deplore the reckless and ignorant use of political or moral terms in attacking modern art. We recall that the Nazis suppressed modern art, branding it 'degenerate,' 'bolshevistic,' 'international' and 'un-German'; that the Soviets suppressed modern art as 'formalistic,' 'bourgeois,' 'subjective,' 'nihilistic' and 'un-Russian'; and that Nazi officials insisted, and Soviet officials still insist, upon a hackneyed realism saturated with nationalistic propaganda.[21]

All that rhetoric was, of course, intended to muzzle the right wing, to ensnare it, by assimilating it with the Nazis and the Communists, all the while proposing modern American abstraction as a liberal symbol. The strategy seemed to work, since the popular press in general was supportive of the manifesto.

Two years of discussions and of public diatribe had therefore been necessary in order to arrive at a status quo among the three great US art institutions, two years during which the ICA, despite all of its efforts, ultimately had to realign itself with MoMA. With the latest manifesto, the ICA was able to regain its liberal credentials, but at the expense of its ideological independence. The

alliance announced therefore a general regrouping of all liberal institutions with the purpose of resisting the aggressive advances of the right wing, which was invading all domains of life, particularly the cultural sphere. It is because the stakes had become so high, not only on a domestic level but also on an international one, that James Plaut was no longer able to play too fine a game, could no longer define subtle differences within cultural liberalism, and in the end had to retreat.

The ICA's position was in fact untenable, for reasons of political naivety. What MoMA and its directors understood was that it had become necessary to present not just a common cultural front but a front that could establish a solid, strong, independent and unique image of American culture: an image that could – vis-à-vis Europe – play the role of driving force of the western world at a time when Paris, which had played that role for a long time, was grappling with problems of internal sedition, if not complete political and cultural disintegration. The 'soft' kind of liberalism, characterised by a big-hearted humanism, was out of place in the savage postwar world. It had to be transformed into a triumphant, optimistic and aggressive creed.

The attacks against modern art also seemed so dangerous because, since the beginning of the 1940s, the modern style had become, in a sense, an icon of democracy. The modernist avant-garde of the Federation of Modern Painters and Sculptors, in particular, which expressed itself through the voices of Gottlieb and Rothko, clearly emphasised this relationship:

> In the U.S. opponents of independent creation sponsored in its stead local scenism and class conscious scene-ism as distinct art movements and these were eventually amalgamated and redirected into regionalism or the school of country art. These story telling movements were partially sold to unsuspecting audiences as the true national and native expression of the modern art movement, at the same time giving lip service to the great tradition of art. There are those who tell us that democracy has outlived itself and that modern art as a forceful movement is ended. The fact remains that true modern art is vigorously alive and has the same great future as democracy.[22]

None the less, as the ICA episode demonstrated, the battle was not yet quite won, despite the optimism exhibited by the avant-garde. The Federation was intent on protecting free and progressive artists in the United States and on defending the 'democratic way of life'. As democracy came under increasing attack in Europe, it became more and more common to say – as was done by the avant-garde literary magazine *Partisan Review* between 1948 and 1949 – that the United States was now the last bastion of democracy. In fact, the ideals of democracy were becoming increasingly associated with, or superimposed on, a form of Americanism. One could go as far as to say that the Federation's motto, the protection of the 'Democratic way of life',

was not in fact very different from the protection of the 'American way of life'.

All criticisms, attacks and recriminations against modern art, whatever their source, were therefore seen as dangerous anti-democratic propositions when Joseph McCarthy appeared on the political scene in 1950. As Dondero and McCarthy supported a populist position, we can clearly see how untenable was the ICA's ambiguous stance. Rene d'Harnoncourt, in an article dated November 1948 and published in *Magazine of Art*, vigorously insisted on the importance of individualism in art (in other words, anti-collectivist, here in agreement with the ICA). But at the same time – in a long tirade much akin to the arguments developed by Schlesinger in *The vital center* – he upheld a new order of society based on the individual and symbolised by modern art:

> The perfecting of this new order would unquestionably tax our abilities to the very limit, but would give us a society enriched beyond belief by the full development of the individual for the sake of the whole. I believe a good name for such a society is democracy, and I also believe that modern art in its infinite variety and ceaseless exploration is its foremost symbol.[23]

For the liberals it was essential to protect modernism and to save culture from the inept hands of the right-wingers, since the latter's populism made them incapable of grasping what were the really important stakes in the confrontation between the two ideologically opposed blocs. That is why the rejection of the word 'modern' by an old ally such as the ICA had, in those difficult and dangerous moments, been perceived as disastrous by the new liberals. The decision to support a *juste milieu* in those troubled times actually helped the opposition. By assuming a position of retreat, the ICA gave the impression of foundering, frightened, under the blows of Dondero and his colleagues. And yet, if one would have looked closely, Wight had chosen painters who, while they surely did not go beyond a certain conformism or a certain formal classicism, were at the same time not particularly in the right wing's good graces. To be sure, fourteen of the twenty-seven contemporary painters included in the Boston exhibition had also been included in the scandal-causing 'Advancing American art' exhibition. Although the selection seemed formally less daring in 1948 than in 1946, none the less it did include artists who were representative of the left (Gropper, Davis, Shahn), even the Communist left (Evergood). This was truly audacious in 1948, even if the works had been selected on the basis of their universality and hence political neutrality. In an article in the *New York Times* in January 1949, Aline B. Louchheim, while she expressed her satisfaction with the ICA's attempt to put American art in perspective, found the aesthetic choices somewhat timid: 'The Institute's new exhibit might be hailed as an excellent though

unadventurous anthology of American art, a show which would be acceptable even to Congress.'[24]

She could not have been more right, since in February 1949 Reuben S. Nathan, chief of the Periodical Section at the Department of the Army Civil Affairs Division (State Department) requested permission to use an article published in *Atlantic Monthly*, based on the catalogue of the exhibition, for republication in the US propaganda mouthpiece in West Germany, *Die Amerikanische Rundschau*.[25]

Notes

A longer version of this essay was published in the catalogue *Dissent: the issue of modern art in Boston*, by the ICA in Boston in 1985. I wish to thank Elisabeth Sussman, David Joselit and David Ross for the help they gave me to locate and organise the ICA archives.

1 Aline B. Louchheim, 'Subject and subterfuge in modern painting', *New York Times*, 25 January 1948, II, p. 8.

2 Howard Devree, 'Outside attacks on modern movement bolstered by work of extremists', *New York Times*, 18 January 1948, II, p. 9.

3 Thomas Craven, 'The degradation of art in America', 2 February 1948 (ICA Archives), pp. 11–13.

4 Devree, 'Outside attacks'.

5 'Exposing the bunk of so-called modern art', *The New York Journal American*, 3 December 1946, cited in *Advancing American art: politics and aesthetics in the State Department exhibition*, catalogue of the exhibition prepared by Margaret Lunne Ausfeld and Virginia M. Mecklenburg, for the Montgomery Museum of Fine Arts in Alabama in 1984. p. 19.

6 Letter from J. T. Soby to James Plaut, 29 February 1948, ICA Archives.

7 Daniel Catton Rich, 'Freedom of the brush', *Atlantic Monthly*, February 1948, pp. 50–1.

8 Arthur Schlesinger Jr, *The vital center: a fighting faith*, Riverside Press, Cambridge, Mass., 1949, p. 159.

9 The group was a very prestigious one, including the likes of Karl Zerbe, Hyman Bloom, David Aronson, Jack Levine, H. W. Janson, Karl Knaths and Lawrence Kupferman.

10 'Report of the panel discussion sponsored by the modern artists' group of Boston', 25 March 1948, mimeo, ICA archives.

11 Frederick S. Wight, *Milestones of American painting in our century*, Chanticler Press for ICA, New York, 1949.

12 *Life*, 21 February 1949, p. 88.

13 *Ibid.*

14 *Ibid.*

15 Letter from J. T. Soby to James Plaut, 21 February 1949, ICA Archives.

16 Alfred Barr, telegram to James Plaut, 23 February 1949, ICA Archives.

17 James Plaut, letter of 1 March 1949, ICA Archives.

18 Letter from Alfred Barr to James Plaut, 12 March 1949, ICA Archives.

19 *Ibid.*

20 Confidential draft of text entitled 'Statement on modern art', 18 March 1949, ICA Archives.

21 Lloyd Goodrich's letter of 13 February 1950, to James Plaut, ICA Archives.

22 'No blackout for art', Federation of Modern Painters and Sculptors, 1942, Archives of American Art, No. 68–75.

23 Rene d'Harnoncourt, 'Challenge and promise: modern art and society', *Magazine of Art*, November 1948, p. 252.

24 Aline B. Louchheim, 'A glance at events during 1949', *New York Times*, 12 January 1949.

25 Letter from Reuben S. Nathan to Frederick Wight, 10 February 1949, ICA Archives.

IV

Museum spaces
and contemporary art

QUESTIONING THE STRUCTURE: THE MUSEUM CONTEXT AS CONTENT

Anne Rorimer

WORKS BY DANIEL BUREN, Michael Asher, Marcel Broodthaers, Lawrence Weiner and John Knight, exhibited and/or acquired by the Art Institute of Chicago during the 1970s and 1980s, are comparable with respect to their common thematic recognition of the role played by intangible aspects of their contextual placement. As these artists have demonstrated in their aesthetic production, the context of art is not only a physical and architectural one since institutional, social, economic, political or historical factors contribute as well to a work's concrete manifestation in time and space. Major works by Buren, Asher, Broodthaers, Weiner and Knight, which have been shown at the Art Institute or belong to the museum's permanent collection, elucidate how these artists have played an important part in dispelling the notion of art's assured autonomy by pointing to its reliance on or involvement with its institutional circumstance.

Daniel Buren (French, born 1938) has worked *in situ*, that is, with direct reference to a given location or situation, since 1967. Probably the first artist to adopt this Latin phrase, which is now used extensively to describe pieces done on site, he associates it with all of his works. Initially desiring to strip painting of any and all illusionistic reference or expressive characteristics so that it might function purely as a sign of itself, Buren arrived at the decision in 1965 to reduce the pictorial content of his work to the repetition of alternating white and coloured vertical bands measuring 8.7 centimetres, or about 3.5 inches, in width. He realised that he did not have to paint them himself, but could order mechanically printed material to suit his particular needs. Commercially obtained, prefabricated material with vertical stripes –

intended to be as neutral a (de)sign as possible – has served to free the artist from the constraints of the canvas's framing edge or the allotted exhibition space. The placement of striped material governs the form and meaning of each work by Buren, who has chosen to direct his concerns away from the canvas field in order to examine and expose the work of art's affiliation with its external surroundings. Having dispensed with the canvas as an arena for exclusive activity, he has explored and visually highlighted its contextual frame of reference in numerous works over the years. 'Right from the start,' Buren has asserted, 'I have always tried to show that indeed a thing never exists in itself . . .'[1]

Works by Buren participate in the given, non-art reality while concurrently commenting on the authority of the museum or gallery, whose delegated exhibition spaces they often circumvent. Two works executed at the Art Institute of Chicago on separate occasions clearly illustrate the dialectical interconnection fostered by Buren between the content of the work and its institutional context. *Up and down, in and out, step by step, a sculpture*, 1977 (fig. 13.1), created for the group exhibition 'Europe in the seventies: aspects of recent art' and later acquired by the museum for its permanent collection, utilises the interior grand staircase of the museum that leads from the main entrance lobby to the upper-floor galleries. When vertically striped paper is cut and glued to the risers of the steps, the staircase takes on a sculptural presence, becoming an object that coexists with the encompassing architectural reality. The staircase of *Up and down . . .* maintains its practical role, providing access to the museum's chronologically arranged galleries

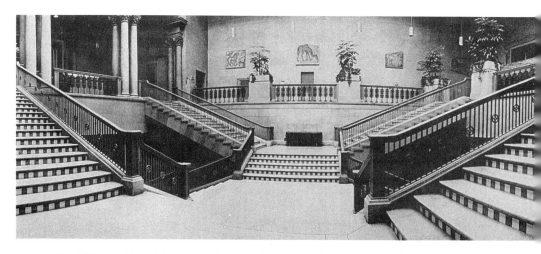

13.1 Daniel Buren, *Up and down, in and out, step by step, a sculpture*, 1977. Installation at the Art Institute of Chicago, 1977. Collection of the Art Institute of Chicago. Photo: Rusty Culp

containing paintings and sculpture from ancient times to the present. As both a sculpture and an actual staircase, the work therefore functions both literally and figuratively to elevate visitors en route to look at art in the museum's 'hallowed halls'.

In contrast to other works in the Art Institute's collection, Buren's work extricates itself from customary placement within rooms exclusively devoted to displaying it and instead interacts with the museum as an architectural and cultural whole. Fusing sculptural form with architectural function, it defines the museum's main stairway as the institution's symbolic pedestal and core. While other works are subject to classification and relocation, generally in isolation from the historical or cultural conditions of their original conception, *Up and down* . . . can neither be removed from its setting nor considered apart from the existing reality with which it coincides.

Exhibited for the duration of a year and a half, *Watch the doors please*, 1980–2, took advantage of the fact that the Art Institute of Chicago is built over an active railway line and that a single large window in the museum's Morton Wing overlooked the tracks that run under and beside the building. With the co-operation of Chicago's Regional Transportation System, Buren enlisted the entire fleet of 165 commuter trains that regularly pass the museum in order to create this work. He adhered a weatherproof vinyl material, printed with vertical stripes in five different colours – white with red, blue, green, yellow and purple – to the central double doors of all the train cars that service the south side of the city and its suburbs. A schedule at the museum window informed visitors of the times they could expect to see a two- or four-car train pass by with coloured doors in sequences determined randomly at the railway yard each day.

Watch the doors please, a work in motion, reversed conventional modes of viewing works of art while turning the tradition of Renaissance perspective inside out. Subject to the conditions of real time and place rather than being affixed to a wall, the work came to viewers, who had to wait for it as they would for any train. Significantly, the expansive glass window at which viewers stood functioned like an enormous, transparent canvas since its vertical and horizontal mullions resembled over-life-size stretcher bars. The passing trains, moreover, with their striped doors, were not an illusion but an actuality. In radical fashion, therefore, Buren replaced the opaque picture plane with the museum's Morton Wing window and thereby brought about the complete fusion of observed reality and art.

When trains pass under the Art Institute – in a way that is probably unique to the city of Chicago – commercial and cultural activity visibly intersect. Because of the coincidence of railway, museum and window, Buren was able to use the commuter trains as the literal vehicle for a work of art that con-

joined a renowned art institution with the quotidian world around it. The striped, rectangular doors of the train could be seen by passengers at station platforms or from many vantage points in the city or suburbs, whether against the Chicago skyline or as transitory flecks of colour intermittently flashing past houses or shrubbery.

Travelling back and forth between an art and non-art context and engendering multiple points of view, *Watch the doors please* could be read in different ways. From the museum window the striped doors, whose rectangular shape ironically alluded to traditional paintings, had to be interpreted in terms of the discourse of art. From outside of the museum, the stripes assumed a purely decorative purpose (and were even thought by certain passengers to be an innovative safety feature installed by the transit authority). In all cases, however, it was a work that fulfilled Buren's aspiration for an art that dispenses with the traditional canvas – for him, a mask, which, under the guise of self-sufficiency, conceals by ignoring the realities of its given context.[2] And just as the conductor alerts passengers at every station to 'watch the doors please', Buren urged museum viewers at the window to look beyond the previously prescribed boundaries of art.

For more than two decades Michael Asher (American, born 1943), one of the foremost practitioners of site-specificity, has sought to explicate within each work's content the relevant aspects of its contextual presentation. His prodigious and protean production has developed in critical response to its own definition as art, which is perforce situated within a particular context. By continuing to discover ways of engaging each work with the relevant aspects of its provided context, he liberates his art from the conditions he chooses to investigate.

Two works by Asher – one exhibited in 1979 in the Art Institute's '73rd American exhibition' and the other in 1982 in its '74th American exhibition' – investigated relationships between sculpture and architecture, on the one hand, and between the work of art and its institutional support, on the other hand. In each instance Asher dealt with the work's container as this is to be both architecturally and institutionally understood in order to question and redefine further the nature of traditional sculpture.[3]

Asher's work of 1979 represented his participation along with fifteen other artists in its ongoing series of exhibitions that over the years provided the Art Institute with the opportunity of regularly presenting the most current American art. Expressing the underlying and unspoken role played by the museum context in organising modes of aesthetic perception and treating the museum as an object of investigation, this work resulted from the repositioning of actual elements already belonging to the existing architectural reality. To realise the work, Asher removed the lifesize, green patinated, weathered

bronze statue of George Washington from where it had stood at the main entrance of the Art Institute for over half a century (fig. 13.2) and relocated it within the permanent collection galleries of the museum. The sculpture is one of a number of twentieth-century casts of the original marble of 1788 by Jean Antoine Houdon. Heretofore the bronze had served as a commemorative monument to the first president of the United States, dressed as leader of the American Revolutionary War, and also as a decorative object that had been firmly ensconced on a stone pedestal in front of the central arch of the museum's neo-Renaissance façade. The sculpture of Washington was taken off its base and installed by Asher in the centre of Gallery 219 (fig. 13.3). At this time Gallery 219 was devoted to European painting, sculpture and decorative arts of the late eighteenth century, that is, to works of the same period as the sculpture by Houdon. Relatively small and nearly square, the room was painted a grey, blue–green colour and contained works of art that had been symmetrically placed around the gallery and on the walls from floor to ceiling in the attempt to evoke, however artificially, the sense of an original period setting.

In a short text for guiding visitors from the American exhibition on the lower floor to Gallery 219 on the upper, Asher stated: 'In this work I am interested in the way the sculpture [of George Washington] functions when it is viewed in its 18th-century context instead of in its prior relationship to the facade of the building . . . Once inside Gallery 219 the sculpture can be seen in connection with the ideas of other European works of the same period.' The relocation of *George Washington* from its centralised exterior position in front of the building's façade to its centralised position in Gallery 219 thus redefined the sculpture's meaning with respect to its new context. Dismantled from its pedestal and divested of its imposing, outdoor monumentality and decorative function in relation to the Art Institute's façade, the sculpture inside the museum had to be considered in terms of the other works of art encompassing it. Although on historical, stylistic and formal grounds the sculpture securely belonged in Gallery 219, it none the less subtly, and humorously as well, sounded a discordant note. The mediocre quality of the cast along with the weathered look of its green patinated surface (coincidentally, however, nearly blending in with the blue/green colour of the gallery walls) did not permit the sculpture of George Washington, the 'Father of his Country', to be completely and unquestionably absorbed into the domain of the gallery despite the statue's period credentials. Although an outdoor sculpture of an American hero took its place stylistically amid European works of its own time, it injected a sign of discontinuity. Standing within the gallery, *George Washington* served as a reminder of the selection, categorisation, and contemporary repositioning that effect the way in which the past is re-created within the confines of the museum vis-à-vis the nature and limits of its particular holdings.

For the materialisation of this work, Asher followed standard museum procedures of installing works of art, which, extracted from the original conditions of their conception and placement, are positioned within designated areas of the museum in chronological sequence and/or in geographical groupings. As a result, he created a work that in itself could not be subjected to ensuing relocations and contextual dislocations. The work already circumvented the institutional procedures upon which it, paradoxically, was founded and to which it critically drew attention.

The '73rd American exhibition' constituted the immediate context of this work, as Asher himself explained in the written handout: in the process of 'locating the sculpture within its own time frame in Gallery 219, I am placing it within the framework of a contemporary exhibition, through my participation in that exhibition'. Thus, not only did Asher exempt his work from the consequences of historical uprooting and repositioning, but he also connected and integrated a contemporary work of art – conceived for an exhibition aimed at presenting examples of the most recent artistic production – with the museum as a whole. Also, he was able to engender a work that was grounded

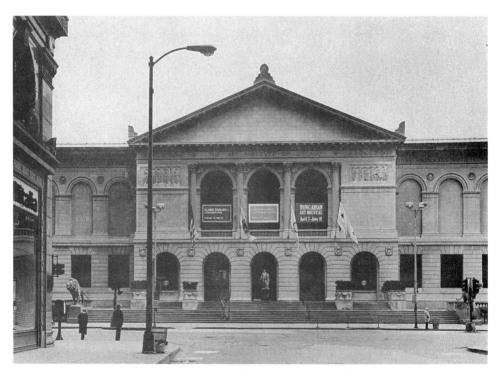

13.2 Michigan Avenue entrance, The Art Institute of Chicago, 1979.
Photo: Rusty Culp

in the past, which it literally embodied in a concrete, material form. Rather than merely quoting or borrowing from the past in postmodern fashion, Asher's work, instead, radically departed from previous forms of aesthetic practice. Bearing witness to the realities of its broader context within the museum and within the history of art in general, the work for the '73rd American exhibition' allied the production of art in the present with that of the past to achieve its own innovative ends.

Whereas the American exhibition furnished the contextual framework for Asher's work, the entirety of Gallery 219 with the sculpture of George Washington at its centre defined the work as a material whole. During the installation of this work, however, Gallery 219 never ceased to serve the purpose of displaying eighteenth-century objects of art. For this reason, the space of the work and the 'real' space of the gallery coincided with each other so that the division between material object and physical surroundings was erased. By extension, the paintings on the walls, necessarily retaining their status as art, *also* became elements of the existing reality by way of their incorporation into another work of art. Asher's work, quite astonishingly,

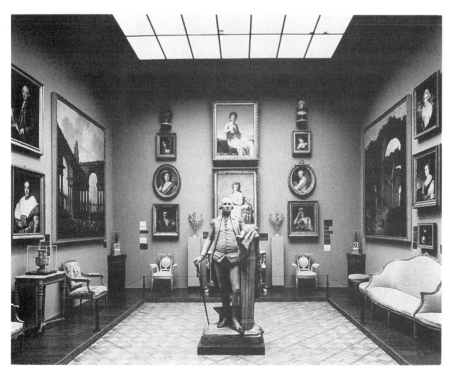

13.3 Michael Asher, *The Art Institute of Chicago, '73rd American Exhibition',*
9 June–5 August, 1979, 1979. Photo: Rusty Culp

therefore inverted traditional perspective in that the paintings on the walls became reality-in-the-context-of-art as opposed to reality being transformed into art-in-the-context-of-reality. At the same time, the centralised figure of Washington, deprived of its former purpose as a monument, served simultaneously as the catalyst for another work of art and as a point of reference for, or reminder of, the tradition of the isolated and detached work of art that Asher had subverted.

The work for the '74th American exhibition' of 1982 specifically expressed the vital function of the museum as an institution for exhibiting art. For this work, which initially had been conceived and proposed for the Institute's permanent collection, Asher engaged two groups of viewers who, at a designated time (for practical purposes only), stood each day in front of two different paintings in the permanent collection galleries: specifically, *Nude in a bath tub*, 1910, by Marcel Duchamp and *Portrait of Kahnweiler*, 1910, by Pablo Picasso. The artist selected these two paintings because of the disparate degree to which they had been reproduced in books, on posters or on postcards, etc. – the Duchamp hardly at all and the Picasso extensively – and disseminated in the public domain as second-hand images. Thus installed in front of two paintings in the same room, the 'model' viewers, paradigmatic of museum visitors, demonstrated the point at which the museum's responsibility to present and the visitors' role to perceive overlap.

Paradoxically, the same institutions that make original works of art available to the public are also those that provide photographs and reproductions. Seeking to dismantle the barriers to direct perception engendered by reproduction, with its capacity to substitute for and potentially dull the experience of the original, Asher's work reproduced as a concrete phenomenon the process of viewing that takes place in a museum. Rather than being a work, however, that was physically and conceptually independent of its institutional context – yet none the less dependent on it for its display – it was a work that could not be detached from the existing situation it sought to acknowledge and consider. Having abandoned the convention of sculpture in the round, the work revolved around the viewing process by materially and thematically embodying it.

Through diverse means Marcel Broodthaers (Belgian, 1924–76) constantly endeavoured to discover ways of releasing the potential of art – with its self-reflective capacity – to serve on an aesthetic plane as a critical force within, and with reference to, the social sphere. His oeuvre challenged traditional relationships between the object of art and the systems of its presentation and reception, with an eye to the situation of the work in the broader cultural framework. Speaking from his awareness of art's existence within 'the context of a world devoted to advertisements, overproduction, and horoscopes',[4]

Broodthaers expressed 'the hope that the viewer [of one of his works] runs the risk – for a moment at least – of no longer feeling at ease'.[5] From 1964, when he formally announced his decision to abandon the writing of poetry in favour of creating objects and images, until his death in 1976, Broodthaers never ceased to be motivated by the idea that, as he put it, 'it is perhaps possible to find an authentic means of calling into question art, its circulation, etc.'.[6]

In his short but highly influential career, Broodthaers deftly and with much humour and wit overturned conventional approaches to the conception and perception of art. Never having restricted himself to the use of any one medium, he is recognised for a body of work that includes books, films and prints while also being renowned for his successive installations centred on the subject of the museum. *Un Jardin d'hiver* (*A wintergarden*), 1974 – reconstructed in 1977 for 'Europe in the seventies: aspects of recent art' under the supervision of the artist's widow – was originally conceived for an exhibition of eight artists at the Palais des Beaux-Arts, Brussels, in 1974. Allocated to a room of its own, this work consisted of a composite arrangement of items brought together in a meaningful and poetic ensemble: potted palm trees; folding garden chairs; five framed black and white enlarged reproductions of nineteenth-century English engravings; a rolled-up red carpet; and a video monitor on a pedestal that, in black and white, recorded the room and passers-by within its purview. Two old-fashioned wooden table vitrines, placed along the side of one wall, contained the original coloured engravings, the open catalogue pages designed by the artist for the Brussels exhibition and a copy of the invitation card for his exhibition. Significantly, the engravings, taken from a book of natural history, represented five different species of mammals, birds and insects, separately grouped in their appropriate category. The five engravings illustrated camels, elephants, falcons, beetles and bees. They didactically portrayed the varying types of animal within each classification. Four of these black-and-white enlargements hung on one of the long walls of the room while the fifth hung on the facing wall. Modelled on the palm court, which at one time graced many a European bourgeois interior as a reminder of more sunny, exotic and essentially inaccessible tropical climes, *Un Jardin d'hiver* introduced various levels of fiction while being composed of real objects in real space. These objects ran the gamut from live plants to reproductions of living creatures encased in vitrines to reproductions of these reproductions secured within frames on the wall.

In large degree, Broodthaers's installation dealt with the idea of captivity and, by implication, decontextualisation. The blown-up engravings additionally suggested the seizure of other lands through the process of colonisation and the capturing of an image in the creation of an illusion. While the rolled

red carpet hinted nostalgically at social pomp and circumstance, the video camera self-reflexively presented the room and its visitors on the monitor. The monitor thereby acted to ground the work in its reality as art although, paradoxically, *Un Jardin d'hiver* had put the viability and veracity of traditional, isolated objects of display in question through the artificiality of its own decor. Moreover, this decor pointedly bore reference to the animal kingdom whose 'subjects', imprisoned within their frames on the wall, metaphorically alluded to the many forms taken by commercially motivated acts of relocation and domination.

If the video monitor anchored the work within the framework of its own context, the pages from the accompanying exhibition catalogue on view in one of the vitrines referred to the domain of language and typography. Using the phrase 'The art of fine printing' to demonstrate all kinds of typefaces, scripts and founts, Broodthaers allied his installation with the realm of language.[7] Believing that 'the language of forms must be united with that of words',[8] based on the idea that language serves as the essential unit of any true construction (and, by extension, in any re-forming of present reality), Broodthaers held out the hope for an art that might 'make a dent in the falsity inherent in culture'.[9] In the idealistic anticipation of a poetic reality founded on language rather than on pictorial illusionism, he endeavoured to maintain the 'value' of art, which he saw as being at risk of becoming mere commodity or decoration gratuitously 'deposited' in museums to adorn walls and rooms without reciprocally offering critical reflection.

The desire to liberate the word from its traditional subordination to the image is a primary, underlying theme of Broodthaers's oeuvre. As he innovatively established within his work in general, language, as a system of representation and reality unto itself, delivers art from the deception wrought by pictures. For Lawrence Weiner (American, born 1942), established for works based solely on words, language itself is not, as it was for Broodthaers, a subject for thematic inquiry in terms of pictorial representation. Quite differently, language provides Weiner with the material out of which his work is created.

More than a quarter of a century ago, Weiner reached the radical conclusion that words by themselves could serve in lieu of other materials typically associated with making art. Since 1968 he has exhibited works that rely on language's unique ability to be the 'substance' of the message conveyed. Weiner treats language as a means of construction and a way of imparting information about verifiable, empirical phenomena of all kinds. Each one of his phrases, however, leaves mental visualisation open-ended although each work is referentially precise. For example, the work MANY COLORED OBJECTS PLACED SIDE BY SIDE TO FORM A ROW OF MANY COLORED OBJECTS, 1979, included in

the Art Institute's '73rd American exhibition', dictates neither the number or colours of the objects in question, nor the length of the row, nor, for that matter, what the objects could be. Literal realisation, based on a viewer's own way of envisioning a particular piece, is always an option, but never a requirement, of his works.[10]

While the internal thematic content of individual works derives from the import of words, presentational format and context play a supporting role whenever a piece is shown. 'Art institutionalises itself',[11] Weiner has pointed out. Since the content of Weiner's work is formed by language, there are, theoretically, as many physical settings and spaces for placing one of his works as there are possible interpretations of it. Contrary to other objects of art, the same piece may be realised anywhere at any time and, if need be, in different locations simultaneously. As Weiner observed early on in connection with the open-ended, linguistic nature of his production, 'When you are dealing with language there is no edge that the picture drops off. You are dealing with something completely infinite.'[12]

Depending on the type of lettering used and on its placement, and depending on factors contributing to the nature of a work's given context, each installation yields a different visual result. Avoiding dictatorial pronouncements or authoritarian expression, Weiner's work fuses its semantic content with its given context. A particular work is never limited or confined to any one place of being but has the ability to engage verbally with its surroundings, whether institutional or not. His work, in fact, does not rely on or demand allocation to a particular site or even to spaces designated for art, but bonds with whatever its place of installation might be. When on display in the Art Institute, MANY COLORED OBJECTS . . . alluded to the arrangement of art objects on view in the – or any – museum while it engendered countless other possible images as well. By using language to create specific pieces with unspecified readings and the potential for ubiquitous placement, and by thus being able to shift the contexts in which his works are placed, Weiner not only alters the frames of reference through which they may be seen but also, in the final analysis, makes it possible for viewers to bring their own frames of reference to bear.

Since the late 1960s, John Knight (American, born 1945) has employed a plurality of representational means in order to generate a dialogue between a work of art and its site. In Knight's case, the site need not be specific to the physical location of the particular work and, in the instance of *Museotypes*, 1983 (fig. 13.4), conceived for an exhibition at the Renaissance Society at the University of Chicago and subsequently purchased by the Art Institute of Chicago, the site has been defined in terms of the museum in general and its role in society as a whole. For *Museotypes*, Knight brought together usually

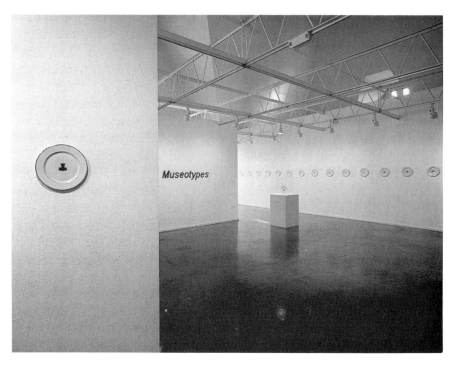

13.4 John Knight, *Museotypes*, 1983. Installation at the Renaissance Society at the University of Chicago, 1983. Collection of the Art Institute of Chicago. Photo: Tom Van Eynde

unrelated representational systems in a work comprised of sixty gold-rimmed, eggshell-coloured, bone china commemorative plates. Presented like a series of collectors' plates, they all possess small-scale, centralised, solid cobalt blue forms whose eccentric, abstract shapes, although appearing to be of a kind, are distinctly differentiated from one another. The title of the piece clarifies the fact that each shape represents the individual ground plan of one of sixty art museums around the world, which Knight has chosen for use as if they were emblematic trademarks or corporate logotypes.

The union of commemorative plate and museum ground plan-cum-logotype functions thematically on a number of levels while it investigates the boundary separating fine art from popular or decorative art. The commemorative plate, as employed by Knight, takes advantage of and discloses the common ground shared by 'high' and 'low' art alike, since it is simultaneously an image-bearing vehicle and, although mass-produced, exists in limited editions as a sought-after collectible that can be hung on a wall or over a mantelpiece to accent an interior decor. With the substitution of his so-called 'museotypes' for the imagery usually associated with collectors's plates –

ranging from historical sites to baseball heroes or from family crests to famous paintings – Knight ironically 'exhibited' and paid homage to the museum as the ultimate site of cultural display and approbation. Each museum, identified by its plan rather than portrayed as an architectural façade, serves literally as an abstract element of *design* at the centre of its plate and figuratively as the *sign* for both a particular building and for the art institution par excellence. Knight's museotype image, therefore, is at once a self-referential, site-specific and, it might also be said, a site-general, form connoting the culturally ordained bastion for housing, exhibiting and sanctioning works of art.

In its appropriation of a popular and commercial form of art, *Museotypes* deliberately treads, so as to question, the dividing line between high and low art and between the art object and the consumer object. Furthermore, the work refers to the interconnection between corporate operations and cultural institutions, which are generally thought to be separate. Because of the obvious reference to good business and selling techniques signalled by the graphic device of the logotype, *Museotypes* thus becomes 'a representation of the museum and its role in the culture'.[13] It bears witness to its own – as well as the institution's – reliance on the greater commercial context to which it, as a work of art, belongs and from which neither it nor the museum is exempt. While addressing the question of how aesthetic value is determined, *Museotypes* endeavours to extricate itself from that which it seeks to critique: the unique and precious object that merely depends upon rarity or nostalgic associations with the past, upon signs of authorial authenticity or expression or upon its decorative appeal, without, in turn, being able to voice its own situation in the culture.

Despite their visual and methodological diversity, the works of Buren, Asher, Broodthaers, Weiner and Knight on view at The Art Institute of Chicago in recent times all seek to comment on their institutional context within their material and thematic parameters while, furthermore, confronting the question of both perspectival and metaphoric illusionism. Through the various methods of their institutional critique and their self-reflexive awareness of their 'place' in the museum, they each reveal, in one way or another, unnoticed or invisible structures – from encompassing architectural elements to the market system – that contribute to their support.

Notes

1 Daniel Buren, 'On the autonomy of the work of art', in *Daniel Buren: around 'Ponctuations'*, Le Nouveau Musée, Lyon, 1980, not paginated.

2 See Buren, 'Critical Limits (1968–70)', *5 Texts*, John Weber Gallery, New York, and Jack Wendler Gallery, London, 1973, p. 45.

3 See also Benjamin H. D. Buchloh, 'Michael Asher and the conclusion of modernist sculpture', in Chantal Pontbriand, ed., *Performance, text(e)s & documents*, Montreal, 1980, pp. 55–65.

4 Marcel Broodthaers, 'Gare au defi: Pop Art, Jim Dine and the influence of René Magritte', in Buchloh, ed., 'Broodthaers: writings, interviews, photographs', *October*, 42, fall 1987, p. 34.

5 Broodthaers, 'Ten thousand francs reward', in Buchloh, p. 43.

6 *Ibid.*, p. 46.

7 For a full explication of the meaning of the catalogue pages as well as the text on the invitation card, see Yves Gevaert, 'Un Jardin d'hiver', in *Marcel Broodthaers: oeuvre graphique essais*, Centre Genevois de Gravure Contemporaine, Geneva, 1991, pp. 81–94.

8 Broodthaers quoted in Birgit Pelzer, 'Recourse to the letter', in Buchloh, p. 166.

9 Broodthaers, 'Ten thousand francs reward', p. 40.

10 According to the artist's statement that generally accompanies installations of his work, 'the decision as to condition rests with the receiver upon the occasion of receivership'.

11 Lawrence Weiner, in Robert C. Morgan, 'A conversation with Lawrence Weiner', *Realife*, New York, 31 December 1979, p. 36.

12 Weiner, in 'Art without space', WBAI-FM symposium, 2 November 1969, in Lucy Lippard, *Six years; the dematerialization of the art object form 1966 to 1972*, Praeger Publishers, New York and Washington, 1973, pp. 131–2.

13 John Knight, in conversation with the author, August 1983.

THE MUSEUM OF CONTEMPORARY ART,
LOS ANGELES: AN ACCOUNT OF COLLABORATION
BETWEEN ARTISTS, TRUSTEES AND AN ARCHITECT

Jo-Anne Berelowitz

SET INTO THE WALL in the lobby of the Museum of Contemporary Art is a large stone tablet commemorating the institution's origin and history. Etched into its surface is the museum's official story. It relates that:

> The Museum of Contemporary Art was conceived in Los Angeles in 1979. A group of citizens shared their visions with Mayor Tom Bradley who appointed a Museum Advisory Committee with William A. Norris, Chairman and Marcia Weisman, Vice Chairwoman. The Advisory Committee and the Community Redevelopment Agency subsequently came together to provide for the museum. The site would be provided by the Community Redevelopment Agency, construction funds by Bunker Hill Associates, and qualifying endowment funds by the museum's Charter Founders.

Leading players who guided the institution through its birth and formative years are honoured and acknowledged by name: founding chairman of the Board, Eli Broad; founding president, William A. Norris; inaugural chairman, William F. Kieschnick; inaugural vice chairman and chairman of the Building Committee, Frederick M. Nicholas; inaugural president, Lenore S. Greenberg; director, Richard Koshalek. The professional staff, the trustees and the supportive community are acknowledged more generally as collective bodies. Their contributions, we are told in the concluding lines, 'brought world attention to this young institution'.

By mapping a sequence of events from point of origin to dénouement (the transformation of a vision into a world-famous museum) the tablet's narrative effects a tidy coherence. But the representation, like all narratives, is a construction, an ordering of meaning, and its neat closure comes at the

expense of what it excludes. Certain key players were excluded from this account, most notably a core group of local artists who worked with passionate dedication for two years to bring to reality their dream of a Los Angeles museum of contemporary art. The following pages present their engagement with and subsequent peripheralisation from this project.

Los Angeles' lack of a museum of contemporary art was long felt to be a major lacuna in the city's cultural life. The city had, once, fleetingly during the 1960s, been host to a contemporary art museum. Or rather, the contiguous city of Pasadena had once had a museum that showed new and exciting American art. But its board of trustees embarked on an ambitious building campaign that bankrupted the institution, and in 1973 it was sold to Norton Simon, who turned it into a repository for his collection of Impressionist masters. Its demise left only the Los Angeles County Museum to showcase contemporary art; but the County is a general purpose 'universal' museum, and its department of contemporary art represents only a minor part of its overall operations. Thus, effectively from 1973 Los Angeles had no art museum that focused on contemporary issues, a situation that the local art community experienced as a severe lack in the city's cultural life and in the development of the careers of its members. Over the years a number of proposals had been made to rectify the situation, but they had come to nothing. Los Angeles seemed doomed to its characterisation as a 'cultural wasteland' whose only culture, as critics loved to point out, was in its yogurt. However, in 1979 a unique confluence of events reopened the possibility of a museum of contemporary art, and when local artists were alerted to them, they marshalled their energies to ensure that the possibility would become fact.

The reinvigoration of the idea of a museum came from prominent supporters of long-time city mayor Tom Bradley. In 1979 Marcia Weisman, a wealthy art collector, and William Norris, lawyer, political savant and recent art collector, independently suggested to Bradley that Los Angeles needed a museum of contemporary art. The suggestion resonated with Bradley whose political machine was then ambitiously transforming Los Angeles into a 'world city' that would assume authority as America's capital of the Pacific Rim. Recognising that 'world cities' offer culture as well as international trade and that a museum would further his internationalist ambitions, Bradley appointed a Museum Advisory Committee with Norris as chairman to look into museum possibilities and to investigate possible sites.

Offer of a site came from the city's Community Redevelopment Agency (or CRA as it is more generally known). Established in 1948 as a public body, empowered with the right of eminent domain (the allocation of land resources by a government agency for ostensibly public purposes), the CRA had a mandate to implement urban renewal in Los Angeles. Gaining power

under the Bradley regime, fuelled by the growth agenda of Bradley's power machine, the Agency interpreted its mandate to mean the transformation of a derelict downtown into the highrise-spiked megalopolis of Bradley's desire. In 1979 when the idea of a contemporary museum was resuscitated, the Agency was considering the disposition of 11.2 acres on Bunker Hill, prime real estate in the heart of the financial and legal centre of the city and adjacent to the Music Center, downtown's principal cultural facility. CRA consensus was that the land should be offered to a single developer as an integrated mixed-use project consisting of office towers, condominiums, a hotel, a cinema complex, restaurants, shops and a cultural element. Preliminary plans had been drawn, mapping out the disposition of the various components. At this point the cultural element had been conceived merely as a large box labelled CULTURE. As the largest redevelopment package ever offered to a developer, this was certainly the largest project ever undertaken in the twenty-one-year history of the twenty-five-square block downtown renewal area. Thus far, renewal had proceeded piecemeal, additively. There was nothing to pull the pieces together and the city still lacked a heart. A project of this magnitude could, if carefully orchestrated, supply downtown with its desired centrepiece.

In conformity with Agency stipulations, one and a half per cent of the total capital investment (a billion dollars) would have to be spent on fine art. When the Agency learned of the quest for a museum site, the dynamics of their project shifted and clarified: instead of spending the money on discrete art objects dispersed over the development's area, they would fund a museum. A major art museum in downtown Los Angeles would help solve the dilemma of how to transmogrify an agglomeration of highrises into a city with a meaningful core. The CULTURE box could now be assigned a *high* cultural function.

The Museum Advisory Committee met with the CRA and agreement was reached that the city would provide land and a building for the museum. The project developer (yet to be selected) would provide money to build a museum of approximately one hundred thousand square feet of interior space at an estimated amount of $16 million.[1] However, there would be no municipal funds for the museum's operating expenses. These would have to come from the private sector and would have to be raised by the museum advocates. Norris's task, now that he had a site and a building, would be to form a board of trustees who would raise a permanent endowment of at least $10 million, an amount adequate to generate 35–40 per cent of operating expenses.[2]

The first three million came in quickly. The first million was donated by Eli Broad, a multinational property developer who was then beginning to collect contemporary art. In return for his largesse, he was made founding chairman of the Board. The second million was donated by Max Palevsky, philanthropist, film producer and founder of a software empire. For his million

dollars he would become chairman of the Architecture Committee, over-seeing all matters pertaining to the museum's architecture. In a letter of 3 April 1980, he made his position quite clear to the museum's board of trustees: 'If, at some future time, the architectural decision is made on other grounds by other people . . . [he would] feel no obligation to the Museum.'[3] This con-tractual condition would reverberate at a later stage in the museum's history when Palevsky's control over architectural matters was, indeed, revoked. The third million was donated by a multinational oil conglomerate, the Atlantic Richfield Corporation. One of their highest ranking officers, William F. Kieschnick, soon to be their chief executive officer, joined MOCA's board of trustees and was later to be the museum's inaugural chairman.

By this stage the local artists had been drawn into the project. In late August they convened a meeting at movie producer Tony Bill's screening room in Venice Beach. About one hundred and fifty artists showed up and Mayor Bradley put in a brief appearance, asking the artists for their support and input. The room held Los Angeles's most prominent, successful and emerging artists including Sam Francis, Ed Moses, Tony Berlant, DeWain Valentine, Robert Graham, Chuck Arnoldi and Alexis Smith. Discussion was heated, and almost as many ideas were generated as there were artists to generate them. Eventually when they disbanded, agreement had been reached on only one point: that they would meet again. A second meeting was held a week later, in early September, with the participants now reduced to half their former number. But there was one notable new addition: light-and-space artist Robert Irwin, whose charismatic leadership would exercise a formative influ-ence on the nascent museum.

The meeting factionalised into two groups: those who viewed the project as an opportunity to design a spectacular building that would bear their sig-nature and in which they would showcase their work, and those who saw it as an opportunity to provide Los Angeles with what it had for so long lacked: a forum for the exchange and generation of artistic ideas, a venue hospitable to the diversity of its artistic citizenry. Los Angeles had long been home to the second largest artistic community in the world, but, unlike New York, it was a community dispersed over a wide geographic area, without a central focus to give it coherence and without a major facility to service it. In the conflict that now arose between personal ambition and enlightened awareness of a benefit for the greater whole, it was the latter constituency that prevailed, but not without a struggle. A temporary truce was established when a core group of about twenty artists from both sides of the dispute banded together to form the Artists Advisory Council, with the agenda of establishing the artists' goals and ideas for the new museum. It became apparent that the faction focusing on a museum that would itself be a work of art was outnumbered. Angered at

their loss of control, they stormed out of the meeting, which then collapsed. At that point it seemed unlikely that any agreements would be reached.

It was then that Irwin began to exercise the leadership role that he would sustain over the next three years. That evening he called every member of the Council, cautioning them that their effectiveness as a body was dependent on their maintenance of a united front. Most of the dissidents never returned, but the core group that did buried their differences and worked together for three years, meeting every Monday night from seven to midnight, debating ideas on what a contemporary museum should be, from curatorial policy to director-ships, architecture, fundraising, trustees, representation, social and political implications. Their discussions had wide-ranging effects on the eventual museum for they alone of the various constituencies engaged in the project understood the architectonics of museum design.[4] Local architect Coy Howard joined the artists as a consultant to provide professional expertise and to advise on issues pertaining to city planning.

By this time the CRA had begun to solicit proposals for the project from various developers. Competition for the project narrowed down to five developers: Bunker Hill Associates, a Los Angeles-based team that included Canadian firm Cadillac Fairview in a consortium with Los Angeles firms; Boston firm Cabot and Forbes; local investment builder Maguire Partners; Chicago-based Metropolitan Structures Inc.; and Olympia and York/Trizec of Canada and Los Angeles. As representatives of the Artists Advisory Council, Howard and Irwin attended various CRA meetings to familiarize themselves with the five developers, to examine their plans and understand their attitudes towards the projected museum.

It very quickly became clear to them that the CRA had only the vaguest notions about museum design. In contrast, the Artists Advisory Council held very clear ideas. Over a long series of intensive planning sessions, they had set down requirements for floor loads, heights of ceilings, loading docks, light-ing. Cognisant of their expertise, Norris invited them to participate in a work-shop to evaluate the five proposals. Carefully scrutinising all five plans, they recommended Maguire's as the most interesting and most favourable to the museum.[5] Ranked lowest on their list was Cadillac Fairview, seemingly not at all interested in the museum, for their design team, headed by Canadian archi-tect Arthur Erickson, had relegated it to the entertainment function of an Angeleno curiosity. Erikson had designed a structure cantered over the street, its angled walls transparent to passing motorists who would thus be able to view the art as they drove by, the world's first drive-by museum, uniquely adapted to the vehicular mode of the Los Angeles lifestyle! The artists hated it, but the CRA, driven by different considerations, thought otherwise. Impressed by Cadillac Fairview's claim to be able to pay for the entire project

in cash, the CRA held a public meeting on 14 July 1980, to announce Cadillac Fairview as the winning developer.[6]

The awarding of the contract to Cadillac Fairview was a tremendous blow to the artists, the first major hurdle they encountered in the attainment of their goals, for they all felt that a museum designed by Erickson would be a disaster, resulting in a building that would in no way be sympathetic to their needs. Their needs were threefold: the first was that the museum be actively engaged with the larger art community, as opposed to being a static repository of collections of already renowned, perhaps defunct, artists. For a long time the artists were filled with trepidation as to whether they would attain this goal, for it ran counter to a course on which the trustees seemed determined to steer the museum. Many of the trustees, themselves collectors, or aspiring collectors, conceived museums to be mirror versions of their own art-engagement, albeit on a grander scale. This difference in focus between the artists and the trustees can be understood in terms of a differential reading of the sign 'museum'. The artists wanted the institution to serve as an active forum for the exchange of artistic ideas; the trustees wanted it to signify 'collection'. Initially it seemed as if the will of the trustees would prevail, for they named the museum-to-be 'The Los Angeles Museum of Modern Art'. Since the period of historical modernism ended in the 1960s, that designation would have meant that the museum would show only dead or late-career artists; no emerging or mid-career artists would get in, nor active exchange of ideas take place. Choosing an appropriate name for the museum was thus a major issue. Robert Irwin and Sam Francis were able to convince the trustees to make the focus contemporary rather than modern, and so it was named the Museum of Contemporary Art.[7]

Their second goal tied in with their first, for the artists wanted a grass-roots director who would be actively engaged with the art community and share their values. However, they recognised that a grass-roots director would be unlikely to carry weight in the international arena and, since Los Angeles had been marginalised for so long, they were eager for their museum to achieve international prominence. For this they would need a director of international renown. Since no one could be both a grass-roots person and an art-world celebrity, they conceived the idea of a dual directorship. As Irwin expressed it:

> There was no single person who was Mr. Magic, who could do everything we wanted them to. We needed a young grass roots person and we needed a real superstar, someone with charisma and focus to draw people into [the project]. Sam Francis was a good friend of Pontus Hulten and I of Richard Koshalek. Best young museum person in the country, untried and untested. Couldn't have raised ten cents on his name! Hulten was an international star who had to report only to the President of France. A different ball game! Royalty! Sam felt Pontus

would be interested. Big question: could they or would they work together? Sam went and visited Pontus; I went and visited Richard. Richard was willing to take the secondary role. So basically Pontus became the front man and Richard came in as his executive. It worked. It knocked the art world on its arse, gave the whole thing a sense of scale. Dynamic![8]

Indeed it was. Pontus Hulten was then the most widely known museum director in the world, for since 1973 he had served as the founding director of the Beaubourg, the most talked-of museum in the world, where he had put together controversial, enormously popular shows that drew more than a million people apiece, many of whom had never attended art museums before. Prior to that he had been responsible, since 1953, for the planning and development of Stockholm's Moderna Museet, becoming its director in 1959, an institution known throughout the museum community for its lively and innovative programming. The fifty-five-year-old Hulten was impressive not only for his curatorial and directorial skills but also as a personality. A huge man, barrel-chested, athletic-looking, with shaven head, he possessed great charm, was renowned for his humour, had a reputation for being an artists' museum man, and was known and respected by collectors the world over.

The thirty-eight-year-old Koshalek's background was more modest. He had served as director of the Hudson River Museum in Yonkers for four years, during which he had managed to salvage the institution from a dire financial situation and turn it into a major local attraction whose programmes even New Yorkers deemed worth the visit. His first job had been at the Walker Art Center in Minneapolis where he had served under Martin Friedman, subsequently becoming curator. For much of his tenure there, the Walker was under construction, and Koshalek had learned to operate what he called 'a guerilla museum', engineering exhibitions without a building by staging them in unexpected sites such as department stores and vacant lots. The fact that MOCA did not yet have a building would in no way discourage him. After the Walker he had served as assistant director of the Visual Arts Programme for the National Endowment for the Arts, and then as director of the Fort Worth Art Museum where he had commissioned works and curated shows by contemporary painters and performance artists, as well as organising programmes on film and music. He was well known to contemporary artists, scholars and critics and had a reputation for being on the cutting edge of current art issues.

Again, the trustees adopted the artists' suggestions, and in August 1980 a public announcement was issued naming Pontus Hulten director of the new museum and Richard Koshalek deputy director. Irwin had been right, for the dual directorship did, indeed stun the art world, and the international art presses excitedly proclaimed the news. The appointments had enormous

strategic resonances, for until this point the museum's reality had existed primarily on paper as a negotiated agreement between the CRA, a developer, and a handful of people who were committed to making it happen. It still had no building and no collection. But now it had the most famous museum administrator in the world as its director. Suddenly Los Angeles no longer seemed the cultural wasteland that critics had loved to deride. Rather, it seemed poised as the new cultural capital of the West Coast, a construal that began with the appointment of Hulten and became more prevalent as the 1980s wore on. Of course, both construals – that Los Angeles was a cultural wasteland and that it was becoming the cultural capital of the west – are myths. But as Irwin astutely noted:

> Myths figure very big in these things. In fact, I felt that was one of the main strategies that we had. And that was the other thing the artists talked about and I tried to talk to the board about: that what we had going for us was a myth: this myth of the West Coast, true or untrue, the myth that the world was moving west, that the east was getting old. It had moved from Europe to the East Coast and now it was going to the West Coast and then off to the Pacific. I love the idea! The thing with MOCA was: we had a myth on our hands. First, we had no collection, no building. We had nothing! But once we got Pontus, we had this thing rolling and it was this great myth. It catalysed everything! When you think about it, for the first six, seven years there was literally nothing there [on the site that MOCA was to occupy]. No substance whatsoever. Which, by the way, is an advantage, because when you're building a myth, the minute you have to reveal the thing, it's not as good, because it never is. We rolled the dice at it. Artists should know about myth-building, because we're in the myth-building business. That's not *what* we do, but it's certainly an extension of what we do; because when you speak about changing the nature of perception, changing the nature of reality, you're playing with people's myths . . .[9]

And that is precisely what they did. MOCA's history has always been more than the sum of a piece of real estate added to a deal between the CRA and a developer, added to a building with collections and a curatorial agenda. Rather, it has been about dreams, visions, ambitions. Clearly, the artists understood this very well in terms of establishing their own goals. Mayor Bradley, city planners, developers and boosters (promoters of urban development projects) have understood it very well in terms of theirs. Viewed from a panoptic perspective, MOCA was always a project designed to change the nature of perception about Los Angeles, a device for the re-visioning of the city. But not all of the dreams could come true, for artists, trustees and city boosters dream very differently. MOCA would thus become a site and cause of struggle, as rival dreamers battled over whose vision would prevail.

Initially, however, the different interest groups worked together and the trustees were amenable to the artists's suggestions. After recruiting Pontus Hulten and achieving the dual directorship, the artists felt that the museum's stature would be further served by internationalising the board of trustees, and again the board adopted their suggestion. And so a select cadre of superstar collectors was solicited: Dominique de Menil, Count Guiseppe Panza di Buomo, Peter Ludwig and Seji Tsutsumi. All had had considerable experience serving as officers of major museums scattered across the globe. Their recruitment was another brilliant strategic move that kept the museum in the heat of the international spotlight. Both Hulten's appointment and the election of an international board of trustees were very effective in catalysing fundraising, for MOCA was now the hottest club in town, and everyone wanted to join. In the words of one participant:

> At a certain point it became an unbelievable thing. I mean people were driving up in wheelbarrows giving money. You couldn't even stop them from giving. Everyone wanted to be on the initial patrons' list. The dump truck kept coming. It became the thing that everyone did. There was a whole series of parties and dances. People became involved. Once they were involved, they wanted to be more involved because it seemed like a fun thing to be involved with.[10]

The PR was brilliant and the community responded. The artists were as involved in fund-raising as the trustees, hosting dozens of fund-raiser parties. By the end of 1980 the endowment campaign was within a couple of million of attaining its goal. The next big challenge would be the architecture; and it was here, more than with any other issue pertaining to the museum, that the artists felt that a great deal was at stake. Their paramount goal was to design a building that met their needs. It was, unquestionably, the most difficult goal to attain.

The history of MOCA's building, or, more accurately, buildings, is a complex one. At around the time of the selection of a developer, an Architecture Committee was formed. Headed by Max Palevsky (who had stipulated control of the design as the condition of his million-dollar donation), its other members were artist-representatives Robert Irwin, Sam Francis and Coy Howard. Later they were joined by Pontus Hulten. The artists were able to convince Palevsky and the CRA that any design by Erickson would foredoom the museum to failure. They wanted to select their own architect, someone of international renown willing and able to work with the artists as members of a design team. The architect's personality thus became an issue, for they needed someone who could set aside ego and 'signature' in favour of teamwork, who was open to discussion about the appropriate relationship between art and architecture in a museum building. The artists knew that they

would have to make their participatory goals very clear, establishing an architect's acceptance of them as a primary condition of employment. After some deliberation they narrowed their choice to six internationally-renowned architects: Sir James Stirling, Kevin Roche, Frank Gehry, Arata Isozaki, Richard Meier and Edward Barnes. In the autumn of 1980 the Architecture Committee set off on a series of international travels to interview the architects and to inspect museums and other facilities designed by them.

Their choice fell upon Japanese architect Arata Isozaki, a close friend of committee member Sam Francis. Isozaki's résumé included the design of two major museum buildings: the Kitakyushu City Museum of Modern Art and the Gunma Prefectural Museum, both in his typical signature style that combined an aggressive sculptural quality with a repetitive expression of square modules. It was not, however, his museums that appealed to the Architecture Committee, but his factories, which had a bare-bones kind of beauty, very straightforward, with minimal detail, precisely what the artists had in mind. They felt that Isozaki understood their sensibility and that they would be able to work together. In January 1981 Isozaki was named the architect of the Museum of Contemporary Art.

However, the committee soon became unhappy with Isozaki: he did not conform to specified deadlines, attend scheduled meetings or visit Los Angeles when his contract stipulated. More seriously, the committee began to question his basic ability to do the job. As a result of the many meetings of the Artists Advisory Council, the Architecture Committee had a very clear understanding of how they wanted the new museum to be, and Isozaki seemed not at all interested in their specifications. They found his interior plans unworkable, for his galleries related awkwardly, little consideration had been given to the movement of people through them, columns blocked viewing lines, doors interrupted primary exhibition halls, loading-docks were too small to accommodate artworks and skylights were inadequate. More serious yet was a fundamental difference of approach: the committee's principal focus at this stage was on the *internal* spaces of the museum; they wanted to design it from the inside out, to produce an interior plan that would work effectively as a museum, and then, after that task was accomplished, to make it look like a great building on the outside. Isozaki wanted to begin with the façade, to design it in his own personal style or 'signature'. His priorities, in other words, ran directly counter to those of the committee.

In the spring of 1982 the situation hit crisis point when Isozaki presented yet another model that the committee found unacceptable and that ignored their guidelines. Once again, they felt that the architect had focused his energies on the façade at the expense of the functional organisation of internal spaces. The façade was, indeed, distinctive: Isozaki had dressed the buildings

in Indian red sandstone, and had angled and elevated the structure that housed the library and board room, so that it served as a gateway. In conformity with his love of geometric volumes, he raised the pyramidal skylights above the southernmost galleries, so that the façade read as a dialogue between geometric forms. While the committee found little to like, the developer and CRA were delighted with the model, for they felt that its signature style would benefit the overall project and turn it into a landmark, enhancing all of downtown by its distinctiveness. But the committee, more intent on creating a venue for art than a monument for downtown, sent Isozaki away to redraft the design, imposing on him the condition that unless he followed their recommendations, they would fire him.

In late March he returned with a design that adopted the artists' blueprint and that basically followed their guidelines: clearly articulated, austere, functional spaces with high ceilings and plain floors; a disposition of galleries that could host two concurrent but unrelated exhibitions, each with its own entrance; loading docks that could easily accommodate outsize contemporary artworks; skylights that maximised the natural light. The exterior was now a plain warehouse-like façade that faced across a sunken plaza to another equally plain structure that had been stripped bare of its pyramids. The low, box-like buildings resembled the industrial warehouses that house so many artists' lofts and in which so much contemporary art gets made. It conveyed the message that the art inside would be art-in-process. It was, in short, the ideal, quintessential, contemporary artist space. There was no longer any trace of the architect's forceful signature style.

The committee was at last satisfied. In celebration, the museum's board of trustees invited the press and their founding members (who now numbered in the several hundreds) to a balloon-lined reception on Grand Avenue (the future site of the museum) to eat fruit off the asphalt and to view the architectural models. It was to be another fun-filled MOCA affair, but one of the guests was not in a party mood: Isozaki. Profoundly unhappy with the model he had felt constrained to produce, he drew the press aside to tell them how little he liked it, how disappointed he was at its selection, how much he preferred his earlier, rejected January model. He told them that he had been forced to adhere to the committee's guidelines 'or be fired'.[11]

The press now leapt into the fray and attacked the Architecture Committee for imposing restraints on an architect of such international renown, framing the issue in terms of an architect's right to artistic autonomy. MOCA, so long the darling of the press, now received its first negative publicity. The Architecture Committee, now under attack, decided to discharge Isozaki from his primary role as architect, retaining him as design adviser only. Accordingly, Palevsky wrote to the architect informing him of his dismissal.

This action served only to fuel the press, and the Board of Trustees, anxious to avoid additional fallout, moved quickly to contain the crisis. On 3 May 1982, they held a meeting to discuss the issue. Of all the principals involved, Isozaki commanded the most international stature, with the possible exception of Sam Francis, who was, in any event, aligned with Isozaki. A majority of the members felt that public support for Isozaki, both local and international, was now so strong that to fire him would alienate potential donors, and since the museum was in the midst of a major endowment campaign, it could ill afford to ignore public opinion. The board decided to retain Isozaki, granting him licence to design his own façade. Their action effectively absolved Isozaki of blame which was, instead, levelled at the Architecture Committee which they disbanded, replacing it by a Building Committee without artist representation. The artists thus lost the ability to further affect the physical form of the space that had once held their hopes and aspirations. They were now effectively out of the design process.

Palevsky too, became marginalised. Since he had lost control of the architectural process, he felt that the board of trustees had contravened the contractual agreement he had spelled out when he had pegged his million-dollar donation to his continued authority over architectural decisions. He felt that he was now freed from any further financial obligation to the museum and that moneys already contributed should be returned to him. In 1984 he filed suit against the museum. Once again, MOCA was the subject of negative publicity.

Although the Isozaki-designed building was not to open until December 1986, MOCA began hosting exhibitions and functioning as a museum in November 1983. Original plans had been for Isozaki's building to open in time for the 1984 Olympic Games (which Los Angeles hosted), but it rapidly became evident that this deadline would not be met. The Artists' Advisory Council was keenly aware that the public's support of the museum could not be sustained over a protracted gestation, and so they persuaded the board to establish an interim facility in which the museum could begin its operations. In addition to sustaining the interest of patrons, the establishment of a temporary space had other advantages: it would carry none of the strictures on decorum that a $16 million edifice would be bound to impose; it could be experimental and lively, for the trustees, fixated on the monument on Bunker Hill, would cast a more lenient eye on the affairs of a temporary venue.

An abandoned warehouse in Little Tokyo was selected as the temporary facility. Local architect Frank O. Gehry was entrusted with its renovation, budgeted to cost one and a half million dollars. Sensitive both to the needs of the artists and to the inherent qualities of the raw space, Gehry

kept his interventions to a minimum. 'My job', as he put it, 'was not to screw it up.'[12] What he did was clean it up: he steam-cleaned the redwood ceiling and perforated it with skylights and a clerestory; put in huge plate window-and-door entrances; enlivened it with ramps and concrete stairs; brought the electricity, plumbing and accessibility to current standards; painted the concrete floors and wall partitions silvery grey, and added movable white backdrops to accommodate artworks. Leaving the façade unaltered except for the new entrance doors, he erected a canopy of steel and chain to create a pedestrian plaza. The result was stunning: 45,000 square feet of exhibition space,[13] copious and flexible enough to accommodate almost any artwork, it looked like an expanded version of an artist's studio loft and was, indeed, exactly the sort of facility that the artists were trying to convince Isozaki to create (fig. 14.1).

The Temporary Contemporary (or TC as it is more commonly known) opened to the public on 23 November 1983, and was a huge and instant success. It was every artist's dream of how a contemporary art museum should look, and it so enthralled the public that questions were raised as to whether a second facility on Bunker Hill was now rendered superfluous.[14] Perhaps it was, but so much money had already been invested in the project on the hill that no one meant seriously to repudiate it. Critics who raised the question immediately answered it by acknowledging that the two buildings could serve very different functions. Such, indeed, was the hope of the artists, for it was now evident that they would have little further input on the design of the building on Bunker Hill. The Temporary Contemporary could answer to their needs, while the building on the hill would satisfy the trustees' and developer's conception of a downtown museum in a major metropolitan area.

14.1 The Temporary Contemporary (TC), Los Angeles. Photo: Squid & Nunns

The opening exhibition in the temporary facility met the artists' highest hopes: it involved no collection, was ephemeral, experimental, site-specific, multi-disciplinary and commissioned works from active, mid-career artists. Entitled 'Available light', it was a collaborative performance piece by New York choreographer Lucinda Childs, Los Angeles architect Frank Gehry and San Francisco composer-in-residence John Adams. Gehry constructed the seating arrangements and the stage across which Ms Childs's dancers performed their stripped-down ballet to John Adams's music for synthesiser. In spite of their disappointments with the design process on Bunker Hill, the artists felt that their dream might still come true, for the show seemed to augur an institution whose spirit was of the laboratory, not the embalmer. MOCA would be a space for lively interaction between engaged artists, not a mausoleum in which to worship the canonised.

But 'Available light' was followed by 'The first show'. Featuring the treasures of eight prominent collectors, it was a showcase of modernist masterpieces, a celebration of acquisition, of traditional museological activity. Five of the eight collectors – de Menil, Ludwig, Panza, Rowan and Weisman – were MOCA trustees, and the exhibition honoured them and, by implication, all who collected on such a scale. The exhibition's very title, 'The first show', negated its more experimental predecessor, 'Available light', while its theme placed a premium on collecting and collectors. If one of its curatorial premises was to woo trustee-collectors into donating their work to the new institution, then it was an undisputed success, for Taft and Rita Schrieber (among the eight collectors honoured by the show) later bequeathed their collection to MOCA, which also acquired Panza's extraordinary ensemble of abstract expressionist and pop art for the bargain price of $11 million. Acquisition of this prized collection focused MOCA's Janus-faced ambivalence more firmly in the direction favoured by the trustees, making it less a forum for the exchange of artistic ideas than a repository for acknowledged great works.

In November 1986 the Isozaki-designed building was officially opened, first to a selected cadre of invited guests, then to the general public (fig. 14.2, 14.3). The press and museum professionals immediately proclaimed it as a master-piece. It was, indeed, a signature building, bearing the unmistakable stamp of Isozaki. The internal spaces, however, carried the stamp of the artists' recommendations; once they had been ousted from the process, Isozaki had adopted their blueprint. The large stone tablet recounting the museum's history was cemented prominently into the lobby wall for all to read, fore-grounding the trustees, eliding the artists who were not only not acknowl-edged for their contributions but who had watched their dreams and hopes for a different kind of museum slip away. Their comments on the experience serve as coda to this narrative:[15]

14.2 The Museum of Contemporary Art, Los Angeles. Photo: Michael Moran

Of course, the big battles came with the architect. We wanted a building that was like the Temporary Contemporary . . . We were really scared and scornful of the edifice complex. The building there on Grand Avenue is fine, but my heart as well as that of most of the artists in this town is with the Temporary Contemporary space. I don't know, I don't know what to think of the experience.

Isozaki, that building that he did. I mean, it was a political building. It was purely a product of politics. He came in here, and I remember, we had meetings with him when he was in the process of designing the building, and he didn't give a shit about our ideas, Well, I don't blame him, because he envisioned himself as being an artist, which he is. I don't want other people telling me how to paint a painting, so he doesn't want other people telling him how to build a building. The difference is: he accepted as a premise that there would be a dialogue with the artists. Then he said: Piss off. I think he just allied himself politically with those who had power to support his position, and then just basically pushed everybody aside.

Once the principals, the board of trustees, came into play, it was obvious that we weren't going to do anything, because they were going to run it the way they

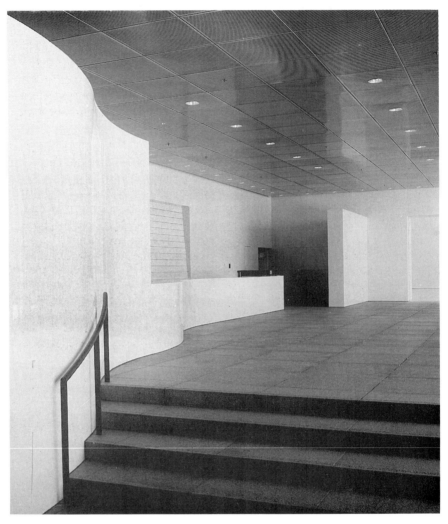

14.3 The Museum of Contemporary Art, Los Angeles, Monroe curve in main entrance lobby

wanted to run it, and they weren't interested in asking us or involving us in any way. There was no recognition of our involvement. None. Personally, I have very negative feelings about the place, because of that. Basically, this is a place that's used as a tool to further the careers of whoever's involved with it.

We wanted this to be an institution for artists, and whoever worked on it would work with us, and it was not going to be dominated by boards of trustees and by the architectural edifice complex and the inflexibility of the art market and international mandates . . . Basically, we wanted power! God! Artists don't ever have any power in something like this because you have to have funds and you

have to have money and you have to have support from the community and a lot of artists on the committee were people like me, who are social outsiders.

We wanted it to be much more fluid. I think Irwin's fantasy – and I think maybe it was shared subliminally by a lot of us – was, we sort of pictured this *bubble* that would kind of bulge one way when we wanted it to, and bulge another way when we wanted that. That it would be this real *fluid* kind of thing in which artists could come and go and do their thing, and it wouldn't just fossilise itself as museums do.

It really got disappointing to me when I realized it was going to be a big fancy building.

I think there was a certain point that we all bit the bullet and understood that in any public facility the developers, oddly enough, were the ones in power. To swallow all of that is real painful when you're an idealist. I think Los Angeles is a very hard city to be an idealist in. It has such movie star tendencies to look at things as glamorous. I don't know how we would ever be able to overcome that image in this culture

The doors started to shut very clearly and definitely on the artists as soon as there was a board of trustees. Historically, patrons consider the artists at best second-class citizens. My contention has always been that if dealers and patrons could possibly get the art without having to deal with artists, that would be their ideal world.

Notes

1 This amount, calculated in 1979/80 dollars, was indexed to inflation, so that the final dollar amount was calculated to be $22 million.

2 The remaining balance would come from memberships, admissions, grants and other sources.

3 Letter from Palevsky to Broad, dated 3 April 1980.

4 Key members included Robert Irwin, Sam Francis, Alexis Smith, Karen Carson, Tom Wudl, Peter Alexander, DeWain Valentine, Vija Celmins, Lita Alburquerque, Melinda Wyatt, Gary Lloyd, Peter Lodato, Fred Eversly, Robert Heinecken, Joe Fay, Roland Reiss and Guy Dill.

5 The Maguire Thomas proposal was also ranked first by local architectural critics.

6 Irwin tells how, at a pivotal meeting, the Cadillac Fairview representative 'whacked his hip pocked with the flat of his hand and exclaimed: "I can pay for this project out of my hip pocket."' Norris describes the same event as 'the deep pocket strategy of Cadillac Fairview'. Cadillac Fairview was the dominant partnership in an association known as Bunker Hill Associates. They subsequently went bankrupt and their role in the consortium was assumed by Metropolitan Structures Inc.

7 The name was changed on 11 July 1980.

8 Robert Irwin, interviewed 16 June 1990.

9 Irwin, interview.

10 This interviewee has requested anonymity.

11 Reported by Joseph Giovannini, *Herald Examiner* architecture critic, 'Dispute over design for the Museum of Contemporary Art', *Los Angeles Herald Examiner*, 29 March 1982.

12 Quoted in Pilar Vilades, 'The undecorated shed', *Progressive Architecture*, March 1984.

13 About 9,000 more than the permanent facility.

14 For example, William Wilson, art critic for the *Los Angeles Times*, wrote: 'No sooner was the place launched . . . than the voice of the people spake unto the fates, saying "This is terrific. Who needs a fancy new museum building up on Bunker Hill, even by so distinguished an architect as Arata Isozaki, when we have this urban miracle' 8 December 1984.

15 These statements were made by artists who served on the Artists Advisory Council. The interviews occurred from June 1990 to October 1990. For obvious reasons I have not revealed their identities.

Notes on contributors

Jo-Anne Berelowitz is Assistant Professor of Art History at San Diego State University, USA. She writes on museums, art issues in southern California, and urban development. Her articles have appeared in *Genders* and the *Oxford Art Journal*.

Christopher Brookeman is Principal Lecturer in English and American Studies in the School of Languages of the University of Westminster, England. He is author of *American culture and society since the 1930s* (1984). He is currently researching the impact and origins of mass production and has recently published an article entitled 'Pencey preppy: cultural codes in *The catcher in the rye*', in *New essays on The catcher in the rye*, ed. J. Salzman (1992).

Annie E. Coombes is Lecturer in the History of Art and Cultural Studies at Birkbeck College, University of London, England. She is co-editor of *The Oxford Art Journal*, and author of *Re-inventing Africa: Museums, material culture and popular imagination in late Victoria and Edwardian England* (forthcoming, Yale University Press).

Christoph Grunenberg studied in Mainz, Berlin and London. He received his Ph.D. from the Courtauld Institute of Art in London, has worked at the National Gallery of Art in Washington DC, and is currently Assistant Curator at the Kunsthalle in Basel, Switzerland.

Serge Guilbaut is Professor of Modern Art History at the Canadian University of British Columbia in Vancouver. He studied and received degrees at the University of Bordeaux and the University of California, Los Angeles. He is editor of a number of books, among them, *Modernism and modernity* (1982) and *Reconstructing modernism* (1990). Guilbaut is author of *How New York stole the idea of modern art* (1983). He is currently at work on a book about cultural exchanges between Paris, New York and Montreal in the 1940s and 1950s called *The spittle, the square and the (un)happy worker*.

Jonathan Harris is Senior Lecturer in Art History at Leeds Metropolitan University, England. He is co-editor of *Art in modern culture* (1992) and co-author of *Modernism in dispute: art since the 40s*. His Ph.D. will shortly be published as *Nationalizing art: the federal art project in New Deal USA 1935–1943* (Cambridge University Press).

Marcia Pointon is Pilkington Professor of History of Art at the University of Manchester, England. She is editor of *Art History* and has published extensively on eighteenth- and nineteenth-century European visual culture. Her most recent books are *Pre-Raphaelites re-viewed* (editor and contributor, 1989), *Naked authority: the body in western painting 1830–1906* (1990), *The body imaged* (edited with K. Adler, 1993) and *Hanging the head: portraiture and social formation in eighteenth-century England* (1993).

Louise Purbrick studied at Portsmouth Polytechnic and, for her Ph.D., at the University of Sussex. She is a Lecturer in the History of Art and Design at Manchester Metropolitan University, England. She has published on early computer design in the *Journal of Design History* and is currently working on a cataloguing project of the nineteenth-century portraits in Manchester Town Hall.

Anne Rorimer is an independent art historian and curator who specialises in the postwar period with an emphasis on the 1960s and 1970s. She lives in Chicago, USA, where she was formerly a curator at the Art Institute. Having initially worked on a curatorial basis with the artists included in the present essay, she has subsequently written comprehensive articles on their work and the work of others of their generation for journals and exhibition catalogues. Currently she is co-organising an exhibition of the period associated with conceptual art for the Museum of Contemporary Art, Los Angeles, entitled *1965–1975: reconsidering the object of art*, scheduled to open in 1995.

Karen Stanworth studied for her Ph.D. at the University of Manchester, England. She has published on eighteenth-century portraiture in *Art History* ('Picturing a personal history: the case of Edward Onslow') and has contributed to *Dance and society in Canada* (ed. Selma Odom and Mary Jane Warner, forthcoming). She lives and teaches in Toronto, Canada and is engaged in research on the relationship between rhetoric, representation and visual culture in colonial politics.

Juliet Steyn teaches cultural theory in the School of Fine Art at the Kent Institute of Art and Design, Canterbury, England. She has published in the *Oxford Art Journal*.

Brandon Taylor is Professor in the Department of History of Art at Winchester School of Art, England. He has written widely on modern art and is the author of *Modernism, postmodernism, realism* (1987), the editor (with Wilfred van der Will) of *The Nazification of art: art, design, architecture, music and film in the Third Reich* (1990), the author of *Art and literature under the Bolsheviks: cultural policy and practice in the Soviet Union, 1917–1932* (2 vols, 1991, 1992) and editor (with Matthew Cullerne Bown) of *Art of the Soviets: painting, sculpture, architecture in a one-party state, 1917–1992* (1993). He is currently working on a book on art and its audiences in London.

Colin Trodd studied at the University of Sussex where he wrote his Ph.D. on 'Formations of cultural identity: art criticism, the National Gallery and the Royal Academy 1820–1863'. He teaches the history and theory of visual culture at Sunderland University, England. He is currently engaged in a study of the articulation of value in Victorian art criticism and the representation of labour in nineteenth-century painting.

Alan Wallach is Ralph H. Wark Professor of the Fine Arts and Acting Director of the American Studies program at the College of William and Mary, Virginia, USA. He writes frequently on museums and on nineteenth-century American art, and was co-curator of 'Thomas Cole: landscape into history' which will appear at the National Museum of American Art, the Wadsworth Atheneum and the New York Historical Society in 1994–5.

Index